T

# NEW
## THE BiG
## BOOK OF
## LAYOUTS

**COLLINS** DESIGN
*An Imprint of HarperCollins Publishers*

For information, address Collins Design, 10 East 53rd Street, New York, NY 10022.

HarperCollins books may be purchased for educational, business, or sales promotional use.
For information, please write: Special Markets Department, HarperCollins*Publishers*,
10 East 53rd Street, New York, NY 10022.

First published in 2010 by:
Collins Design
*An Imprint of* HarperCollins*Publishers*
10 East 53rd Street
New York, NY 10022
Tel: (212) 207-7000
Fax: (212) 207-7654
collinsdesign@harpercollins.com
www.harpercollins.com

Distributed throughout the world by:
HarperCollins*Publishers*
10 East 53rd Street
New York, NY 10022
Fax: (212) 207-7654

Book design by Anderson Design Group, Nashville, TN.
www.AndersonDesignGroup.com

Library of Congress Control Number: 2010920531

ISBN: 978-0-06-197011-5

Produced by Crescent Hill Books, Louisville, KY
www.CrescentHillBooks.com

Printed in China
First printing, 2010

TABLE
OF CONTENTS

NEW
THE
BiG
BOOK OF
LAYOUTS

## JOEL ANDERSON

JOEL ANDERSON_ is an Emmy-winning designer and current owner of Anderson Design Group in Nashville, Tennessee. Since 1993, his firm has focused on branding and publication design for clients such as Golden Books, National Geographic, DreamWorks, Universal Studios, Capitol Records and others. A graduate of the Ringling School of Art & Design, Joel paints, gardens, and has written and published 11 books. Joel lives with his wife and four children in Nashville, TN. In his spare time, he creates classic poster designs & gifts for **www.SpiritofNashville.com**.

# Anderson Design Group, *Owner & Creative Director*

Depending on where you are in your design career, the term "layout" may mean different things. If you are just getting started, it refers to what you do with your heart and soul during each creative effort. (You lay out everything you are—and ever hope to be—only to have your boss or client trample it wearing spiky shoes.) For the seasoned designer, you have discovered that "layout" refers to the boundaries that have been laid out for you to work within each time you take on another design assignment. These are immovable markers like budgets, due dates, printing specs, (and maybe even the client's wife's personal taste.) After 24+ years in design, I love it when boundaries are clearly laid out. With clear parameters set, I can get to work devising ways to communicate visually on an informational and emotional level, arranging words and pictures into layouts that meet the client's objectives and sometimes even win awards.

I always start with the facts. What is the core message? Who is the target audience? Who is our competition? What is the budget, and when is it due? Then I get inspired by looking at work done by other designers. Let's see... research, inspiration and oh yes, caffeine. Then I'm ready to start arranging text and imagery on some sort of surface. (When I graduated from art school in 1986, I used a knife, galleys of type-set copy and a Rapidograph pen at a drawing table.) In the 90's I began arranging words and pictures on a Mac. Today, because so many folks who have a computer fancy themselves to be designers, I combine old-school illustrative and typographical techniques with the computer to make my work stand out in the crowd.

*A good layout is a visual communications tool. It gets noticed. It also must inform, allure, and convince someone to act. It starts with skillful and creative handling of typography and imagery.* As the designer, it's your job to find or create the right fonts. The same goes for photos and illustrations. All the Photoshop tricks in the world won't improve a layout that contains poorly selected type or images.

A great layout draws the eye to the right place and moves the viewer to see things in the proper order. Emphasis is added by careful selection of color, contrast, texture, size and placement of the various components. A masterful layout creates a level of clever playfulness by using positive and negative space— the design elements and the background on which they appear—to tie all of the elements together.

*In design, form must always follow function.* An effective package design or book cover must first communicate what the product is, then start convincing you why you should pick it up, and ultimately, why your life will be better once you buy it. Form (fonts, colors, imagery and arrangement) follows function (the message and objective.)

For example, the form of a layout for an energy drink label must follow the function—which is to grab a young male's attention and make him feel like he will hear heavy metal music in his head and live fearlessly and without limits as soon as he consumes this beverage. *To achieve the marketing objective, the form (fonts, colors and imagery) would need to convey motion, energy, and raw power. The emphasis should be on the brand and snappy tag line, (not on the ingredients panel.)*

When you think about it, good layouts are not just confined to graphic design. A beautiful garden speaks to the soul and draws you in for a stroll. A well-designed kitchen ends up being the center of home life when functionality, accessibility, space, color, proportion, and arrangement work together. Even a great song has an effective layout.

Where do you get ideas for great layouts? Inspiration is everywhere. I see examples of good (and horrific) layouts every time I go to the grocery store, bookstore, or drive down the street. Your next great layout idea will probably happen as you observe the design that permeates our culture, and as you absorb the genius of other successful designers, such as those featured in this book. When you re-apply that inspiration within the boundaries of your next design challenge, you just might create a great layout.

## KATIE JAIN

KATIE JAIN_ Born and raised in the Pacific Northwest, Katie Jain came to San Francisco to study design at the California College of Arts and Crafts. She began her career at Templin Brink Design, where she created work for clients such as American Eagle Outfitters, Peace Cereal, Quiksilver and Williams-Sonoma. Then, with Joel Templin, she co-founded Hatch Design, a San Francisco based branding and graphic design firm centered on one powerful idea: the best design is honest, hands-on and human. At Hatch, they have created award-winning work for global companies including: Apple, Coca-Cola, GE, Johnson & Johnson, Harrah's, Hilton, Starbucks and many others, as well as launched their first hatchling, JAQK Cellars.

Katie's design work has been recognized for excellence in virtually every major branding and design competition around the world. She is an active participant of the San Francisco chapter of the AIGA and is regularly invited to address design, advertising, educational, and business organizations across the U.S., and is a frequent judge of design competitions. Katie's firm, Hatch, recently received an important distinction from the graphic design publication, Graphis, as one of the "Top 45 Branding Agencies in the U.S." In 2008, Katie was selected as a "Person to Watch" within the design industry by Graphic Design USA.

# Hatch Design, Owner & Creative Director

As vehicles for communicating vast amounts of information, layouts are one of the most important outputs of graphic designers, writers and marketers. The New Big Book of Layouts, with its diversity of categories and depth of examples within each (particularly the case studies), will be a useful reference and resource for anyone tasked with the challenge of communicating through type, image and color on the page or screen.

The mark of a great layout is two-fold:

First, layouts should be clear and organized. This allows readers to access and decipher the entire story without getting frustrated or sidetracked. *A strong grid should provide the foundation for words and images, as well as a natural flow for typography.* This allows you to lead the reader through the page. In essence, a proper grid directs the reader's eye, and tells them where to look first, then next, and so on.

Too many large focal points cause visual confusion, and are always a sign of a poorly planned layout.

At Hatch Design, we often look to the grids of Brockman, Tschichold and other modernists when beginning a layout design. Sometimes, the design is inspired from an old poster layout from our collection of found ephemera, or an advertisement from our library of vintage design annuals. I also recall an exercise from a Typography class in school: we were asked to create a sketch of a random scene in nature, then use that sketch to inform a grid with pencil and tracing paper. Using an Exacto blade and ruler, we began formatting a page by gluing lines of text on the grid—columns and margins all working to hold the story together. The placement of every piece of type (down to the page marker), played an important role in structuring the design grid.

Whatever a designer's starting point, learning and practicing the basics of a strong grid, rich in contrast and scale, can never be under-emphasized. In the first few pages of your book or on the first screen of a website, you are introducing your grid to your readers. *Headlines and section dividers, call-outs and captions all provide the tools for navigation.* Readers, in turn, learn your method of communication and depend on the system given them so they can easily navigate through chapters. They develop expectations regarding where to find certain information. *Pauses, breaks, and scale changes help with pacing, while typographic hierarchy emphasizes the big idea over the nitty-gritty details.*

A functional, perfectly organized grid is not enough, however. It also has to be interesting, beautiful or surprising in some way to make the layout more engaging. Knowing when to break out of the grid or combine type and image in unexpected ways is the second component necessary for making a great layout. It creates a dynamic tension that motivates readers to dive further. What's the difference between a good layout and a great one? The best designers set a clear, organized pace—then disrupt it every so often with an infusion of creativity.

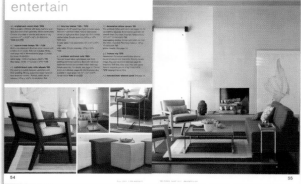

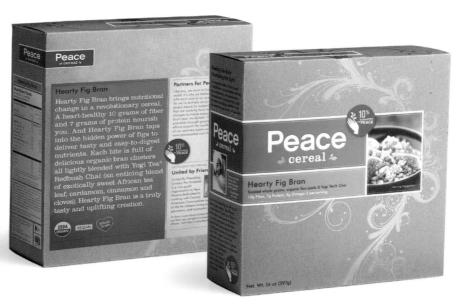

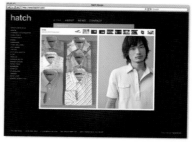

## ERIN MAYES

ERIN MAYES_ has worked as an art director and designer for over 20 years and has served in this capacity for Pentagram, Danilo/Black Inc., Roger Black Consulting, *Men's Journal*, Village Voice, *Washington Post*, and Whittle Communications. Her clients have included J. Crew, Random House, Reader's Digest, HOW magazine, The Museum of Fine Art, Chronicle Books, and Society of Illustrators.

Since leaving Pentagram in 2006, she founded Em Dash LLC, a graphic design firm in Austin, Texas. Her clients include Society of Illustrators, University of Florida, Simon & Schuster, Random House and others.

Erin has received awards from AIGA, the Society of Publication Designers, the Type Directors Club, Print magazine, and American Illustration.

Erin currently teaches advanced visual design at the University of Texas at Austin.

# Em Dash, *Design Director*

A number of years ago, I had the opportunity to work for one of my design heroes, Roger Black.

One assignment was to redesign a well known financial magazine. The magazine executives wanted to modernize its look and move into a more upscale market.

My coworkers and I spent weeks creating variations on logo typography, cover images, magazine spreads, and nuanced wording to better represent this new, modern face of the magazine. Roger was great about giving everyone latitude to play with layouts, which we presented to him in a big presentation before showing the client.

Now, I have to admit that I was always a little intimidated by Roger. He can be frank. Very frank. And at that point in my career I wasn't completely comfortable hearing un-softened critique. But there I was, explaining my thoughts behind all the choices I'd made for the design of a magazine that, frankly, I would probably never read and didn't quite understand. I remember the long, long pause after I'd explained some obvious use of italic sans serif as the logo to convey the idea of "moving into the future," when Roger asked, *"So, Mayes. Where's the idea?"*

I had no clue what he was talking about. And I had no idea how to respond.

I babbled something about how the idea behind the cover was that it looked more upscale, that the idea behind the italic was motion, that the idea was blah blah blah blah. I totally missed the point.

I can't say that a lightbulb went off in my mind that day. Roger's comment stung, but it took me years to figure out why. What I realize now is that I had decorated the magazine. I paid attention to the veneer but had completely left the story of the magazine untold. I made it look pretty, but for no real purpose. I left out the meaning. I left out the idea behind why this magazine, or for that matter any piece of design, exists in the first place: to communicate an idea on a level that works in the two most important languages — visual as well as editorial. It's a difficult thing to verbalize — this moment when words and pictures work hand in hand so perfectly to communicate and connect emotionally to the reader. Great designers like George Lois seem to have an uncanny knack for making it look easy.

There are many rules from many different disciplines about how to make a good layout — about how to compose a page, how lowercase italic type should never have loose letter spacing, how you shouldn't use the color purple for anything. But most of those can be broken. *The best of the design in this book focuses instead on advancing a big idea, and speaks on a level beyond those rules.* The design that becomes truly timeless is the one that makes people think or laugh or change their perspective. At least that's a goal worth striving toward.

Fortunately for me, Roger's slightly annoyed voice is always in the back of my head asking, "So, Mayes. Where's the idea?"

# CHIPSHOP

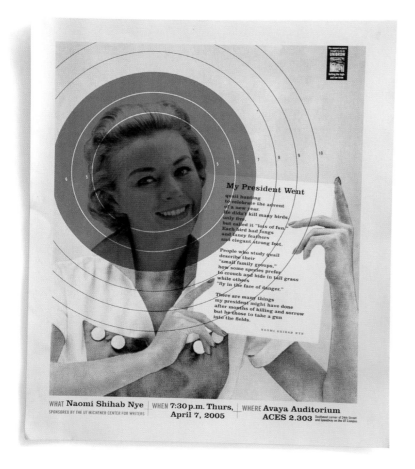

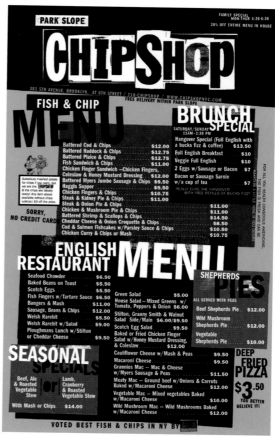

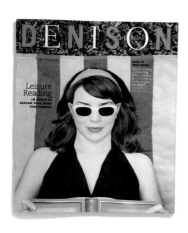

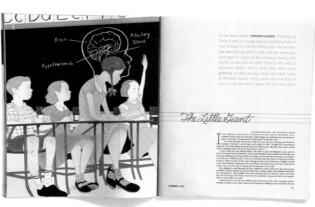

# Advertising

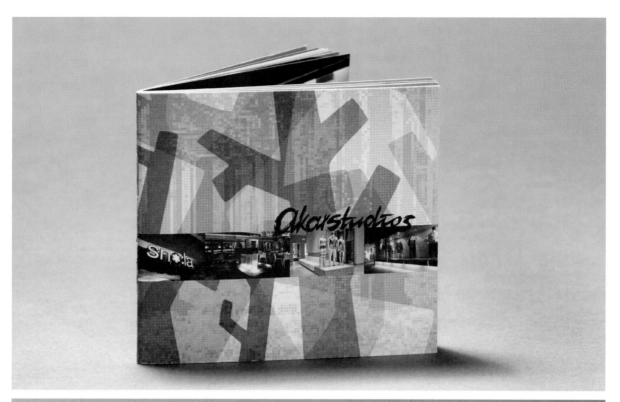

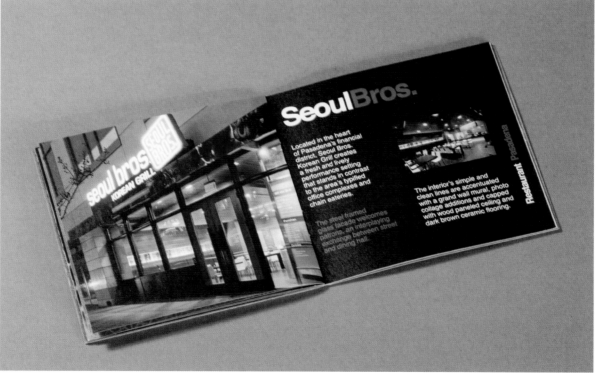

AKARSTUDIOS_ SANTA MONICA, CA, UNITED STATES
**CREATIVE TEAM**: Sean Morris, Sat Garg
**CLIENT**: AkarStudios

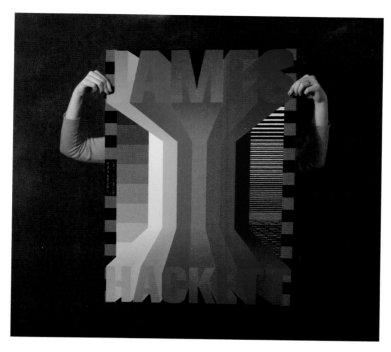

LANDOR ASSOCIATES_ SYDNEY, AUSTRALIA
**CREATIVE TEAM**: Jason Little, Joao Peres
**CLIENT:** James Hackett

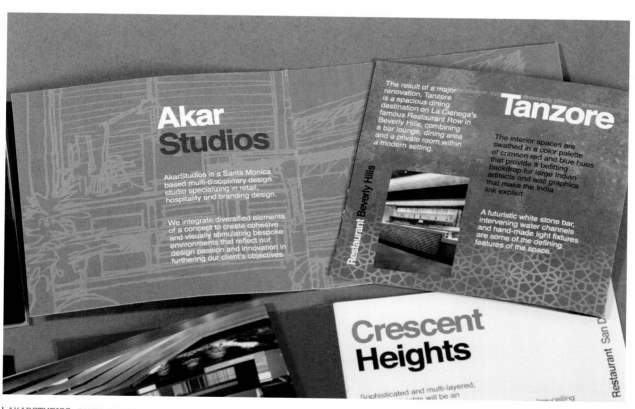

AKARSTUDIOS_ SANTA MONICA, CA, UNITED STATES
**CREATIVE TEAM**: Sean Morris, Sat Garg
**CLIENT**: AkarStudios

KNIGHTS HAVE FACES TOO

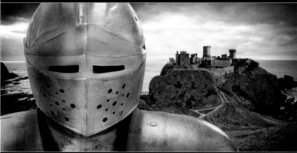

Each year, countless game characters have their faces hidden from the world. This cruelty has got to stop!

It's our mission to end helmet tyranny by animating facial performances better and more affordably than any other solution on the market.

Join our cause today by calling 310.656.6565 or by visiting EndHelmetTyranny.org.

Proud Sponsor of:
FRAHG
FRIENDS AGAINST HELMETS in GAMES

BOARDERS HAVE FACES TOO

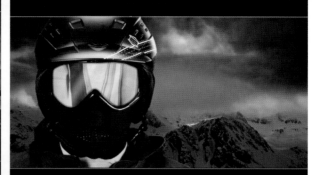

Each year, countless game characters have their faces hidden from the world. This cruelty has got to stop!

It's our mission to end helmet tyranny by animating facial performances better and more affordably than any other solution on the market.

Join our cause today by calling 310.656.6565 or by visiting EndHelmetTyranny.org.

Proud Sponsor of:
FRAHG
FRIENDS AGAINST HELMETS in GAMES

RACERS HAVE FACES TOO

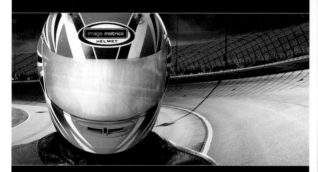

Each year, countless game characters have their faces hidden from the world. This cruelty has got to stop!

It's our mission to end helmet tyranny by animating facial performances better and more affordably than any other solution on the market.

Join our cause today by calling 310.656.6565 or by visiting image-metrics.com.

Proud Sponsor of:
FRAHG
FRIENDS AGAINST HELMETS in GAMES

SOLDIERS HAVE FACES TOO

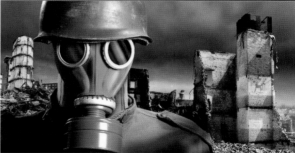

Each year, countless game characters have their faces hidden from the world. This cruelty has got to stop!

It's our mission to end helmet tyranny by animating facial performances better and more affordably than any other solution on the market.

Join our cause today by calling 310.656.6565 or by visiting EndHelmetTyranny.org.

Proud Sponsor of:
FRAHG
FRIENDS AGAINST HELMETS in GAMES

BLUESPARK STUDIOS_ SANTA MONICA, CA, UNITED STATES
**CREATIVE TEAM**: David Brzozowski, Tim Mather, Eric Schumacher
**CLIENT**: Image Metrics

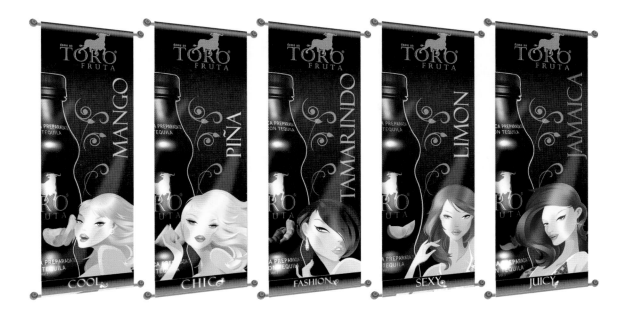

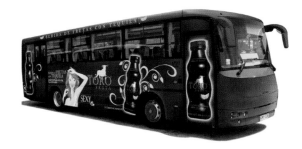

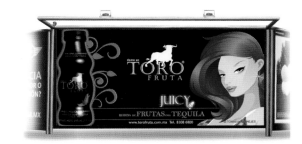

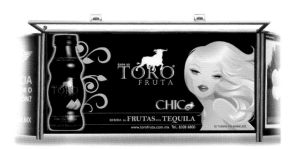

AXIOMACERO... MONTERREY, NUEVO LEON, MEXICO
**CREATIVE TEAM**: Mabel Morales, Kitty Guerrero, Carmen Rodriguez
**CLIENT**: Toma Products

ANGELA POWIRO_ INDONESIA
**CREATIVE TEAM**: Angela Powiro
**CLIENT**: Angela Powiro

18

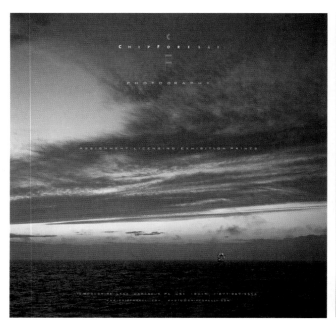

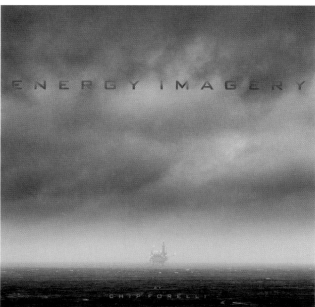

CHIP FORELLI STUDIO, LLC_ DAMASCUS, PA, UNITED STATES
**CREATIVE TEAM**: Chip Forelli
**CLIENT**: Self-promotion

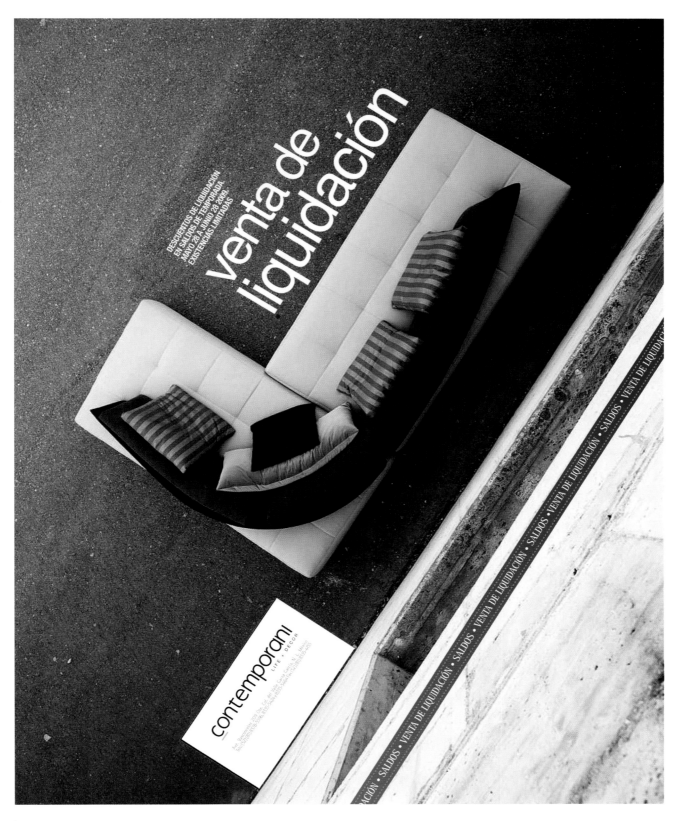

venta de liquidación

DESCUENTOS DE LIQUIDACIÓN.
EN SALDOS DE TEMPORADA.
MAYO 28 A JUNIO 28 2009.
EXISTENCIAS LIMITADAS.

contemporani
LIFE + DECOR

VENTA DE LIQUIDACIÓN • SALDOS • VENTA DE LIQUIDACIÓN • SALDOS • VENTA DE LIQUIDACIÓN • SALDOS • VENTA DE LIQUIDACIÓN

CINCODEMAYO DESIGN_ MONTERREY, NUEVO LEON, MEXICO
**CREATIVE TEAM**: Mauricio Alanis, Eugenio Alanis
**CLIENT**: Contemporani Life + Decor

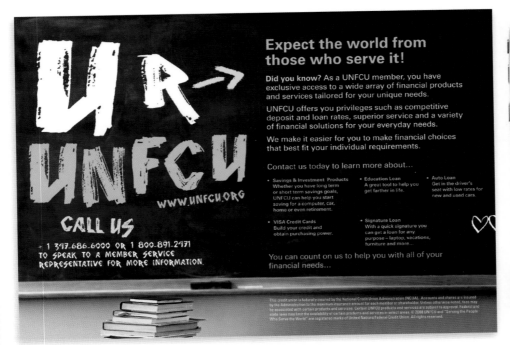

## An In-Depth Look

# United Nations Federal Credit Union

Using stock photography models as stand-ins for your client's customers typically is a no-brainer, but when the client is the United Nations Federal Credit Union (UNFCU), it is ever more critical that the persons depicted represent the very diversity of its members. "We came up with the tagline, YOU ARE UNFCU," says Betsy Thomas, account manager at IridiumGroup in New York. *"We took the root of the fact that YOU are what makes up this organization, YOU are the one thing that makes the business successful. We're a strong and viable institution and that's because of YOU."*

Yi Son Ko, working as creative director, struggled to find the right stock portraits to go with the campaign. "It was very hard because of so many people and races," she says of UNFCU's eighty thousand-plus members worldwide. "We had only three posters, but we wanted the person to be someone who looks like anyone."

"The key is to [represent] Nairobi, Geneva, Rome, Washington D.C.... everywhere on every continent," Thomas says of the membership, comprised of United Nations employees and their families. "We have to hit on all kinds of cultural types, so that we aren't ignoring anyone's face. We kept it simple, bold and bright—a tenet of their brand—and [related to] the members by showing faces that could be any one of them."

While the faces may look familiar, the agency took a definite departure from previous incarnations of UNFCU's branding, which runs across multiple platforms including direct mail, in-branch posters, takeaway cards, e-mail and an online presence. "Since we worked with portraits, we wanted to make it

really simple and distinctive from other campaigns," says Ko. "I wanted to use black and make it different." Says Thomas: *"They gave us real freedom as to how to use the portraits. They didn't direct us to use portraits, but it was kind of unsaid, as it's member-driven. We had some iconographic directions we showed them and they were drawn to this one."*

Phase 1 consists of black backgrounds and colorful, sentence-within-a-sentence word acrobatics conceived by owner and President Dwayne Flinchum, with copy written by Thomas, but the following year's Phase 2 takes the imagery to a higher level. "Yi Son changed the backgrounds to make it more vibrant," Thomas says of the decision to maintain the solid-field element while introducing the bold colors of the previous year's text as backdrops for the increasingly international-looking models, calm and confident despite the storm outside. "Between the first and second [phase], banks took a big hit. The mortgage crisis also affects the credit unions of course, but UNFCU remains very strong and healthy. They haven't been lending out subprime mortgages, and we wanted to reinforce that they have what their members need."

The UNFCU campaign, which took five months from conception to inception, underwent no major changes; the message was clear from the start. Says Thomas of the credit union customers, "They know they're members of this organization, but most of them don't even know what that means. We wanted to promote this idea of membership."

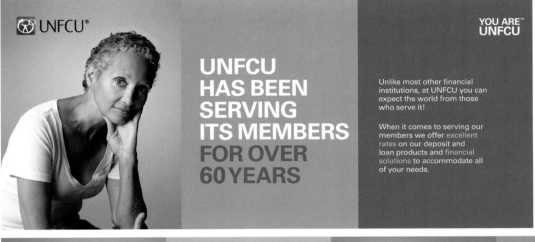

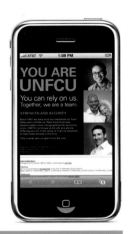

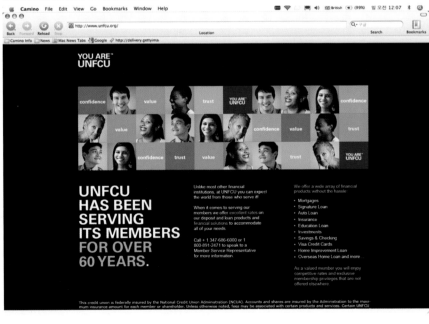

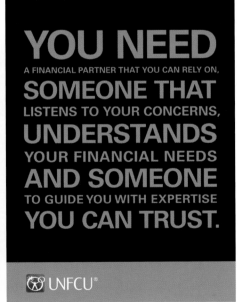

IRIDIUMGROUP INC.... NEW YORK, NY, UNITED STATES
**CREATIVE TEAM**: Dwayne Flinchum, Yi Son Ko, Betsy Thomas
**CLIENT**: United Nations Federal Credit Union

CAROL MCLEOD DESIGN_ MASHPEE, MA, UNITED STATES
**CREATIVE TEAM**: Carol McLeod, Brian Charron
**CLIENT**: SAMPAR USA LLC

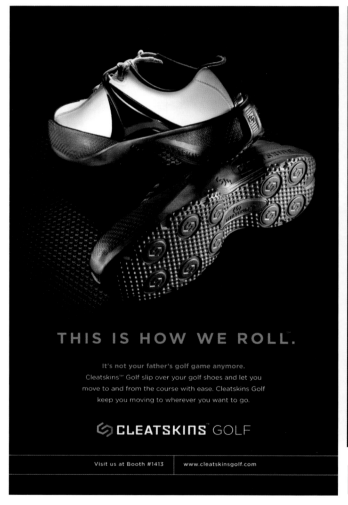

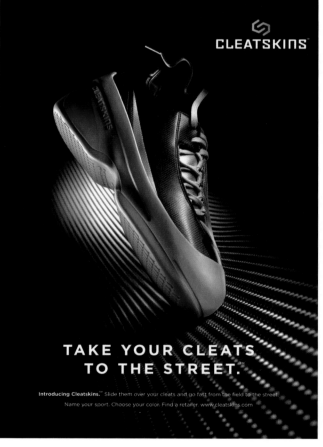

THE UXB_ BEVERLY HILLS, CA, UNITED STATES
**CREATIVE TEAM:** NancyJane Goldston, Glenn Sakamoto, Elizabeth Bennett, Rick Chou
**CLIENT:** Cleatskins

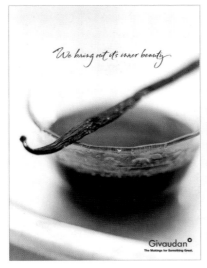

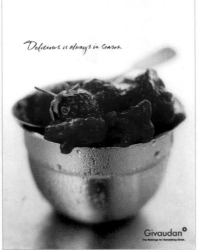

**HOLLY DICKENS DESIGN INC.** CHICAGO, IL, UNITED STATES
**CREATIVE TEAM**: Lynn Grundman, Jeff Kauck, Holly Dickens
**CLIENT**: Givaudan

**OHTWENTYONE.** EULESS, TX, UNITED STATES
**CREATIVE TEAM**: Jon Sandruck
**CLIENT**: The American College of Emergency Physicians

**INNOVATIVE INTERFACES MARKETING.** EMERYVILLE, CA, UNITED STATES
**CREATIVE TEAM**: Gene Shimshock, Spenser Thompson, Dean Hunsaker, Ellen Lafferty
**CLIENT**: Innovative Interfaces

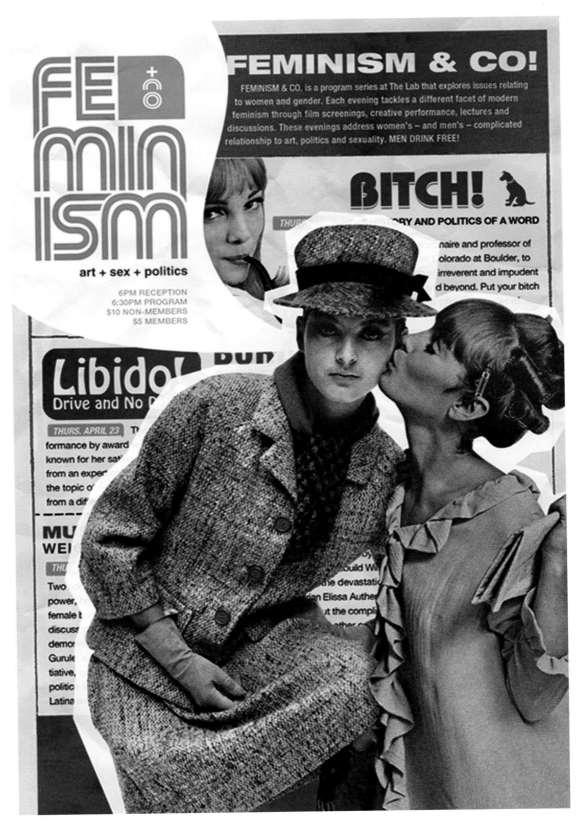

ELLEN BRUSS DESIGN_ DENVER, CO, UNITED STATES
**CREATIVE TEAM**: Ellen Bruss, Jorge Lamora, Charles Carpenter, Geoff Allen
**CLIENT**: The Lab

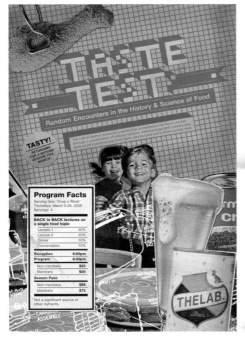

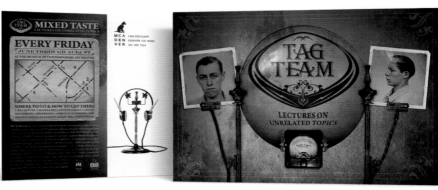

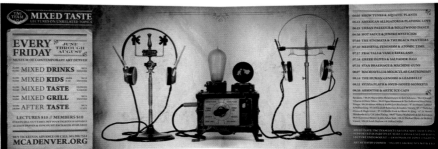

ELLEN BRUSS DESIGN_ DENVER, CO, UNITED STATES
**CREATIVE TEAM**: Ellen Bruss, Jorge Lamora, Charles Carpenter, Geoff Allen
**CLIENT**: The Lab

Reach.

Cool.

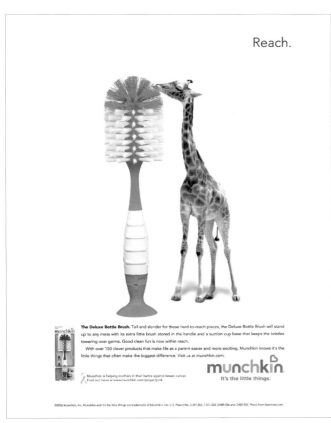

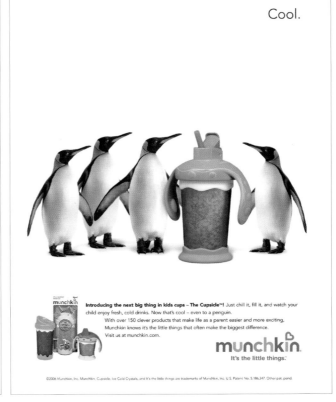

THE UXB_ BEVERLY HILLS, CA, UNITED STATES
**CREATIVE TEAM**: NancyJane Goldston, Glenn Sakamoto, Myla Conroy
**CLIENT**: Munchkin®

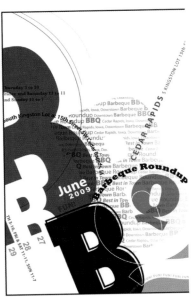
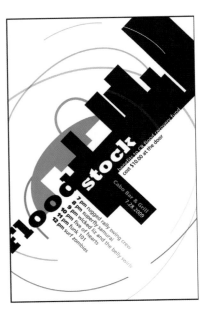

UNIVERSITY OF NORTHERN IOWA_ ELY, IA, UNITED STATES
**CREATIVE TEAM**: Jorunn Musil
**CLIENT**: Cedar Rapids Area Convention & Visitors Bureau

IE DESIGN + COMMUNICATIONS_ HERMOSA BEACH, CA, UNITED STATES
**CREATIVE TEAM**: Marcie Carson, Jane Lee
**CLIENT**: USC Viterbi School of Engineering

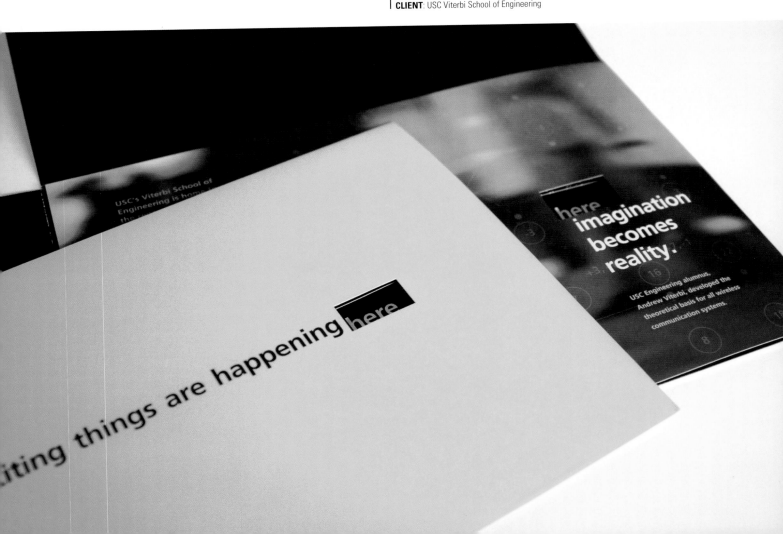

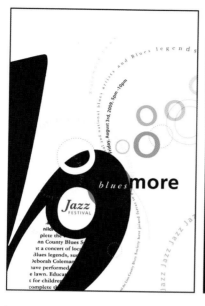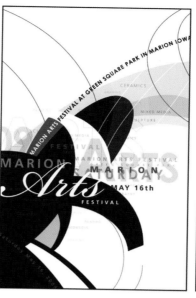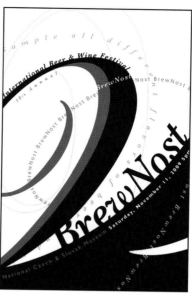

UNIVERSITY OF NORTHERN IOWA_ ELY, IA, UNITED STATES
**CREATIVE TEAM**: Jorunn Musil
**CLIENT**: Cedar Rapids Area Convention & Visitors Bureau

27

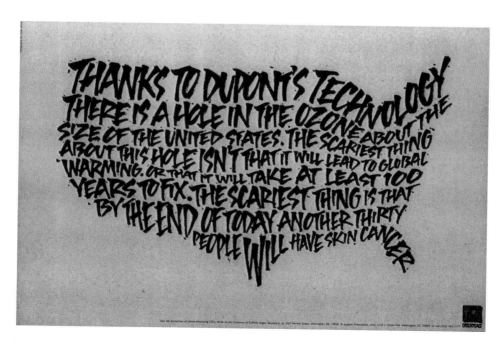

HOLLY DICKENS DESIGN INC._ CHICAGO, IL, UNITED STATES
**CREATIVE TEAM**: Holly Dickens
**CLIENT**: GREENPEACE

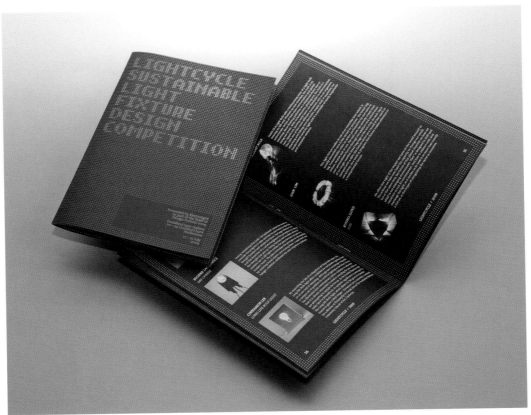

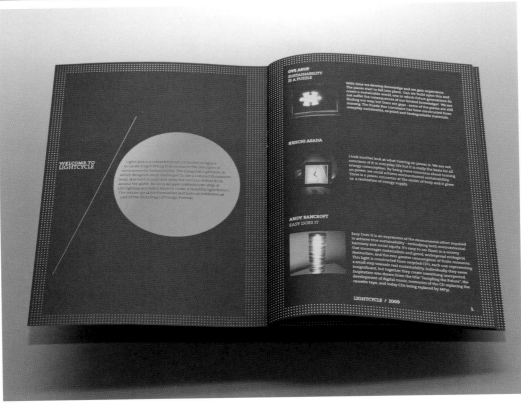

BÜRO NORTH_ MELBOURNE, AUSTRALIA
**CREATIVE TEAM**: Soren Luckins, Sarah Napier, Shane Loorham
**CLIENT**: Electrolight

GABRIELLE GOZO— PHILADELPHIA, PA, UNITED STATES
**CREATIVE TEAM**: Gabrielle Gozo, Ian Cross, Monica Gursky
**CLIENT**: I-SITE

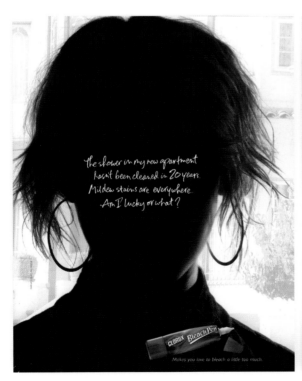

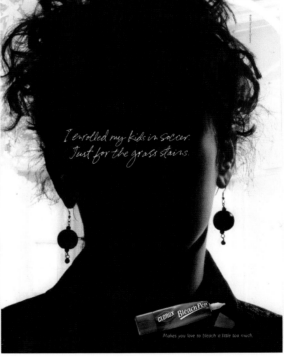

HOLLY DICKENS DESIGN INC.— CHICAGO, IL, UNITED STATES
**CREATIVE TEAM**: Dennis McVey, Holly Dickens
**CLIENT**: Clorox

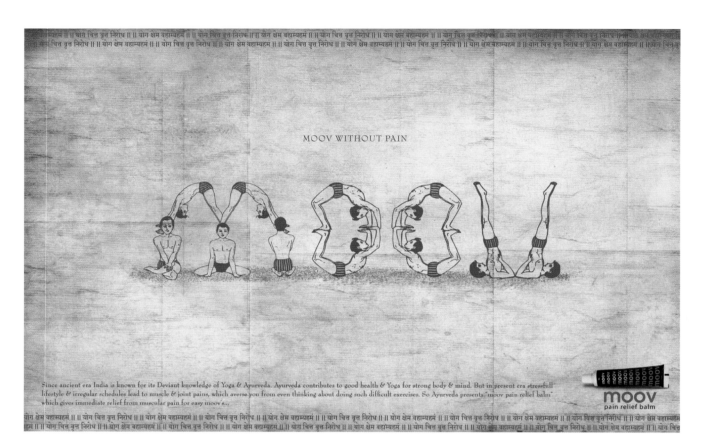

NARENDRA KESHKAR_ INDORE, MADHYA PRADESH, INDIA
**CREATIVE TEAM**: Narendra Keshkar
**CLIENT**: Moov

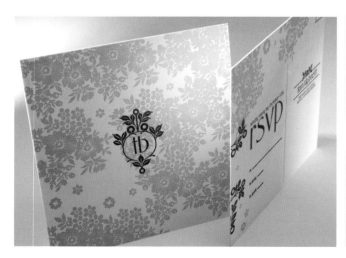

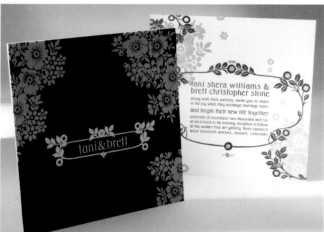

STUDIO E FLETT DESIGN_ GORHAM, ME, UNITED STATES
**CREATIVE TEAM**: Erin Flett, Cliff Kucine
**CLIENT**: Tani & Brett Stone

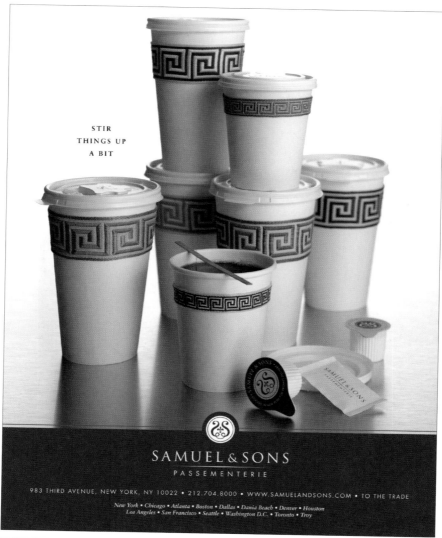

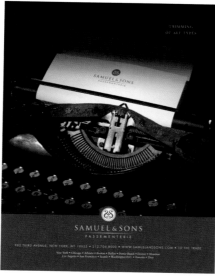

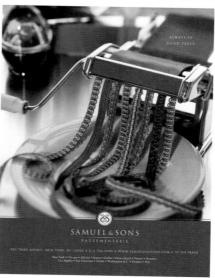

TOM DOLLE DESIGN_ NEW YORK, NY, UNITED STATES
**CREATIVE TEAM**: Chris Riely, Tom Dolle, Monica Stevenson
**CLIENT**: Samuel & Sons

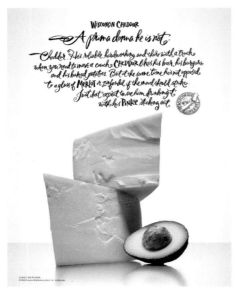
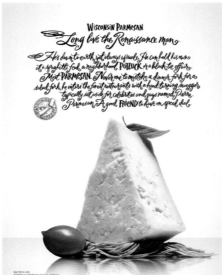
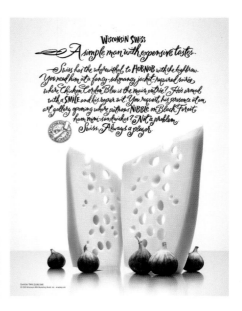

## An In-Depth Look

## Cheese Campaign

While Wisconsin has long been synonymous with cheese, few are truly aware of the many gourmet styles and varieties produced in the state. The fact is, Wisconsin boasts more award-winning cheeses than anywhere else in the world. So, when the Wisconsin Milk Marketing Board decided it was time to change the overall perception of Wisconsin Cheese as, well, ordinary, they called on Shine Advertising.

"After the first bite, you quickly realize that each cheese has its own personality," said art director and associate creative director John Krull. *"Every variety has such a unique story to tell. This campaign uses these personalities to help bring to life the inherent flavor and desirability of each."*

The four full-page ads feature Wisconsin Cheddar, Swiss, Parmesan, and Blue. The ads ran in Gourmet, Food and Wine, Vanity Fair, and several other national publications.

"Beautifully delicious," said Mike Kriefski, co-founder and creative director of Shine. "That's the best way to describe these ads. This campaign uses the unique personalities of cheese to create a fresh new persona for the Wisconsin Cheese brand — intriguing, surprising, and, of course, beautifully delicious."

To give the ads a truly unique look, Shine turned to photographer Ashton Worthington for his fashion-inspired approach to still-life. Ashton's bold, clean imagery added the contemporary flair that Shine sought. The beautiful and monolithic wedges of cheese, as well as the artful garnishes, came compliments of New York food stylist Nir Adar.

The final, and possibly most distinctive, design element was the typography. For that, Krull enlisted Chicago illustrator Holly Dickens. To add credence to a campaign rooted in personality and individuality, each headline was hand-lettered with ink and brush.

*"We wanted every element of the design to reflect the amazing quality and craftsmanship of Wisconsin Cheese,"* said Kriefski. "The reality is, Wisconsin Cheese is equally as comfortable in a five-star restaurant in New York or Los Angeles as it is at a Packers game being served with beer and brats. If ever there was a campaign that allowed consumers an opportunity to truly understand and appreciate Wisconsin Cheese, this is it."

**SHINE ADVERTISING_ MADISON, WI, UNITED STATES**
**CREATIVE TEAM**: Michael Kriefski, John Krull, James Breen, Chad Bollenbach, Holly Dickens
**CLIENT**: Wisconsin Cheese

WISCONSIN BLUE

# Never holds his tongue.

Not one for idle CHITCHAT. Blue doesn't waste time with social pleasantries. When ordering a bottle of red, he neither asks the sommelier for advice nor requests to see the WINE list. Pinot noir it is. That's Blue. He's bold, determined, and opinionated. To not LOVE him is to not know him. And to not know him is a crying shame.

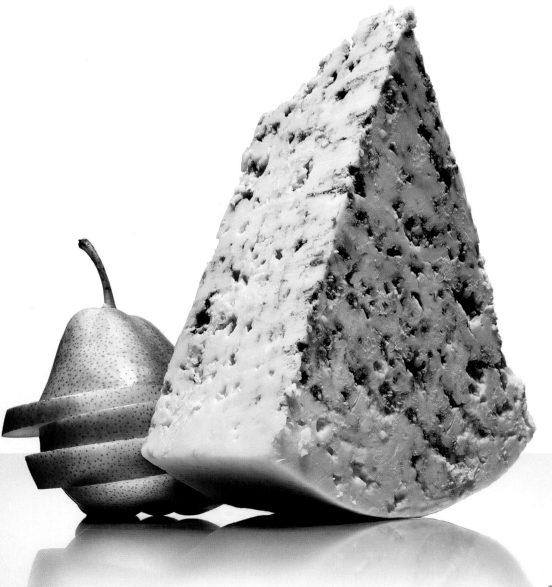

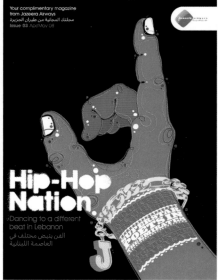
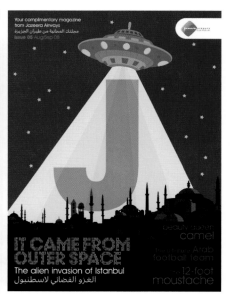

TRANSMISSION_ BRIGHTON, UNITED KINGDOM
**CREATIVE TEAM**: Stuart Tolley
**CLIENT**: Jazeera Airways

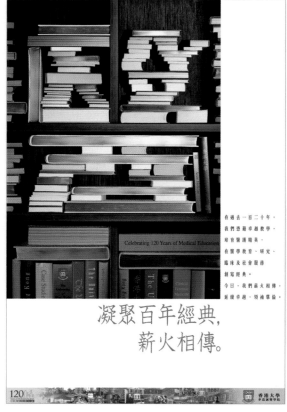
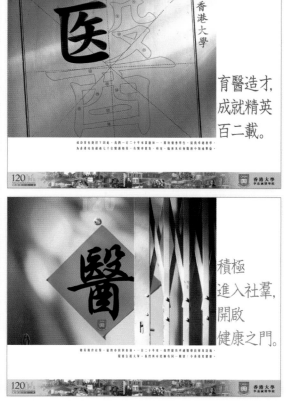

TINKVISUALCOMMUNICATIONS_ HONG KONG
**CREATIVE TEAM**: Kelvin Hung, Lai Yuen Yan, Timothy Lau, Sammy Chung
**CLIENT**: University of Hong Kong - Li Ka Shing Faculty of Medicine

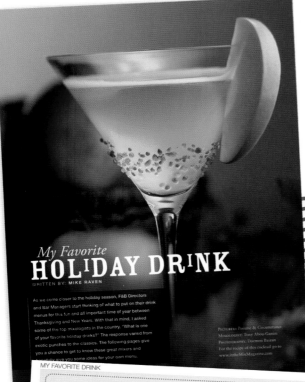

## My Favorite
# HOLIDAY DRINK
WRITTEN BY: MIKE RAVEN

As we come closer to the holiday season, F&B Directors and Bar Managers start thinking of what to put on their drink menus for this fun and all important time of year between Thanksgiving and New Years. With that in mind, I asked some of the top mixologists in the country, "What is one of your favorite holiday drinks?" The response varied from exotic punches to the classics. The following pages give you a chance to get to know these great mixers and hopefully give you some ideas for your own menu.

PICTURED: Pomme & Circumstance
MIXOLOGIST: Tony Abou-Ganim
PHOTOGRAPHY: Daemon Baizan
For the recipe of this cocktail go to
www.inthemixmagazine.com

## TONY *Abou-Ganim*

Tony Abou-Ganim is truly a modern mixologist. He has helped open many famous restaurants and bars in New York and San Francisco, including Harry Denton's Starlight Room atop the Sir Francis Drake Hotel. It was here that Tony created his first specialty drink menu featuring several of his original cocktail recipes - the Sunsplash, the Starlight, and his signature cocktail recipe, the Cable Car. In 1998, Tony was hand-picked by Steve Wynn to create the cocktail program at his Bellagio Resort. Tony immediately implemented his philosophy of bartending and drink preparation: quality ingredients and proper technique create great drinks. He went on to develop hundreds of original cocktails for the resort's twenty-two bars. Currently, Tony operates his own beverage consulting firm specializing in bar staff training, product education, and cocktail development.

As the National Ambassador of the US Bartenders Guild, www.usbg.org, and Associate Member of the Museum of the American Cocktail, www.museumoftheamericancocktail.org, Tony continues to educate about the history and lore of cocktails, as well as lead the bar industry into continually improving the art of the cocktail. He is also an accomplished writer with articles in many national magazines including his feature in every issue in the Mix, The Life and Times of the Modern Mixologist.

Tony lives in Las Vegas where he hones his craft daily by creating, sharing, and enjoying the very best cocktails.

### HELEN'S TOM & JERRY BATTER
Ingredients:
8 jumbo eggs, 1½ cups powdered sugar, ½ teaspoon cream of tartar, Freshly-grated nutmeg, Hot water

For each drink: ¾ oz Appleton Jamaican Rum, ¾ oz Hennessy V.S Cognac

Directions: Separate egg whites and yolks. In a large mixer, beat yolks until thin; transfer to another bowl. Clean mixer and add the egg whites and cream of tartar; beat until stiff. Add powdered sugar and fold in yolks. Mix until batter is thick but light.

In a pre-heated mug, add 1 heaping ladle of batter. Add rum and cognac. Top with hot water and dust with freshly-grated nutmeg. Serve with a paddle or spoon.

*www.themodernmixologist.com*

HOLIDAY CLASSIC

**Perfect For WARMING UP your Guests**

MY FAVORITE DRINK

## DALE *DeGroff*

Legendary bartender Dale DeGroff, aka "King Cocktail," is universally acknowledged as the world's premier mixologist whose innovations have globally impacted the industry. Winner of the 2009 James Beard Wine & Spirits Professional Award, DeGroff has been credited with bringing back the classic cocktail and reinventing the profession of bartending, setting off a cocktail explosion around the world. Author of the award-winning The Craft of the Cocktail and the newly-released The Essential Cocktail (Random House 2009), DeGroff is also the founding President of The Museum of the American Cocktail. This non-profit organization hosts an exhibit in New Orleans that features the 200-year history of the cocktail and offers monthly seminars in mixology. For more information visit www.Kingcocktail.com or www.museumoftheamericancocktail.org.

This recipe, which Dale created in 1999 to honor the coming of the new millennium, appears in his book, The Essential Cocktail, with this story: "In 1999, more than a hundred years after Byron published his version of the East India Cocktail and fifty years after a guy named Bill Kelly published his in a book called The Roving Bartender, I decided to reinvent the East India. I called it the Millennium Cocktail, in honor of the upcoming turn of the calendar and for the Millennium bottling of Courvoisier, who had hired me to create a drink for the special product. It was quite a bit juicier than the earlier versions, and had the additional garnishes of freshly grated nutmeg and a flamed orange peel. Soon after my genius invention, I learned of the prior versions and I sheepishly acknowledged that I was not, after all, the inventor of this exceptional drink."

### THE MILLENNIUM COCKTAIL
Ingredients:
1½ oz Courvoisier Millennium Cognac, 1 oz Bols Orange Curaçao, 1½ oz pineapple juice, 1 dash Angostura bitters, Flamed orange peel, for garnish, Nutmeg, for grating

Directions: Combine the Cognac, Curaçao, pineapple juice, and bitters with ice, and shake. Strain into a chilled cocktail glass and garnish by flaming the orange peel over the top of the drink and dusting with freshly grated nutmeg.

COCKTAIL

**Perfect For NEW YEARS**

## CHARLOTTE *Voisey*

Charlotte Voisey is the Mixologist for William Grant & Sons, USA. She is one of today's top talents in the cocktail world and has managed some of the best cocktail bars in London, Barcelona, and Buenos Aires. When Charlotte opened a classic cocktail bar, Apartment 195, on King's Road in London in 2002, it was promptly named London's Bar of the Year. In 2004, she was named UK's Bartender of the Year and in 2006, she moved stateside to work with William Grant & Sons to represent Hendrick's Gin.

This recipe has been adapted from the original 1850 recipe found in the book, Drinking with Dickens, written by Cedric Dickens, great-grandson of Charles Dickens.

### "MR. MICAWBER'S FAVOURITE"
Ingredients:
3 full tea cups of Hendrick's gin
3 full tea cups of Madeira wine
3 cloves
1 pinch of grated nutmeg
1 large teaspoon of cinnamon powder
1 teaspoon of brown sugar
6 large lemon twists
1 small slice of orange
3 big chunks of fresh pineapple
4 large spoons of honey
The juice of a lemon
A dash of water

Directions: Mix all the ingredients in a pot; warm up to a simmer and leave to simmer for twenty minutes. Sometimes the punch will get better and better as you cook it more and more. When you think it is ready, pour in the tea pot and serve hot with some gingerbread on the side.

This recipe is inspired by Charles Dickens' own gin punch recipe, so etiquette requires that you repeat this quote while pouring the first cup: "Punch, my dear Copperfield, like time and tide, waits for no man." David Copperfield, 1850.

*www.grantusa.com*

PUNCH

**Perfect For PARTIES**

35

SELLIER DESIGN_ MARIETTA, GA, UNITED STATES
**CREATIVE TEAM**: Julie Cofer, Mike Raven
**CLIENT**: iMi Agency

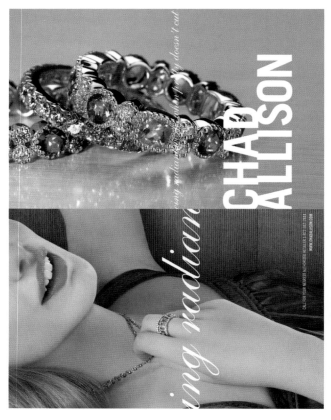
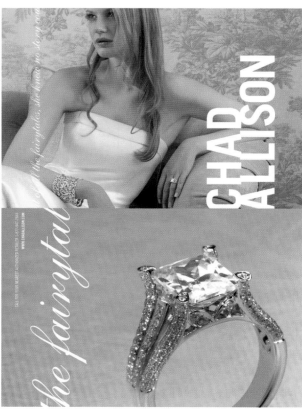

THE O GROUP_ NEW YORK, NY, UNITED STATES
**CREATIVE TEAM**: Jason B Cohen, J Kenneth Rothermich, Melissa Scheetz, Jennifer Eggers
**CLIENT**: Chad Allison

PAUL SNOWDEN_ BERLIN, GERMANY
**CREATIVE TEAM**: Paul Snowden
**CLIENT**: BOYS NOIZE

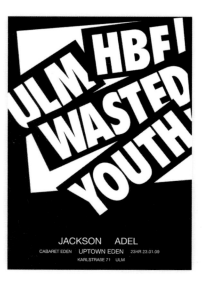

PAUL SNOWDEN_ BERLIN, GERMANY
**CREATIVE TEAM**: Paul Snowden
**CLIENT**: Cabaret Eden, Ulm / WASTED GERMAN YOUTH

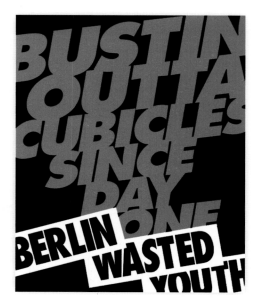

PAUL SNOWDEN_ BERLIN, GERMANY
**CREATIVE TEAM**: Paul Snowden
**CLIENT**: Waagerbau

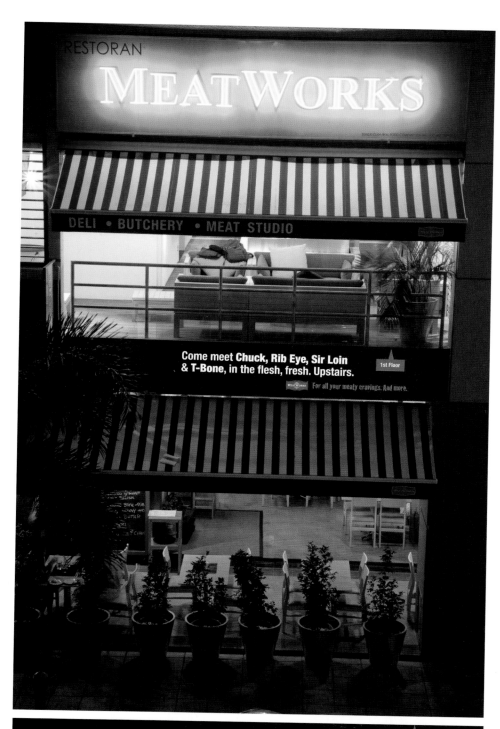

SCRATCHDISK CREATIVE SDN BHD_ SELANGOR DE, MALAYSIA
**CREATIVE TEAM**: Vernon Chan, Jason Lim
**CLIENT**: MeatWorks Restaurant

**ORGANIC GRID_** PHILADELPHIA, PA, UNITED STATES
**CREATIVE TEAM**: Michael McDonald
**CLIENT**: Bauman Rare Books

38

**NETRA NEI_** SEATTLE, WA, UNITED STATES
**CREATIVE TEAM**: Netra Nei, Mik Nei
**CLIENT**: Ten Pachi Modern Salon and Store

**NETRA NEI_** SEATTLE, WA, UNITED STATES
**CREATIVE TEAM**: Netra Nei
**CLIENT**: Inform Interiors

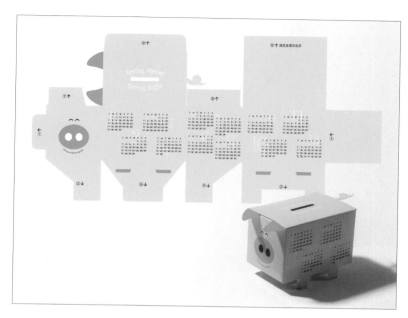

TINKVISUALCOMMUNICATION_ HONG KONG
**CREATIVE TEAM**: Kelvin Hung, Tony Leung
**CLIENT**: ORBIS Hong Kong

39

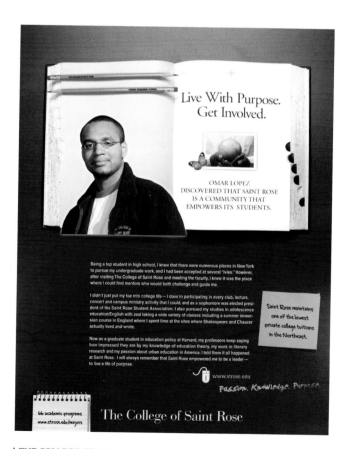

NARENDRA KESHKAR_ INDORE, MADHYA PRADESH, INDIA
**CREATIVE TEAM**: Narendra Keshkar, Mitesh Joshi, Vishal Shah, Hozefa Alekhanwala
**CLIENT**: ACME

THE COLLEGE OF SAINT ROSE_ ALBANY, NY, UNITED STATES
**CREATIVE TEAM**: Mark Hamilton, Chris Parody, Lisa Haley Thomson
**CLIENT**: The College of Saint Rose

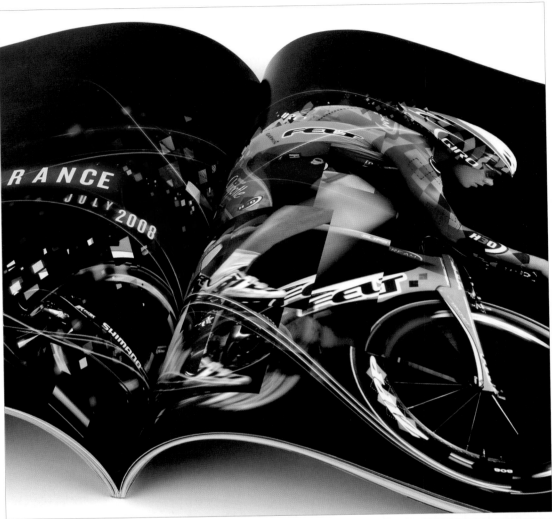

40

MOXIE SOZO_ BOULDER, CO, UNITED STATES
**CREATIVE TEAM**: Leif Steiner, Charles Bloom
**CLIENT**: Slipstream

NARENDRA KESHKAR_
INDORE, MADHYA PRADESH, INDIA
**CREATIVE TEAM:** Narendra Keshkar
**CLIENT:** ACME

MENDES PUBLICIDADE_
BALEM, PARA, BRAZIL
**CREATIVE TEAM:** Oswaldo Mendes, Marcelo Amorim
**CLIENT:** Governo do Pará

MOWAIL_ CYRIAX, NRW, GERMANY
**CREATIVE TEAM:** David Grasekamp, Helga Mols
**CLIENT:** City of Pszczyna, Polonia

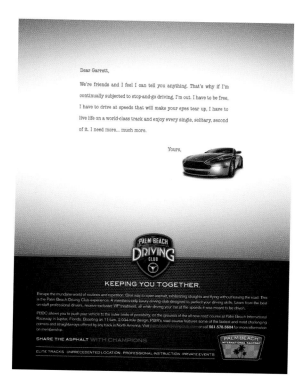

SPLASH:DESIGN_
KELOWNA, BC, CANADA
**CREATIVE TEAM:** Phred Martin
**CLIENT:** Cottswood Interiors

LEGACY DESIGN GROUP_
HOCKLEY, TX, UNITED STATES
**CREATIVE TEAM:** Eric Theriot, Susan Nelson
**CLIENT:** Exterran

PEAK SEVEN ADVERTISING_
DEERFIELD BEACH, FL, UNITED STATES
**CREATIVE TEAM:** Darren Seys, Josh Munsee, Brian Tipton
**CLIENT:** Palm Beach International Raceway

# Banners/
# Billboards

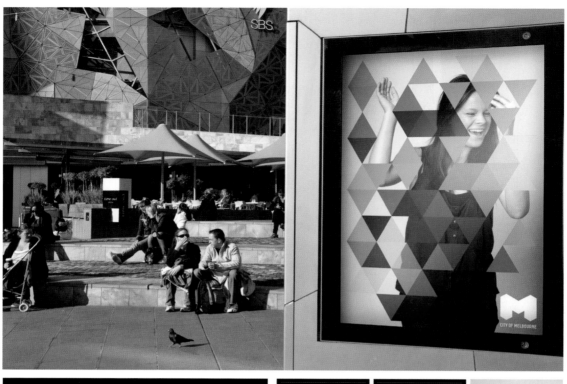

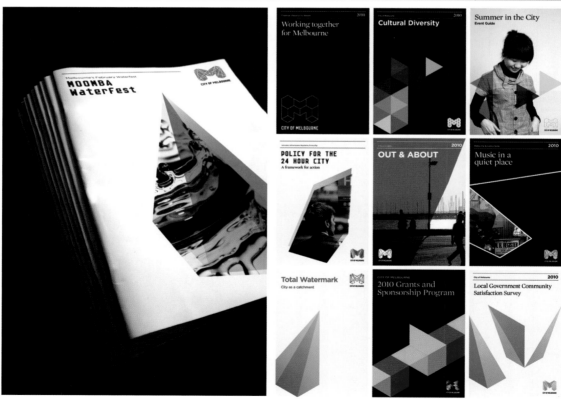

LANDOR ASSOCIATES_ SYDNEY, AUSTRALIA
**CREATIVE TEAM**: Jason Little, Sam Pemberton, Jefton Sungkar, Ivana Martinovic
**CLIENT**: City of Melbourne

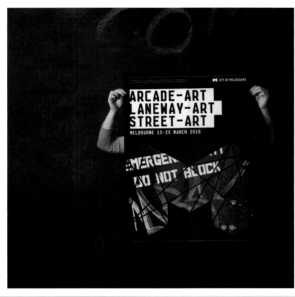

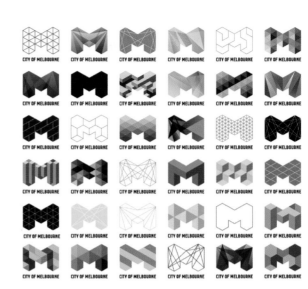

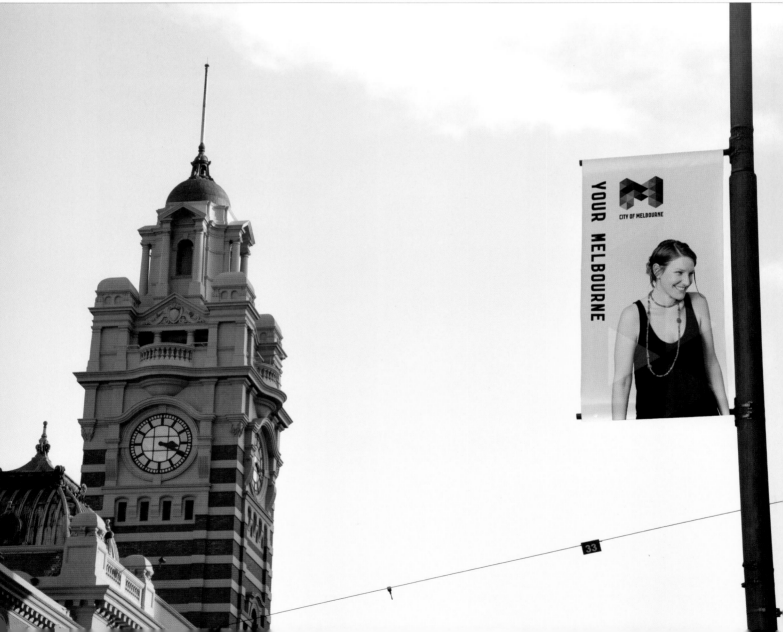

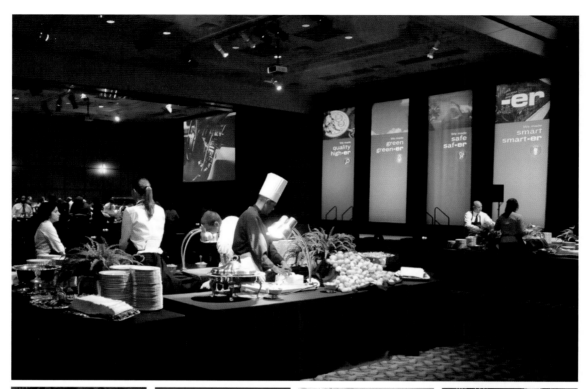

46

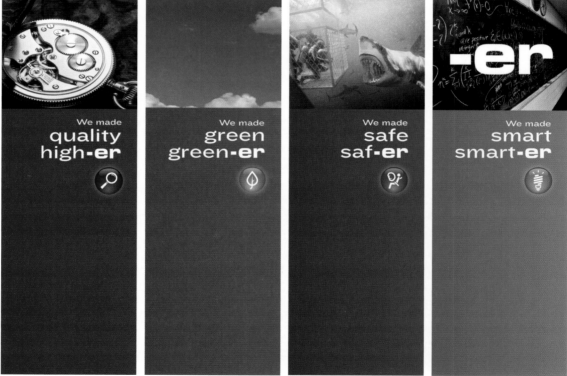

We made
**quality
high-er**

We made
**green
green-er**

We made
**safe
saf-er**

We made
**smart
smart-er**

JACKSON-DAWSON COMMUNICATIONS_ DEARBORN, MI, UNITED STATES
**CREATIVE TEAM**: Mike Lucas, Shawn Carter, Steve Flemion, Shane Morris
**CLIENT**: Ford Motor Company

# Breast canswer.

800-826-HOPE
cityofhope.org

THE PHELPS GROUP_ SANTA MONICA, CA, UNITED STATES
**CREATIVE TEAM**: Howie Cohen, Armand Kerechuk, Erin Culling, Harvey Kaner
**CLIENT**: City of Hope

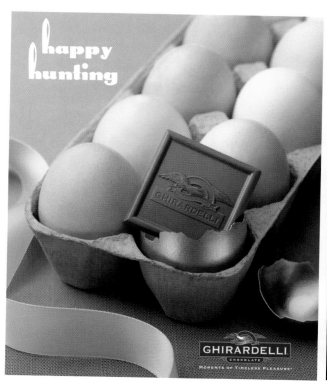

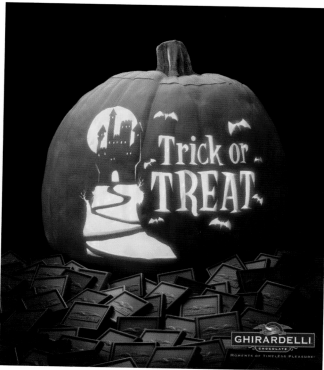

GHIRARDELLI CHOCOLATE COMPANY_ SAN LEANDRO, CA, UNITED STATES
**CREATIVE TEAM**: Alissa Chandler, Kirk Amyx, Felicia Gonzalez, Heather Jordan
**CLIENT**: Ghirardelli Chocolate Company

**SPLASH:DESIGN_ KELOWNA, BC, CANADA**
**CREATIVE TEAM**: Phred Martin
**CLIENT**: Cottswood Interiors

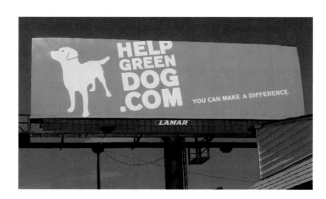

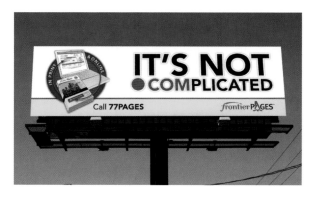

**CRANIUM STUDIO_ DENVER, CO, UNITED STATES**
**CREATIVE TEAM**: Alex Valderrama, Nate Valderrama
**CLIENT**: Freedom Service Dogs, Inc.

**DIXON SCHWABL_ VICTOR, NY, UNITED STATES**
**CREATIVE TEAM**: Deanna Varble, Marshall Statt, PJ Galgay, Kara Painting
**CLIENT**: FrontierPages

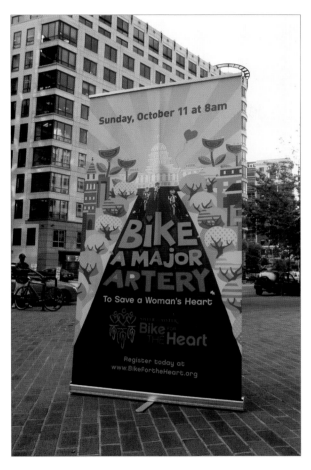

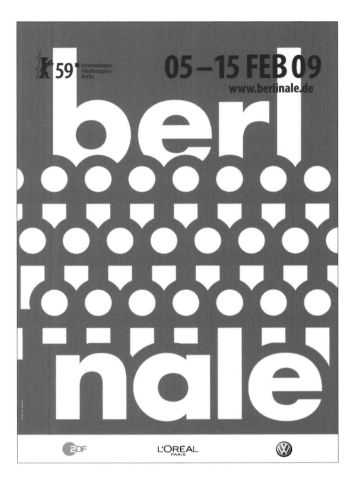

LEVINE & ASSOCIATES, INC._ WASHINGTON, DC, UNITED STATES
**CREATIVE TEAM**: Greg Sitzmann, Lee Calderon
**CLIENT**: Sister to Sister

PAUL SNOWDEN_ BERLIN, GERMANY
**CREATIVE TEAM**: Paul Snowden
**CLIENT**: Internationale Filmfestspiele Berlin

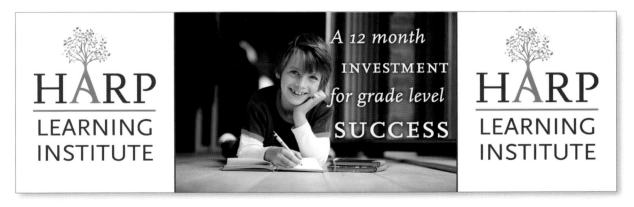

FIREBOX MEDIA_ SAN FRANCISCO, CA, UNITED STATES
**CREATIVE TEAM**: Audrey Feely
**CLIENT**: Harp Learning Institute

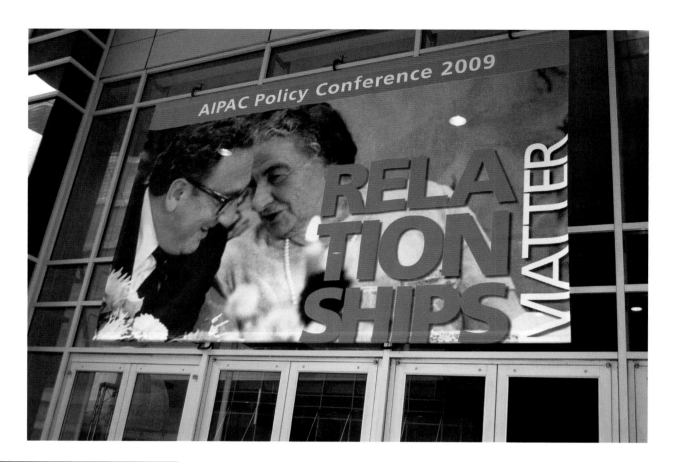

## An In-Depth Look

## AIPAC 2009 Policy Conference Signage

No other American city has as many lobbyists as Washington, D.C., and with 100,000 members, few organizations have as much political influence as the American Israel Public Affairs Committee (AIPAC). Their annual Policy Conference draws over seven thousand attendees from across the U.S. to hear from leaders including the president, vice-president, congressional representatives as well as top officials from the Israeli government. For the 2009 event, Beth Singer, principal and creative director of Arlington, Virginia-based Beth Singer Design (BSD) and Howard Smith, principal and communication strategist, led their team in branding the conference based on the theme, "Relationships Matter"—while at the same time designing a seamless visual experience for attendees at the capital's massive Washington Convention Center.

"The conference has a dual purpose: to educate attendees and to inspire their support for a strong U.S.-Israel relationship," Singer says. "We created a fully branded environment to carry the client's message and to create a strong emotional connection to the client's cause." The branding permeated all elements, ranging from large hanging banners and a ninety-foot-wide stage set, to the smallest details of printed programs and nametags. Smith, who is also Singer's husband, led the team in incorporating the branding into multimedia "billboards" displaying an ever-changing portfolio of client-supplied historic images used throughout the conference. Adds Smith: "We focus equally on two things: a great attendee experience and branded visual

assets for post-conference marketing." Smith took care to ensure that the client's name appeared in images taken at the event. "We had to think about photography from all angles," he says. "When [Israeli President] Shimon Peres, [U.S. Vice-President] Joe Biden and [former House Speaker] Newt Gingrich addressed the conference, the client wanted to make sure there was beautiful, branded imagery in the still and video images taken by the news media and broadcast worldwide."

Singer and Smith's treatment is a study in balance. "The small space and the huge space are equally important," says Smith. "For the media, the small number of square feet surrounding the speakers needs to be balanced with the scale of each image, and the typography relative to the whole stage for the people in the room." Singer adds, "AIPAC is a bipartisan organization, and we have to be very sensitive to that." The banners throughout the main floor show a balanced mix of American and Israeli political figures from across the ideological spectrum—each underscoring the importance of one-on-one relationships in advocating for their cause. Attendees, too, could get in on the act; as the conference progressed, photographs from each day were interspersed with a revolving multimedia slideshow of more well-known faces. "The purpose was to demonstrate that it's not just relationships between leaders that matter, but also the relationships YOU make," says Singer. Adds Smith, "Your picture is up there with Henry [Kissinger] and Golda [Meir]!" Relationships matter, indeed.

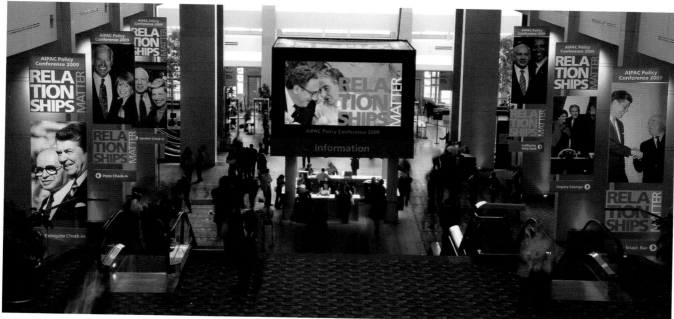

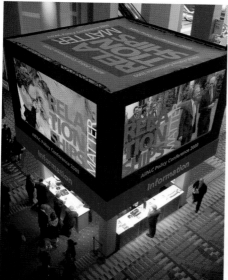

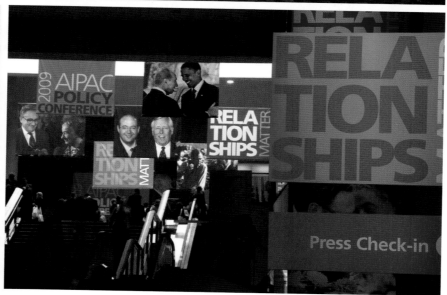

In such a massive physical space, attendees can easily get disoriented. "We always employ excellence in design, but it's just one piece of the puzzle," says Singer. "You can find yourself drawn in with the aura and atmosphere, but you also need to know where to check in, where to get a bite to eat and how to find the bus back to your hotel at the end of a long day."

Singer and Smith credit AIPAC's communications director, Renee Rothstein, with making it a truly collaborative process and encouraging them to use the big space in a bigger way. Of the event, which took six months from conception to actual staging, Singer says, "Seven thousand attendees see— and feel—our work and get energized. It's exhilarating to be a part of that."

BETH SINGER DESIGN_ ARLINGTON, VA, UNITED STATES
CREATIVE TEAM: Beth Singer, Howard Smith
CLIENT: American Israel Public Affairs Committee

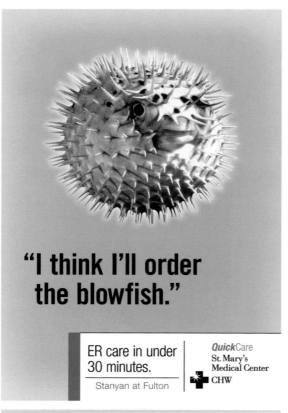

"I think I'll order the blowfish."

ER care in under 30 minutes.
Stanyan at Fulton

*Quick*Care
St. Mary's
Medical Center
CHW

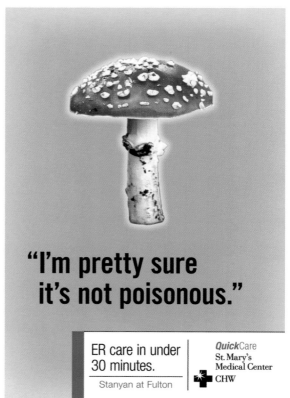

"I'm pretty sure it's not poisonous."

ER care in under 30 minutes.
Stanyan at Fulton

*Quick*Care
St. Mary's
Medical Center
CHW

52

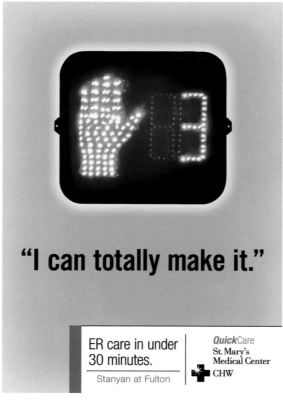

"I can totally make it."

ER care in under 30 minutes.
Stanyan at Fulton

*Quick*Care
St. Mary's
Medical Center
CHW

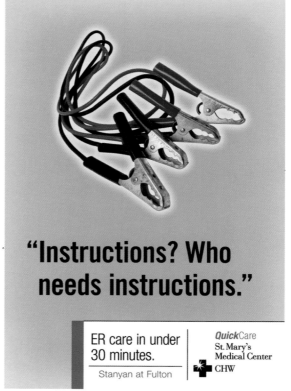

"Instructions? Who needs instructions."

ER care in under 30 minutes.
Stanyan at Fulton

*Quick*Care
St. Mary's
Medical Center
CHW

ARSON_ SAN FRANCISCO, CA, UNITED STATES
**CREATIVE TEAM**: Lotus Child, Hugh Gurin, Tim Spry
**CLIENT**: St. Mary's Hospital

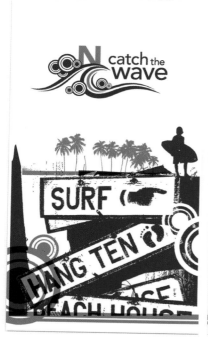

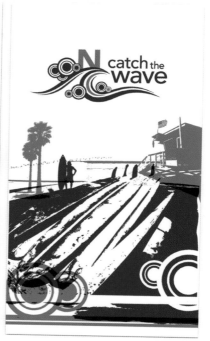

LEIBOLD ASSOCIATES, INC.— NEENAH, WI, UNITED STATES
**CREATIVE TEAM**: Ryan Wienandt, Joe Maas
**CLIENT**: Neenah Paper, Inc.

53

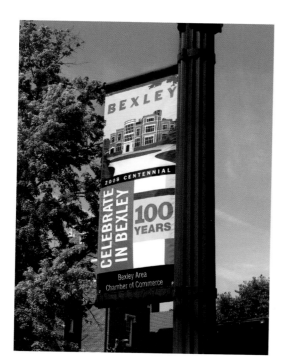

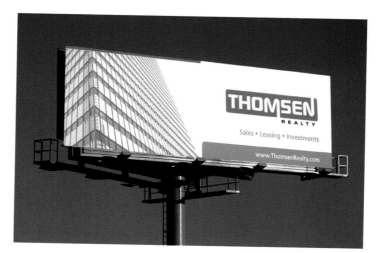

LEIBOLD ASSOCIATES, INC.— NEENAH, WI, UNITED STATES
**CREATIVE TEAM**: Ryan Wienandt, Mark Vanden Berg
**CLIENT**: Thomsen Realty

SCOTT ADAMS DESIGN ASSOCIATES—
MINNEAPOLIS, MN, UNITED STATES
**CREATIVE TEAM**: Scott Adams
**CLIENT**: Bexley Chamber of Commerce

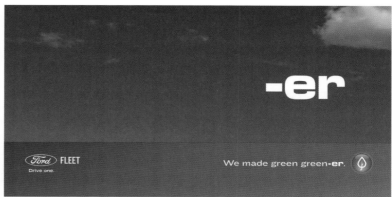

We made green green-**er**.

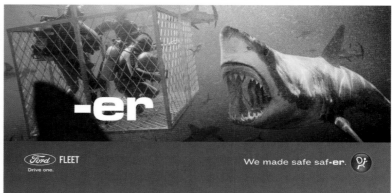

We made safe saf-**er**.

54

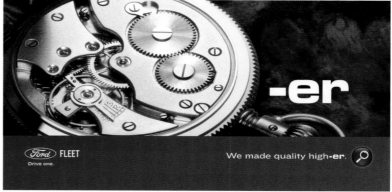

We made quality high-**er**.

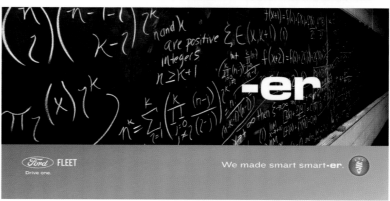

We made smart smart-**er**.

JACKSON-DAWSON COMMUNICATIONS_ DEARBORN, MI, UNITED STATES
**CREATIVE TEAM**: Mike Lucas, Shawn Carter, Steve Flemion, Shane Morris
**CLIENT**: Ford Motor Company

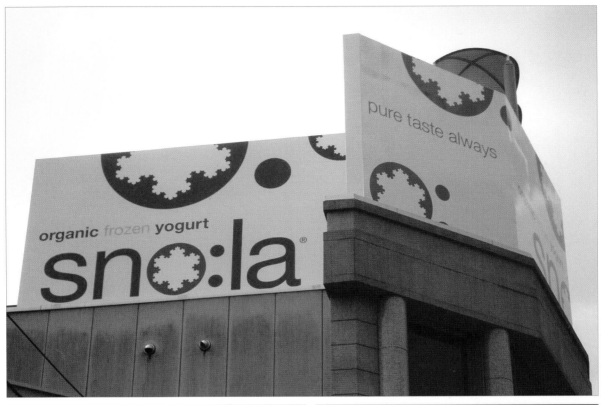

**AKARSTUDIOS**_ SANTA MONICA, CA, UNITED STATES
**CREATIVE TEAM**: Sean Morris, Sat Garg
**CLIENT**: Sno:LA

Books

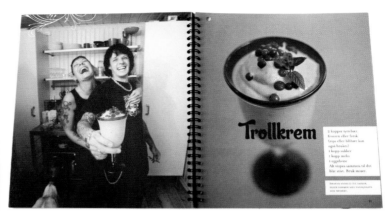

**UREDD_** TRONDHEIM, NORWAY
**CREATIVE TEAM:** Sylvia P. Helle
**CLIENT:** Britt G. Moen

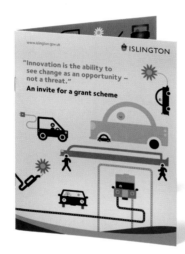
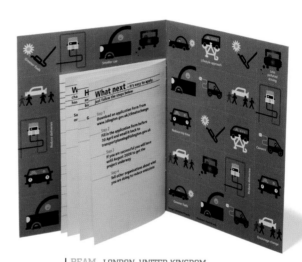

**BEAM_** LONDON, UNITED KINGDOM
**CREATIVE TEAM:** Christine Fent, Dominic Latham-Koenig
**CLIENT:** Islington Council

**344 DESIGN, LLC_** PASADENA, CA, UNITED STATES
**CREATIVE TEAM:** Stefan G. Bucher, Lisa Jann, Robert Wedemeyer
**CLIENT:** L.A. Louver

BETH SINGER DESIGN_ ARLINGTON, VA, UNITED STATES
**CREATIVE TEAM:** Beth Singer, Howard Smith, Deborah Eckbreth, Eric Greitens
**CLIENT:** Eric Greitens

344 DESIGN, LLC_ PASADENA, CA, UNITED STATES
**CREATIVE TEAM:** Stefan G. Bucher, Lisa Jann, Robert Wedemeyer
**CLIENT:** L.A. Louver

PH.D A DESIGN OFFICE_ SANTA MONICA, CA, UNITED STATES
**CREATIVE TEAM:** Michael Hodgson, Derrick Schultz, Julie Markell, Lyn Bradley
**CLIENT**: Twentieth Century Fox Entertainment

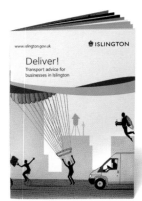

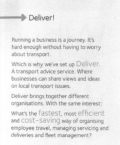
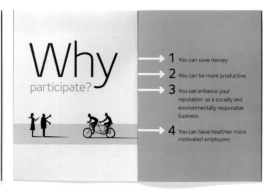

BEAM_ LONDON, UNITED KINGDOM
**CREATIVE TEAM:** Christine Fent, Dominic Latham-Koenigz
**CLIENT**: Islington Council

ACTOR'S CHOICE:
Monologues for Women
Edited by Erin Detrick

Foreword by Broadway casting director Kate Schwabe

ACTOR'S CHOICE:
Monologues for Men
Edited by Erin Detrick

Foreword by Broadway casting director Kate Schwabe

ACTOR'S CHOICE:
Monologues for Teens
Edited by Erin Detrick

Foreword by Broadway casting director Kate Schwabe

ALR DESIGN_ RICHMOND, VA, UNITED STATES
**CREATIVE TEAM:** Noah Scalin
**CLIENT:** Playscript's, Inc.

61

EMSPACE GROUP_ HAGERSTOWN, MD, UNITED STATES
**CREATIVE TEAM:** Gail Snodgrass
**CLIENT:** Bahr Vermeer Haecker

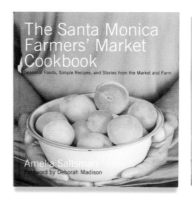

PH.D A DESIGN OFFICE_ **SANTA MONICA, CA, UNITED STATES**
**CREATIVE TEAM:** Michael Hodgson
**CLIENT:** Amelia Saltsman

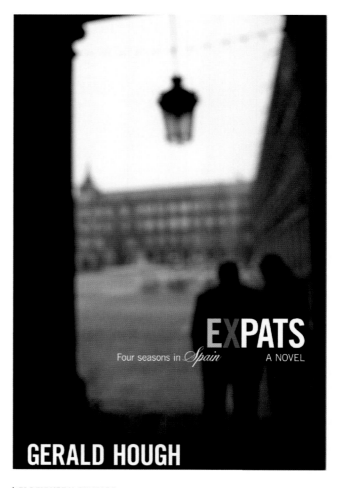

KELLY BRYANT DESIGN_ **AUBURN, AL, UNITED STATES**
**CREATIVE TEAM:** Kelly Bryant, Roger Salter
**CLIENT:** Solid Ground Christian Books

CLOCKWORK STUDIOS_ **SAN ANTONIO, TX, UNITED STATES**
**CREATIVE TEAM:** Terri Gaines, Steve Gaines, Gerald Hough
**CLIENT:** Primera Latino Marketing

This tropical light is
a hot and blinding one –
rather than making objects
appear before your eyes,
it literally evaporates them.

**BEAM_** LONDON, UNITED KINGDOM
**CREATIVE TEAM:** Christine Fent, Dominic Latham-Koenig
**CLIENT:** Robert Sandelson Gallery London

63

**IAN LYNAM CREATIVE DIRECTION & GRAPHIC DESIGN_** TOKYO, JAPAN
**CREATIVE TEAM:** Ian Lynam, Uleshka Asher, Astrid Klein, Mark Dytham
**CLIENT:** Klein Dytham Architecture

**A** PLACE BETWEEN **A** & **B**

**A** AAAAAAAAA BBBBBBBB **B**

VKP DESIGN_ HAARLEM, NETHERLANDS
**CREATIVE TEAM:** Vanessa Paterson
**CLIENT:** Central St.Martins

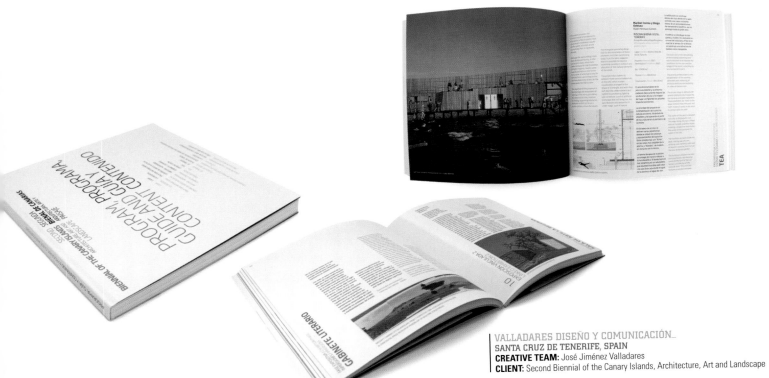

VALLADARES DISEÑO Y COMUNICACIÓN_
SANTA CRUZ DE TENERIFE, SPAIN
**CREATIVE TEAM:** José Jiménez Valladares
**CLIENT:** Second Biennial of the Canary Islands, Architecture, Art and Landscape

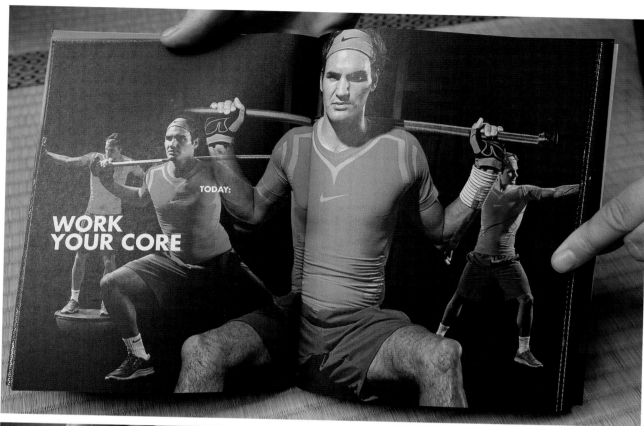

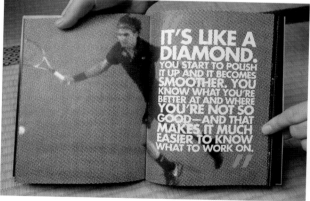

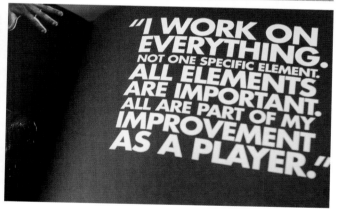

IAN LYNAM CREATIVE DIRECTION & GRAPHIC DESIGN_ TOKYO, JAPAN
**CREATIVE TEAM:** Ian Lynam, Joshua Berger, Plazm
**CLIENT:** Nike Asia Pacific

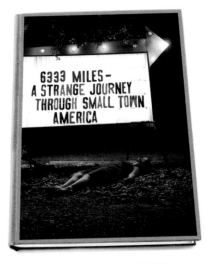
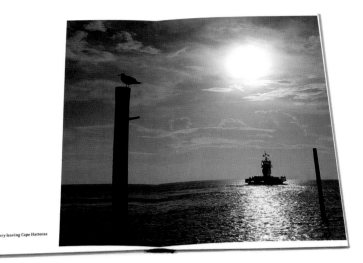

The ferry leaving Cape Hatteras

NICO AMMANN_ ZURICH, SWITZERLAND
**CREATIVE TEAM:** Nico Ammann, Rebecca Barkin
**CLIENT:** 6333 Miles Rebecca Barkin

66

RULE29_ GENEVA, IL, UNITED STATES
**CREATIVE TEAM:** Justin Ahrens, Kerri Liu, Kara Merrick, Craig Clark
**CLIENT:** Life in Abundance International

## Nuestro color es el naranja

Representa el entusiasmo, la felicidad, la atracción, la creatividad, la determinación, el éxito, el ánimo y el estímulo. Es el color de la comunicación, del calor afectivo, equilibrio, de la seguridad, de la confianza, color de las personas que creen que todo es posible. Estimula el optimismo, la generosidad y el entusiasmo.

Ideal para salas de estudio / reunión, lugares donde conversar, generar ideas, intercambiar opiniones. La visión del color naranja produce la sensación de mayor aporte de oxígeno al cerebro, produciendo un efecto vigorizante y de estimulación de la actividad mental.

¿Por qué el equipo de fútbol de Holanda se viste de naranja? El color naranja es el color de la familia real holandesa. En el día de la reina muchísimos holandeses se visten de color naranja. Lo mismo sucede durante los campeonatos internacionales de fútbol. En muchas ciudades holandesas hay calles enteras pintadas de naranja. Probablemente Holanda es el único país del mundo donde hay que vestirse de naranja si se quiere pasar inadvertido. En días de fiesta nacional, el mejor camuflaje es de color naranja.

Y de Holanda nos gusta como entienden el diseño, en eso nos sentimos algo holandeses.

## Our color is orange

It represents enthusiasm, happiness, attraction, creativity, determination, success, spirit and stimulus. It is the color of the communication, affection, balance, safety and confidence. It is the color of the person who believes that anything is possible. It stimulates optimism, generosity and enthusiasm.

Is ideal for study / meeting rooms and places of converse - anywhere that allows for generating of ideas and exchanging of opinions. The vision behind orange produces the sensation of a greater contribution of oxygen to the brain, enabling invigoration and the stimulation of mental activity.

Why do the entire Holland football team dress in orange? orange is the color of the dutch royal family. On the queen's day most of the dutch will dress up in orange. Additionally, during the international football championships they too dress in orange. In many dutch cities you will find entire streets painted in orange. Perhaps Holland is the only country in the world where you should dress in orange if you want to pass unnoticed. On national holidays, the best camouflage is of orange color.

And from Holland we like the way they understand the design, in this we feel a bit dutch.

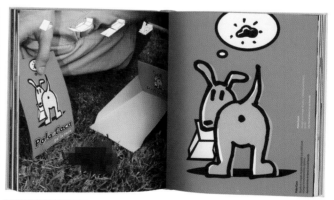

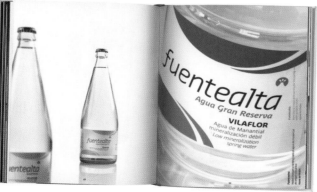

VALLADARES DISEÑO Y COMUNICACIÓN_ SANTA CRUZ, SANTA CRUZ DE TENERIFE, SPAIN
**CREATIVE TEAM**: Pepe Valladares
**CLIENT:** Valladares Diseño y Comunicación (self promotion)

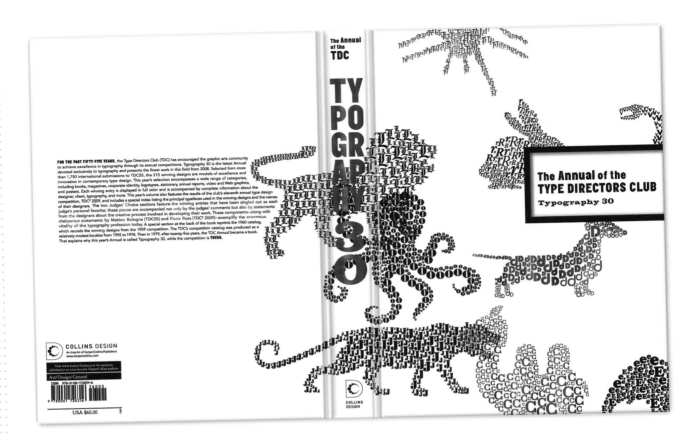

## An In-Depth Look

## Typography 30

The Type Directors Club (TDC) has been producing its annual book for three decades, and when they asked Sharon Werner and Sarah Forss from Werner Design Werks to produce the package for *Typography 30*, the St. Paul designers knew it was an honor—and a chance to do something completely different. "They're pretty open to us doing what we want, as long as it meets their needs and doesn't look like last year," says Werner, the firm's owner. *"But we knew it needed to translate to other countries pretty easily and be appropriate for an international competition."*

The book, which goes out to TDC members and is available at retail for art directors, designers, typographers and anyone who has an interest in creating imagery with type, attracts entries from nearly twenty-five thousand potential contributors in nineteen countries. "The book showcases the selected entries from the TDC55 competition and [type design competition] TDC2," Werner says. "They began with a catalog in 1955, but then started producing the annual books in 1979."

As Werner and Forss were very familiar with the competition, they didn't require much of a creative brief to get started. "We know what it is, how they use it, who the audience is," says Forss. "But our familiarity with it was kind of a downfall." Their first contribution to the project, a call for entries, was rejected outright. "They felt it was too cold and austere and a little bit academic, which they'd done in the past," Werner says. "They said they wanted some-thing more friendly, more approachable, so we went back to the drawing board and came back with these animals and typography, giving it a science-y feel."

To give the poster, call for entries and, ultimately, the book a "wild world of the animal kingdom" (as Werner puts it) theme, Werner and Forss created a typographic menagerie of animals from A to Z—composed entirely of the first letter of each creature's name. Although it was time-consuming, the duo enjoyed the process enough to invite the TDC's two chairpersons, two juries and director to submit portraits of themselves for the same treatment. *"We asked the designers if they had a type font they designed, or one they particularly liked and we built their portraits from these,"* says Werner. "Some people said Helvetica because it's one they really loved and it fit their personality. Some of them worked better than others, because the fonts were better suited for creating a portrait. But as a group they look good, because of the diversity." (Werner and Forss, given the chance, both would choose Clarendon to represent themselves in a similar illustrative manner.)

In the case of *Typography 30*, having diversity does not mean the designers gave themselves license to create a jumble. "We tried to keep these [illustrated] kinds of pages as the divider pages and have those be fun and where we could put our personality, and then have the pages with the work be clean and straight and let the work speak for itself," Werner says. "We wanted to give it as much space and as much air as we could and keep the credits really tidy at the top… giving the work its own museum setting." Having definite divisions, she feels, contributes to a comfortable organization that's appealing to even the most discriminating design connoisseur. "That's why people buy the book: for the work in the book, not for our design," she says. "We give it a nice package so someone will be interested in picking it up and looking at it."

WERNER DESIGN WERKS_ ST. PAUL, MN, UNITED STATES
**CREATIVE TEAM:** Sharon Werner, Sarah Nelson-Forss
**CLIENT**: HarperCollins Publishers / The Type Directors Club

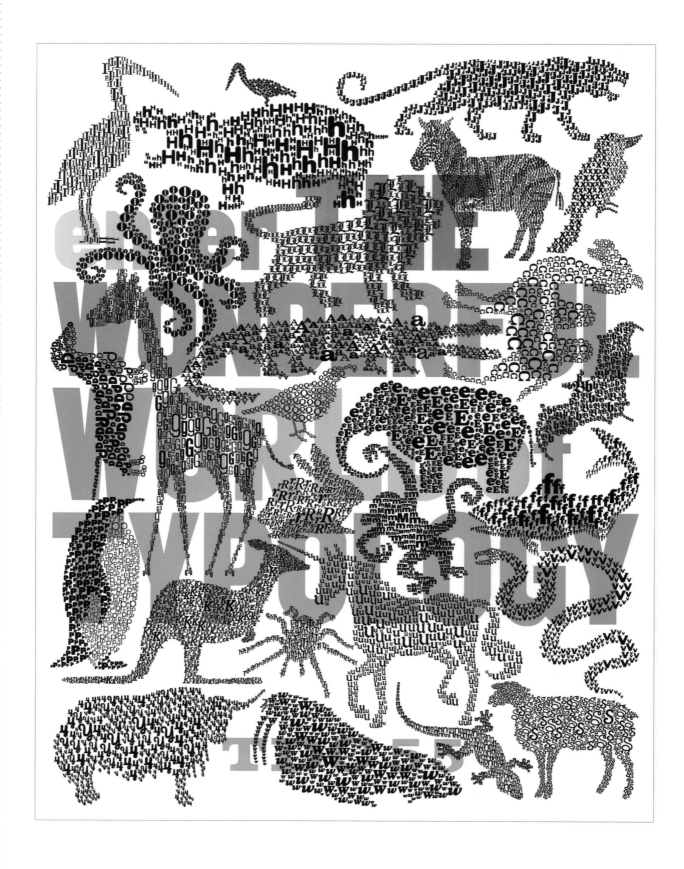

MATTEO
**BOLOGNA**
chairman

Matteo Bologna is the founding partner
and president of New York–based
Mucca Design Corporation, where he
also serves as creative director. Born
and raised in Milan, his grounding in
architecture, graphic design, illustration,
and typography facilitated his early
business successes and inspired his
decision to escape from Italy and
create a New York City agency.

Under Bologna's direction, the Mucca
Design team has solved numerous
design challenges and created
uniquely successful identities for widely
varied brands, among them: Pastis and
Balthazar restaurants in New York,
Victoria's Secret, Adobe Systems,
Barnes & Noble, Target, HarperCollins,
Starr Restaurants, Patina Restaurant
Group, Penguin, Random House, and
Domaine de Canton. Mucca Design is
also responsible for the highly
successful re-branding and art direction
of Rizzoli in Italy and its paperback
division, BUR.

The work produced by Mucca Design
has been widely recognized by industry
publications, including Communication
Arts, Eye, Graphis, How Magazine,
Print, and Step Inside Design; and by
competitions and exhibitions organized
by the American Institute of Graphic
Arts (AIGA), the Art Directors Club, the
James Beard Foundation, and the Type-
Directors Club.

**VICTORIA'S SECRET**

The chairmen and judges each selected a typeface for his or her type portrait.

---

166   poster

DESIGN
Barry Kalpinski
Madison, Wisconsin

ART DIRECTION
Barry Kalpinski

CREATIVE DIRECTION
Peter Bell

COPYWRITER
Sandy Geer

AGENCY
Hiebing

CLIENT
Madison Museum of
Contemporary Art

PRINCIPAL TYPE
Engravers

DIMENSIONS
17.25 × 23 in.
(43.8 × 58.4 cm)

PRINCIPAL TYPE
Arnhem
Futura
MADface

DIMENSIONS
various

CLIENT
Museum of Arts and
Design (MAD)

STUDIO
Pentagram Design
New York

ART DIRECTION
Michael Bierut

DESIGN
Michael Bierut
Joe Marianek
New York

corporate
identity   167

---

WERNER DESIGN WERKS_ ST. PAUL, MN
**CREATIVE TEAM**: Sharon Werner, Sarah Nelson-Forss
**CLIENT**: HarperCollins Publishers / The Type Directors Club

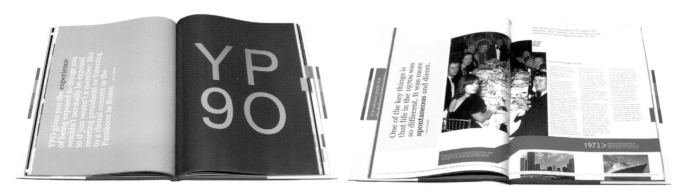

SPATCHURST_ BROADWAY, AUSTRALIA
**CREATIVE TEAM**: Steven Joseph, Nicky Hardcastle
**CLIENT**: Young President's Organization

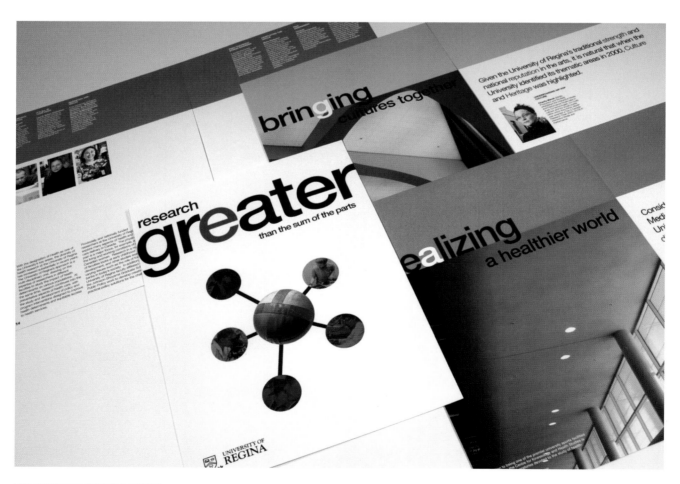

BRADBURY BRANDING & DESIGN_ REGINA, SK, CANADA
**CREATIVE TEAM**: Catharine Bradbury
**CLIENT**: University of Regina

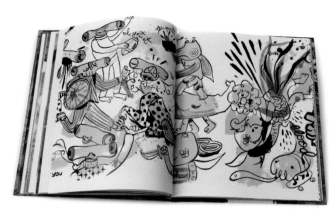

IAN LYNAM CREATIVE DIRECTION & GRAPHIC DESIGN_ TOKYO, JAPAN
**CREATIVE TEAM**: Ian Lynam, Bwana Spoons
**CLIENT**: Top Shelf

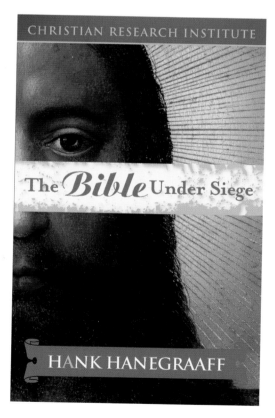

IDEASTREAM DESIGN INC._ VANCOUVER, CANADA
**CREATIVE TEAM**: Catherine Worrall MGDC, Leanne Davis LGDC
**CLIENT**: West Fraser Timber

SAINT DWAYNE DESIGN_ CHARLOTTE, NC, UNITED STATES
**CREATIVE TEAM**: Dwayne Cogdill
**CLIENT**: Christian Research Institute

ALEXANDER EGGER_ VIENNA, AUSTRIA
**CREATIVE TEAM**: Alexander Egger, Isolde Fitzel
**CLIENT**: Designforum Vienna

VKP DESIGN_ HAARLEM, NETHERLANDS
**CREATIVE TEAM**: Vanessa Paterson
**CLIENT**: Central St.Martins

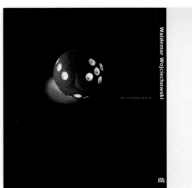 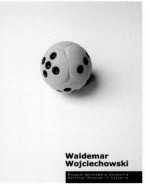 

YOTAM HADAR_ TEL AVIV, ISRAEL
**CREATIVE TEAM**: Yotam Hadar
**CLIENT**: Self Initiated

WEST-POMERANIAN UNIVERSITY OF TECHNOLOGY_ SZCZECIN, POLAND
**CREATIVE TEAM**: Waldemar Wojciechowski
**CLIENT**: National Museum in Szczecin

PONDEROSA PINE DESIGN_ RENO, NV, UNITED STATES
**CREATIVE TEAM**: Vicky Shea, Lisa Perrett, Liz Encarnacion, Susan Hom
**CLIENT**: Cider Mill Press

288_ RIO DE JANEIRO, BRAZIL
**CREATIVE TEAM**: Guilherme Howat
**CLIENT**: Student Work

THINK STUDIO, NYC_ NEW YORK, NY, UNITED STATES
**CREATIVE TEAM**: John Clifford, Herb Thornby
**CLIENT**: The Monacelli Press

KROG_ LJUBLJANA, SLOVENIA
**CREATIVE TEAM**: Edi Berk, Dragan Arrigler
**CLIENT**: Mladinska Knjiga, Ljubljana

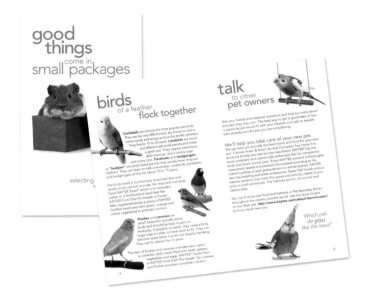

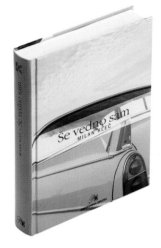

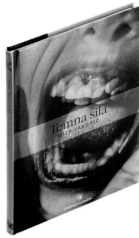

**LEIBOLD ASSOCIATES, INC.** NEENAH, WI, UNITED STATES
**CREATIVE TEAM:** Therese Joanis
**CLIENT:** Kaytee Products, Inc.

**KROG** LJUBLJANA, SLOVENIA
**CREATIVE TEAM:** Edi Berk
**CLIENT:** Presernova druzba, Ljubljana

77

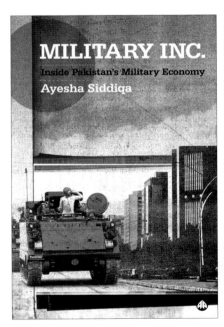

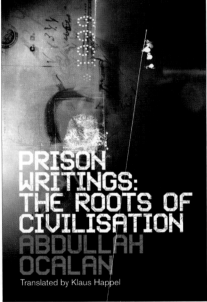

**TRANSMISSION** BRIGHTON, UNITED KINGDOM
**CREATIVE TEAM:** Stuart Tolley
**CLIENT:** Pluto Press

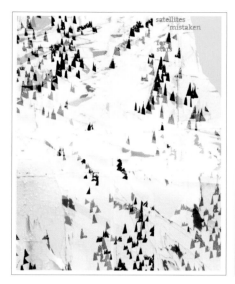
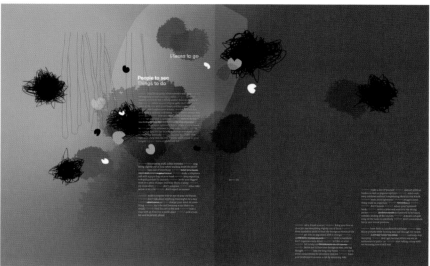

ALEXANDER EGGER_ VIENNA, AUSTRIA
**CREATIVE TEAM**: Alexander Egger
**CLIENT:** Rupa Publishing

344 DESIGN, LLC_ PASADENA, CA, UNITED STATES
**CREATIVE TEAM:** Stefan G. Bucher, Lisa Jann, Robert Wedemeyer
**CLIENT:** L.A. Louver

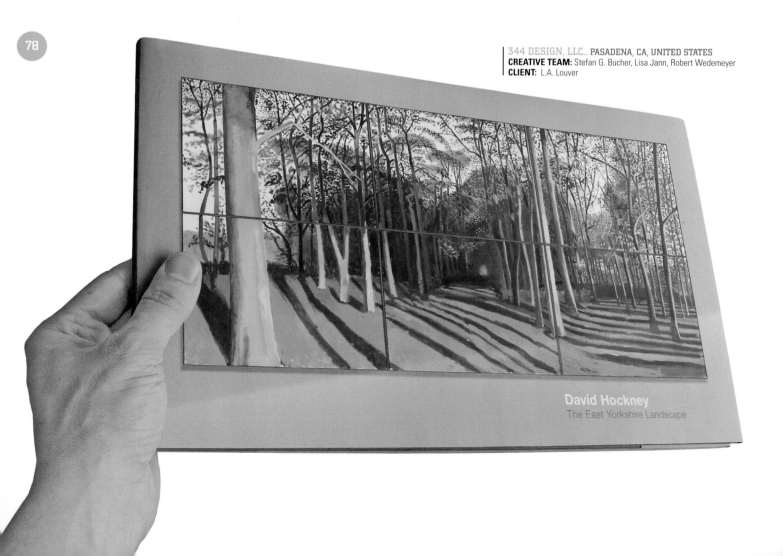

344 DESIGN, LLC_ PASADENA, CA, UNITED STATES
**CREATIVE TEAM:** Stefan G. Bucher,  Ze Frank
**CLIENT:** HOW Books

79

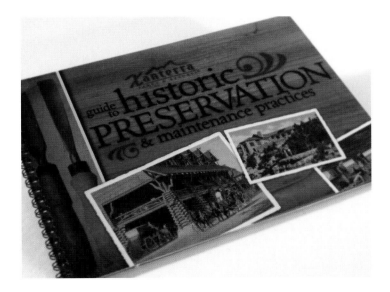

JM DESIGNS_ LOVELAND, CO, UNITED STATES
**CREATIVE TEAM:** John Metcalf
**CLIENT:** Xanterra Parks & Resorts

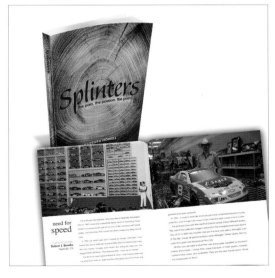

PAIGE1MEDIA_ BROKEN ARROW, OK, UNITED STATES
**CREATIVE TEAM:** JP Jones
**CLIENT:** Barbara Howell

COLORYN STUDIO_
RICHMOND, VA, UNITED STATES
**CREATIVE TEAM**: Ryn Bruce
**CLIENT**: Coloryn Studio

VKP DESIGN_ HAARLEM, NETHERLANDS
**CREATIVE TEAM**: Vanessa Paterson
**CLIENT**: Central St.Martins

80

PH.D A DESIGN OFFICE_
SANTA MONICA, CA, UNITED STATES
**CREATIVE TEAM**: Michael Hodgson, Derrick Schultz,
Julie Markell, Lyn Bradley
**CLIENT**: Twentieth Century Fox Entertainment

BRADBURY BRANDING & DESIGN_ REGINA, SK, CANADA
**CREATIVE TEAM**: Catharine Bradbury
**CLIENT**: Moose Jaw Museum & Art Gallery

THINK STUDIO, NYC_ NEW YORK, NY, UNITED STATES
**CREATIVE TEAM**: Herb Thornby, John Clifford
**CLIENT**: Stewart, Tabori and Chang

344 DESIGN, LLC_ PASADENA, CA, UNITED STATES
**CREATIVE TEAM**: Stefan G. Bucher, Stephen Berkman, Steven Colover, Ged Clarke / Tarsem
**CLIENT**: Googly Films

82

ALEXANDER EGGER_ VIENNA, AUSTRIA
**CREATIVE TEAM**: Alexander Egger, Isolde Fitzel
**CLIENT**: Designforum

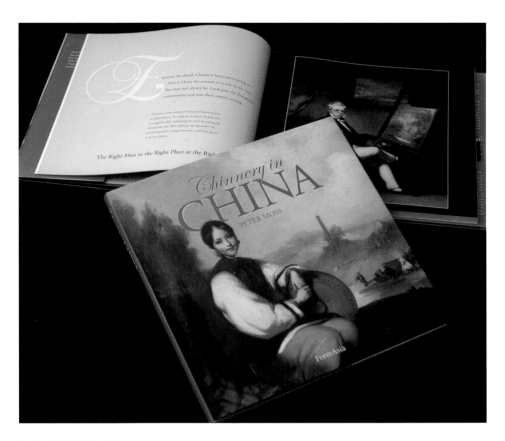

GRAPHICAT LIMITED_ HONG KONG, CHINA
**CREATIVE TEAM**: Colin Tillyer
**CLIENT**: FormAsia

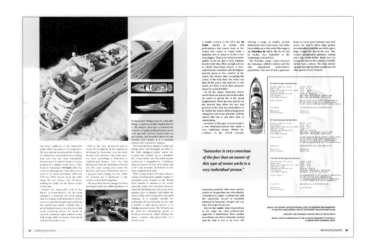

FUTURE IMAGING DESIGN_ MONTREAL, CANADA
**CREATIVE TEAM**: Alex Furness
**CLIENT**: Sunseeker Yachts

PH.D A DESIGN OFFICE_ SANTA MONICA, CA, UNITED STATES
**CREATIVE TEAM**: Michael Hodgson, Derrick Schultz
**CLIENT**: Chronicle Books

Brochures

86

BERTZ DESIGN GROUP_ MIDDLETOWN, CT, UNITED STATES
**CREATIVE TEAM**: Lorraine Connelly
**CLIENT**: Choate Rosemary Hall

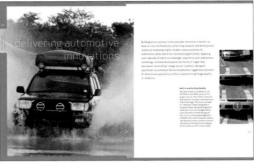

MOXIE SOZO_ BOULDER, CO, UNITED STATES
**CREATIVE TEAM**: Leif Steiner, Pushpita Saha
**CLIENT**: Além International

MUELLER DESIGN_ OAKLAND, CA, UNITED STATES
**CREATIVE TEAM**: Kyle Mueller, Charmian Naguit
**CLIENT**: OmniVision

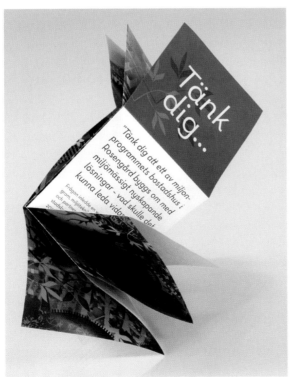

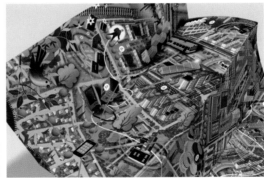
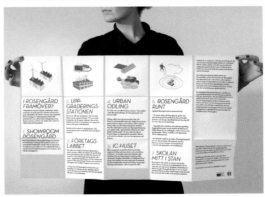

NILS-PETTER EKWALLS ILLUSTRATIONSBYRÅ_ MALMÖ, SWEDEN
**CREATIVE TEAM**: Nils-Petter Ekwall, Magdalena Alevrá, Sofie Karavida
**CLIENT**: Malmö stads Stadsbyggnadskontor

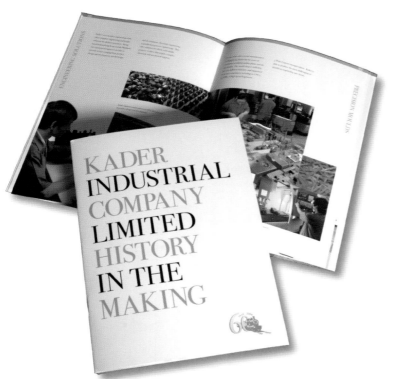

GRAPHICAT LIMITED_ HONG KONG, CHINA
**CREATIVE TEAM**: Colin Tillyer, Arion Wong
**CLIENT**: Kader Holdings Company Limited

BRONSON MA CREATIVE_ SAN ANTONIO, TX, UNITED STATES
**CREATIVE TEAM**: Bronson Ma, Max Wright
**CLIENT**: Association of Corporate Counsel-D/FW Chapter

MICHELLEROBERTSDESIGN_ BARNEVELD, NY, UNITED STATES
**CREATIVE TEAM**: Michelle Roberts
**CLIENT**: Sweet Pea Promotions

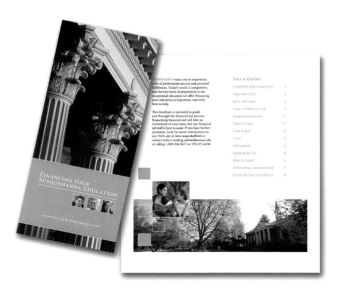

SUSQUEHANNA UNIVERSITY_ SELINSGROVE, PA, UNITED STATES
**CREATIVE TEAM**: Nicholas Stephenson, Steven Semanchik
**CLIENT**: Susquehanna University

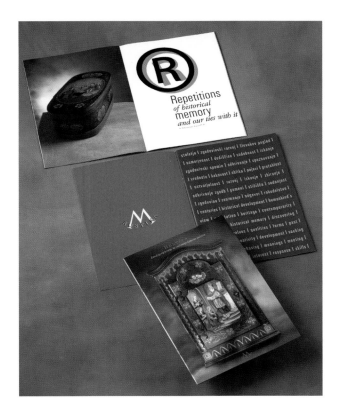

KROG_ LJUBLJANA, SLOVENIA
**CREATIVE TEAM**: Edi Berk, Boris Gaberscik, Janez Puksic
**CLIENT**: Gallery Rustika, Ljubljana

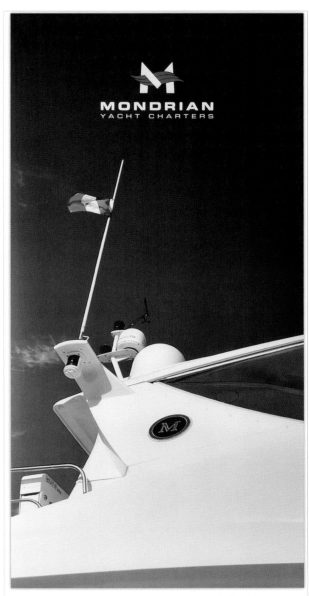

JACOB TYLER_ SAN DIEGO, CA, UNITED STATES
**CREATIVE TEAM**: Les Kollegian, Gordon Tsuji
**CLIENT**: Mondrian Yacht Charters

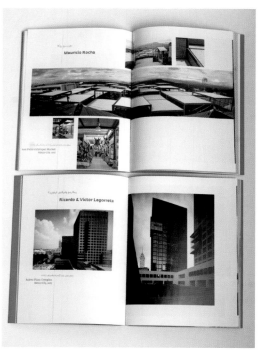

MAYDA FREIJE MAKDESSI_ BEIRUT, LEBANON
**CREATIVE TEAM**: Mayda Freije Makdessi , Amani BouDargham, Nour Tabet
**CLIENT**: The Embassy of Mexico in Lebanon, in collaboration with the Department of Architecture and Design of AUB

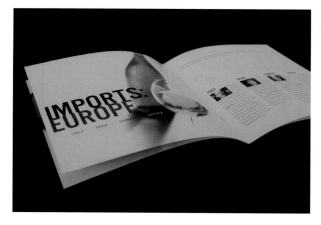

IE DESIGN + COMMUNICATIONS_ HERMOSA BEACH, CA, UNITED STATES
**CREATIVE TEAM**: Marcie Carson, Jane Lee, Christine Kenney
**CLIENT**: Altus Pharmaceuticals

IE DESIGN + COMMUNICATIONS_ HERMOSA BEACH, CA, UNITED STATES
**CREATIVE TEAM**: Marcie Carson, Christine Kenney
**CLIENT**: K&L Wine Merchants

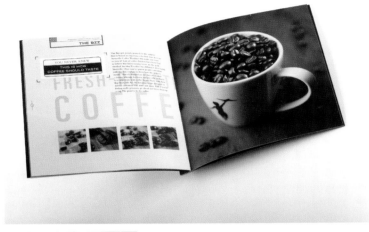

ALPHABET ARM_ BOSTON, MA, UNITED STATES
**CREATIVE TEAM**: Aaron Belyea, Ryan Frease
**CLIENT**: BzzAgent Inc.

# FORESTS
towering trees, falling leaves

### A Sea of Green

*If any one landscape on Earth has proved itself most useful to humanity, it would be the forests, for they have provided lumber for homes and ships, firewood, food, medicines and a plethora of folk stories and deities. Forests' usefulness have also been their undoing; many of the world's great forests are either much reduced by logging or on their way.* North America's forests once stretched nearly the length of the continent, North to South, and from the Atlantic Ocean to the edge of the Great Plains. In fact, few places on Earth retain any virgin forests.

The one of all forests on Earth is the Taiga, which circles the planet from Sweden to Siberia to Alaska and Canada. It's a cold, evergreen forest that is the largest single terrestrial biological zone on the planet. It's where most of the world's trees live, and it's populated almost entirely by evergreen species. The Taiga is also a vast player in the seasonal changes in carbon dioxide levels in the entire atmosphere. Every spring the trees awaken and start absorbing carbon dioxide and releasing oxygen. In the fall, the trees slow down and hibernate, and carbon dioxide from an

Sometimes called "the phantom of the north" the great gray owl flies with slow, quiet wing beats. As it comes in for the kill, its wings flap in utter silence and with lightning speed. It swoops to the earth, plunging its talons into the snow. A great gray owl's hearing is so acute that they can detect scurrying rodents in their trails underneath the snow. Rarely seen, these large gray owls have round heads with no ear tufts, distinctive facial disks and bright yellow eyes. Great gray owls can eat up to a third of their weight daily, and when rearing chicks, they have to double their efforts.

array of sources builds up. At large as the taiga is, however, the trees are not able to keep up with the carbon dioxide increases have added to the atmosphere since the dawn of the Coal Age and the Industrial Revolution.

Giant trees south of the taiga form other forests, but are impressive for entirely different reasons. The coastal redwoods are the tallest trees in the world, towering 300 feet above the ground along the foggy coasts from southern Oregon down to Monterey County, California. These 20-million-year-old forests were extensively logged in the 1890s and early 1900s. Luckily, and unbeknownst to the loggers, these trees can sprout like weeds from their own roots. Today you can tell when you're in a second-growth redwood forest because these are always younger trees growing in a ring around a decayed giant

stump. They make an eerie circle of columns, like some sort of strange sylvan temple.

As towering as the coastal redwoods are, they're outclimbable compared to their Sierra Nevada cousins, the giant sequoias. These are the largest trees on Earth. They can get as tall as coast redwoods, but are far wider, some reaching 35 feet in diameter. The oldest giant sequoia is about 3,200 years old, based on a carving of its annual growth rings.

Extra water and summer heat make broad, water-warring leaves possible and speeds up decay of older leaves on the ground, which feed the soil and recycle many nutrients to the trees. Warmer in many regions around the globe are often arid, will cause many leaves to drop from their tree such as tropical trees in India and some desert places share this leaf-dropping tactic.

## JUNGLES
packed with life

*The Mighty Jungle*

## MOUNTAINS
islands in the sky

*Mountains Primeval*

KUTZTOWN UNIVERSITY_ BLANDON, PA, UNITED STATES
**CREATIVE TEAM**: William Michael Riedel, Laurel Bonhage
**CLIENT**: Discovery Channel

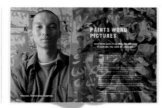
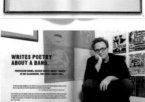
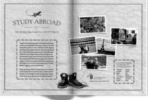
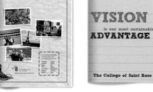
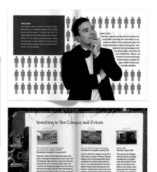

**THE COLLEGE OF SAINT ROSE_**
ALBANY, NY, UNITED STATES
**CREATIVE TEAM**: Mark Hamilton, Chris Parody,
Lisa Haley Thomson, John Backmann
**CLIENT**: The College of Saint Rose

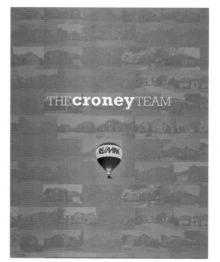

**PEAK SEVEN ADVERTISING_** DEERFIELD BEACH, FL, UNITED STATES
**CREATIVE TEAM**: Darren Seys
**CLIENT**: P&H Interiors

**OHTWENTYONE_** EULESS, TX, UNITED STATES
**CREATIVE TEAM**: Jon Sandruck
**CLIENT**: The Croney Team

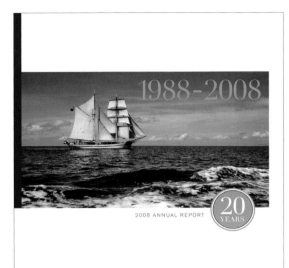

ROYCROFT DESIGN_ **BOSTON, MA, UNITED STATES**
**CREATIVE TEAM**: Jennifer Roycroft
**CLIENT**: Arbella Insurance Group

PEOPLE DESIGN_ **GRAND RAPIDS, MI, UNITED STATES**
**CREATIVE TEAM**: Yang Kim, Michele Brautnick
**CLIENT**: izzydesign

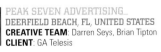

PEAK SEVEN ADVERTISING_
**DEERFIELD BEACH, FL, UNITED STATES**
**CREATIVE TEAM**: Darren Seys, Brian Tipton
**CLIENT**: GA Telesis

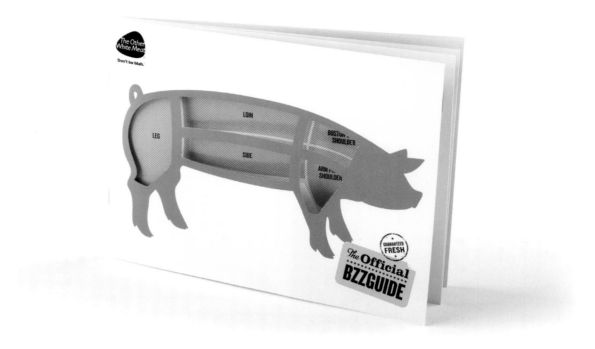

## An In-Depth Look

## Bzzz Guides

For all the negative press pigs have gotten in our culture, it may come as a surprise to many people that pork is leaner than many other types of meat. Getting out such messages are what BzzGuides (pronounced "Buzz Guides") are all about. "The client, BzzAgent, is a top word-of-mouth media network hired by the National Pork Board to do a campaign for them," says Aaron Belyea, art director at Alphabet Arm in Boston. "A BzzGuide functions as a training manual for the agents out in the field to create word-of-mouth."

Belyea and designer Ryan Frease have worked with BzzAgent on other campaigns, creating BzzGuides for products from Burt's Bees, American Express and T.G.I. Friday's, among others, but this one was different. "In some cases, it's an exercise in staying with the brand and executing something that looks good and communicates the message," says Frease. "However, for this one, the client opened the doors stylistically and let us bring a lot of creativity to it."

The BzzGuides, sent to volunteer word-of-mouth marketers ("agents") for the purpose of telling their friends about their experience with the product. "The purpose is to inspire the agents to talk about it and give them some information that they might not know about the product, some interesting points about it, facts that they can use, who might be interested, where you can buy it," says Frease. *"Our job is to make it visually interesting and incorporate some of the established brand but also speak directly to the BzzAgents."* The BzzGuide includes recipes, nutritional information charts and delectable photography in order to get people excited about "The Other White Meat."

Having a lifelong familiarity with the product—in fact, Frease is the grandson of an Iowa pig farmer—led to the additional challenge of creative

self-editing. "The concept is driven by the kitschy supermarket vernacular of days gone by, and there's so much to pull from, like the vintage signs and price tags, and as designers we're really drawn to that," Frease says. "But we didn't want to overshadow the concept or make it feel dated, but to modernize it while paying respect to old supermarkets and butcher shops." This homage is evident in the package of the guide itself: A chart reminiscent of a butcher's poster (albeit with brighter colors and die-cut windows) introduces readers to the origin of various cuts of meat, a GUARANTEED FRESH stamp adorns the pages and the whole thing is wrapped in brown uncoated butcher paper and sealed with a sticker. "It takes you back to the old days when people would get their meat from the butcher, but also seamlessly showcases the product," says Belyea. "When we presented it to the client they got a kick out of it because it looked like a premium piece."

*Supplied with the brand identity, copy and food photography, Alphabet Arm developed the concept and overall aesthetic. "There are a lot of little nuances within the design," Belyea says. "We wanted to use typography and really craft a beautiful looking piece that would make a strong impact out of the gate, but the more time you spent with it, the more you would appreciate the small details."* Says Frease: "We knew the tactile quality of the butcher paper and the interaction you have with the diagram would be fun for the agents to work with." And Belyea adds, "People are excited when they get these guides in the mail, and we knew this would be one they'd want to keep or share with friends."

The turnaround time was as fast as a proverbial greased pig, with Frease and Belyea having just a couple of short weeks to bring together all the pieces—including whipping the talent into shape. "One thing that's kind of funny is,

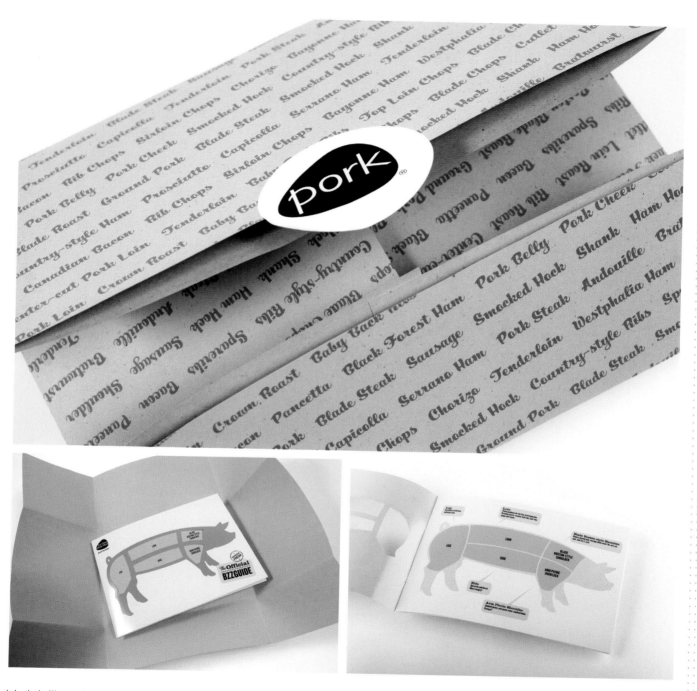

the original pig illustration that we proposed was a bit, shall we say, big boned," says Frease. "The client wanted to show in the content of the guide that pork is a healthy alternative, and they wanted the pig to reflect that. So he became more fit as the process went along." Jokes Belyea, a vegetarian: "We had our tubby little friend on a treadmill for about two weeks."

ALPHABET ARM_ BOSTON, MA
**CREATIVE TEAM**: Aaron Belyea, Ryan Frease
**CLIENT**: BzzzAgents Inc.

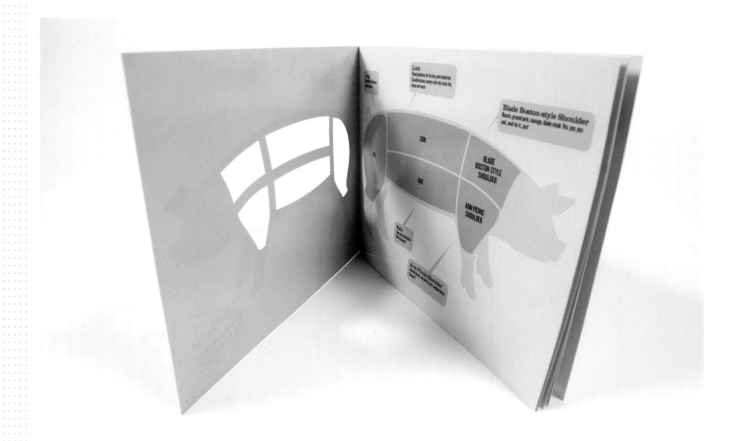

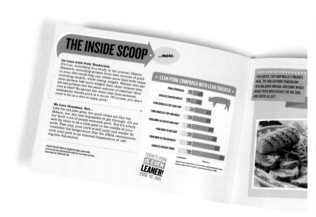

ALPHABET ARM_ BOSTON, MA
**CREATIVE TEAM**: Aaron Belyea, Ryan Frease
**CLIENT**: BzzzAgents Inc.

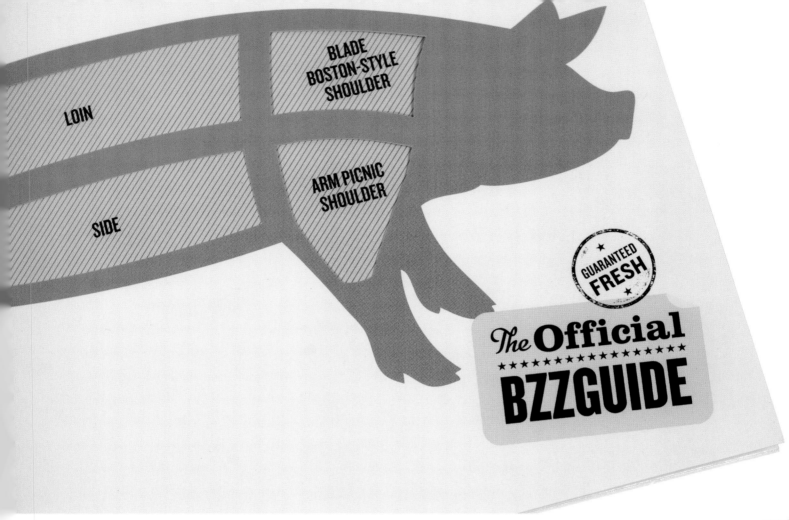

LOIN

SIDE

BLADE BOSTON-STYLE SHOULDER

ARM PICNIC SHOULDER

GUARANTEED FRESH

The Official **BZZGUIDE**

# WHAT'S THE BZZ?

*Fresh*

Did you know that, globally, we eat more pork than any other meat?[1]

Maybe you're thinking: "Why do people around the world love it so much, and are there really that many ways to prepare it? Whenever I cook it, it dries out in no time. Plus, it's not the healthiest, right?"

It sure seems easier to resort to the same ol' chicken or beef. That gets tired, though, doesn't it?

With this campaign, you can forget about Grandma's hockey puck pork chops (we still love you, Grams). Turns out there are plenty of reasons why pork is so popular. First, there are countless ways to enjoy all the different cuts of pork. Just giving a few examples doesn't do the deliciousness justice, but how about applewood-smoked bacon at breakfast? A lean ham sandwich for lunch? Juicy grilled pork chops with applesauce, or a pork stir fry with fresh veggies for ?? Plus, pork complements so many flavors and ?? in just about any recipe, once you know ?? aring it properly...so say good-bye to

If that's not enough, many cuts of pork are lean — pork tenderloin, in particular, is not only delicious but it's as lean as skinless chicken breast[2] And while food prices seem to keep rising, pork is still one of the most relatively affordable lean proteins in the meat case.

**NEW RECIPES & IDEAS EACH WEEK** ★★★★★★★ WHY BE BLAH WHEN YOU CAN IMPRESS PEOPLE (AND THEIR TASTE-BUDS) WITH DELICIOUS PORK? LOGIN TO BZZAGENT.COM EACH WEEK AND CHECK THE CAMPAIGN HOMEPAGE FOR NEW FEATURED RECIPES AND OTHER GREAT TIPS. ★★★★★★★★★

This campaign will arm you with some new ideas to help break out of your food rut. We'll even make sure you have access to expert and easy-to-follow tips, as well as thousands of tasty recipes that the whole family (from the kids to Grandma) will love.

1 USDA-Foreign Agriculture Service. 2005.
2 U.S. Department of Agriculture, Agricultural Research Service National Nutrient Database for Standard Reference, Release 19 and the Revised USDA Nutrient Data Set for Fresh Pork. 2006.

# JUST

**Storing You**
First, keep
refrigerat
a freezer
keep se
for up
pork
flavo
one

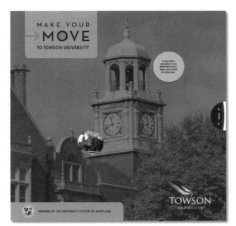

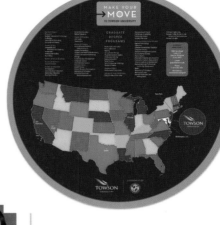

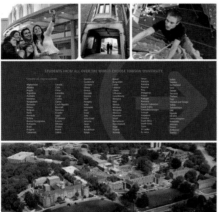

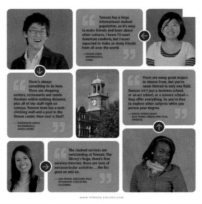

TOWSON UNIVERSITY_
TOWSON, MD, UNITED STATES
**CREATIVE TEAM**: Eleni Swengler, Dan Fuchs,
Kanji Takeno, Desiree Stover
**CLIENT**: International Admissions Program

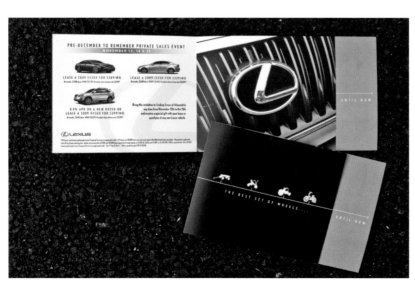

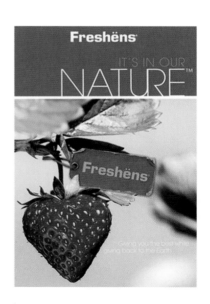

SIMPATICO DESIGN STUDIO_ ALEXANDRIA, VA, UNITED STATES
**CREATIVE TEAM**: Amy Simpson
**CLIENT**: Lindsay Lexus of Alexandria

SELLIER DESIGN_
MARIETTA, GA, UNITED STATES
**CREATIVE TEAM**: Julie Cofer, Pauline Pellicer,
Kriston Sellier
**CLIENT**: Freshëns Quality Brands

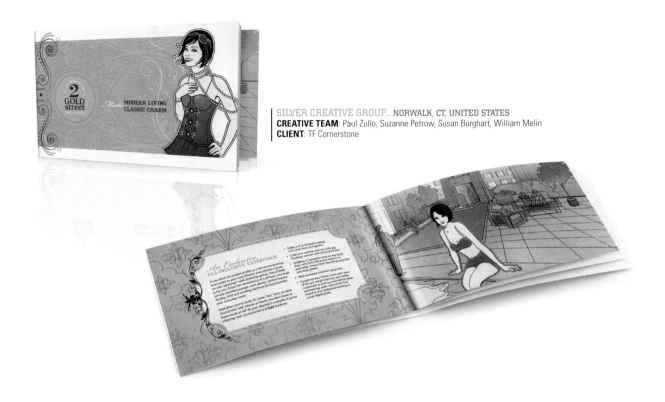

99

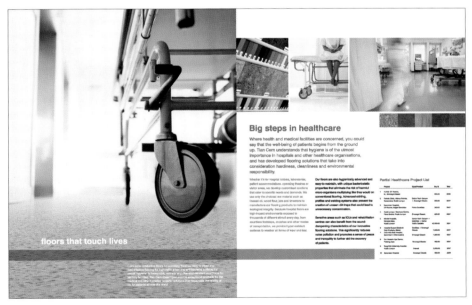

**Big steps in healthcare**

Where health and medical facilities are concerned, you could say that the well-being of patients begins from the ground up. Tian Cern understands that hygiene is of the utmost importance in hospitals and other healthcare organisations, and has developed flooring solutions that take into consideration hardiness, cleanliness and environmental responsibility.

floors that touch lives

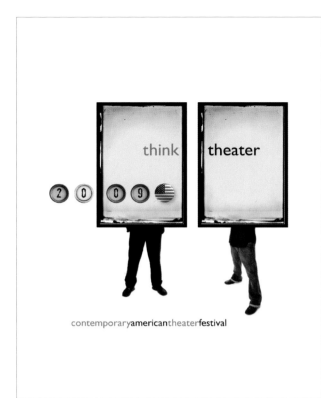

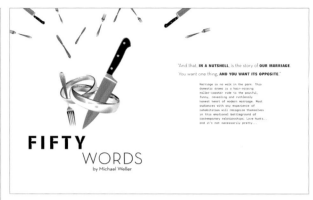

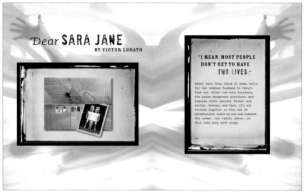

100

**UNFOLDING TERRAIN_ HAGERSTOWN, MD, UNITED STATES**
**CREATIVE TEAM**: Francheska Guerrero
**CLIENT**: Contemporary American Theater Festival at Shepherd University

**STORM CORPORATE DESIGN_**
**AUCKLAND, NEW ZEALAND**
**CREATIVE TEAM**: Rehan Saiyed
**CLIENT**: Lusanne Project Management

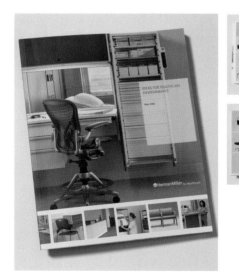

**PEOPLE DESIGN_ GRAND RAPIDS, MI, UNITED STATES**
**CREATIVE TEAM**: Kevin Budelmann, Michele Brautnick, Jessica Lee, Yang Kim
**CLIENT**: Herman Miller

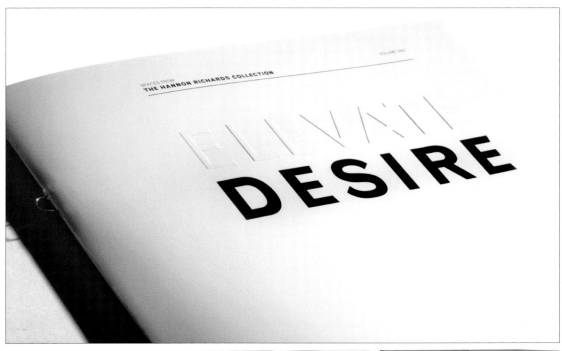

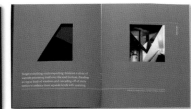

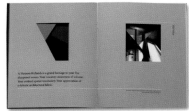
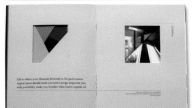
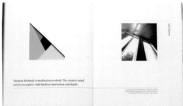

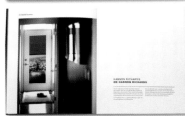
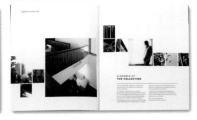
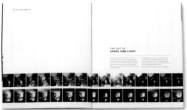

FOUNDRY_ CALGARY, AB, CANADA
**CREATIVE TEAM**: Alison Wattie, Kylie Henry, Ric Kokotovich, Mitzi Duvall
**CLIENT**: Hannon Richards

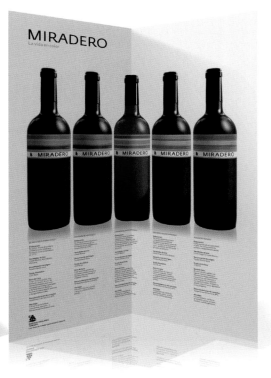

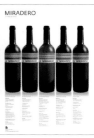

VALLADARES DISEÑO Y COMUNICACIÓN_ SANTA CRUZ, SANTA CRUZ DE TENERIFE, SPAIN
**CREATIVE TEAM**: José Jiménez Valladares
**CLIENT**: Bodegas Insulares Tenerife

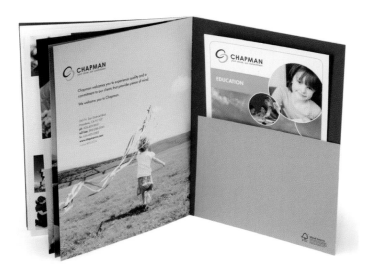

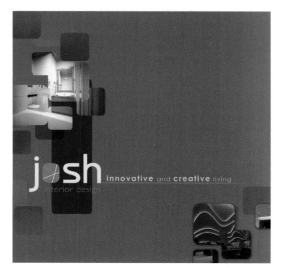

COPIA CREATIVE, INC._ SANTA MONICA, CA, UNITED STATES
**CREATIVE TEAM**: Copia Creative Team
**CLIENT**: Chapman

NOVIENATALIE.NET_ BANDUNG, JAWA BARAT, INDONESIA
**CREATIVE TEAM**: Novie Natalie Stephens
**CLIENT**: Josh Interior

STORM CORPORATE DESIGN_ AUCKLAND, NEW ZEALAND
**CREATIVE TEAM**: Rehan Saiyed
**CLIENT**: Manukau Water Limited

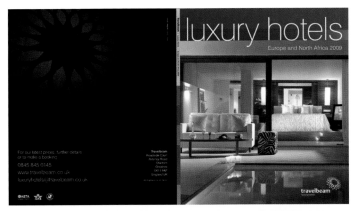

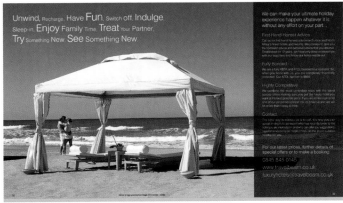

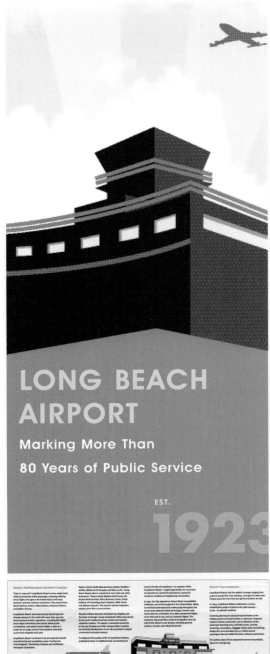

IMAGINE_ MANCHESTER, UNITED KINGDOM
**CREATIVE TEAM**: David Caunce, Karl Edginton
**CLIENT**: Travelbeam

HA DESIGN_ GLENDORA, CA, UNITED STATES
**CREATIVE TEAM**: Handy Atmali
**CLIENT**: Long Beach Airport/Davis + Associates



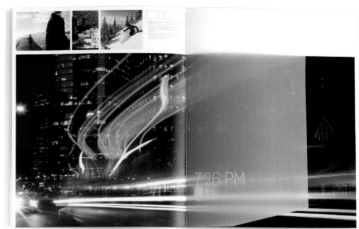

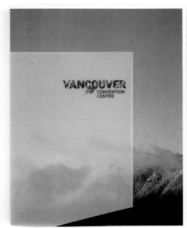

**KARACTERS DESIGN GROUP_** VANCOUVER, BC, CANADA
**CREATIVE TEAM**: James Bateman, Dan O'Leary, Brandon Thomas, Neil Shapiro
**CLIENT**: Vancouver Convention Centre

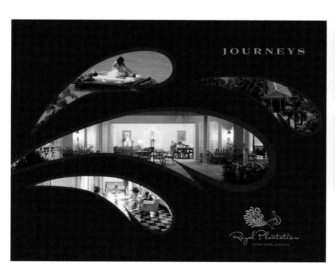

**SANDALS RESORTS_** MIAMI, FL, UNITED STATES
**CREATIVE TEAM**: Scott Peiffer, Mike Menendez
**CLIENT**: Royal Plantation

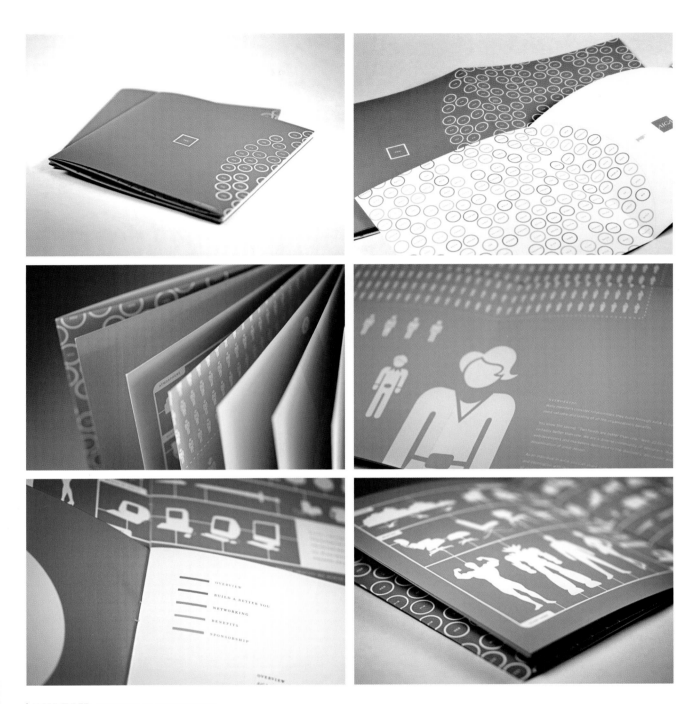

JACOB TYLER_ SAN DIEGO, CA, UNITED STATES
**CREATIVE TEAM**: Les Kollegian, Gordon Tsuji, Adam Roop
**CLIENT**: AIGA San Diego

106

CRUMPLED DOG DESIGN_ LONDON, UNITED KINGDOM
**CREATIVE TEAM**: Christina Wilkins
**CLIENT**: Buckley Gray Yeoman

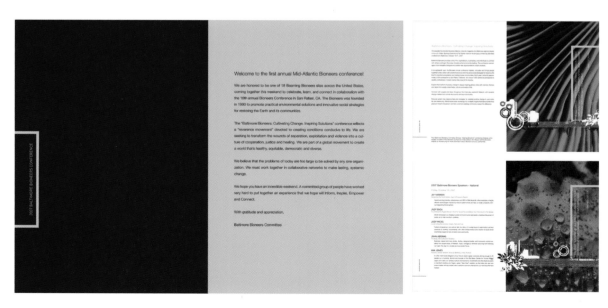

SUBSTANCE151_ BALTIMORE, MD, UNITED STATES
**CREATIVE TEAM**: Ida Cheinman, Rick Salzman
**CLIENT**: Baltimore Bioneers

FOUNDRY_ CALGARY, AB, CANADA
**CREATIVE TEAM**: Zahra Al-Harazi, Louise Uhrenholt, Fritz Tolentino
**CLIENT**: Nexen Inc

107

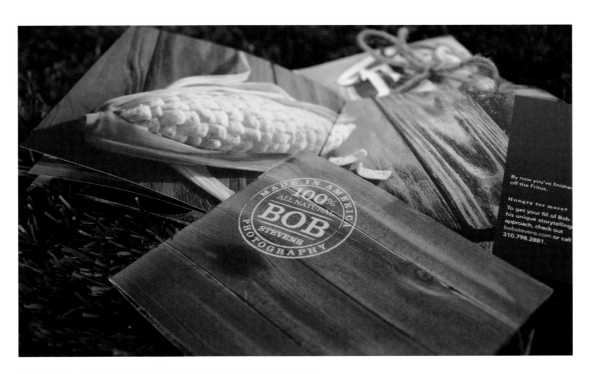

IE DESIGN + COMMUNICATIONS_ HERMOSA BEACH, CA, UNITED STATES
**CREATIVE TEAM**: Marcie Carson, Nicole Bednarz
**CLIENT**: Bob Stevens Photography

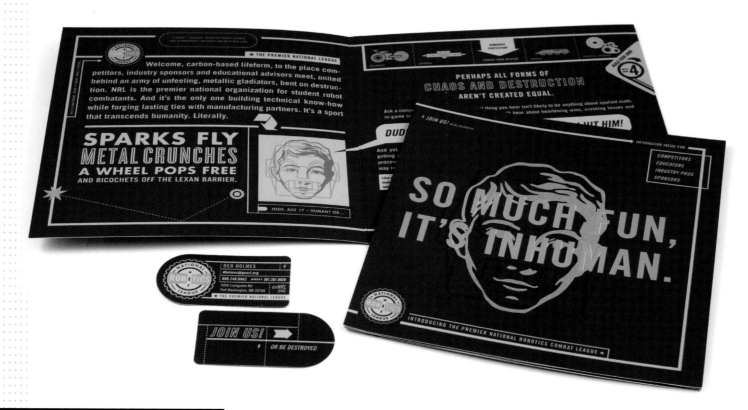

## An In-Depth Look

## National Robotic League

Robot combat has come to America's schools, and that's a good thing. "The National Robotics League (NRL) brand is all about building, and the nuts and bolts of engineering," says Blake Howard, partner and creative director at Matchstic in Atlanta. "The NRL was the first to use robots as an educational tool for high school students. We created a brochure, but the fun part is where students or teachers can build a robot themselves."

The NRL claims itself as "the premier national organization for high school competitions that combines fun with technical know-how in the mechanical and engineering industry, a.k.a. robot combat." Matchstic describes the brochure as "combining excitement and hands-on experience, allowing students to pop out the perforated die cut robot and assemble it."

It sounds fun, but warring robots—or the principles behind their construction—is serious business. "One of the major things on [the client's] mind was to change the perception of the machining and manufacturing industry," says designer Alvin Diec. Presented with the challenge of promoting the understaffed and otherwise unglamorous manufacturing industry as a viable (not to mention cool) career option, Diec related it to what he calls "the extreme sport of robot combat." "We're tying this manufacturing/engineering into something tangible they could have fun with," he says. *"How do we translate this into a brand and have it express this in an exciting way?"*

The audience—mostly male high school students, teachers and administrative leaders—got their first crack at robot-building at a National Leadership Skills Conference in Kansas City. "Our primary target is definitely high school students, to attract them and get them excited," Diec explains. "Our secondary aim is to appear on a professional and legitimate level to teachers and instructors that the NRL is a serious organization committed to challenging kids and also bridging that gap between fun and career options." Beyond that, he says, there's a tertiary market made of industry sponsors and potential employers for the next generation of engineers cutting their teeth on paper construction—varnished, 120# black cover stock, but still paper.

"The client loves the extra dimension of the punch-out robot," Howard says, "but I would probably say production was a little difficult. The [four-month] timeline to develop the entire brand was really tight." The original concept, a metallic silver ink on Black French construction paper, turned into six-color (four colors plus metallic ink and spot varnish) print on stock paper as the specs proved to be as exacting—and difficult—as those used in design of an actual robot. "Production was a bit tough, getting the perforation on the back just right And the ease of use of the robot" Matchstic, along with naming the brand and developing NRL's identity, also designed the organization's Web site, environmental displays and apparel for the conference and the additional collateral such as business cards.

*"One thing we talk about a lot is instead of having a shotgun approach we're more like a sniper—one shot,"* says Howard. While students may explore many educational and job options, the main goal is to narrow the impact after their initial shotgun blast. "There's a disconnect between fun and having this career," he says. "The NRL became this bridge between kids doing something fun like an extreme sport and a career like engineering."

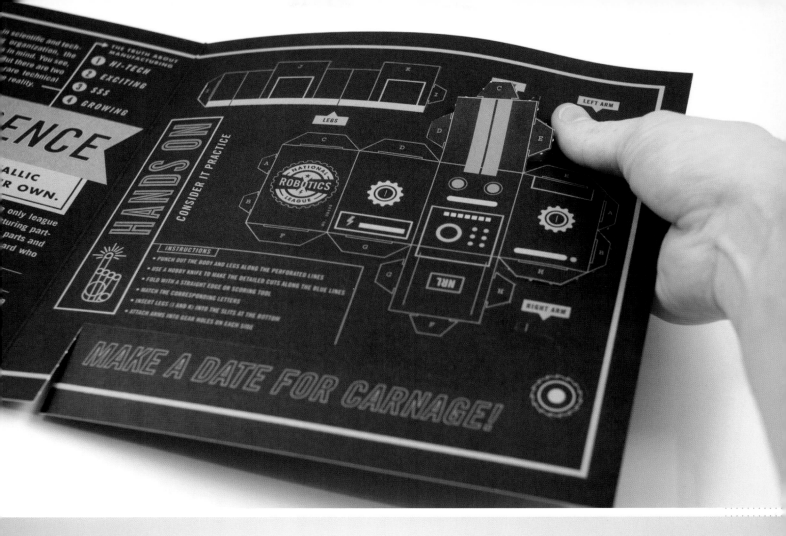

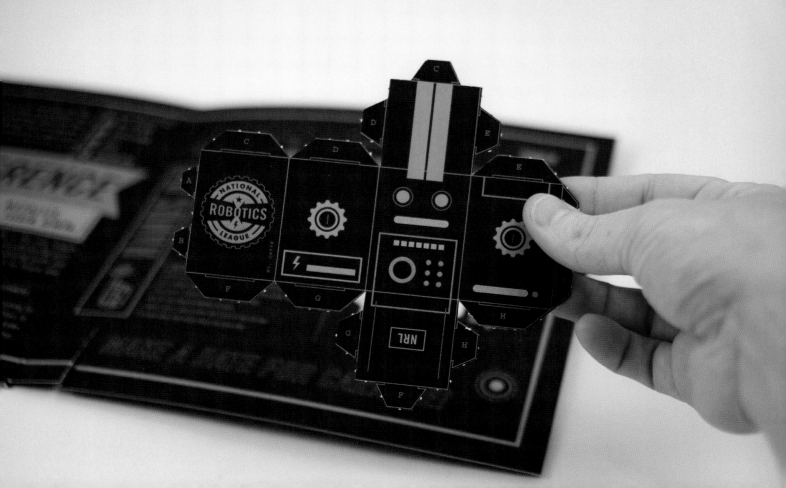

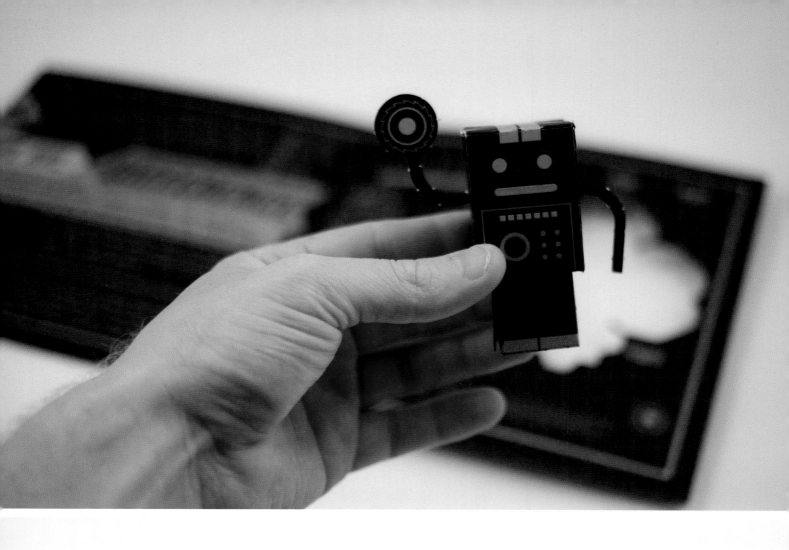

Some of NRL's most prolific competitors now serve manufacturers in scientific and technical roles. This, too, is by design. In fact, NRL's founding organization, the National Tooling and Machining Association, had precisely this in mind. You see, far from withering on the vine, U.S. manufacturing is hiring. But there are two challenges: one is finding people with the increasingly rare technical skills. The second is overcoming popular myths to reveal the reality.

THE TRUTH ABOUT MANUFACTURING

1. HI-TECH
2. EXCITING
3. $$$
4. GROWING

# THE NRL DIFFERENCE

ROBOT BATTLE LEAGUES ARE MULTIPLYING SO FAST, YOU'D THINK THE METALLIC BEASTIES WERE CAPABLE OF REPRODUCING ON THEIR OWN.

**BUILD VALUABLE INDUSTRY-SCHOOL LINKS**

↓

**EVERYBODY WINS!** *THE ONLY LEAGUE FORMALIZING TIES BETWEEN COMPETITORS AND MANUFACTURERS*

↑

GET TURNED ON TO CAREER POSSIBILITIES

So what makes NRL different? For starters, NRL is the only league formalizing ties between competitor teams and manufacturing partners. Makes sense, right? If you're going to be machining parts and engineering a 'bot from scratch, you need someone on board who does that sort of thing all the time.

The bonus, for both sides, is that those ties have a way of leading to other things. Competitors get turned on to the career possibilities in manufacturing. Manufacturers build valuable industry-school links by helping competitors engineer a lean, mean, fighting machine. Everybody wins, regardless of the result in the arena.

## HANDS ON

CONSIDER IT PRACTICE

LEGS

NATIONAL ROBOTICS LEAGUE

### INSTRUCTIONS

- PUNCH OUT THE BODY AND LEGS ALONG THE PERFORATED LINES
- USE A HOBBY KNIFE TO MAKE THE DETAILED CUTS ALONG THE BLUE LINES
- FOLD WITH A STRAIGHT EDGE OR SCORING TOOL
- MATCH THE CORRESPONDING LETTERS
- INSERT LEGS (J AND K) INTO THE SLITS AT THE BOTTOM
- ATTACH ARMS INTO GEAR HOLES ON EACH SIDE

E A DATE FOR

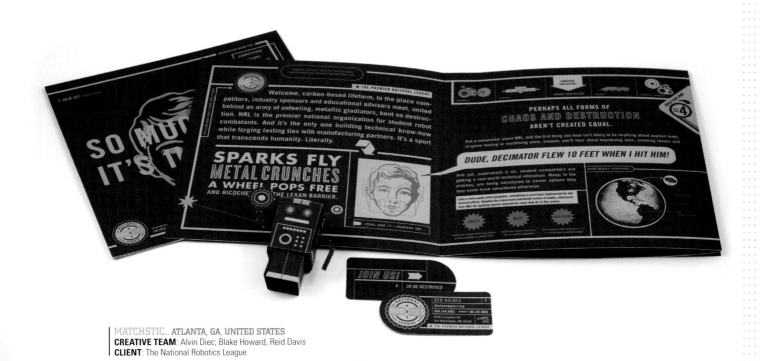

MATCHSTIC_ ATLANTA, GA, UNITED STATES
**CREATIVE TEAM**: Alvin Diec, Blake Howard, Reid Davis
**CLIENT**: The National Robotics League

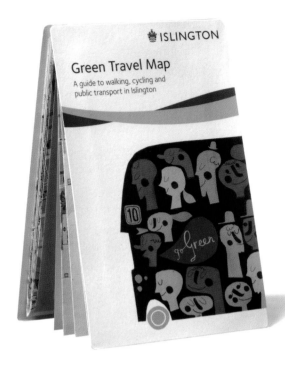

BEAM_ LONDON, UNITED KINGDOM
**CREATIVE TEAM**: Christine Fent, Dominic Latham-Koenig
**CLIENT**: Islington Council

2ND FLOOR DESIGN_ PORTSMOUTH, VA, UNITED STATES
**CREATIVE TEAM**: Mary Hester
**CLIENT**: Well Now Magazine

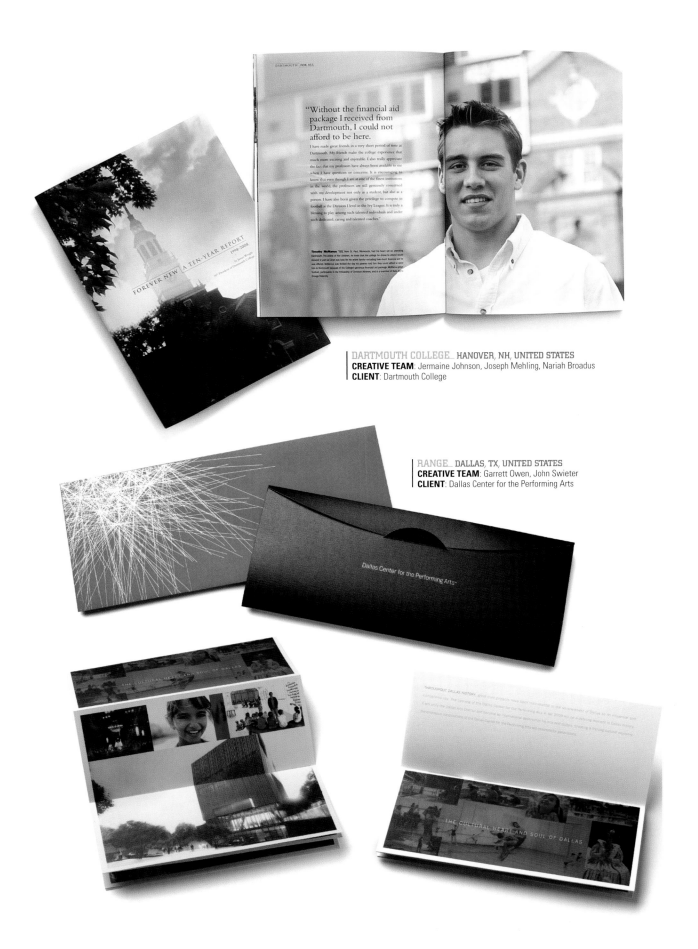

DARTMOUTH COLLEGE_ HANOVER, NH, UNITED STATES
**CREATIVE TEAM**: Jermaine Johnson, Joseph Mehling, Nariah Broadus
**CLIENT**: Dartmouth College

RANGE_ DALLAS, TX, UNITED STATES
**CREATIVE TEAM**: Garrett Owen, John Swieter
**CLIENT**: Dallas Center for the Performing Arts

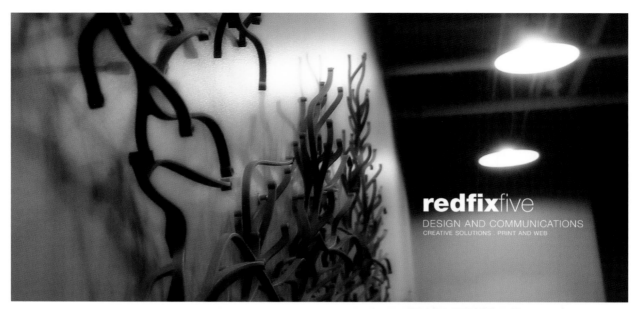

114

REDFIXFIVE _ IRVINE, CA, UNITED STATES
**CREATIVE TEAM**: Craig Mannino
**CLIENT**: Redfixfive

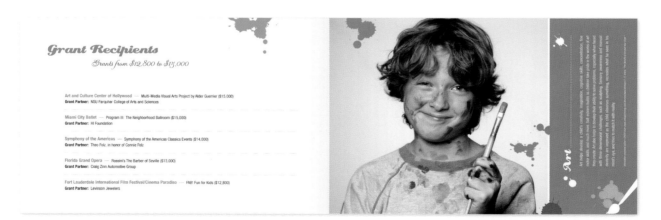

GREEN GROUP STUDIO_ GREENACRES, FL, UNITED STATES
**CREATIVE TEAM**: Clara Mateus
**CLIENT**: BankAtlantic Foundation

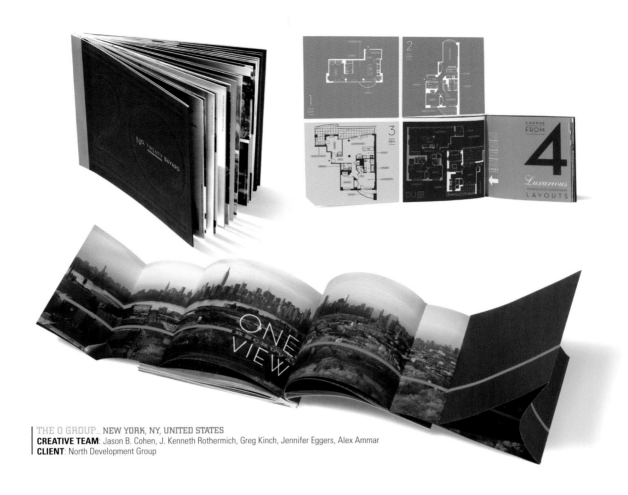

**THE O GROUP_** NEW YORK, NY, UNITED STATES
**CREATIVE TEAM**: Jason B. Cohen, J. Kenneth Rothermich, Greg Kinch, Jennifer Eggers, Alex Ammar
**CLIENT**: North Development Group

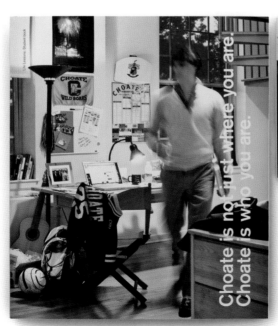

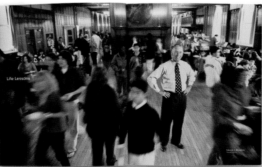

**BERTZ DESIGN GROUP_** MIDDLETOWN, CT, UNITED STATES
**CREATIVE TEAM**: Bertz Design Group, Paul Horton, Lorraine Connelly
**CLIENT**: Choate Rosemary Hall

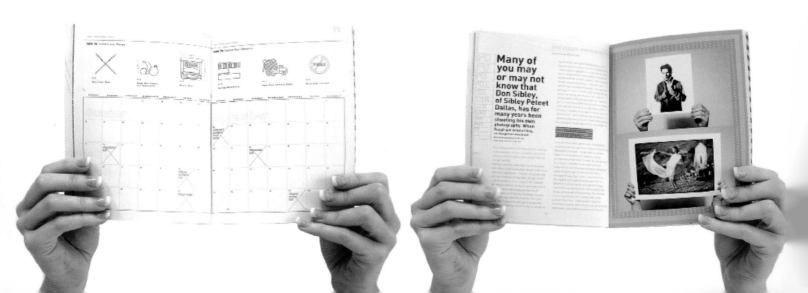

116

RANGE DESIGN, INC._ DALLAS, TX, UNITED STATES
**CREATIVE TEAM**: Garrett Owen, Josh Ege, Maya Kwan, John Swieter
**CLIENT**: Dallas Society of Visual Communications

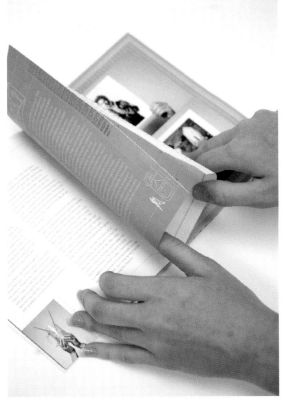

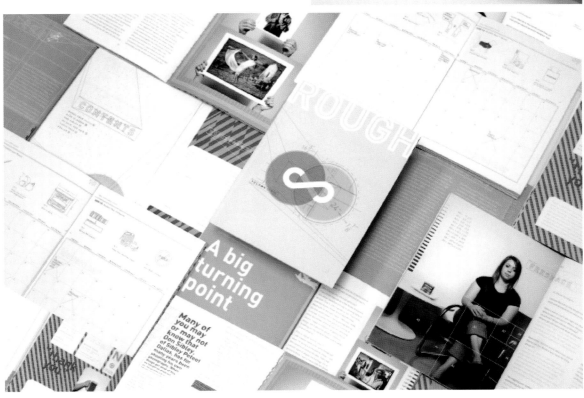

FLYNN DESIGN, GROOVINBY, LTD_ JACKSON, MS, UNITED STATES
**CREATIVE TEAM:** Heidi Flynn Barnett, Jim Garrison,
Charlie Godbold, Keith Tatum
**CLIENT:** EastGroup Properties / The Ramey Agency

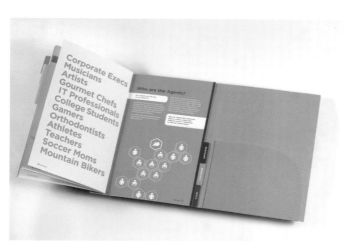

ALPHABET ARM_ BOSTON, MA, UNITED STATES
**CREATIVE TEAM:** Aaron Belyea, Ryan Frease
**CLIENT:** BzzAgent Inc.

TOM DOLLE DESIGN_ NEW YORK, NY, UNITED STATES
**CREATIVE TEAM:** Tom Dolle, Chris Riely, Cheryl Loe
**CLIENT:** Foundation Center

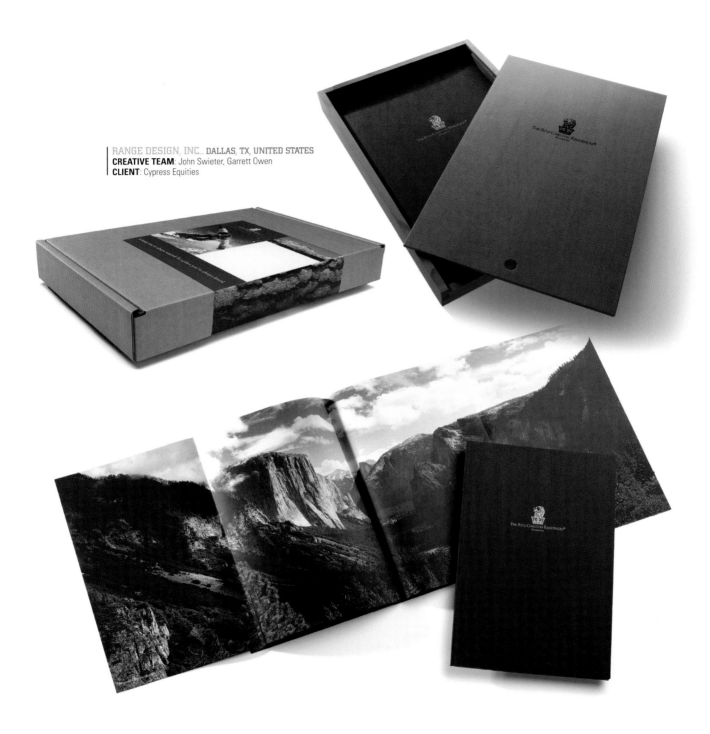

RANGE DESIGN, INC., DALLAS, TX, UNITED STATES
**CREATIVE TEAM**: John Swieter, Garrett Owen
**CLIENT**: Cypress Equities

119

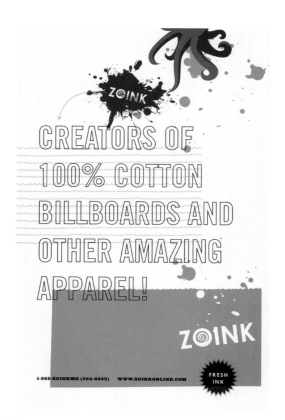

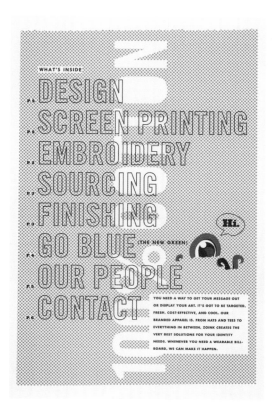

## An In-Depth Look

### Zoink

If a squid squirting ink made a sound—and who are we to know it doesn't?—what would it be? Blake Howard, partner and creative director at Atlanta's Matchstic, and designer Alvin Diec found the answer even before anyone asked the question. Explains Howard:

"As we worked on the identity, we obviously said the word 'Zoink' a lot, since that's the client's name," explains Howard. Zoink is a local t-shirt screenprinting company. "To us, the word sounded like something you'd say if you got scared or startled. Then we thought about how squid squirt ink when they are scared, and that's when Honkey Tonk the Ink-Squirting Squid came to life."

The crew at Matchstic had worked with Zoink before—in fact, they'd used the shirt company as a vendor, so when Zoink came to them, everyone knew how deep the water was. "They just really needed some differentia-tion," says Howard. *"Screenprinting is such a competitive market, and they wanted to be seen by design firms like us as the place to go for quality and the best experience. We were their audience and they knew we were going to be a good fit."* He adds that working in a new kind of business-to-business model is "visually interesting and appealing to designers. Designers are our audience, which was fun."

For the brochure, Diec's biggest challenge lay in being true to the nature of screenprinting while staying within Zoink's budget. "Our original plan from the beginning was to try to get it screenprinted, which would be the perfect tie-in for Zoink but it was out of budget," he says. "So we settled for offset. If we'd had it printed digitally, it definitely would have lost the feel we were going for and it would not have worked out the way we wanted."

Not only does the ink appearance mimic the screenprinting style, but the overall design piece mirrors the medium. *"The client came to us and asked, with a relatively small budget, what could we do that wouldn't be quite a brochure that everyone is used to,"* Diec says. Starting with function, he says that Matchstic internally batted around a lot of different ideas until hitting upon "something quirky enough to fit the brand but also very budget-oriented." The result is a brochure printed on two large pieces of paper, like two pieces of newsprint, that fold into a self-mailer. "The whole aspect of screenprinting—pushing ink through these halftone screens, like a newspaper—is how we arrived at the newspaper-looking piece and how it folded out," he explains. "We limited it to two or three colors total, and with those limitations we were able to fit into their budget."

The audience—decisionmakers of small to medium-sized businesses—got it right away. "They're more progressive and creative," Howard says, "and we also wanted to really tie into what Zoink does and the personality of it." As for the ink-slinging squid and his halftone ocean, "the design was something that had to tie into their brand identity, and more or less the style and aesthetics were already established."

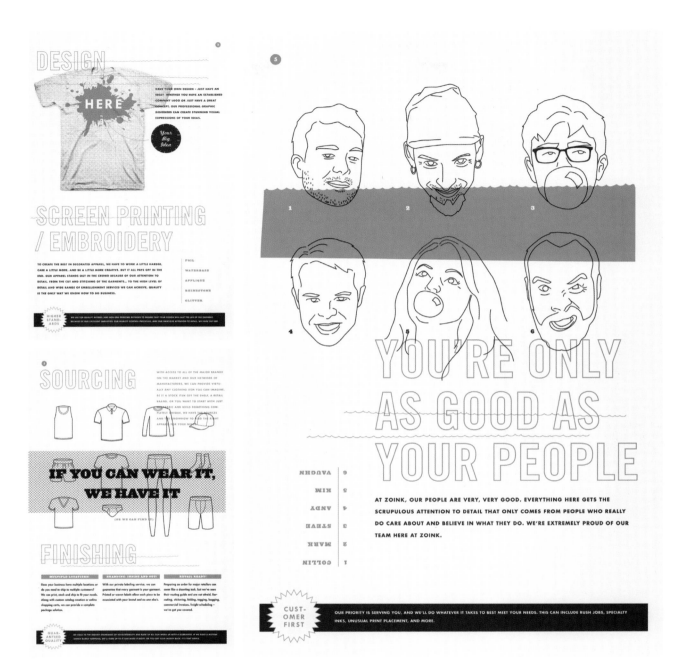

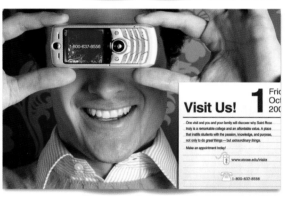

**THE COLLEGE OF SAINT ROSE_** ALBANY, NY, UNITED STATES
**CREATIVE TEAM:** Mark Hamilton, Chris Parody, Lisa Haley Thomson
**CLIENT:** The College of Saint Rose

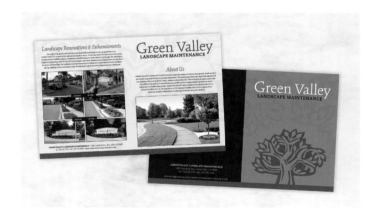

**AMBIENT_** MILLER PLACE, NY, UNITED STATES
**CREATIVE TEAM:** Scott Mosher
**CLIENT:** Green Valley Landscaping

**KROG_** LJUBLJANA, AL, SLOVENIA
**CREATIVE TEAM:** Edi Berk, Dragan Arrigler
**CLIENT:** Vodovod-Kanalizacija, Ljubljana

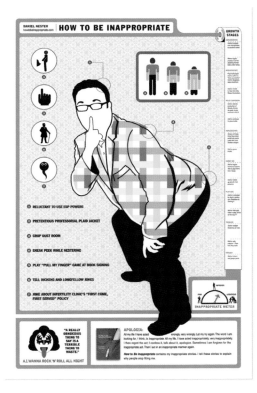

THE COLLEGE OF SAINT ROSE_ ALBANY, NY, UNITED STATES
**CREATIVE TEAM**: Mark Hamilton, Chris Parody, Daniel Nester
**CLIENT**: Daniel Nester - How to be Inappropriate

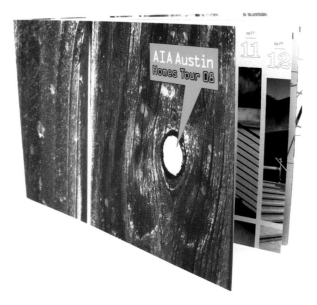

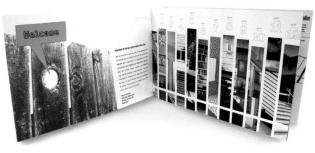

CREATIVE SUITCASE_ AUSTIN, TX, UNITED STATES
**CREATIVE TEAM**: Rachel Clemens, Mackenzie Walsh
**CLIENT**: American Institute of Architects

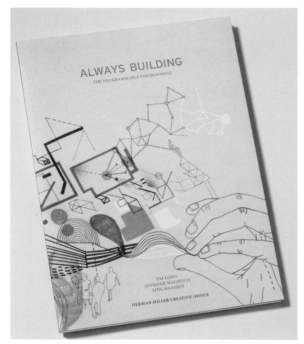

124

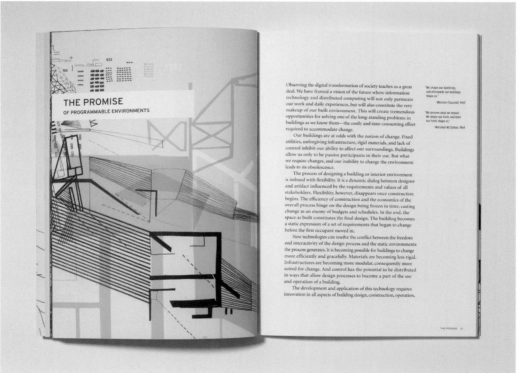

PEOPLE DESIGN_ GRAND RAPIDS, MI, UNITED STATES
**CREATIVE TEAM**: Brian Hauch, Yang Kim, Kevin Budelmann, Julie Ridl
**CLIENT**: Herman Miller

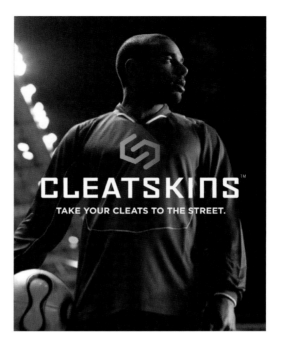

CREATIVE SUITCASE_ AUSTIN, TX, UNITED STATES
**CREATIVE TEAM**: Rachel Clemens, Jennifer Wright
**CLIENT**: The University of Texas School of Law

THE UXB_ BEVERLY HILLS, CA, UNITED STATES
**CREATIVE TEAM**: NancyJane Goldston, Glenn Sakamoto,
Elizabeth Bennett, Rick Chou
**CLIENT**: Cleatskins™

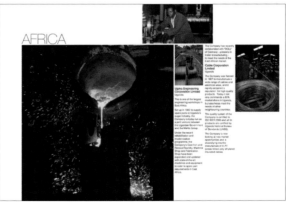

MOONLIGHT CREATIVE GROUP_ CHARLOTTE, NC, UNITED STATES
**CREATIVE TEAM**: Jesse Weser, Jenni Miehle, Karen Ponischil
**CLIENT**: Childress Klein Properties

GRAPHIC COMMUNICATION CONCEPTS_
MUMBAI, MAHARASHTRA, INDIA
**CREATIVE TEAM**: Sudarshan Dheer
**CLIENT**: Mehta Group

126

MOXIE SOZO_ BOULDER, CO, UNITED STATES
**CREATIVE TEAM**: Leif Steiner, Laura Kottlowski, Teri Gosse, Charles Bloom
**CLIENT**: Smart Wool

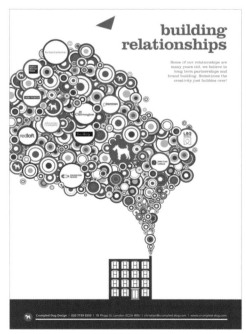

CRUMPLED DOG DESIGN_ LONDON, UNITED KINGDOM
**CREATIVE TEAM**: Crumpled Dog
**CLIENT**: Crumpled Dog Design

PEAK SEVEN ADVERTISING_ DEERFIELD BEACH, FL, UNITED STATES
**CREATIVE TEAM**: Darren Seys, Stacy Mathrani
**CLIENT**: Diamond Falls Estates

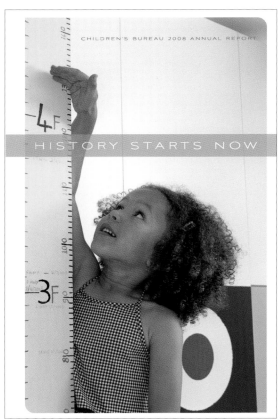

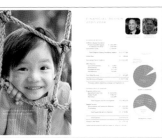

B.G. DESIGN_ LOS ANGELES, CA, UNITED STATES
**CREATIVE TEAM**: Beth Goldfarb
**CLIENT**: Children's Bureau

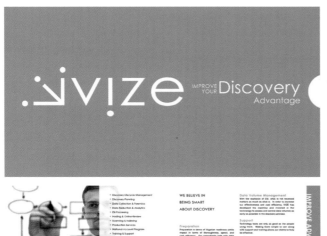

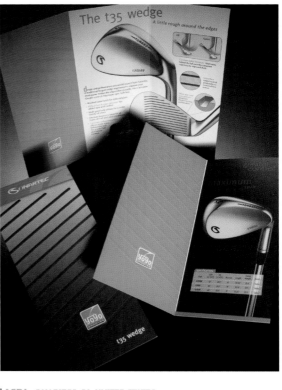

COPIA CREATIVE, INC._ SANTA MONICA, CA, UNITED STATES
**CREATIVE TEAM**: Copia Creative Team
**CLIENT**: IVIZE Group, LLC.

LCDA_ SAN DIEGO, CA, UNITED STATES
**CREATIVE TEAM**: Laura Coe Wright, Tracy Castle
**CLIENT**: Sonartec

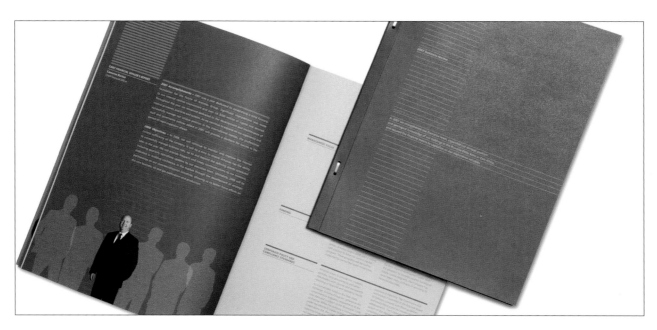

FOUNDRY_ CALGARY, AB, CANADA
**CREATIVE TEAM**: Zahra Al-Harazi, Louise Uhrenholt
**CLIENT**: Artumas

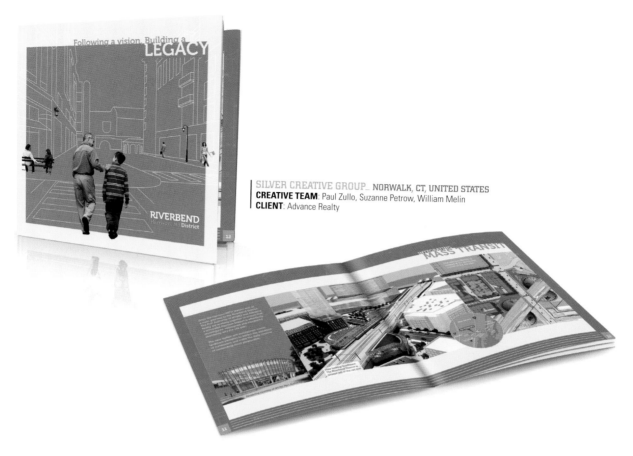

**SILVER CREATIVE GROUP_ NORWALK, CT, UNITED STATES**
**CREATIVE TEAM**: Paul Zullo, Suzanne Petrow, William Melin
**CLIENT**: Advance Realty

129

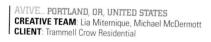

**AVIVE_ PORTLAND, OR, UNITED STATES**
**CREATIVE TEAM**: Lia Miternique, Michael McDermott
**CLIENT**: Trammell Crow Residential

**AVIVE_ PORTLAND, OR, UNITED STATES**
**CREATIVE TEAM**: Lia Miternique, Daniel Root, Willow Casella
**CLIENT**: Doernbecher Children's Hospital/Nike

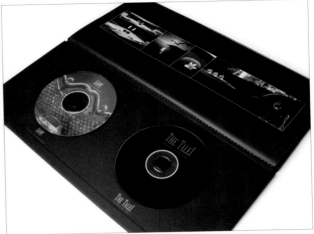

STORM CORPORATE DESIGN_ AUCKLAND, NEW ZEALAND
**CREATIVE TEAM**: Rehan Saiyed
**CLIENT**: Lusanne Project Management

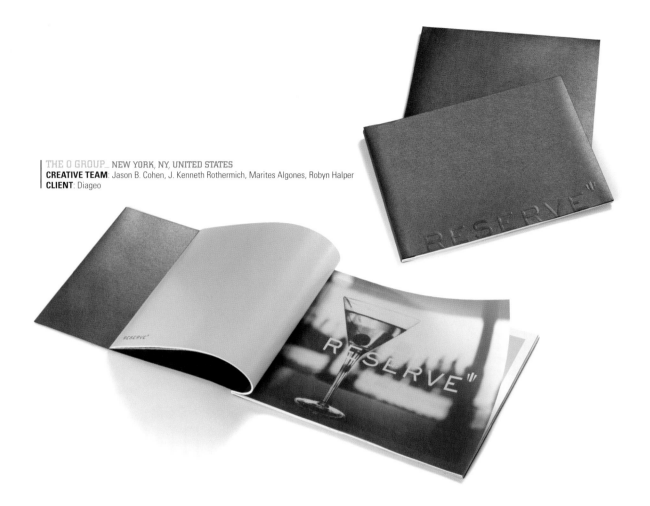

THE O GROUP_ NEW YORK, NY, UNITED STATES
**CREATIVE TEAM**: Jason B. Cohen, J. Kenneth Rothermich, Marites Algones, Robyn Halper
**CLIENT**: Diageo

131

VGREEN DESIGN_ CORSICANA, TX, UNITED STATES
**CREATIVE TEAM**: Virginia Green
**CLIENT**: Department of Art

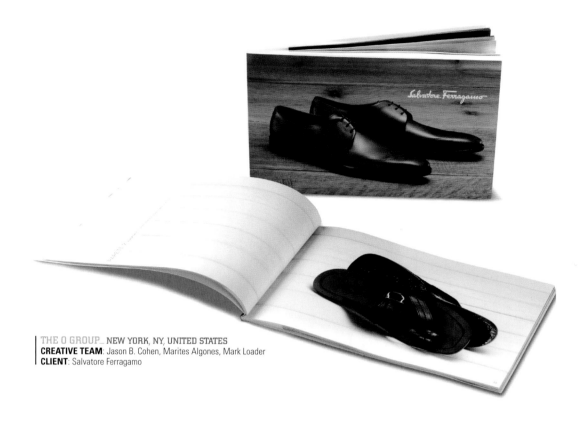

THE O GROUP_ NEW YORK, NY, UNITED STATES
**CREATIVE TEAM**: Jason B. Cohen, Marites Algones, Mark Loader
**CLIENT**: Salvatore Ferragamo

132

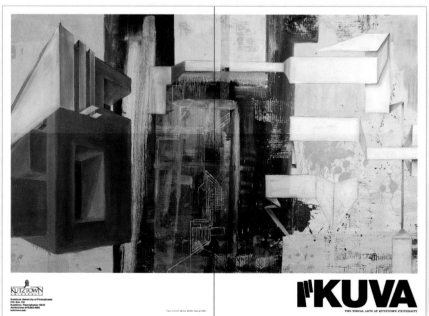

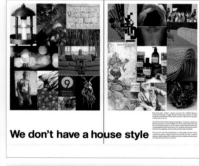

DESIGN GRACE_ JERSEY CITY, NJ, UNITED STATES
**CREATIVE TEAM**: Holly Tienken, Sean Patrick Sullivan
**CLIENT**: Kutztown University College of Visual Arts

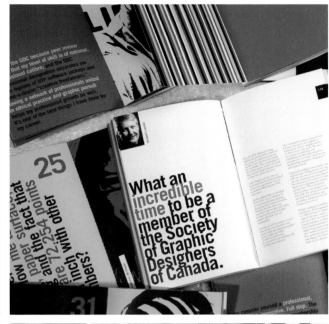

BRADBURY BRANDING & DESIGN

# WOW

Society of Graphic Designers of Canada 2007 Annual Report

**Award winner:** The Black Book Annual Report 100 Show; Communication Arts Awards Annual,
Applied Arts Awards Annual, Graphis Annual Reports, Unisource Annual Report Show,
Society of Graphic Designers of Canada, 2008 Frontiers Award of Excellence
**Published:** Chosen for inclusion in *Font: Classic Typefaces for Contemporary Graphic Design*,
published by Rotovision, UK

# WEE GEE

A master at marketing himself, Weegee was *the* American paparazzo of the 1930s and 40s. Born Arthur Fellig, Weegee adopted a pseudonym that phonetically captured the way others described him: as clairvoyant as a Ouija board. He was first on the scene, whether it was a grizzly crime in New York or a Hollywood happening, snapping pictures that he would credit with "Weegee the Famous." Truth be known, Weegee was cleverly ahead of the curve, not clairvoyant. He was first to request a permit for a portable police-band radio (often

beating authorities to the scene, he was unabashedly the world's first "ambulance chaser"), and he built a darkroom in the back of his car to publish his photos on the spot. He was good at what he did, and created a market for it—the public soon craved the immediacy of his photographs, and he became as well-known as his work. How's that for staying one step (or in Weegee's case, many steps) ahead of the competition?

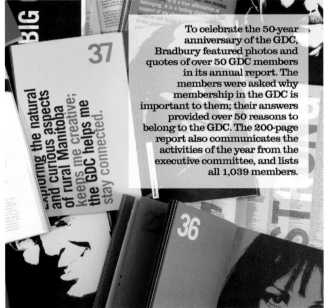

To celebrate the 50-year anniversary of the GDC, Bradbury featured photos and quotes of over 50 GDC members in its annual report. The members were asked why membership in the GDC is important to them; their answers provided over 50 reasons to belong to the GDC. The 200-page report also communicates the activities of the year from the executive committee, and lists all 1,039 members.

133

BRADBURY BRANDING & DESIGN_ REGINA, SK, CANADA
**CREATIVE TEAM:** Catharine Bradbury
**CLIENT:** Bradbury Branding & Design

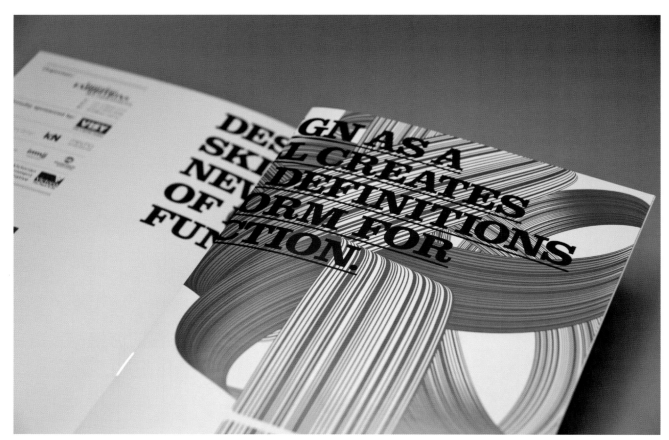

134

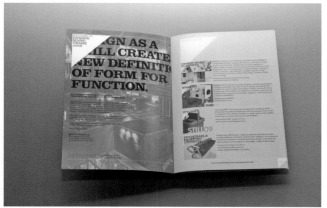

BÜRO NORTH_ **AUSTRALIA**
**CREATIVE TEAM**: Soren Luckins, Shane Loorham
**CLIENT**: State of Design

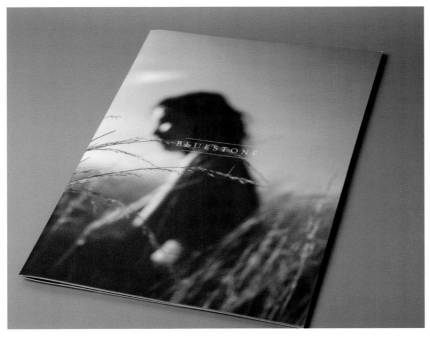

BÜRO NORTH_ AUSTRALIA
**CREATIVE TEAM**: Soren Luckins, Skye Luckins
**CLIENT**: Sunland Group

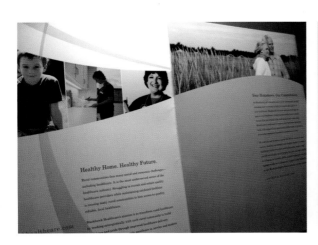

BRONSON MA CREATIVE_ SAN ANTONIO, TX, UNITED STATES
**CREATIVE TEAM**: Bronson Ma
**CLIENT**: Blackhawk Healthcare

135

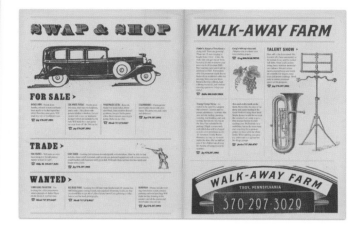

NICOLE ZIEGLER DESIGN_ CHICAGO, IL, UNITED STATES
**CREATIVE TEAM**: Nicole Ziegler
**CLIENT**: Ziegler Family

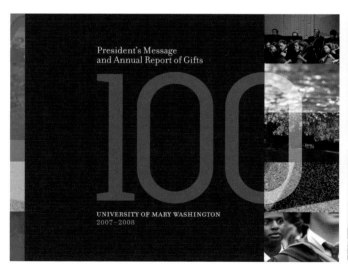

DESIGN NUT, LLC_ KENSINGTON, MD, UNITED STATES
**CREATIVE TEAM**: Brent M. Almond, Anna Barron Billingsley, Lynda Richardson
**CLIENT**: University of Mary Washington

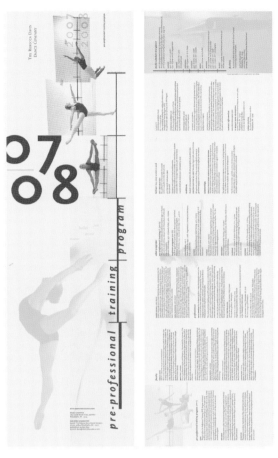

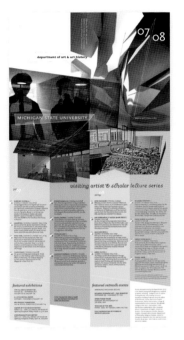

137

| THRIVE DESIGN_ EAST LANSING, MI, UNITED STATES
**CREATIVE TEAM**: Kelly Salchow MacArthur, Ana Morrongiello
**CLIENT**: Rebecca Davis Dance Company

| THRIVE DESIGN_
EAST LANSING, MI, UNITED STATES
**CREATIVE TEAM**: Kelly Salchow MacArthur,
Michael Hersrud, Joe Kuszai, Barret Kaltz
**CLIENT**: MSU Department of Art + Art History

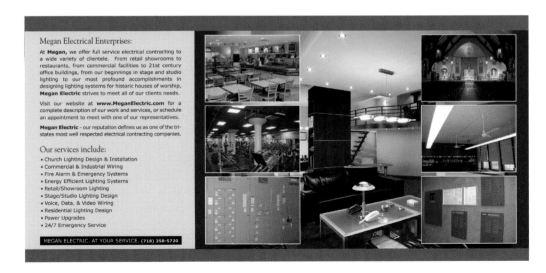

| AMBIENT_ MILLER PLACE, NY, UNITED STATES
**CREATIVE TEAM**: Scott Mosher
**CLIENT**: Megan Electric

## An In-Depth Look

## Palm Beach Supercar Weekend, Sponsorship Guide

The town of Palm Beach, on Florida's south Atlantic coast, is home to mammoth mansions and sparkling private beaches that have beckoned celebrities, athletes and giants of industry for over a century. This area is also the backdrop for Palm Beach Supercar Weekend, a showcase for some of the world's most engineered—and most expensive—cars.

"A friend was a sponsor of the event and mentioned that they were looking for a Web design company," says Allen Borza, who runs Green Group Studio in nearby Greenacres. "But it turned out to be much more than that. In the end we designed their logos, billboards, ads and of course the Web site, too."

Green Group Studio, which specializes in environmentally-conscious design and production, may seem an odd choice for an event that features supercars, which he describes as "expensive, exotic, often limited production cars that embody a high level of horsepower and design." These supercars also signify a high level of income, something Borza sought to appeal to when he and partner/creative director Clara Mateus created the sponsorship guide for potential event sponsors.

"We met with [Supercar Inc.'s founder] John Temerian and discussed the need to explain the event and the different sponsorship level packages," Borza says. *Originally staged by Temerian as a real estate event at the Gossmann Estate (once owned by Donald Trump) to show exotic cars as a kind of FOR SALE sign at the property, "the idea was to make contacts with the affluent who could afford expensive cars and expensive homes."*

*Like the cars, the Temerian wanted things to go fast, and he made the ride as smooth as he could.* "We didn't have a lot of revisions," Mateus says of the project, which had a two-week deadline. "It was a quick turnaround but after the first meeting it was clear what he wanted. We did three cover designs, and he loved them so much he had me put them together for a screensaver!" Mateus worked with the client's extant waving checkered flag logo to make the guide feel locally produced in the best possible way. "He was very adamant about it looking very 'Palm Beach,'" she says. "When he saw what we did with the design, he was thrilled. It was just what he wanted."

Today, the Supercar Weekend is a family event, drawing car enthusiasts from all walks of life to the Flagler Waterfront in West Palm Beach. And, Borza says, thanks to his firm's influence and a client willing to think differently, it's a little greener, too." A lot of our clients are green builders and green architects, and the supercar weekend was going to happen with or without us," he says. "Through us they were able to make the event more eco-friendly." Green Group produced the sponsorship guide as a downloadable PDF rather than the originally conceived printed publication; they also supplied electronic invitations for the event's VIP reception and afterparty. "We encourage our clients to save trees and ink," Borza explains. "Many times, they're open to it… they just didn't realize there are more environmentally-friendly options available."

The client also shares Borza's enthusiasm, and now is considering featuring green supercars, such as the Tesla electric supercar, in future events.

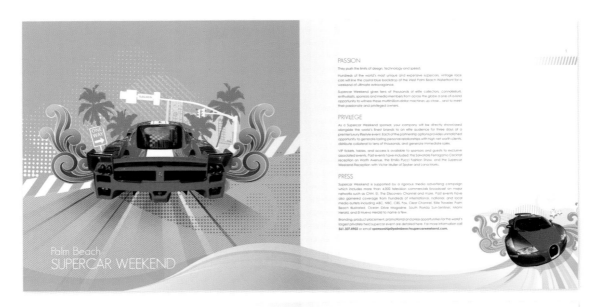

## PASSION

They push the limits of design, technology and speed.

Hundreds of the world's most unique and expensive supercars, vintage race cars will line the crystal blue backdrop of the West Palm Beach Waterfront for a weekend of ultimate extravagance.

Supercar Weekend gives tens of thousands of elite collectors, connoisseurs, enthusiasts, sponsors and media members from across the globe a one-of-a-kind opportunity to witness these multimillion-dollar machines up close... and to meet their passionate and privileged owners.

## PRIVILEGE

As a Supercar Weekend sponsor, your company will be directly showcased alongside the world's finest brands to an elite audience for three days at a premier luxury lifestyle event. Each of the partnership options provides unmatched opportunity to generate lasting personal relationships with high net worth clients, distribute collateral to tens of thousands, and generate immediate sales.

VIP tickets, tables, and access is available to sponsors and guests to exclusive associated events. Past events have included: the Salvatore Ferragamo Cocktail reception on Worth Avenue, the Emilio Pucci Fashion Show, and the Supercar Weekend Reception with Victor Muller of Spyker and Lana Marks.

## PRESS

Supercar Weekend is supported by a rigorous media advertising campaign which includes more than 4,000 television commercials broadcast on major networks such as CNN, E!, The Discovery Channel and more. Past events have also garnered coverage from hundreds of international, national, and local media outlets including ABC, NBC, CBS, Fox, Clear Channel, Elite Traveler, Palm Beach Illustrated, Ocean Drive Magazine, South Florida Sun-Sentinel, Miami Herald, and El Nuevo Herald to name a few.

Branding, product placement, promotional and press opportunities for the world's largest privately held supercar event are detailed here. For more information call 561.307.4902 or email sponsorship@palmbeachsupercarweekend.com.

## Palm Beach SUPERCAR WEEKEND

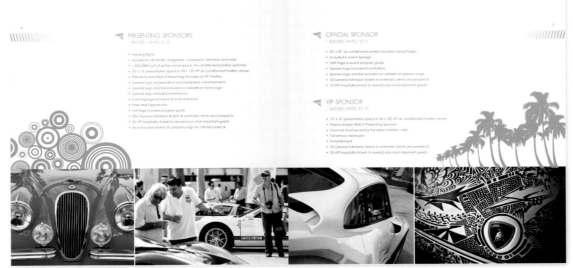

### PRESENTING SPONSORS
- $75,000 LIMITED TO 8

### OFFICIAL SPONSOR
- $25,000 LIMITED TO 3

### VIP SPONSOR
- $20,000 LIMITED TO 10

GREEN GROUP STUDIO_ GREENACRES, FL, UNITED STATES
**CREATIVE TEAM**: Clara Mateus, Allen Borza, John Burrow
**CLIENT**: Supercar Inc.

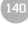

THE O GROUP_ NEW YORK, NY, UNITED STATES
**CREATIVE TEAM**: Jason B. Cohen, J. Kenneth Rothermich, Miriam Weiskind, Alex Ammar
**CLIENT**: Shvo Marketing

IE DESIGN + COMMUNICATIONS_ HERMOSA BEACH, CA, UNITED STATES
**CREATIVE TEAM**: Marcie Carson, Nicole Bednarz
**CLIENT**: Duke Law School

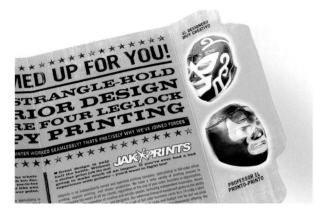

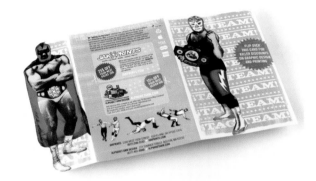

141

**ALPHABET ARM**_ BOSTON, MA, UNITED STATES
**CREATIVE TEAM**: Aaron Belyea, Ryan Frease
**CLIENT**: Jakprints

**BRADBURY BRANDING & DESIGN**_ REGINA, SK, CANADA
**CREATIVE TEAM**: Catharine Bradbury
**CLIENT**: Faculty of Education

**BRONSON MA CREATIVE**_ SAN ANTONIO, TX, UNITED STATES
**CREATIVE TEAM**: Bronson Ma
**CLIENT**: John Paul II High School

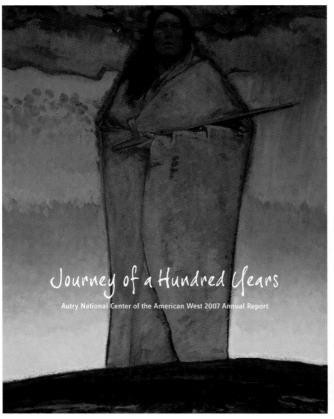

*Journey of a Hundred Years*

Autry National Center of the American West 2007 Annual Report

COLLECTIONS: CULTURAL TREASURES
IN THE DIGITAL AGE

DEAR FRIENDS OF THE AUTRY ■

142

**B.G. DESIGN_** LOS ANGELES, CA, UNITED STATES
**CREATIVE TEAM**: Beth Goldfarb
**CLIENT**: Autry National Center of the American West

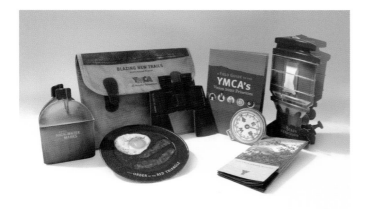

**ANDERSON DESIGN GROUP_** NASHVILLE, TN, UNITED STATES
**CREATIVE TEAM**: Joel Anderson, Jade Novak, Amy Olert, Scott Thomas
**CLIENT**: YMCA of Middle Tennessee

**IE DESIGN + COMMUNICATIONS_**
HERMOSA BEACH, CA, UNITED STATES
**CREATIVE TEAM**: Marcie Carson, Jane Lee
**CLIENT**: UC Irvine Merage School of Business

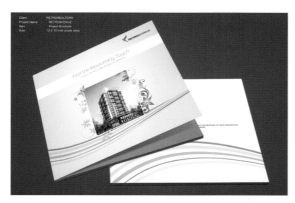

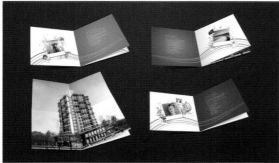

NARENDRA KESHKAR_ INDORE, MADHYA PRADESH, INDIA
**CREATIVE TEAM:** Narendra Keshkar, Vishal Shah, Hozefa Alekhanwala
**CLIENT:** Retro Realtors

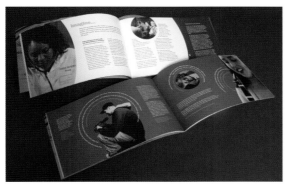

TOWSON UNIVERSITY_ TOWSON, MD, UNITED STATES
**CREATIVE TEAM:** Eleni Swengler, Dan Fuchs, Kanji Takeno, Desiree Stover
**CLIENT:** Stewardship Programs and Donor Relations

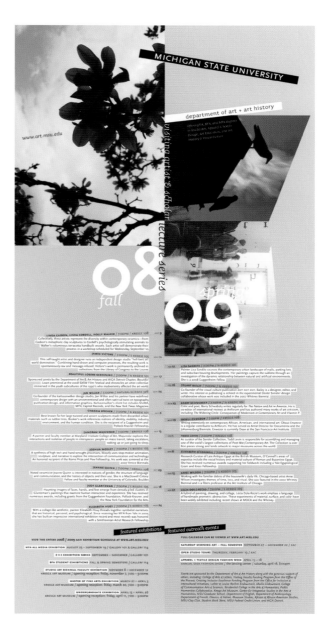

THRIVE DESIGN_ EAST LANSING, MI, UNITED STATES
**CREATIVE TEAM:** Kelly Salchow MacArthur, Alex Nichols,
Kaern Shinaver, James Shurter
**CLIENT:** MSU Department of Art + Art History

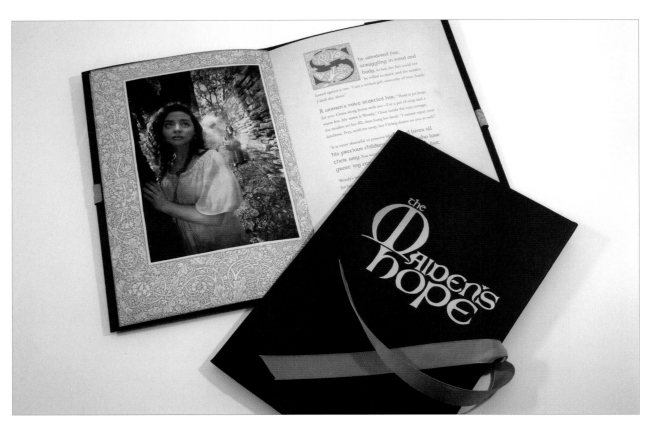

144

| ANDERSON DESIGN GROUP_ **NASHVILLE, TN, UNITED STATES**
**CREATIVE TEAM**: Joel Anderson, Jade Novak, Emily Keafer, Jeff Frazier
**CLIENT**: Hope Clinic for Women

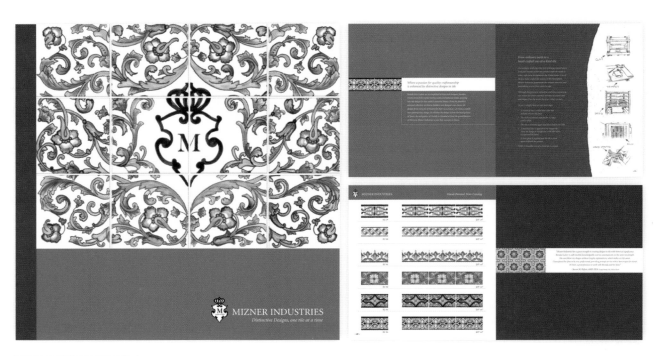

| PEAK SEVEN ADVERTISING_ **DEERFIELD BEACH, FL, UNITED STATES**
**CREATIVE TEAM**: Darren Seys, Stacy Mathrani
**CLIENT**: Mizner Industries

145

ALOOK
BACKAT
AURA

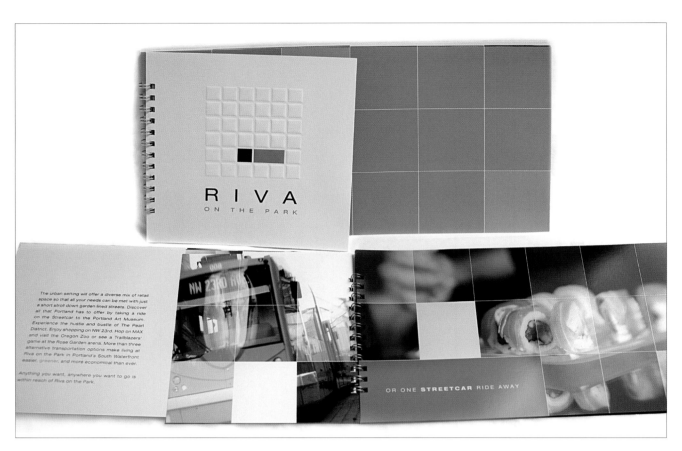

146

AVIVE_ PORTLAND, OR, UNITED STATES
**CREATIVE TEAM**: Lia Miternique, Michael McDermott
**CLIENT**: Trammell Crow Residential

BETH SINGER DESIGN_ ARLINGTON, VA, UNITED STATES
**CREATIVE TEAM**: Beth Singer, Suheun Yu, Sucha Snidvongs, Deborah Eckbreth
**CLIENT**: American Red Cross

DESIGN NUT, LLC_ KENSINGTON, MD, UNITED STATES
**CREATIVE TEAM**: Brent M. Almond
**CLIENT**: Fight for Children

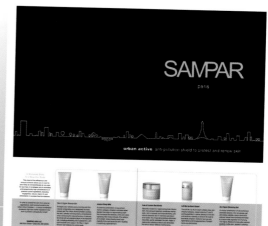

CAROL MCLEOD DESIGN_ MASHPEE, MA, UNITED STATES
**CREATIVE TEAM**: Carol McLeod, Brian Charron
**CLIENT**: SAMPAR USA LLC

CARACOL CONSULTORES_ MORELIA, MICHOACÁN, MEXICO
**CREATIVE TEAM**: Luis Jaime Lara, Myriam Zavala, Sergio Salazar
**CLIENT**: Consejo de Comunicación para el Desarrollo de Michoacán A.C.

GRAPHICAT LIMITED_ HONG KONG, CHINA
**CREATIVE TEAM**: Colin Tillyer, Ada Ng
**CLIENT**: Harvest Capital Partners

MYTTON WILLIAMS_ BATH, UNITED KINGDOM
**CREATIVE TEAM:** Bob Mytton, Matt Michaluk, Steve Kenyon, Marcus Ginns
**CLIENT:** Bath Spa University

CAROL MCLEOD DESIGN_ MASHPEE, MA, UNITED STATES
**CREATIVE TEAM:** Carol McLeod, Chris Daigneault
**CLIENT:** Encore Construction Co.

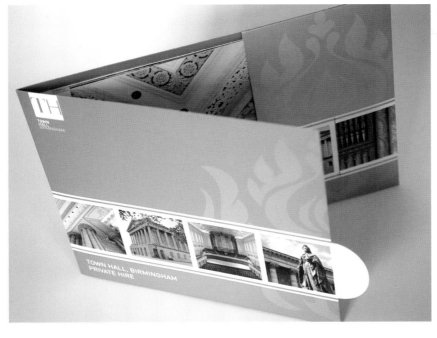

ESSENCE DESIGN LIMITED_ SUTTON COLDFIELD, WEST MIDLANDS, UNITED KINGDOM
**CREATIVE TEAM**: Regine Wilber, Rachel Khor, Manuela Voigt, Claire Nicholls
**CLIENT**: Performances Birmingham

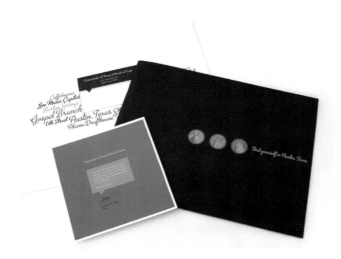

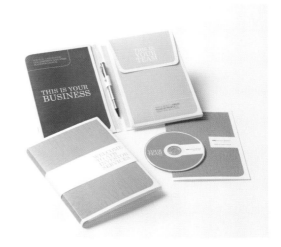

CREATIVE SUITCASE_ AUSTIN, TX, UNITED STATES
**CREATIVE TEAM**: Rachel Clemens, Jennifer Wright, Justin Clemens
**CLIENT**: The University of Texas School of Law

FOUNDRY_ CALGARY, AB, CANADA
**CREATIVE TEAM**: Zahra Al-Harazi, Louise Uhrenholt
**CLIENT**: ATB Investor Services

150

UNFOLDING TERRAIN_ HAGERSTOWN, MD, UNITED STATES
**CREATIVE TEAM**: Francheska Guerrero
**CLIENT**: Dow Benedict

UNIT DESIGN COLLECTIVE_ SAN FRANCISCO, CA, UNITED STATES
**CREATIVE TEAM**: Ann Jordan, Shardul Kiri
**CLIENT**: GALA Globalization & Localization Association

UNIT DESIGN COLLECTIVE_ SAN FRANCISCO, CA, UNITED STATES
**CREATIVE TEAM**: Ann Jordan, Shardul Kiri
**CLIENT**: GALA Globalization & Localization Association

SUBSTANCE151_ BALTIMORE, MD, UNITED STATES
**CREATIVE TEAM**: Ida Cheinman, Rick Salzman
**CLIENT**: Baltimore Bioneers

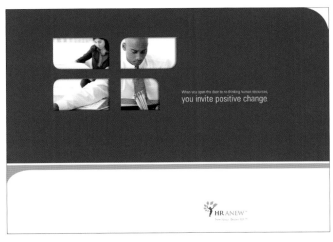

SUBSTANCE151_ BALTIMORE, MD, UNITED STATES
**CREATIVE TEAM**: Ida Cheinman, Rick Salzman, Susan Olson
**CLIENT**: HR Anew

151

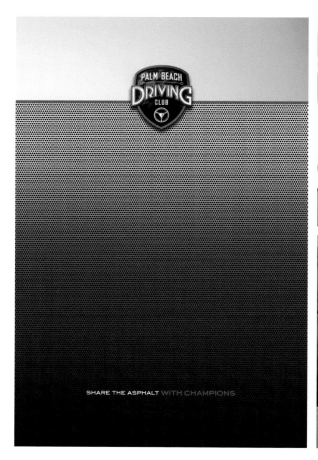
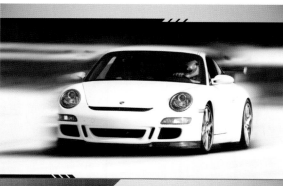
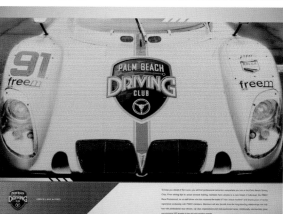

SHARE THE ASPHALT WITH CHAMPIONS

152

PEAK SEVEN ADVERTISING_ DEERFIELD BEACH, FL, UNITED STATES
**CREATIVE TEAM**: Darren Seys, Josh Munsee, Brian Tipton
**CLIENT**: Palm Beach International Raceway

IE DESIGN + COMMUNICATIONS_ HERMOSA BEACH, CA, UNITED STATES
**CREATIVE TEAM**: Marcie Carson, Jane Lee, Christine Kenney
**CLIENT**: Ken Blanchard Companies

IE DESIGN + COMMUNICATIONS_
HERMOSA BEACH, CA, UNITED STATES
**CREATIVE TEAM**: Marcie Carson, Jane Lee, Christine Kenney
**CLIENT**: Los Angeles Biomedical Research Institute -
at Harbor-UCLA Medical Center

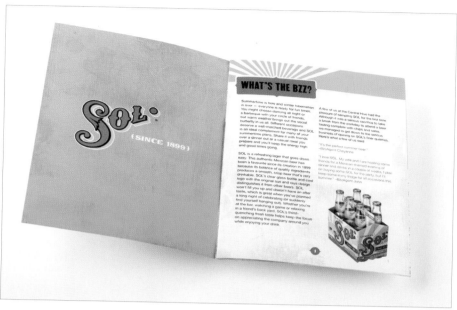

ALPHABET ARM_ BOSTON, MA, UNITED STATES
**CREATIVE TEAM**: Aaron Belyea, Ryan Frease
**CLIENT**: BzzAgent Inc.

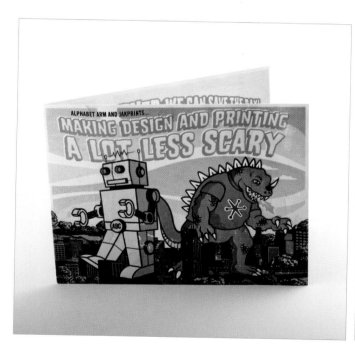

ALPHABET ARM_ BOSTON, MA, UNITED STATES
**CREATIVE TEAM**: Aaron Belyea, Ryan Frease
**CLIENT**: Jakprints

# Cards & Invitations

BRONSON MA CREATIVE_ SAN ANTONIO, TX, UNITED STATES
**CREATIVE TEAM:** Bronson Ma
**CLIENT:** Parago

SUSQUEHANNA UNIVERSITY_ SELINSGROVE, PA, UNITED STATES
**CREATIVE TEAM:** Nicholas Stephenson, Amanda Lenig
**CLIENT:** Susquehanna University

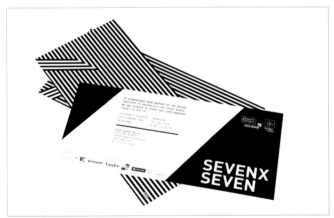

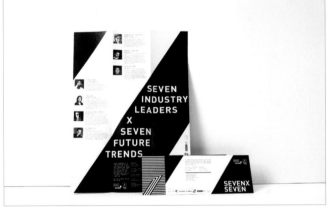

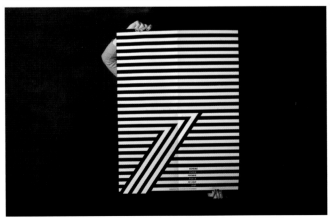

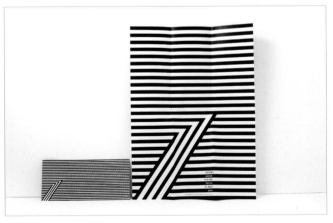

LANDOR ASSOCIATES_ SYDNEY, AUSTRALIA
**CREATIVE TEAM:** Jason Little, Malin Holmstrom
**CLIENT:** Design Institute of Australia

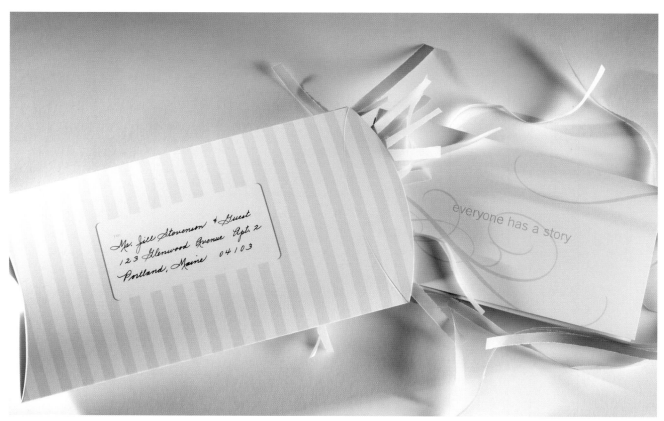

158

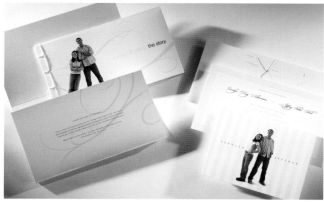

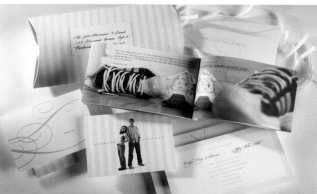

**SOLAK DESIGN CO._ NEW HARTFORD, CT, UNITED STATES**
**CREATIVE TEAM:** Jeff Solak, Robin Price, Paul Horton
**CLIENT:** Self-promotion

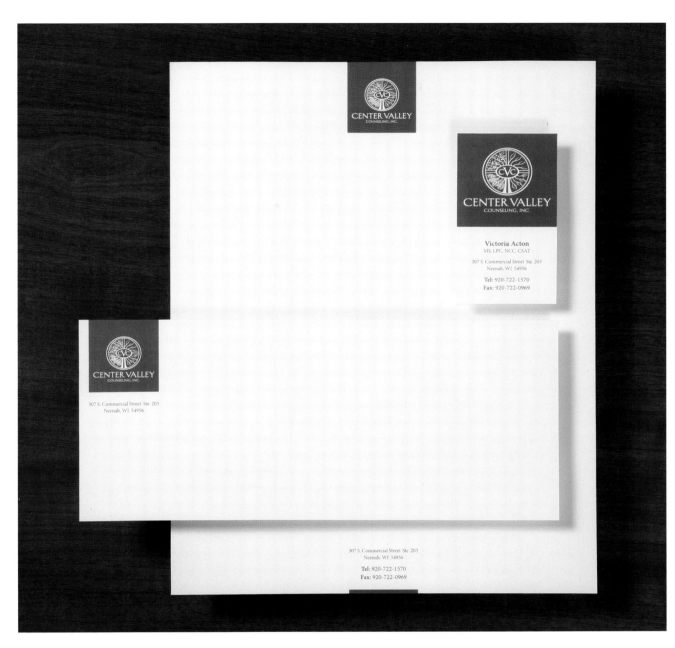

LEIBOLD ASSOCIATES, INC._ NEENAH, WI, UNITED STATES
**CREATIVE TEAM:** Ryan Wienandt, Mark Vanden Berg
**CLIENT:** Center Valley Counseling, Inc.

P & J DESIGNS_ ATLANTA, GA, UNITED STATES
**CREATIVE TEAM:** Pauline Pellicer, Jessica Wong
**CLIENT:** Meghan Lips

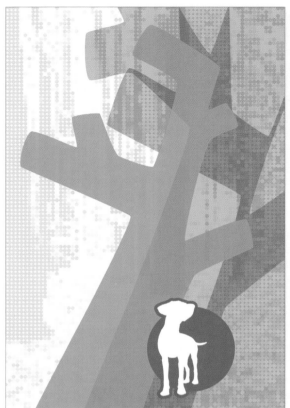

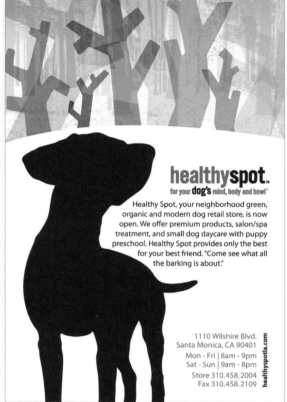

healthyspot.
for your **dog's** mind, body and bowl

Healthy Spot, your neighborhood green, organic and modern dog retail store, is now open. We offer premium products, salon/spa treatment, and small dog daycare with puppy preschool. Healthy Spot provides only the best for your best friend. "Come see what all the barking is about."

1110 Wilshire Blvd.
Santa Monica, CA 90401
Mon - Fri | 8am - 9pm
Sat - Sun | 9am - 8pm
Store 310.458.2004
Fax 310.458.2109

healthyspotla.com

160

AKARSTUDIOS_ SANTA MONICA, CA, UNITED STATES
**CREATIVE TEAM:** Sean Morris
**CLIENT:** HealthySpot

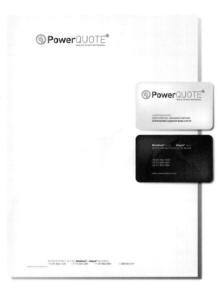

**LEO MENDES DESIGN_** RIO DE JANEIRO, BRAZIL
**CREATIVE TEAM:** Leo Mendes
**CLIENT:** Power Quote

**STUDIO E FLETT DESIGN_** GORHAM, ME, UNITED STATES
**CREATIVE TEAM:** Erin Flett, Cliff Kucine
**CLIENT:** Erin Flett, Studio e paper

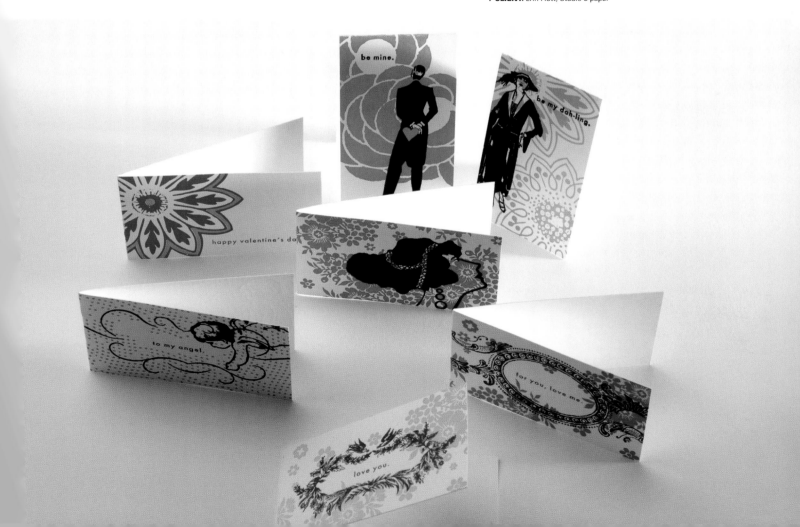

162

**MICHELLE ROBERTS DESIGN_** BARNEVELD, NY, UNITED STATES
**CREATIVE TEAM:** Michelle Roberts
**CLIENT:** Farrington Custom Packaging

*Farm*
# THOMPSON SEED POTATO

6541 JEFFERSON ROAD | P 308•762•7699
ALLIANCE, NE 69301 | F 308•762•7899

**Seed Our Specialty**

*Lisa Hickman*
lisa.hickman@ymail.com
C 308•760•2611

**DARCYLEA DESIGN_** SIDNEY, NE, UNITED STATES
**CREATIVE TEAM:** Darcy Hinrichs
**CLIENT:** Countrywide Potato

THE GRAFIOSI_ NEW DELHI, INDIA
**CREATIVE TEAM:** Pushkar Thakur
**CLIENT:** Self-Promotion

UNIT DESIGN COLLECTIVE_ SAN FRANCISCO, CA, UNITED STATES
**CREATIVE TEAM:** Ann Jordan, Shardul Kiri
**CLIENT:** Tach Tech

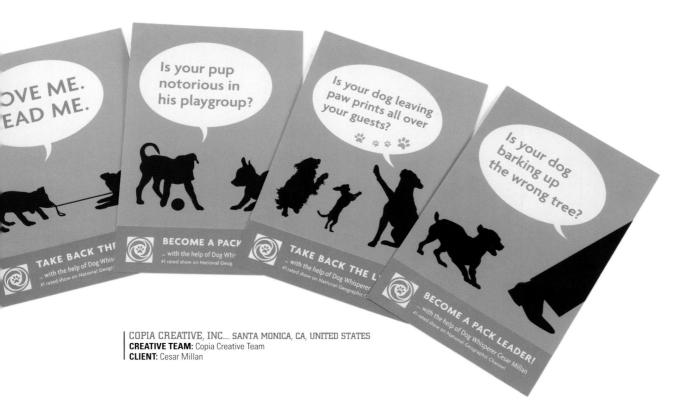

COPIA CREATIVE, INC._ SANTA MONICA, CA, UNITED STATES
**CREATIVE TEAM:** Copia Creative Team
**CLIENT:** Cesar Millan

164

COPIA CREATIVE, INC._ SANTA MONICA, CA, UNITED STATES
**CREATIVE TEAM:** Copia Creative Team
**CLIENT:** Chapman

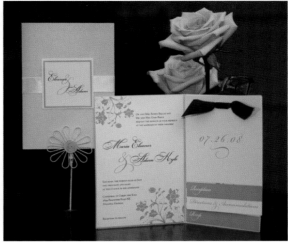

**JOE KNEZIC/CEREBRAL LEASING**_ HARRISBURG, PA, UNITED STATES
**CREATIVE TEAM:** Joe Knezic
**CLIENT:** Kevin & Emily

**P & J DESIGNS**_ ATLANTA, GA, UNITED STATES
**CREATIVE TEAM:** Pauline Pellicer
**CLIENT:** Eleanor Baccay

**CRUMPLED DOG DESIGN**_ LONDON, UNITED KINGDOM
**CREATIVE TEAM:** Christina Wilkins
**CLIENT:** Buckley Gray Yeoman

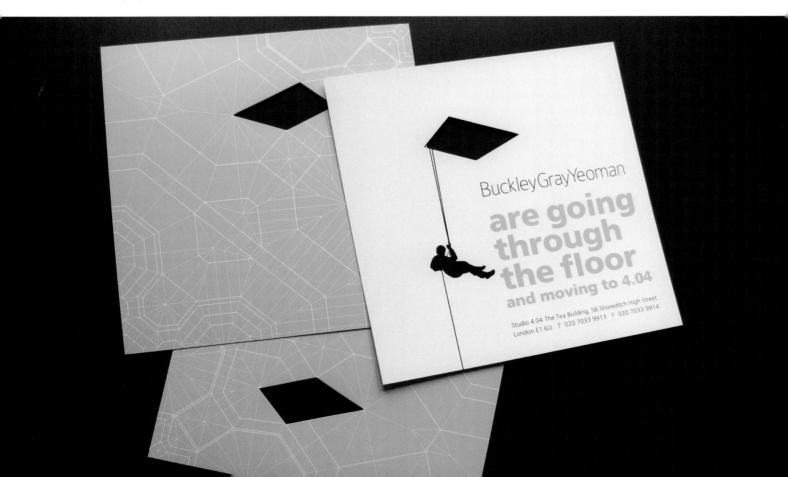

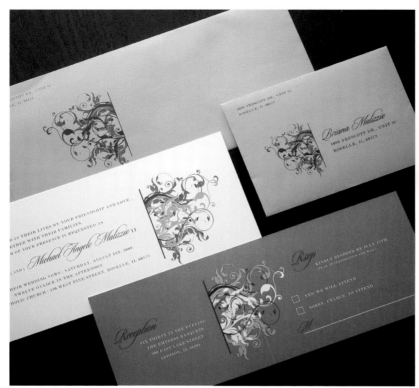

**TEN26 DESIGN GROUP, INC._**
**CRYSTAL LAKE, IL, UNITED STATES**
**CREATIVE TEAM:** Kelly Demakis
**CLIENT:** Briana and Michael

166

**STERK WATER_ ANTWERP, BELGIUM**
**CREATIVE TEAM:** Frank Schouwaerts
**CLIENT:** BeeldStudio

**DEFTELING DESIGN_ PORTLAND, OR, UNITED STATES**
**CREATIVE TEAM:** Alex Wijnen
**CLIENT:** Cecily Ink

FOUNDRY_ CALGARY, AB, CANADA
**CREATIVE TEAM:** Alison Wattie, Kylie Henry
**CLIENT:** Maria Tomas Interiors

167

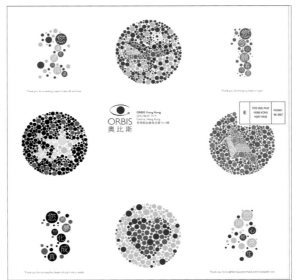

TINKVISUALCOMMUNICATION_ HONG KONG
**CREATIVE TEAM:** Kelvin Hung, Fat Tsoi
**CLIENT:** ORBIS Hong Kong

TRACY KRETZ FREELANCE_ HARRISBURG, PA, UNITED STATES
**CREATIVE TEAM:** Tracy L. Kretz
**CLIENT:** Harrisburg Young Professionals

STORM CORPORATE DESIGN_ AUCKLAND, NEW ZEALAND
**CREATIVE TEAM:** Rehan Saiyed
**CLIENT:** Glaxo Smith Kline

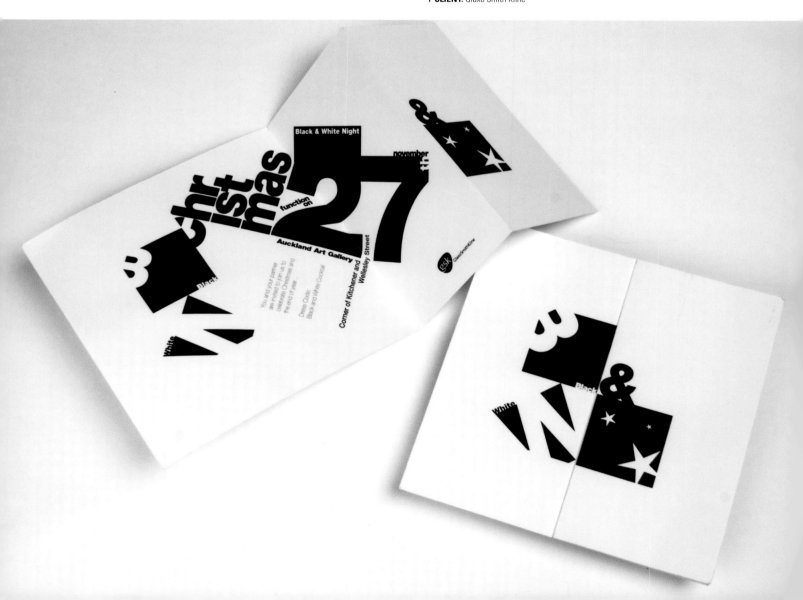

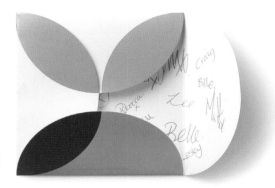

ALOOF DESIGN_ LEWES, EAST SUSSEX, UNITED KINGDOM
**CREATIVE TEAM:** Sam Aloof, Jon Hodkinson, Andrew Scrase
**CLIENT:** realhair

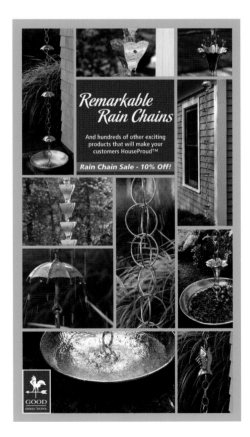

D STREET DESIGN_ SAN CLEMENTE, CA, UNITED STATES
**CREATIVE TEAM:** Lynne Door
**CLIENT:** Glenn Feldmann Darby & Goodlatte

SANDORMAX_ SANDY HOOK, CT, UNITED STATES
**CREATIVE TEAM:** Zoltan Csillag, Julia Nable, Blair Carney
**CLIENT:** Good Directions

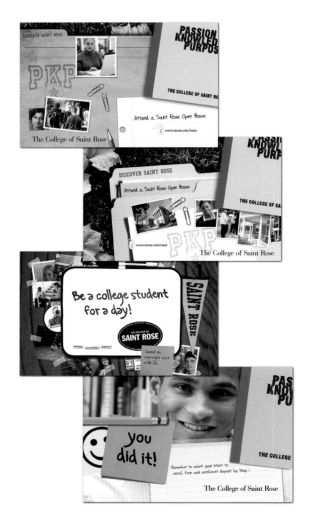

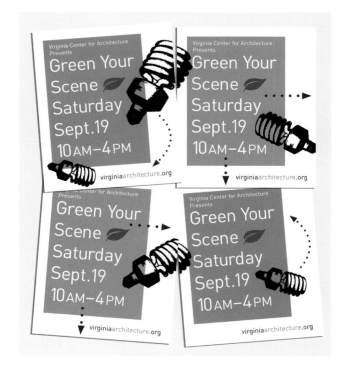

170

THE COLLEGE OF SAINT ROSE_ ALBANY, NY, UNITED STATES
**CREATIVE TEAM:** Mark Hamilton, Chris Parody, Lisa Haley Thomson
**CLIENT:** The College of Saint Rose

SUBCOMMUNICATION_ MONTREAL, QC, CANADA
**CREATIVE TEAM:** Sebastien Theraulaz, Valerie Desrochers
**CLIENT:** Subtitude.com

THINKHAUS_ RICHMOND, VA, UNITED STATES
**CREATIVE TEAM:** John O'Neill
**CLIENT:** Virginia Center For Architecture

P & J DESIGNS_ ATLANTA, GA, UNITED STATES
**CREATIVE TEAM:** Jessica Wong
**CLIENT:** Richard Castelo

3 ADVERTISING_ ALBUQUERQUE, NM, UNITED STATES
**CREATIVE TEAM:** Tim McGrath, Sam Maclay
**CLIENT:** Self-promotion

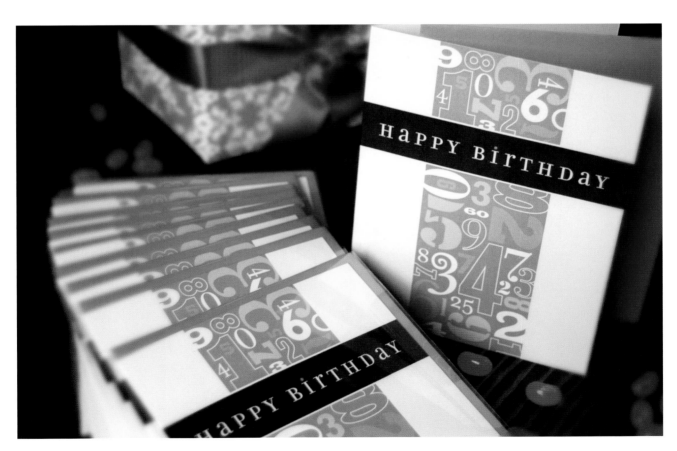

DEFTELING DESIGN_ PORTLAND, OR, UNITED STATES
**CREATIVE TEAM:** Alex Wijnen
**CLIENT:** Cecily Ink

ARCHETYPE DESIGN STUDIO_ FLUSHING, NY, UNITED STATES
**CREATIVE TEAM:** Dagmar Jeffrey
**CLIENT:** Gutenberg Printing

172

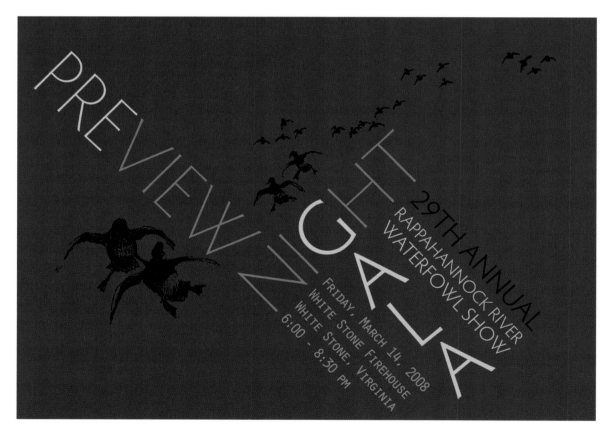

COLORYN STUDIO_ RICHMOND, VA, UNITED STATES
**CREATIVE TEAM:** Ryn Bruce
**CLIENT:** Rappahannock River Waterfowl Show

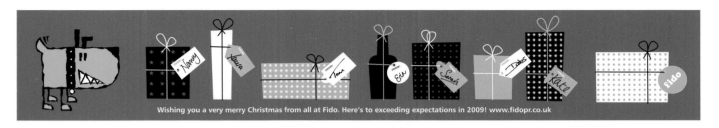

Wishing you a very merry Christmas from all at Fido. Here's to exceeding expectations in 2009! www.fidopr.co.uk

**IMAGINE_** MANCHESTER, UNITED KINGDOM
**CREATIVE TEAM:** David Caunce
**CLIENT:** Fido PR

**ALR DESIGN_** RICHMOND, VA, UNITED STATES
**CREATIVE TEAM:** Noah Scalin
**CLIENT:** New York Foundation for the Arts

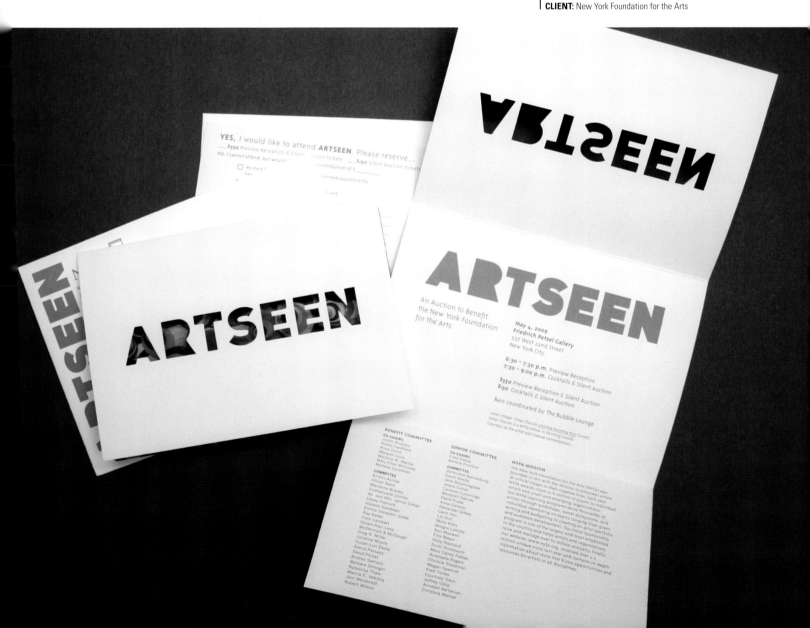

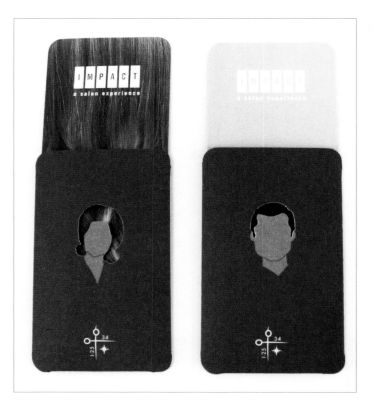

174

LITTLE UTOPIA, INC._ LOS ANGELES, CA, UNITED STATES
**CREATIVE TEAM:** Alyssa Lang
**CLIENT:** Self-promotion

CREATIVE SUITCASE_ AUSTIN, TX, UNITED STATES
**CREATIVE TEAM:** Rachel Clemens, Jennifer Wright
**CLIENT:** Impact Salon

ELLEN BRUSS DESIGN_ DENVER, CO, UNITED STATES
**CREATIVE TEAM:** Ellen Bruss, Geoff Allen
**CLIENT:** Shelli Nelligan

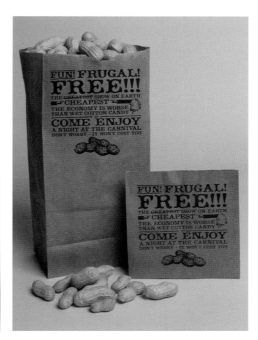

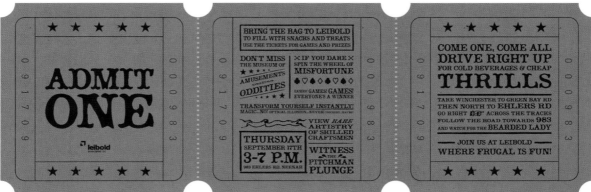

LEIBOLD ASSOCIATES, INC.— NEENAH, WI, UNITED STATES
**CREATIVE TEAM:** NIck Maggio, Ryan Wienandt, Jake Weiss, Therese Joanis
**CLIENT:** Leibold Associates, Inc.

## A SAMPLE OF MAMA LOU'S FEATS OF STRENGTH:

Pounding nails into wood with her fist

Human tug-of-war— Mama Lou vs. 10 people

Breaking a flaming board with her hands

Eating fire →

→ Amazing weight lifts with her tongue

→ One armed pushups

Crushing apples in biceps

Bending metal bars

Bending nails

→ Ripping telephone books in half

## CALL TO BOOK NOW!
(+01) 206·816·9781
MamaLou@StrongWomanShow.com
www.StrongWomanShow.com

→ Breaking chopsticks in butt cheeks

PHONEBOOKS. YOUR HEART.

NEITHER STAND A CHANCE.

**ANDY GABBERT DESIGN_** OAKLAND, CA, UNITED STATES
**CREATIVE TEAM:** Andy Gabbert
**CLIENT:** Mama Lou American Strong Woman

**JAM DESIGN & COMMUNICATIONS LTD_** LONDON, UNITED KINGDOM
**CREATIVE TEAM:** JAM
**CLIENT:** Veuve Clicquot

**LCDA_** SAN DIEGO, CA, UNITED STATES
**CREATIVE TEAM:** Laura Coe Wright, Ryoichi Yotsumoto
**CLIENT:** Laura Coe Design Associates

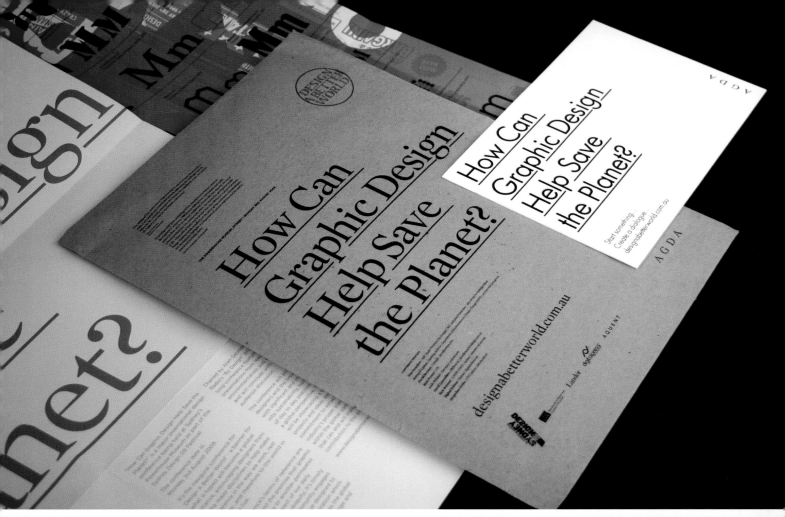

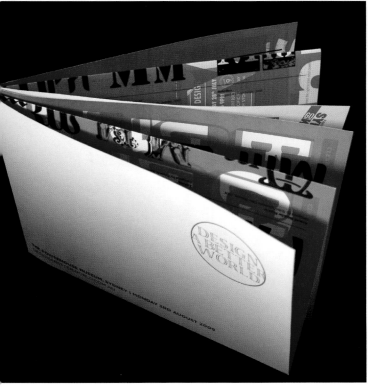

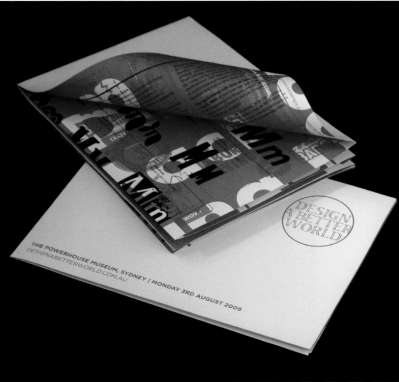

LANDOR ASSOCIATES_ SYDNEY, AUSTRALIA
**CREATIVE TEAM:** Jason Little, Sam Pemberton, Ivanã Martinóvic
**CLIENT:** The Australian Graphic Design Association (AGDA)

SEESAW DESIGNS_ SCOTTSDALE, AZ, UNITED STATES
**CREATIVE TEAM:** Lindsay Tingstrom, Angela Hardison, Raquel Raney
**CLIENT:** SeeSaw Designs

178

ROBINSON THINKS_ CHARLOTTE, NC, UNITED STATES
**CREATIVE TEAM:** Jason Robinson
**CLIENT:** Morrison & Castelli

P & J DESIGNS_ ATLANTA, GA, UNITED STATES
**CREATIVE TEAM:** Jessica Wong
**CLIENT:** JLM Couture

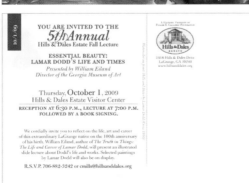

KELSEY ADVERTISING & DESIGN_
LAGRANGE, GA, UNITED STATES
**CREATIVE TEAM:** Niki Studdard
**CLIENT:** Hills & Dales Estate

ESSENCE DESIGN LIMITED_ SUTTON COLDFIELD,
WEST MIDLANDS, UNITED KINGDOM
**CREATIVE TEAM:** Regine Wilber, Rachel Khorn
**CLIENT:** Spa Breaks

179

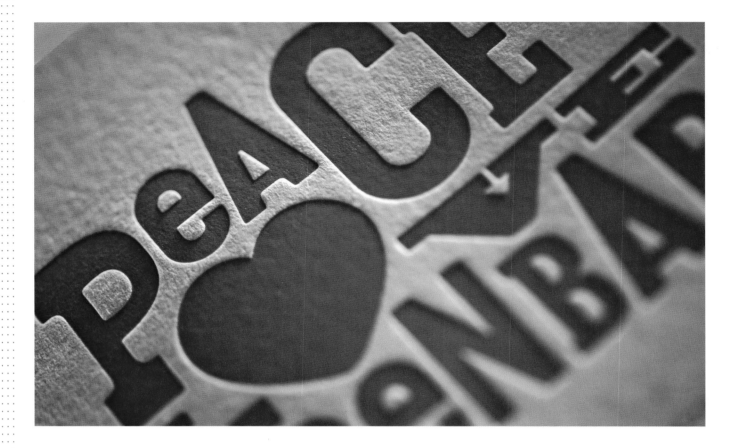

## An In-Depth Look

## Peace, Love & Open Bar

Every designer knows that too many fonts in one place can be deadly—but also that some rules are made to be broken. Addressing both principles, Jacob Tyler Creative Group artfully threw everything he had at his clients, along with free drinks. And they loved him for it.

"We rented out a restaurant for a holiday party and invited friends and clients," the San Diego creative director, Les Kollegian, said of his firm, the nine-person Jacob Tyler Creative Group. "We just wanted to create a really nice letterpress invitation and really explore typography. Funny thing is, when we design for clients, we're limited to their budget—very corporate—and we usually don't have the opportunity to design for ourselves. We created this for ourselves with no limitations."

In eliminating their limitations, Kollegian, along with senior designer Gordon Tsuji and designer Jessica Recht, used a blend of serif and sans-serif fonts from "about six" font families, including Clarendon, Wingdings and Avenir. *"We really just wanted to explore different type families and give it a warm feel, and I knew Gordon would be great to lead the effort,"* Kollegian says. *"[We wanted to] say, look, you can mix a lot of font families and it still works."*

Coming up with a theme for the party "was kind of a joke, with an open bar being the equivalent of happiness," he says. "'Peace, love and happiness' would get people to the party." Kollegian drew from his love of psychedelic-era rock posters with their layered typefaces and stylized fonts,

but opted for a more elegant look that included making "Peace, Love and Open Bar" into a typographic logo in itself.

Trying on a variety of fonts wasn't the only first for Kollegian and Tsuji. "We haven't done letterpress invites for a party specifically, but we've done letterpress-based design for business cards and brochures," Kollegian says. Keeping the overall event experience a sensual one, right down to the invitations, played at the forefront of the package. "The texture was important; when people felt it, their fingers would run over it and they'd get into it. We did do multiple versions on brown stock with blue ink, but ended up with the white and red for the theme of the month, plus our logo is red. So we played a little on our brand. We sent it out with a red metallic envelope so the white really popped when they opened it up."

Tsuji and Recht popped out the invitation design in less than twelve hours. Says Kollegian: "You're always trying to quickly budget; when you do it yourself you want to get it done. Gordon is phenomenal with type, so it came together pretty quickly." He then ensured that the final product arrived in invitees' mailboxes on a soft, thick stock, "like a work of art that someone could frame."

To save money for drinks later, the Jacob Tyler crew restricted themselves to a tight financial budget: a maximum of five hundred dollars for two hundred fifty invitations. "We wanted to create something we could mail simply, and also print through letterpress without being charged an arm and

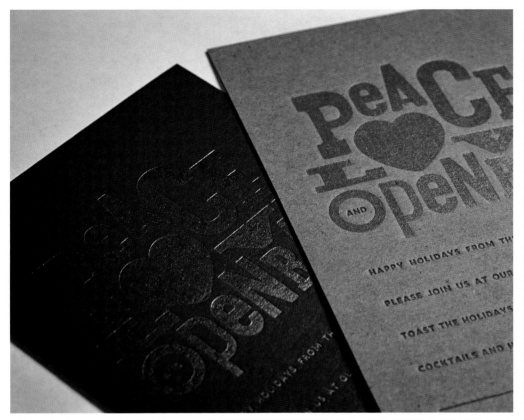
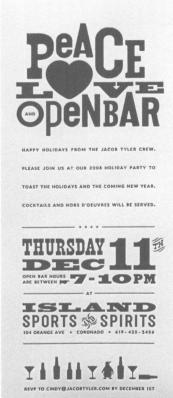
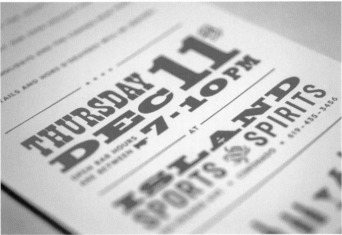
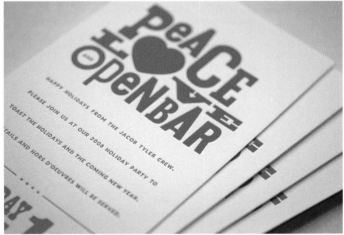

a leg," Kollegian says. "[We originally conceived of a] square, but it cost more to mail, so we shifted to a thinner version that could go into a standard long envelope. We also wanted to use metallic ink, but it cost too much. There are never as many hurdles as when you're designing for yourself."

The agency's employees weren't the only ones allowed to design for themselves: At the party, the firm employed on-site screen printers to print original artwork onto souvenir t-shirts for guests. "One design was the bottom of the

invite, one was the 'Peace, Love and Open Bar' logo and the other two were holiday-related designs. You could do whatever you wanted, front or back."

On the invitations and the t-shirts, one typographic element stands out like a mysterious visitor to Southern California on Christmas Eve. "The penguin was just for fun," Kollegian says. "It's an Easter egg for people to look at, and we knew it would start a conversation…and that's what effective design is all about."

**JACOB TYLER CREATIVE GROUP_ SAN DIEGO, CA, UNITED STATES**
**CREATIVE TEAM:** Gordon Tsuji, Jessica Recht
**CLIENT:** Jacob Tyler Creative Group

OAKLEY DESIGN STUDIO_ PORTLAND, OR, UNITED STATES
**CREATIVE TEAM:** Tim Oakley
**CLIENT:** Self-promotion

182

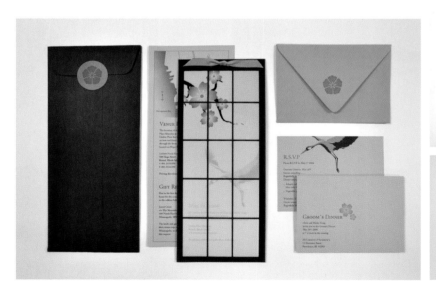

GRAPHIC FACTION, INC._ MINNEAPOLIS, MN, UNITED STATES
**CREATIVE TEAM:** Elizabeth Anderson, Jason Craig
**CLIENT:** Elizabeth Anderson & Jason Craig

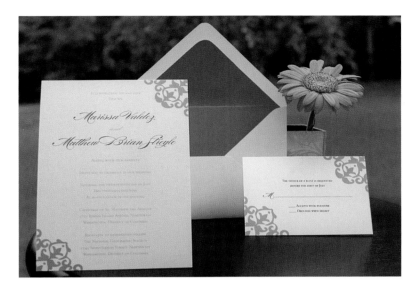

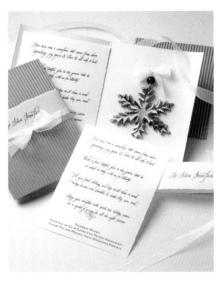

**P & J DESIGNS_** ATLANTA, GA, UNITED STATES
**CREATIVE TEAM:** Pauline Pellicer
**CLIENT:** Marissa Valdez

**LCDA_** SAN DIEGO, CA, UNITED STATES
**CREATIVE TEAM:** Laura Coe Wright, Leanne Lally
**CLIENT:** Laura Coe Design Associates

183

**PEAK SEVEN ADVERTISING_** DEERFIELD BEACH, FL, UNITED STATES
**CREATIVE TEAM:** Darren Seys, Brian Tipton
**CLIENT:** Headquarter Honda

**P & J DESIGNS_**
ATLANTA, GA, UNITED STATES
**CREATIVE TEAM:** Pauline Pellicer
**CLIENT:** JLM Couture

**LEHMAN GRAPHIC ARTS_** QUEENSBURY, NY, UNITED STATES
**CREATIVE TEAM:** Lisa Lehman
**CLIENT:** St. Mary's-St. Alphonsus Regional Catholic School

**GEYRHALTER DESIGN_**
SANTA MONICA, CA, UNITED STATES
**CREATIVE TEAM:** Fabian Geyrhalter, Julia Hou
**CLIENT:** Match Creative Talent

**ANDY GABBERT DESIGN_**
OAKLAND, CA, UNITED STATES
**CREATIVE TEAM:** Andy Gabbert, Erica Mohar
**CLIENT:** Carolina Steinert & Dan Shay

**ALEXANDER EGGER_** VIENNA, AUSTRIA
**CREATIVE TEAM:** Alexander Egger
**CLIENT:** Pilotprojekt

184

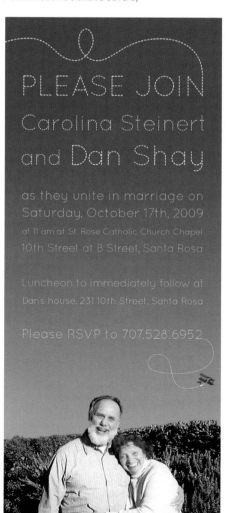

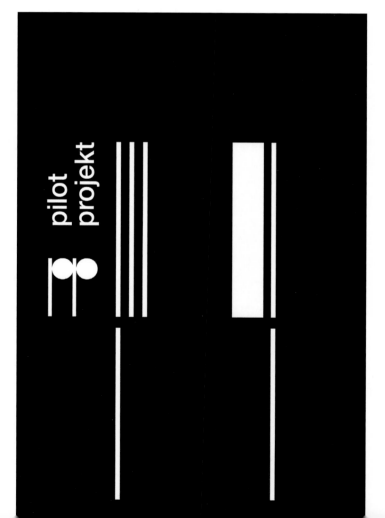

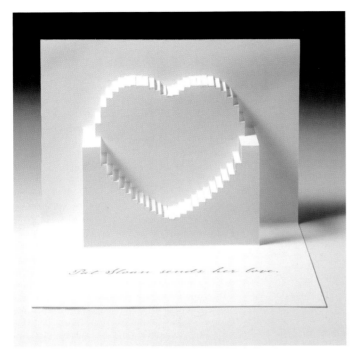

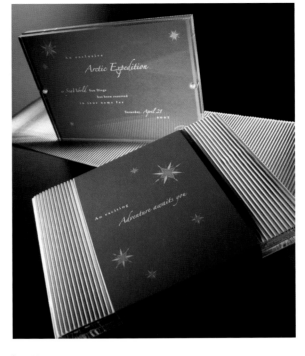

PAT SLOAN DESIGN_ FORT WORTH, TX, UNITED STATES
**CREATIVE TEAM:** Pat Sloan
**CLIENT:** Self-promotion

LCDA_ SAN DIEGO, CA, UNITED STATES
**CREATIVE TEAM:** Laura Coe Wright, Tracy Castle
**CLIENT:** SeaWorld

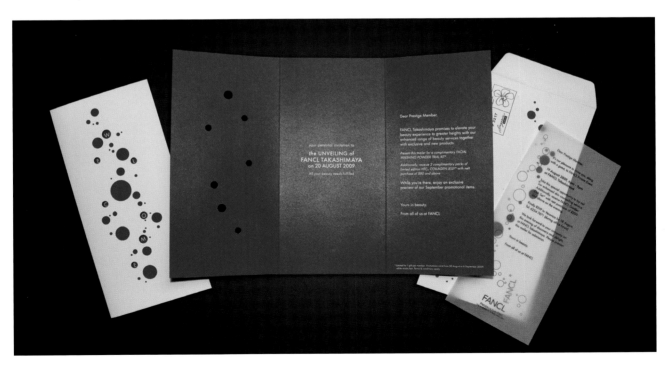

PLANET ADS & DESIGN PTE. LTD._ SINGAPORE
**CREATIVE TEAM:** Hal Suzuki, Suzanne Lauridsen, Edwin Enero III
**CLIENT:** FANCL

BERTZ DESIGN GROUP_ MIDDLETOWN, CT, UNITED STATES
**CREATIVE TEAM:** Bertz Design
**CLIENT:** Middlesex Hospital

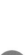
186

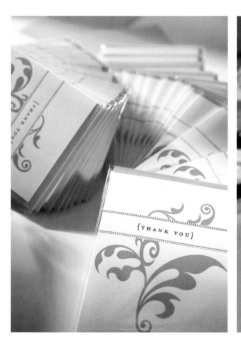

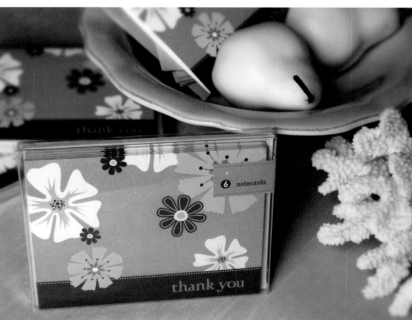

DEFTELING DESIGN_ PORTLAND, OR, UNITED STATES
**CREATIVE TEAM:** Alex Wijnen
**CLIENT:** Cecily Ink

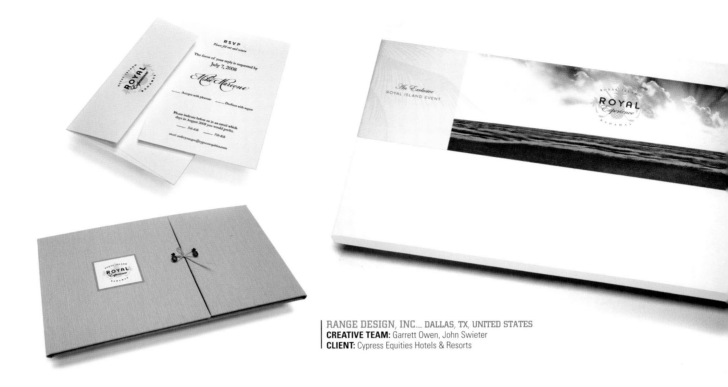

RANGE DESIGN, INC._ DALLAS, TX, UNITED STATES
**CREATIVE TEAM:** Garrett Owen, John Swieter
**CLIENT:** Cypress Equities Hotels & Resorts

187

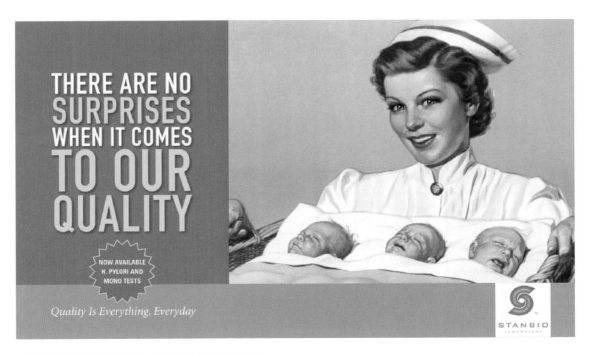

THERE ARE NO SURPRISES WHEN IT COMES TO OUR QUALITY

NOW AVAILABLE
H. PYLORI AND
MONO TESTS

*Quality Is Everything. Everyday*

STANBIO
LABORATORY

CLOCKWORK STUDIOS_ SAN ANTONIO, TX, UNITED STATES
**CREATIVE TEAM:** Terri Gaines, Steve Gaines, Shawn Meek
**CLIENT:** Stanbio Laboratories

  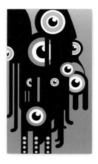  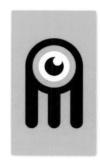 

**344 DESIGN, LLC_** PASADENA, CA, UNITED STATES
**CREATIVE TEAM:** Stefan G. Bucher
**CLIENT:** Open Intelligence Agency

188

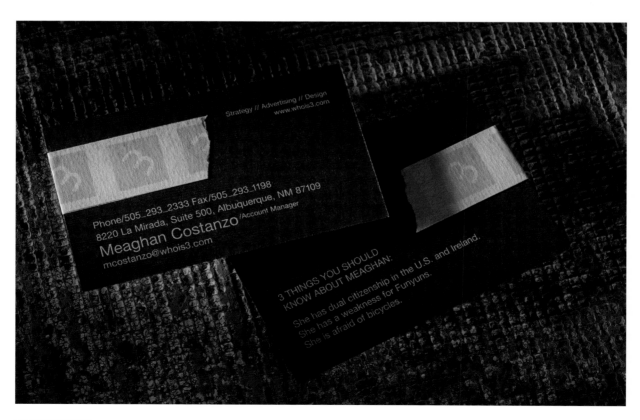

**3 ADVERTISING_** ALBUQUERQUE, NM, UNITED STATES
**CREATIVE TEAM:** Tim McGrath, Sam Maclay
**CLIENT:** Self-promotion

DESIGN NUT, LLC_ KENSINGTON, MD, UNITED STATES
**CREATIVE TEAM:** Brent M. Almond
**CLIENT:** Reading Is Fundamental

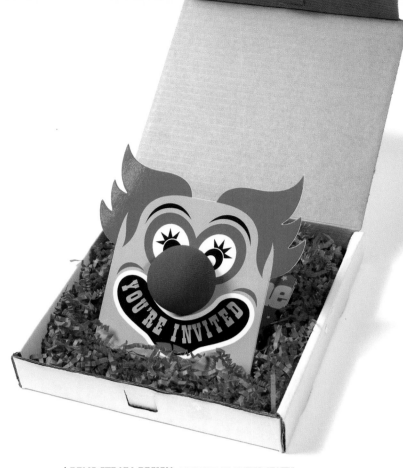

REMO STRADA DESIGN_ LINCROFT, NJ, UNITED STATES
**CREATIVE TEAM:** Remo Strada
**CLIENT:** Reservoir Capital

189

PEAK SEVEN ADVERTISING'S
**HOLIDAY SURVIVAL GUIDE**

HERE ARE SOME TRIED AND TRUE EXCUSES THAT WILL CERTAINLY GET YOU OUT OF ANY HOLIDAY PARTY:

"GOD SENT ME AN EMAIL, CAN'T DISCUSS DETAILS, WILL CALL YOU MONDAY."

"SWEET, MERCIFUL CHOLERA IS BACK."

"I WANT TO COME, BUT MY SPLIT PERSONALITY WON'T LET ME."

"I'M RECOVERING FROM A RABID SQUIRREL ATTACK."

"NINJAS WON'T LET ME LEAVE."

"THERE'S A "LOVE BOAT" MARATHON ON TV."

PEAK SEVEN ADVERTISING_ DEERFIELD BEACH, FL, UNITED STATES
**CREATIVE TEAM:** Josh Munsee, Brian Tipton, Stacy Mathrani
**CLIENT:** Self-promotion

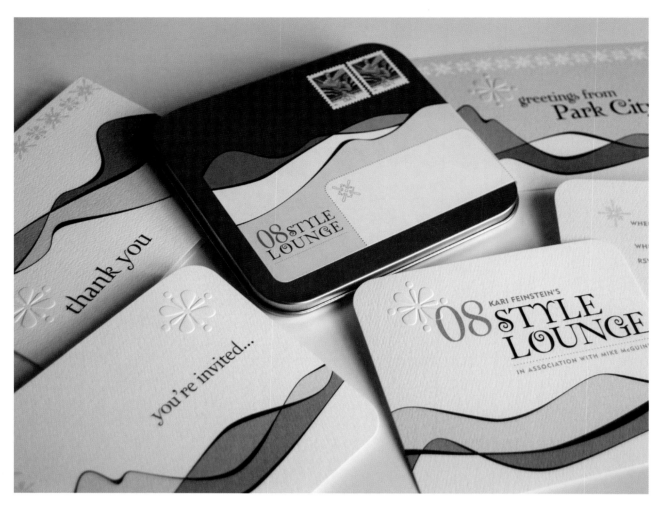

| DEFTELING DESIGN_ PORTLAND, OR, UNITED STATES
**CREATIVE TEAM:** Alex Wijnen
**CLIENT:** Kari Feinstein PR

| DELPHINE KEIM-CAMPBELL_ MOSCOW, ID, UNITED STATES
**CREATIVE TEAM:** Delphine Keim-Campbell
**CLIENT:** Gritman Medical Center

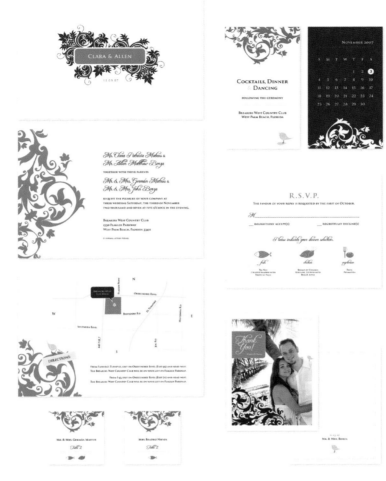

191

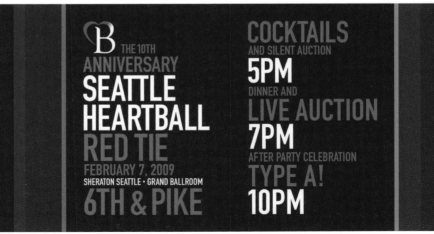

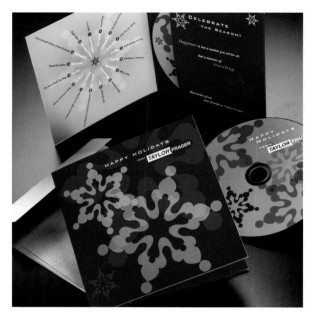

NETRA NEI_ SEATTLE, WA, UNITED STATES
**CREATIVE TEAM:** Netra Nei
**CLIENT:** raumplus

LCDA_ SAN DIEGO, CA, UNITED STATES
**CREATIVE TEAM:** Laura Coe Wright, Tracy Castle
**CLIENT:** Taylor Frager

OMMA CREATIVE_ MARIETTA, GA, UNITED STATES
**CREATIVE TEAM:** Brad Weaver
**CLIENT:** French Paper Company & Mac Paper Distributors

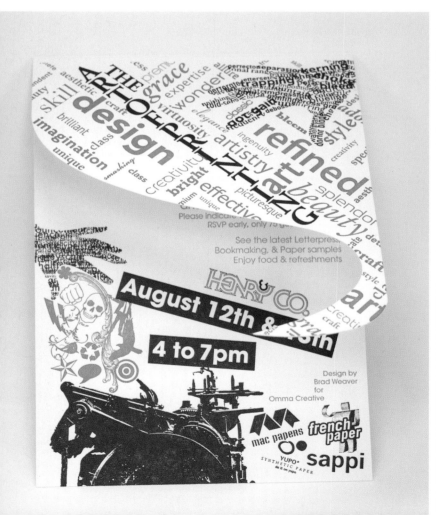

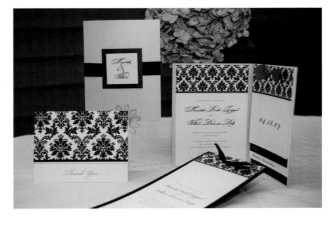

**IE DESIGN + COMMUNICATIONS_** HERMOSA BEACH, CA, UNITED STATES
**CREATIVE TEAM:** Marcie Carson, Christine Kenney
**CLIENT:** MelloMar Brasil Biquinis

**P & J DESIGNS_** ATLANTA, GA, UNITED STATES
**CREATIVE TEAM:** Pauline Pellicer, Jessica Wong
**CLIENT:** Meredith Trippel

193

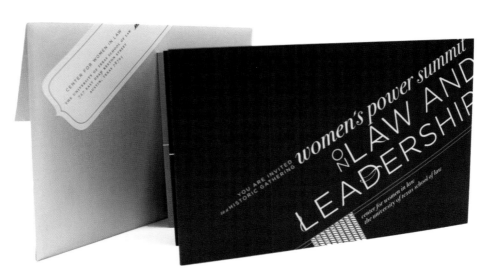

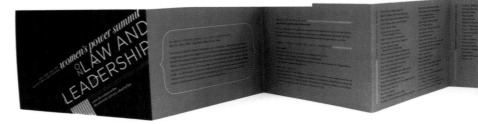

**CREATIVE SUITCASE_** AUSTIN, TX, UNITED STATES
**CREATIVE TEAM:** Rachel Clemens, Jennifer Wright
**CLIENT:** The University of Texas School of Law

COCKTAILS
DRINKS
HOR'DOURVES
MUSIC
LOVE

## 50TH ANNIVERSARY PARTY
### DICK AND LYNN MILLER
SATURDAY OCTOBER 3RD 2009
THE LOG DEN
6626 STATE HIGHWAY 42
EGG HARBOR, WISCONSIN 54209
## CELEBRATE WITH THEM
## ON THIS JOYOUS OCCASION!
HOSTED BY • TERRI, MIKE, MARK AND JULIE

RSVP BEFORE
SEPTEMBER 25TH
TO MARK MILLER
608.288.5486

PARTY

LOVE

CELEBRATE

NO GIFTS PLEASE

ROW **50**

ROW **50**

6:00 PM

THANKS

SEAT **50**

SECTION **LOVE**

ROW **50**

SEAT **50**

SEAT **50**

10031959-2009

**UNIVERSITY WISCONSIN MILWAUKEE_** WAUWATOSA, WI, UNITED STATES
**CREATIVE TEAM:** Sarah Hill
**CLIENT:** Grandparents

194

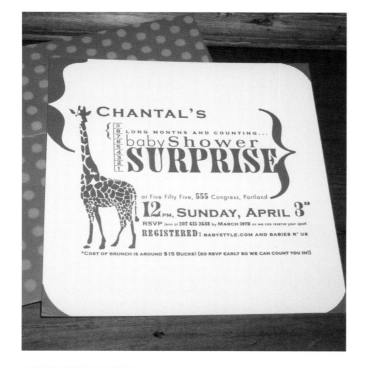

**STUDIO E FLETT DESIGN_** GORHAM, ME, UNITED STATES
**CREATIVE TEAM:** Erin Flett
**CLIENT:** Chantal Young

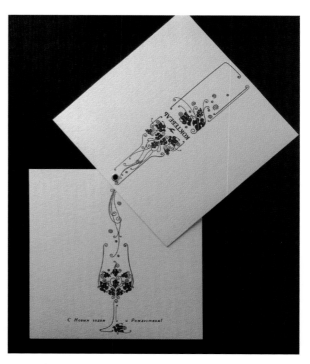

**YURKO GUTSULYAK_** KYIV, UKRAINE
**CREATIVE TEAM:** Yurko Gutsulyak
**CLIENT:** Koktebel

| CALL ME AMY DESIGN_ SEATTLE, WA, UNITED STATES | STUDIO E FLETT DESIGN_ GORHAM, ME, UNITED STATES | ARTSTAND, LLC_ NEW YORK, NY, UNITED STATES |
|---|---|---|
| **CREATIVE TEAM:** Amy Reisman | **CREATIVE TEAM:** Erin Flett | **CREATIVE TEAM:** Loredana Sangiuliano |
| **CLIENT:** Vida Verde | **CLIENT:** Daughter | **CLIENT:** Self-promotion |

| ROYCROFT DESIGN_ BOSTON, MA, UNITED STATES |
|---|
| **CREATIVE TEAM:** Jennifer Roycroft |
| **CLIENT:** Lindenmeyr Munroe |

AXIOMACERO_ MONTERREY, NUEVO LEON, MEXICO
**CREATIVE TEAM:** Mabel Morales, Carmen Rodriguez, Alan Zuñiga
**CLIENT:** Tostadas Charras

TOM DOLLE DESIGN_ NEW YORK, NY, UNITED STATES
**CREATIVE TEAM:** Chris Riely, Tom Dolle
**CLIENT:** Tom Dolle Design

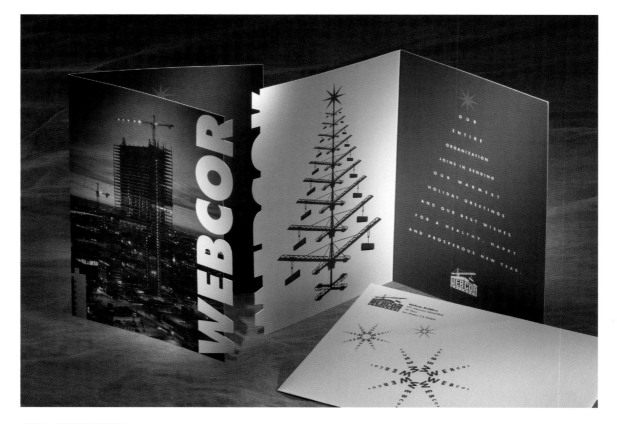

GEE + CHUNG DESIGN_ SAN FRANCISCO, CA, UNITED STATES
**CREATIVE TEAM:** Earl Gee
**CLIENT:** Webcor Builders

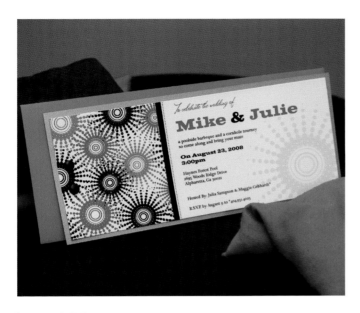

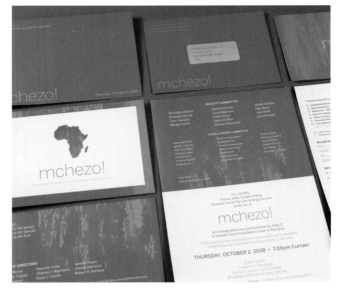

P & J DESIGNS_ ATLANTA, GA, UNITED STATES
**CREATIVE TEAM:** Pauline Pellicer
**CLIENT:** Maggie Gebhardt

MSDS_ NEW YORK, NY, UNITED STATES
**CREATIVE TEAM:** Ryan Reynolds, Matthew Schwartz
**CLIENT:** Touch Foundation

THINKHAUS_ RICHMOND, VA, UNITED STATES
**CREATIVE TEAM:** John O'Neill
**CLIENT:** Thinkhaus LLC

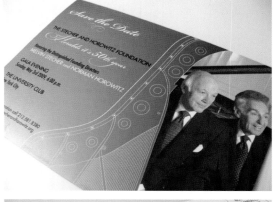
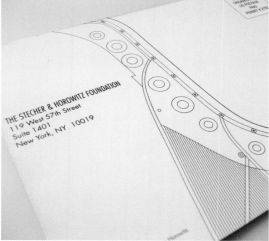

**GREEN GROUP STUDIO_** GREENACRES, FL, UNITED STATES
**CREATIVE TEAM:** Clara Mateus
**CLIENT:** Junior Achievement of South Florida, Inc.

**ARCHETYPE DESIGN STUDIO_** FLUSHING, NY, UNITED STATES
**CREATIVE TEAM:** Dagmar Jeffrey
**CLIENT:** The Stecher and Horowitz Foundation

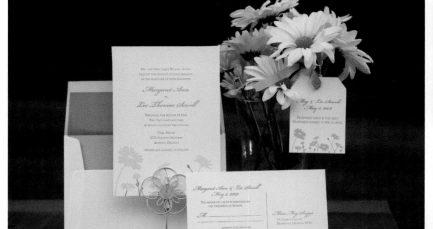

**P & J DESIGNS_** ATLANTA, GA, UNITED STATES
**CREATIVE TEAM:** Jessica Wong, Pauline Pellicer
**CLIENT:** Meg Suggs

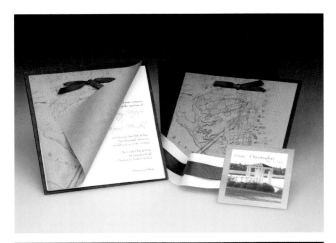

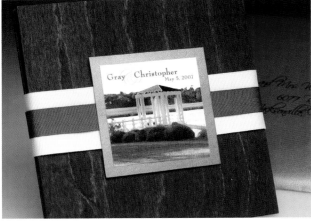

Please join us in celebrating
the recent graduation of

*Darcy Lea Hinrichs*

The Art Institute of Pittsburgh, PA
Bachelor of Science, Graphic Design
*Saturday, July 12th, 2008*
*5:00 p.m.*

2205 Linden Street
Sidney, Nebraska 69162

RSVP by July 5th
308.254.2085

**DARCYLEA DESIGN** SIDNEY, NE, UNITED STATES
**CREATIVE TEAM:** Darcy Hinrichs, Rajshel Juhan
**CLIENT:** Darcy Hinrichs

**GHL DESIGN** RALEIGH, NC, UNITED STATES
**CREATIVE TEAM:** Gray Heffner
**CLIENT:** Herndon Wedding

**P & J DESIGNS** ATLANTA, GA, UNITED STATES
**CREATIVE TEAM:** Pauline Pellicer
**CLIENT:** Melanie Scherer

199

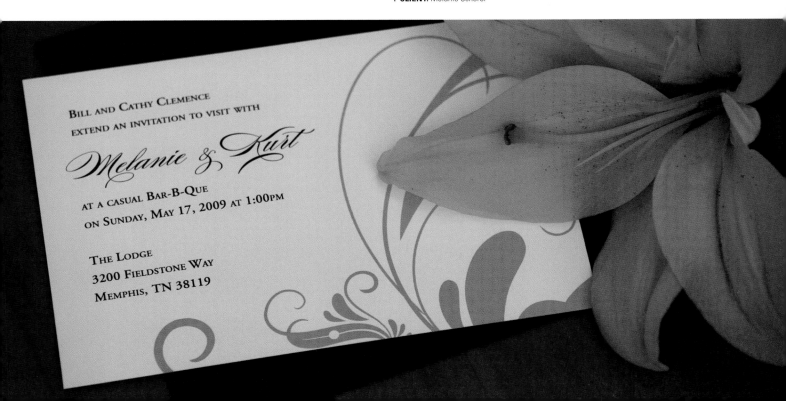

BILL AND CATHY CLEMENCE
EXTEND AN INVITATION TO VISIT WITH

*Melanie & Kurt*

AT A CASUAL BAR-B-QUE
ON SUNDAY, MAY 17, 2009 AT 1:00PM

THE LODGE
3200 FIELDSTONE WAY
MEMPHIS, TN 38119

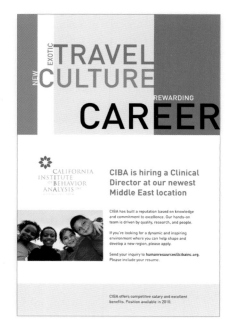

CYAN CONCEPT INC._ SAGUENAY, QC, CANADA
**CREATIVE TEAM:** Valérie Laporte
**CLIENT:** Agency In for Bon Apparte

COPIA CREATIVE, INC._
SANTA MONICA, CA, UNITED STATES
**CREATIVE TEAM:** Copia Creative Team
**CLIENT:** California Institute of Behavior Analysis Inc.

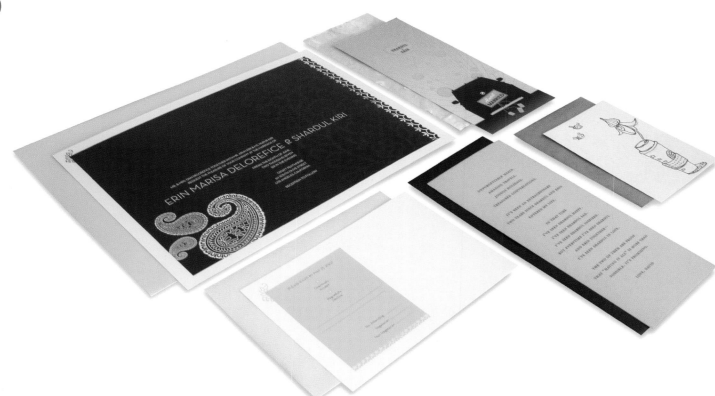

UNIT DESIGN COLLECTIVE_ SAN FRANCISCO, CA, UNITED STATES
**CREATIVE TEAM:** Ann Jordan, Shardul Kiri, Erin Delorefice, David Blacker
**CLIENT:** Erin Delorefice

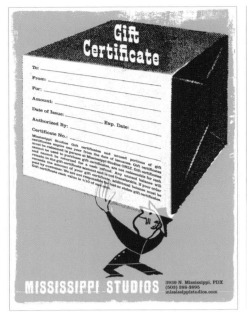

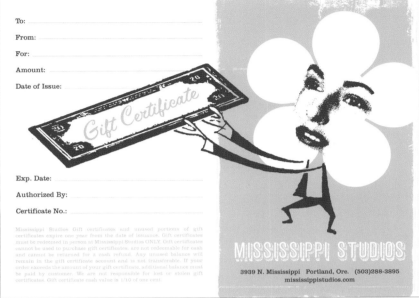

**DOTZERO DESIGN_** PORTLAND, OR, UNITED STATES
**CREATIVE TEAM:** Karen Wippich, Jon Wippich
**CLIENT:** Mississippi Studios

**ELEMENTS_** NEW HAVEN, CT, UNITED STATES
**CREATIVE TEAM:** Amy Graver, Rebekka Kuhn, Kerry Ober
**CLIENT:** Self-promotion

201

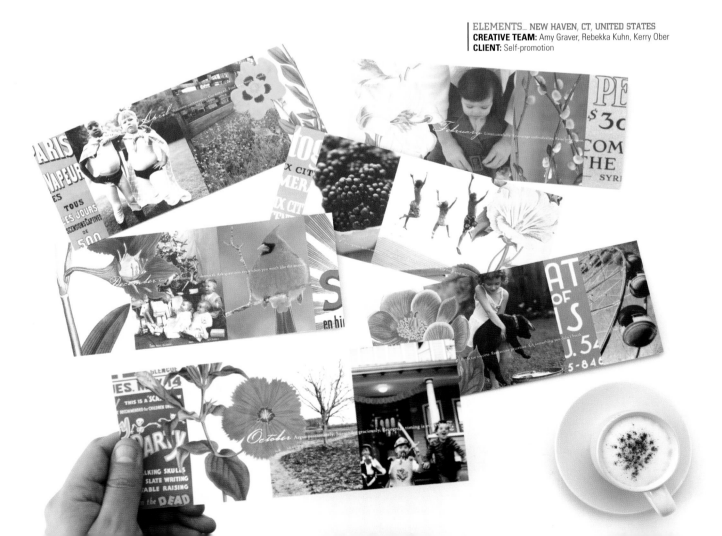

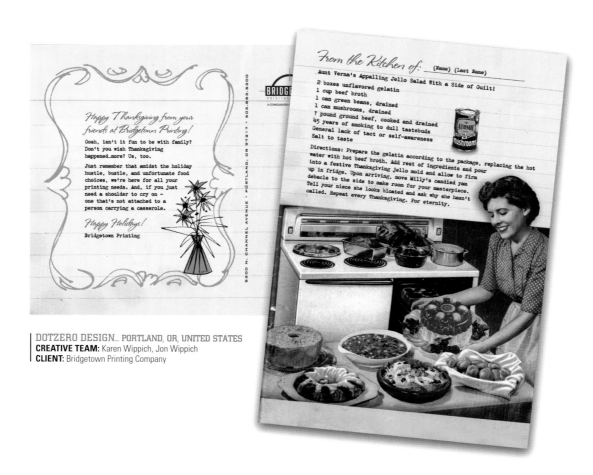

Happy Thanksgiving from your
friends at Bridgetown Printing!

Gosh, isn't it fun to be with family?
Don't you wish Thanksgiving
happened more? Us, too.

Just remember that amidst the holiday
hustle, bustle, and unfortunate food
choices, we're here for all your
printing needs. And, if you just
need a shoulder to cry on –
one that's not attached to a
person carrying a casserole.

Happy Holidays!
Bridgetown Printing

5300 N. CHANNEL AVENUE · PORTLAND, OR 97217 · 503-863-3300

*From the Kitchen of:* ___ (Name) (Last Name)

Aunt Verna's Appalling Jello Salad With a Side of Guilt!

2 boxes unflavored gelatin
1 cup beef broth
1 can green beans, drained
1 can mushrooms, drained
1 pound ground beef, cooked and drained
45 years of smoking to dull tastebuds
General lack of tact or self-awareness
Salt to taste

Directions: Prepare the gelatin according to the package, replacing the hot
water with hot beef broth. Add rest of ingredients and pour
into a festive Thanksgiving jello mold and allow to firm
up in fridge. Upon arriving, move Milly's candied yam
debacle to the side to make room for your masterpiece.
Tell your niece she looks bloated and ask why she hasn't
called. Repeat every Thanksgiving. For eternity.

**DOTZERO DESIGN_ PORTLAND, OR, UNITED STATES**
**CREATIVE TEAM:** Karen Wippich, Jon Wippich
**CLIENT:** Bridgetown Printing Company

202

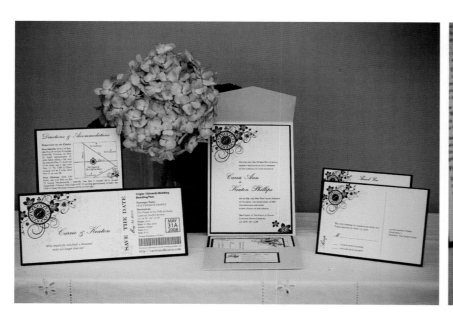

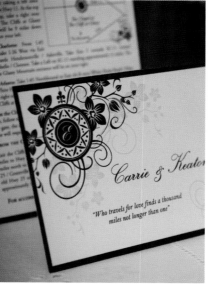

**P & J DESIGNS_ ATLANTA, GA, UNITED STATES**
**CREATIVE TEAM:** Pauline Pellicer
**CLIENT:** Carrie Edwards

**CREATIVE SUITCASE** AUSTIN, TX, UNITED STATES
**CREATIVE TEAM:** Rachel Clemens, Jennifer Wright
**CLIENT:** The University of Texas School of Law

203

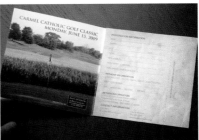

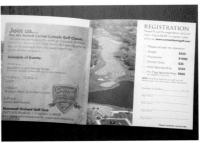

**TEN26 DESIGN GROUP, INC.** CRYSTAL LAKE, IL, UNITED STATES
**CREATIVE TEAM:** Tony Demakis
**CLIENT:** Carmel Catholic High School

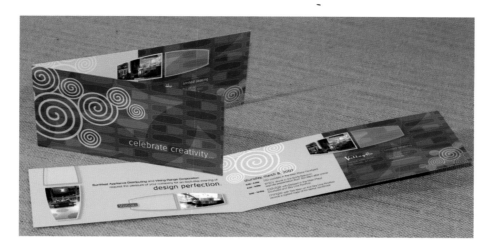

RIPE CREATIVE_ PHOENIX, AZ, UNITED STATES
**CREATIVE TEAM:** Susannah Fields, Mark Anthony Munoz
**CLIENT:** SunWest Appliance Distributing

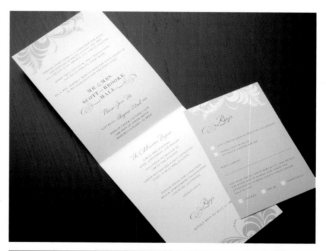

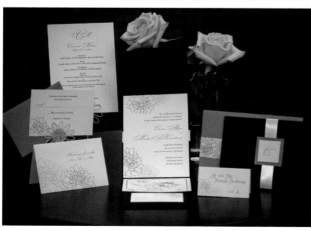

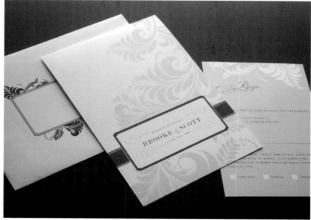

P & J DESIGNS_ ATLANTA, GA, UNITED STATES
**CREATIVE TEAM:** Pauline Pellicer
**CLIENT:** Carrie Sandola

TEN26 DESIGN GROUP, INC._ CRYSTAL LAKE, IL, UNITED STATES
**CREATIVE TEAM:** Kelly Demakis
**CLIENT:** Brooke and Scott

**ELEMENTS_** NEW HAVEN, CT, UNITED STATES
**CREATIVE TEAM:** Amy Graver
| **CLIENT:** Self-promotion

**FOUNDRY_** CALGARY, AB, CANADA
**CREATIVE TEAM:** Zahra Al-Harazi, Louise Uhrenholt
| **CLIENT:** Banff Park Lodge

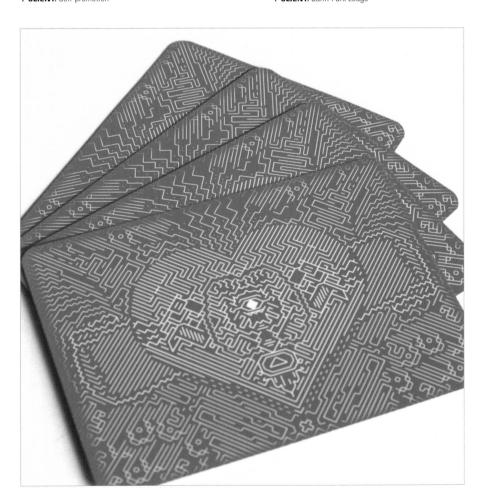

**SUBCOMMUNICATION_** MONTREAL, QC, CANADA
**CREATIVE TEAM:** Sebastien Theraulaz
| **CLIENT:** Subtitude.com

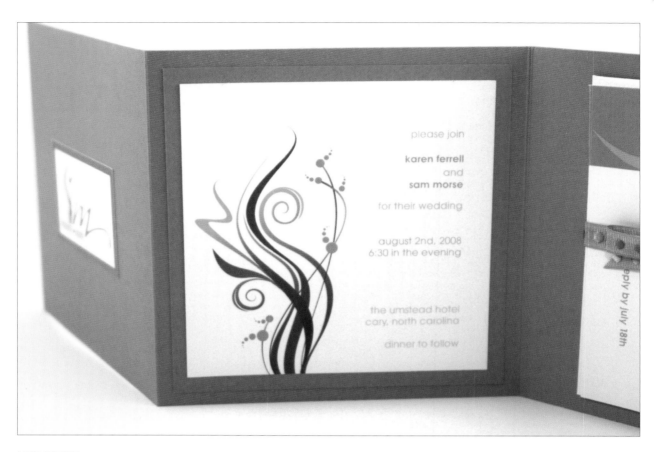

GHL DESIGN_ RALEIGH, NC, UNITED STATES
**CREATIVE TEAM:** Gray Heffner
**CLIENT:** Karen and Sam Morse

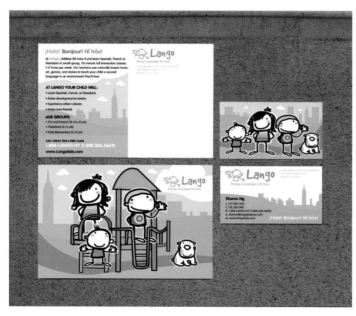

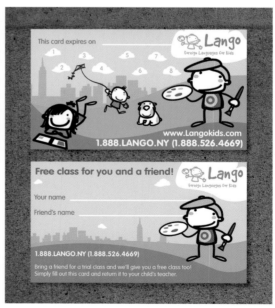

JUST NIKKI_ BROOKLYN, NY, UNITED STATES
**CREATIVE TEAM:** Nikki Kurt
**CLIENT:** Sharon Ng

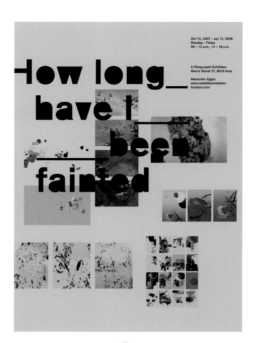

**DEFTELING DESIGN** PORTLAND, OR, UNITED STATES
**CREATIVE TEAM:** Alex Wijnen
**CLIENT:** Cecily Ink

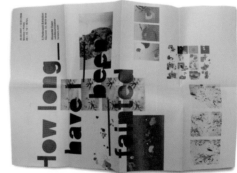

207

**CYAN CONCEPT INC.** SAGUENAY, QC, CANADA
**CREATIVE TEAM:** Valérie Laporte
**CLIENT:** Allard hervieu Communications for Sherbrooke University

**ALEXANDER EGGER** VIENNA, UNITED STATES
**CREATIVE TEAM:** Alexander Egger
**CLIENT:** Pilotprojekt

# Catalogs

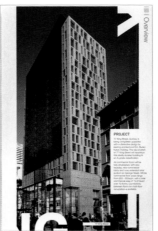

**SPATCHURST_ BROADWAY, AUSTRALIA**
**CREATIVE TEAM:** Steven Joseph, Nicky Hardcastle, Sarah Magro
**CLIENT:** King Vest

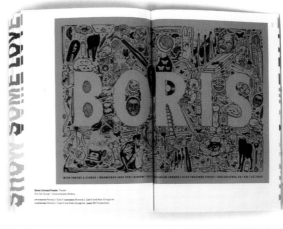

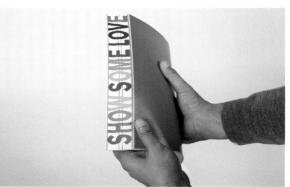

211

**GDLOFT_** PHILADELPHIA, PA, UNITED STATES
**CREATIVE TEAM:** Allan Espiritu, Christian Mortlock, Matthew Benarik, Mike Park
**CLIENT:** AIGA Philadelphia

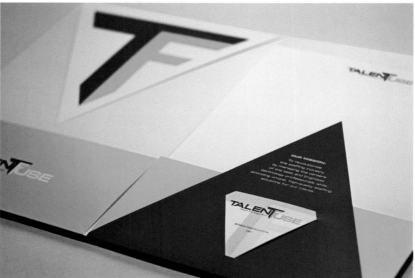

**JACOB TYLER_** SAN DIEGO, CA, UNITED STATES
**CREATIVE TEAM:** Les Kollegian
**CLIENT:** TalentFuse

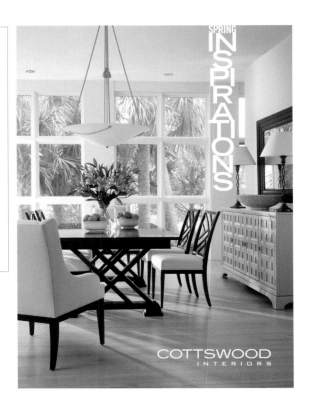

**SPLASH:DESIGN_** KELOWNA, BC, CANADA
**CREATIVE TEAM**: Phred Martin
**CLIENT**: Cottswood Interiors

212

**344 DESIGN, LLC_** PASADENA, CA, UNITED STATES
**CREATIVE TEAM**: Stefan G. Bucher
**CLIENT**: Capitol Records

**NORA BROWN DESIGN_** BROOKLINE, MA, UNITED STATES
**CREATIVE TEAM**: Nora Brown, Sally Brown
**CLIENT**: Roll Over Rover Threads, Inc.

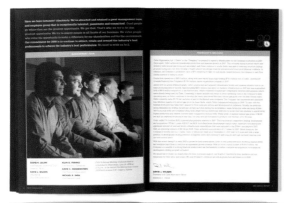

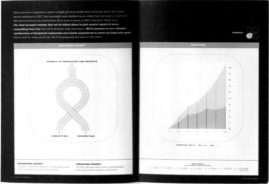

We chose a four-leaf clover as our mark. It's a well-known symbol of good luck and just an all-round interesting shape. And while we've always delivered consistently superior results, strong investment returns, and good fortune to our shareholders, **luck has had very little to do with it.**

**2007 ANNUAL REPORT**

Celtic ☘
EXPLORATION LTD.

213

How do you prosper in a declining market? By having the **financial clout** to carry you through the rough patches. By collecting **quality assets** that will continue to generate cash flow. By **strategic thinking** that never wavers from the end goal. By **amassing a team** that is comprised of thinkers, visionaries, builders of wealth.

By having a four-leaf clover in your back pocket.
*Not that luck has anything to do with our ability to deliver continued value to our shareholders. But we're covering all our bases.*

Celtic ☘
EXPLORATION LTD.

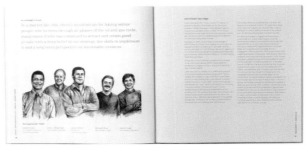

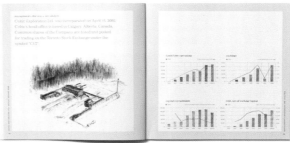

**FOUNDRY_** CALGARY, AB, CANADA
**CREATIVE TEAM:** Zahra Al-Harazi, Kylie Henry, Kieran Brett
**CLIENT:** Celtic Exploration

**FOUNDRY_** CALGARY, AB, CANADA
**CREATIVE TEAM**: Zahra Al-Harazi, Kylie Henry, Kieran Brett, Louise Uhrenholt
**CLIENT**: ProspEx

214

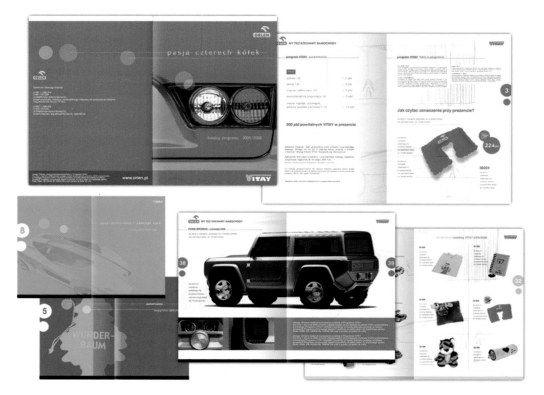

**DSN_** WARSAW, POLAND
**CREATIVE TEAM**: Michal Piotrowski
**CLIENT**: PKN ORLEN

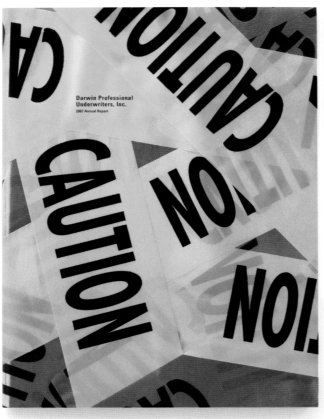

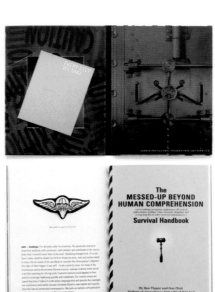

**BERTZ DESIGN GROUP_** MIDDLETOWN, CT, UNITED STATES
**CREATIVE TEAM:** Bertz Design, Tim Curry
**CLIENT:** Darwin Professional Underwriters

215

**DSN_** WARSAW, POLAND
**CREATIVE TEAM:** Michal Piotrowsk
**CLIENT:** Carrefour Markets

**FOUNDRY_** CALGARY, AB, CANADA
**CREATIVE TEAM:** Zahra Al-Harazi, Kylie Henry
**CLIENT:** Golder Associates

## An In-Depth Look

## Innovative Beverage Concepts

Despite the empire built by Starbucks, there are still plenty of thriving non-corporate cafes—even in the coffee capital of Seattle, Washington. In the spirit of caffeinated independence, Irvine, Calfornia-based Innovative Beverage Concepts (IBC) approached Seattle designer Mary Chin Hutchison of Mary Hutchison Design LLC to devise a catalog as unique as its products.

In order to ensure that the catalog wouldn't get lost in the shuffle of so many other brochures targeted at independent baristas, Hutchison took a different approach. "There's a subculture," says Hutchison. "A lot of baristas like to think of themselves as being in the know about what the latest products are, and they want to pick most organic and fair trade things." To best illustrate the understanding of this core clientele, Hutchison devised a new kind of catalog that would take readers through a day in the life of a barista. "The idea of shooting each product just didn't seem that appealing, because all [the client's] competitors did the same thing: the same shot of a frappe drink. So we definitely wanted to add a lifestyle aspect to the presentation."

In thirteen years, IBC had built a steadily growing catalog of products, but, says Hutchison, up until recently had no logical way to present the entire product line and its ability to fulfill the needs of independent coffee shop owners throughout the country and abroad. However, Hutchison found it somewhat difficult to find just the right shop to establish this attitude visually. "The only real problem was finding an independent who wanted to be in a catalog, because they didn't want to be seen as a sellout," she says of the eventual finalists, which ranged from "a very granola, Earth mom feeling place" deemed too rustic to a shop that gave off too much of an urban vibe with its "too modern and concrete" décor. Hutchison and her client found the ideal hybrid in Seattle's hip Capitol Hill neighborhood.

"I kind of suggested it," Hutchison says. "This [shop] had records around, very non-Starbucks." The records fit the client's desire for "a slight rock and roll feel," and the photo shoot took place in a real-life situation: real baristas using real IBC products in a real morning rush. ("We didn't want to disrupt the shop for the entire day," Hutchison explains.) The resulting layout shows the baristas using the client's products to make drinks for its customers—all while maintaining a sense of approachable authenticity.

"The client wanted to show off the attitude of the company and its ability to source the best ingredients while working with small independents," Hutchison says.

## barista pro line

Now Mocafe has added real bits of candy to our line of award winning blended mocha frappés to create a new addictive flavor and texture sensation in the blended beverage category.

TASTE AND COMPARE THE DIFFERENCE
REAL INGREDIENTS MAKE

1-888-662-2334

**FOOD SERVICE:**
PROFESSIONAL LINE LATTE MIXES
4 – 3 LB BAGS

| | | | |
|---|---|---|---|
| Java Chip | 794176 | White Chocolate | 794281 |
| Maui Mocha | 794164 | Peanut Butter Mocha | 794790 |
| Toffee Mocha | 794765 | No Sugar Added | |
| No Sugar Added Mocha | 794281 | Vanilla Latte | 794686 |

**PROMOTIONAL ITEMS:**
POSTERS

16 I LEADING COFFEE HOUSE BRANDS SINCE 1996

CALL AND ORDER TODAY OR VISIT US AT WWW.MOCAFE.NET I 17

## precious divinity chai

Authentic, original, naturally intoxicating blend of fresh ginger, clove, cardamom, cinnamon, wild flower honey and estate grown Darjeeling Black tea.

1-888-662-2334

### blended fruit cremes

1-888-662-2334

**RETAIL:**
CANISTERS
12/12 OZ.

| | |
|---|---|
| Spiced | 794185 |
| Vanilla | 794190 |
| Mango | 794195 |
| Spiced Decaf | 794116 |

INDIVIDUAL SERVING PACKETS
100/1.25 OZ.

| | |
|---|---|
| Spiced | 794170 |
| Mango | 794171 |
| Vanilla | 794172 |

**FOOD SERVICE:**
6 – 3 LB BAGS

| | |
|---|---|
| Spiced | 794191 |
| Vanilla | 794186 |
| Mango | 794196 |
| Decaf | 794624 |

**PROMOTIONAL ITEMS:**
POSTER
TABLE TENT CARD

8 I LEADING COFFEE HOUSE BRANDS SINCE 1996

CALL AND ORDER TODAY OR VISIT US AT WWW.MOCAFE.NET I 9

**MARY HUTCHISON DESIGN LLC_ SEATTLE, WA, UNITED STATES**
**CREATIVE TEAM**: Mary Chin Hutchison
**CLIENT**: Innovative Beverage Concepts

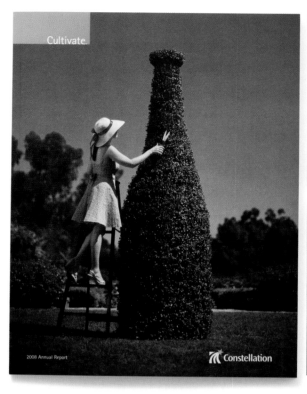

**BERTZ DESIGN GROUP_** MIDDLETOWN, CT, UNITED STATES
**CREATIVE TEAM:** Bertz Design, John Myers, Mike Martin
**CLIENT:** Constellation Brands

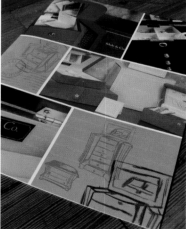

**THE UXB_** BEVERLY HILLS, CA, UNITED STATES
**CREATIVE TEAM:** NancyJane Goldston, Glenn Sakamoto,
Ashlee McNulty, Seda Berber
**CLIENT:** EnvironmentalLights.com

**MICHELLE ROBERTS DESIGN_** BARNEVELD, NY, UNITED STATES
**CREATIVE TEAM:** Michelle Roberts
**CLIENT:** Mele & Co.

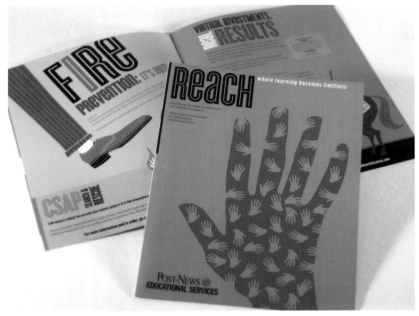

**JM DESIGNS_** LOVELAND, CO, UNITED STATES
**CREATIVE TEAM**: Mark Holly, John Metcalf
**CLIENT**: The Denver Newspaper Agency

219

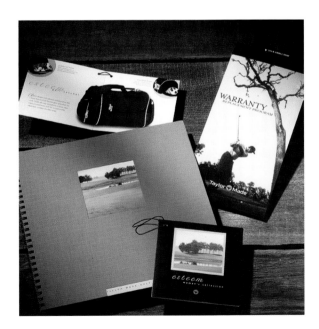

**LCDA_** SAN DIEGO, CA, UNITED STATES
**CREATIVE TEAM**: Laura Coe Wright, Leanne Lally
**CLIENT**: Taylor Made Golf

**BRADBURY BRANDING & DESIGN_** REGINA, SK, CANADA
**CREATIVE TEAM**: Catharine Bradbury
**CLIENT**: Society of Graphic Designers of Canada

**BÜRO NORTH_** MELBOURNE, AUSTRALIA
**CREATIVE TEAM**: Soren Luckins, Skye Luckins, Sarah Napier, David Williamson
**CLIENT**: Studio Project

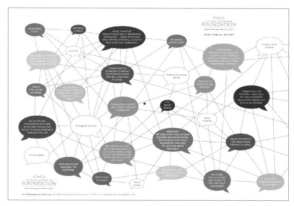

**SPLASH:DESIGN_**
KELOWNA, BC, CANADA
**CREATIVE TEAM**: Phred Martin
**CLIENT**: Central Okanagan Foundation

**ESSENCE DESIGN LIMITED_**
SUTTON COLDFIELD, WEST MIDLANDS, UNITED KINGDOM
**CREATIVE TEAM**: Regine Wilber, Rachel Khor, Claire Nicholls
**CLIENT**: Goldis Tiles

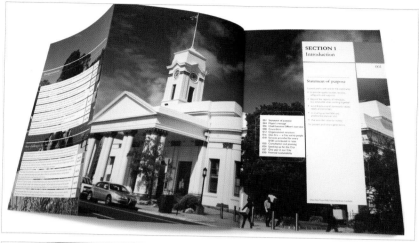

221

**HOUSEMOUSE_ MELBOURNE, AUSTRALIA**
**CREATIVE TEAM**: Miguel Valenzuela, Andrea Taylor
**CLIENT**: Glen Eira City Council

**DJBDESIGN_ ALLENTOWN, PA, UNITED STATES**
**CREATIVE TEAM**: Dean Ballas, Jared Strouse
**CLIENT**: get READY girls!

**DJBDESIGN_ ALLENTOWN, PA, UNITED STATES**
**CREATIVE TEAM**: Dean Ballas
**CLIENT**: game day girls!

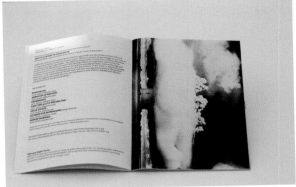

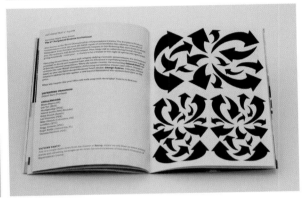

**IAN LYNAM CREATIVE DIRECTION & GRAPHIC_ TOKYO, JAPAN**
**CREATIVE TEAM:** Ian Lynam
**CLIENT:** Peripheral Produce

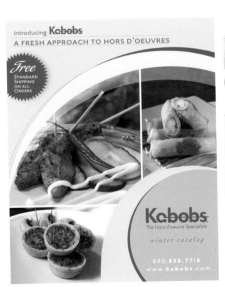

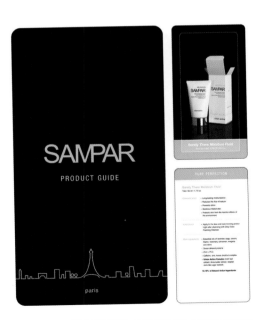

**YELLOBEE STUDIO_ ATLANTA, GA, UNITED STATES**
**CREATIVE TEAM:** Alison Scheel
**CLIENT:** Menu Inspirations

**CAROL MCLEOD DESIGN_ MASHPEE, MA, UNITED STATES**
**CREATIVE TEAM:** Carol McLeod, Brian Charron
**CLIENT:** SAMPAR USA LLC

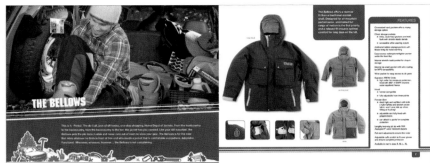

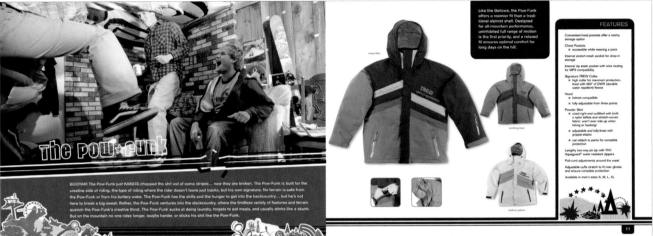

BLUE MARBLE CREATIVE_ WHITE SALMON, WA, UNITED STATES
**CREATIVE TEAM**: Lisa Mullis, Christine Fisher
**CLIENT**: TREW

ENZO CREATIVE_ SUMMIT, NJ, UNITED STATES
**CREATIVE TEAM**: Lou Leonardis, Jen Gero
**CLIENT**: Luke Simon

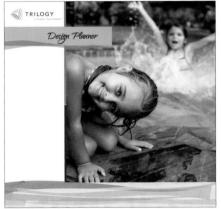

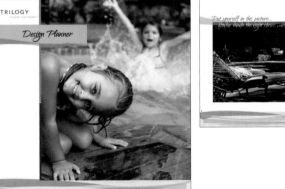

TOMATO GRAPHICS_ AMARILLO, TX, UNITED STATES
**CREATIVE TEAM**: Rock Langston
**CLIENT**: Trilogy Pools

SUBCOMMUNICATION_ MONTREAL, QC, CANADA
**CREATIVE TEAM**: Sebastien Theraulaz, Valerie Desrochers
**CLIENT**: Regroupement Québécois de la danse

224

FOUNDRY_ CALGARY, AB, CANADA
**CREATIVE TEAM**: Zahra Al-Harazi, Louise Uhrenholt
**CLIENT**: Savanna Energy Services Corp

CLOCKWORK STUDIOS_ SAN ANTONIO, TX, UNITED STATES
**CREATIVE TEAM**: Terri Gaines, Steve Gaines, Shawn Meek, Laura Trial
**CLIENT**: The Market Foundation

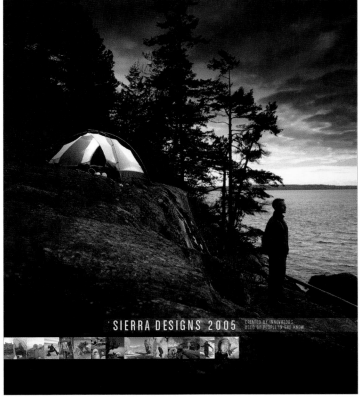

225

MOXIE SOZO _ BOULDER, CO, UNITED STATES
**CREATIVE TEAM**: Leif Steiner, Teri Gosse
**CLIENT**: Sierra Designs

MOXIE SOZO _ BOULDER, CO, UNITED STATES
**CREATIVE TEAM**: Leif Steiner, Teri Gosse, Charles Bloom, Nate Dyer
**CLIENT**: SmartWool

MOXIE SOZO _ BOULDER, CO, UNITED STATES
**CREATIVE TEAM**: Leif Steiner, Laura Kottlowski,
Teri Gosse, Anh Phan
**CLIENT**: Sierra Designs

# Magazines

228

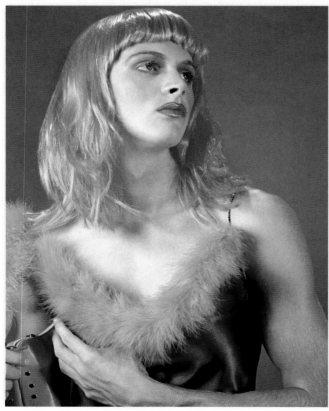

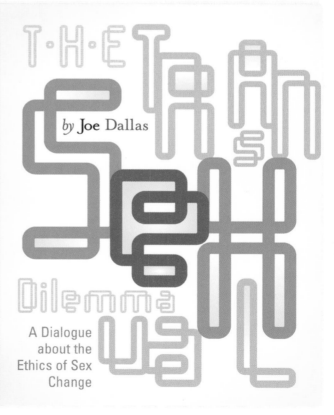

SAINT DWAYNE DESIGN_ CHARLOTTE, NC, UNITED STATES
**CREATIVE TEAM:** Dwayne Cogdill, Scala / Art Resource, Paul Hartog
**CLIENT:** Christian Research Journal

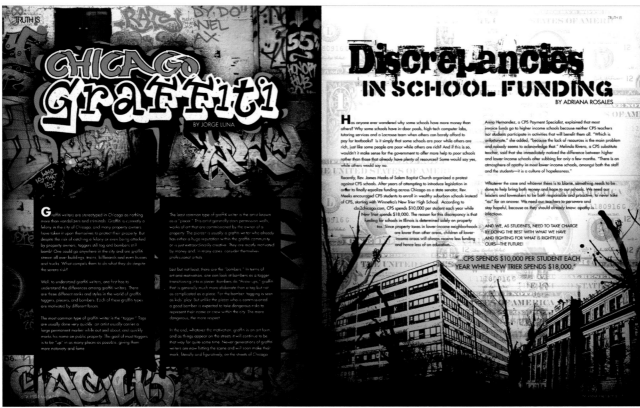

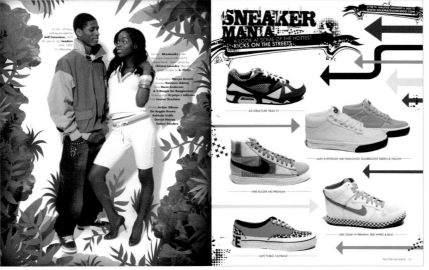

ANGEL D'AMICO ILLUSTRATION AND DESIGN_ CHICAGO, IL, UNITED STATES
**CREATIVE TEAM:** Angel D'Amico, Mireya Acierto
**CLIENT:** Truestar Magazine

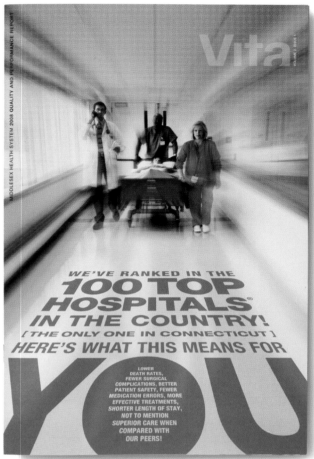

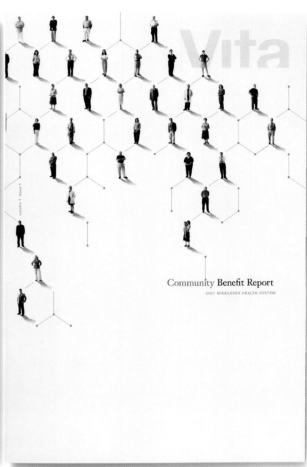

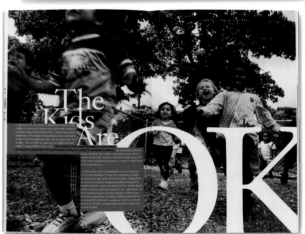

BERTZ DESIGN GROUP_ MIDDLETOWN, CT, UNITED STATES
**CREATIVE TEAM**: Paul Horton, Peg Arico
**CLIENT**: Middlesex Hospital

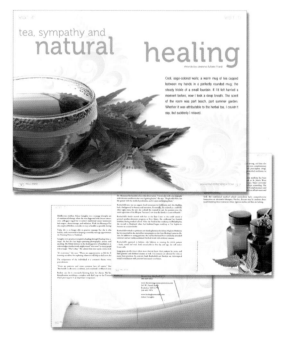

KALICO DESIGN_ FREDERICK, MD, UNITED STATES
**CREATIVE TEAM**: Kimberly Dow, Donna Elbert, Melissa Howes-Vitek
**CLIENT**: Find It Frederick magazine

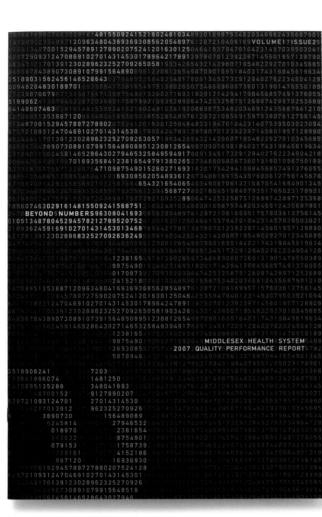

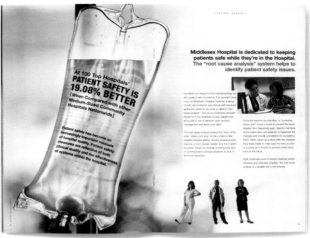

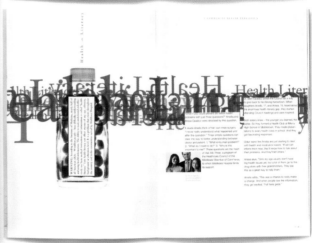

BERTZ DESIGN GROUP_ MIDDLETOWN, CT, UNITED STATES
**CREATIVE TEAM:** Paul Horton, Peg Arico
**CLIENT:** Middlesex Hospital

EMSPACE GROUP_ OMAHA, NE, UNITED STATES
**CREATIVE TEAM:** Heidi Mihelich, Juliane Bautista, Gail Snodgrass
**CLIENT:** Joslyn Art Museum

PAUL SNOWDEN_ BERLIN, GERMANY
**CREATIVE TEAM:** Paul Snowden, Elisabeth Mcgrath
**CLIENT:** BANG BANG BERLIN

CALAGRAPHIC DESIGN_ ELKINS PARK, PA, UNITED STATES
**CREATIVE TEAM:** Ronald J. Cala II, Genevieve Astrelli, Curtis Clarkson
**CLIENT:** CMYK Magazine

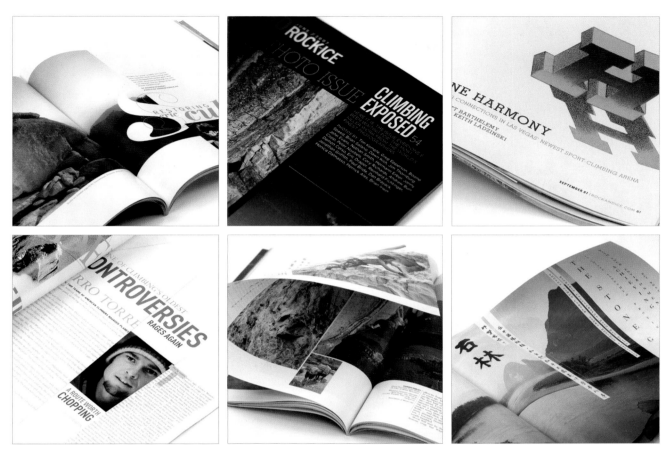

MOXIE SOZO_ BOULDER, CO, UNITED STATES
**CREATIVE TEAM**: Leif Steiner, Sarah Layland, Diana MacLean, Natalie Little
**CLIENT**: Rock and Ice Magazine

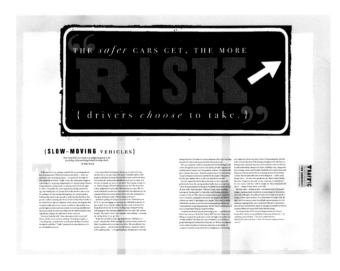

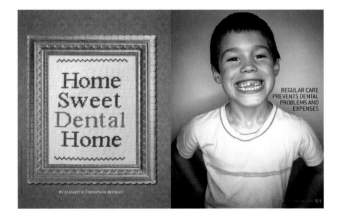

TEAM US DESIGN_ PHILADELPHIA, PA, UNITED STATES
**CREATIVE TEAM**: Justin Renninger, Alice Drueding
**CLIENT**: Re:Lit Newsletter

ROY CREATIVE_ ROCKVILLE, MD, UNITED STATES
**CREATIVE TEAM**: Nancy Mogel Roy
**CLIENT**: The Magazine Group - National Hemophilia Foundation, HemAware magazine

 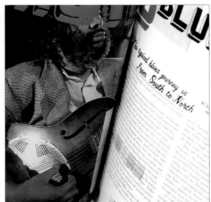 

 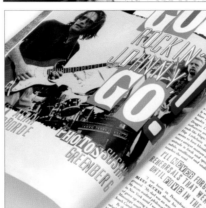 

234

**MOXIE SOZO_** BOULDER, CO, UNITED STATES
**CREATIVE TEAM**: Leif Steiner
**CLIENT**: Blues Access Magazine

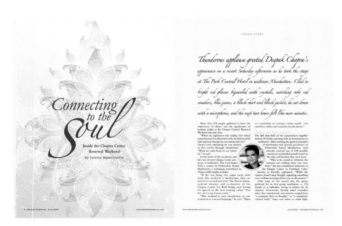

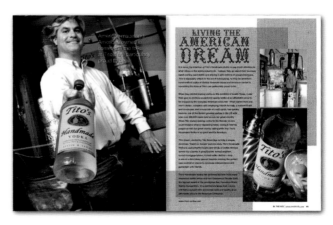

**ANA PAULA RODRIGUES DESIGN_** NEWARK, NJ, UNITED STATES
**CREATIVE TEAM**: Ana Paula Rodrigues
**CLIENT**: Elevated Existence Magazine

**SELLIER DESIGN_** MARIETTA, GA, UNITED STATES
**CREATIVE TEAM**: Julie Cofer, Mike Raven
**CLIENT**: iMi Agency

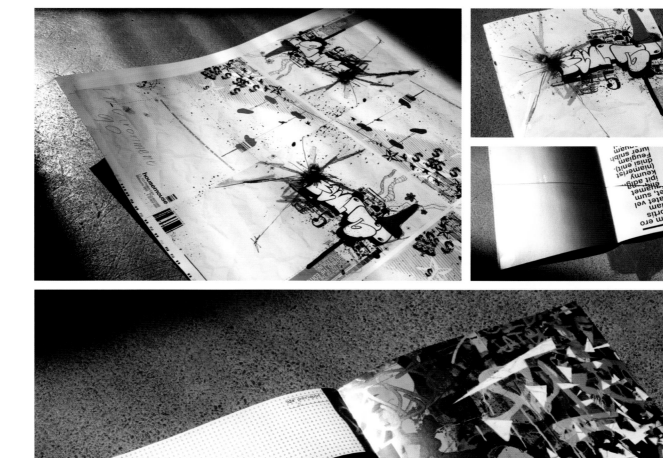

HOUSEMOUSE_ MELBOURNE, AUSTRALIA
**CREATIVE TEAM:** Miguel Valenzuela, Arron Curran
**CLIENT:** housemouse

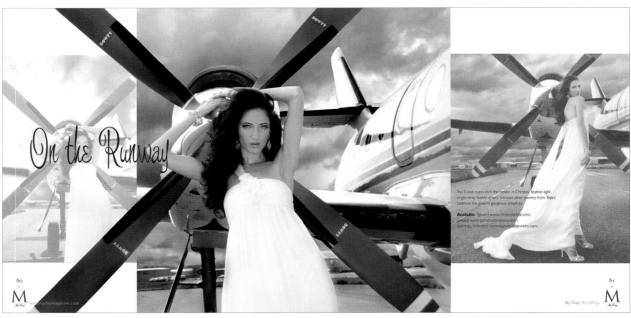

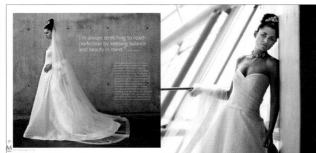

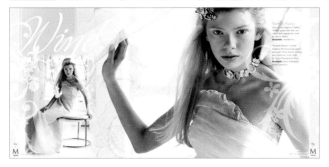

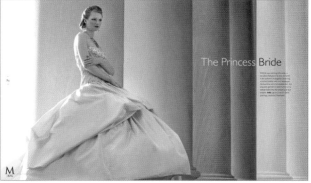

236

COURTNEY & CO DESIGN_ FOREST HILL, MD, UNITED STATES
**CREATIVE TEAM**: Cynthia Courtney, Jennifer Hughes, Lisa Hetrick, Roy Cox
**CLIENT**: My Day Magazine

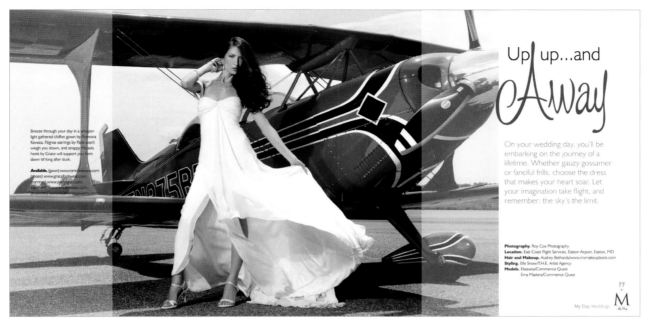

**COURTNEY & CO DESIGN_** FOREST HILL, MD, UNITED STATES
**CREATIVE TEAM**: Cynthia Courtney, Lisa Hetrick, Roy Cox
**CLIENT**: My Day Magazine

**237**

artistic flair

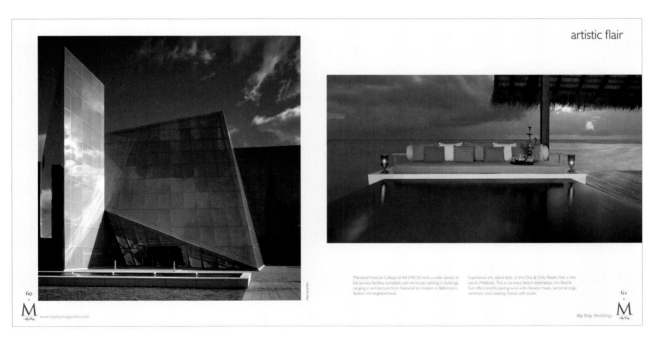

**COURTNEY & CO DESIGN_** FOREST HILL, MD, UNITED STATES
**CREATIVE TEAM**: Cynthia Courtney, Alain Jaramillo
**CLIENT**: My Day Magazine

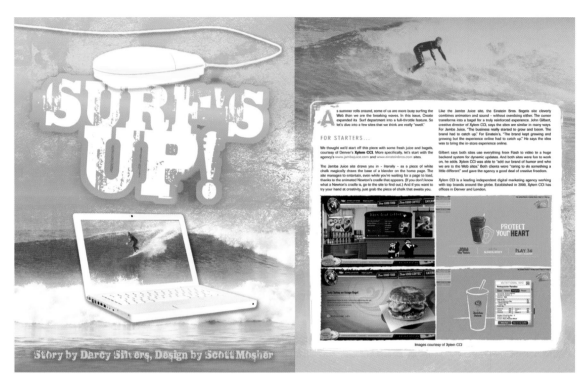

AMBIENT_ MILLER PLACE, NY, UNITED STATES
**CREATIVE TEAM**: Scott Mosher
**CLIENT:** Create Magazine

MC2 COMMUNICATIONS_ CHICAGO, IL, UNITED STATES
**CREATIVE TEAM:** Michelle Crisanti, Kathleen Furore, Brenda Russel
**CLIENT:** el Restaurante Mexicano

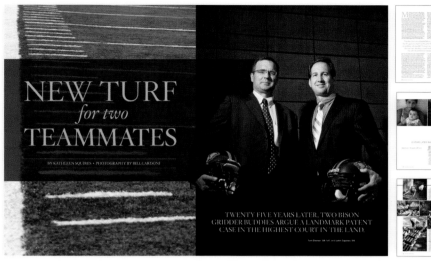

**BUCKNELL UNIVERSITY_ LEWISBURG, PA, UNITED STATES**
**CREATIVE TEAM:** Josie Fertig, Bill Cardoni, Gigi Marino
**CLIENT:** Bucknell University

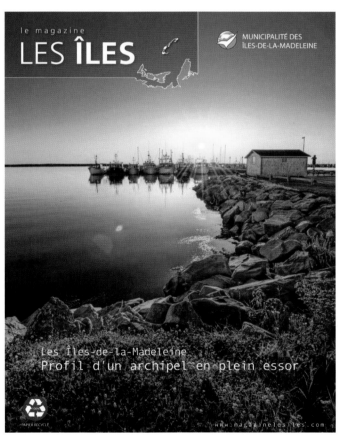

**GEMINI 3D_ ÎLES DE LA MADELEINE, QC, CANADA**
**CREATIVE TEAM:** Daniel Bouffard, Dany Bouffard, Nancy Thorne
**CLIENT:** Municipalité des Îles-de-la-Madelein

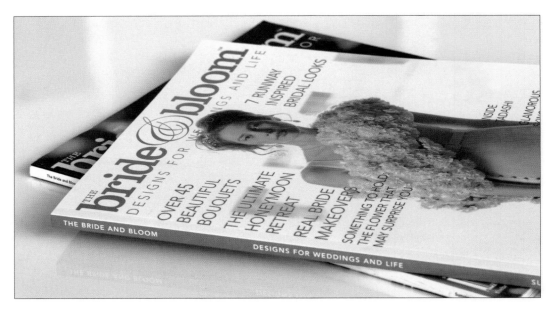

IE DESIGN + COMMUNICATIONS_ HERMOSA BEACH, CA, UNITED STATES
**CREATIVE TEAM**: Marcie Carson, Jane Lee, Nicole Bednarz
**CLIENT:** Bride & Bloom Magazine

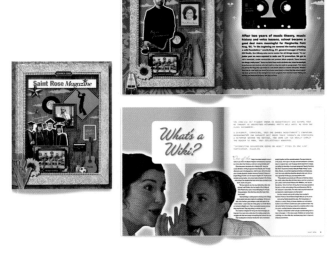

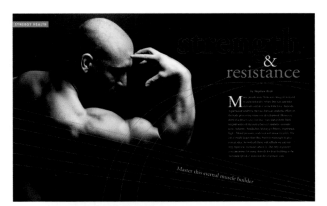

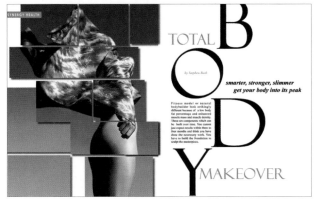

THE COLLEGE OF SAINT ROSE_ ALBANY, NY, UNITED STATES
**CREATIVE TEAM:** Mark Hamilton, Chris Parody, Lisa Haley Thomson, Jane Gottlieb
**CLIENT:** The College of Saint Rose

2ND FLOOR DESIGN_ PORTSMOUTH, VA, UNITED STATES
**CREATIVE TEAM**: Mary Hester
**CLIENT:** Synergy Health Magazine

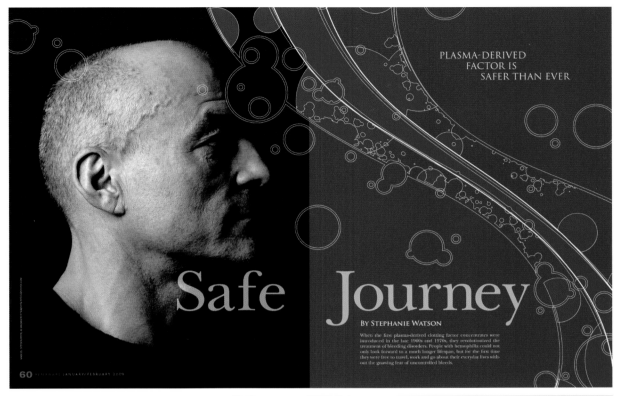

PLASMA-DERIVED
FACTOR IS
SAFER THAN EVER

# Safe Journey

BY STEPHANIE WATSON

When the first plasma-derived clotting factor concentrates were introduced in the late 1960s and 1970s, they revolutionized the treatment of bleeding disorders. People with hemophilia could not only look forward to a much longer lifespan, but for the first time they were free to travel, work and go about their everyday lives without the gnawing fear of uncontrolled bleeds.

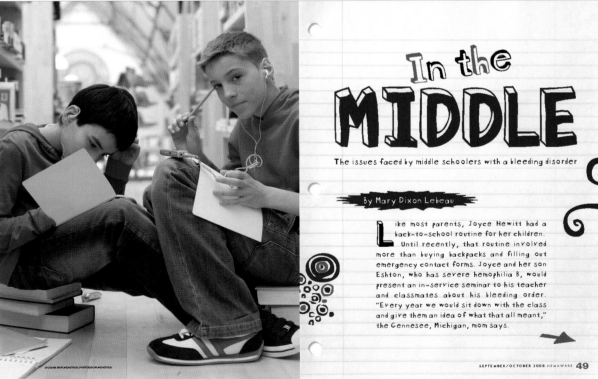

## In the MIDDLE

The issues faced by middle schoolers with a bleeding disorder

By Mary Dixon Lebeau

Like most parents, Joyce Hewitt had a back-to-school routine for her children. Until recently, that routine involved more than buying backpacks and filling out emergency contact forms. Joyce and her son Eshton, who has severe hemophilia B, would present an in-service seminar to his teacher and classmates about his bleeding order. "Every year we would sit down with the class and give them an idea of what that all meant," the Gennesee, Michigan, mom says.

ROY CREATIVE ROCKVILLE, MD, UNITED STATES
**CREATIVE TEAM**: Nancy Mogel Roy
**CLIENT**: The Magazine Group - National Hemophilia Foundation, HemAware magazine

241

242

STORM CORPORATE DESIGN_ AUCKLAND, NEW ZEALAND
**CREATIVE TEAM:** Rehan Saiyed
**CLIENT:** Lusanne Project Management

ROY CREATIVE_ ROCKVILLE, MD, UNITED STATES
**CREATIVE TEAM:** Nancy Mogel Roy
**CLIENT:** Wiesner Media - Bank Advisor Magazine

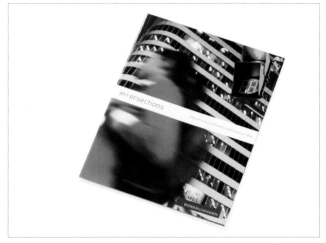

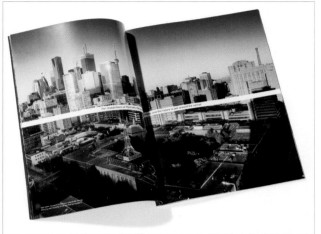

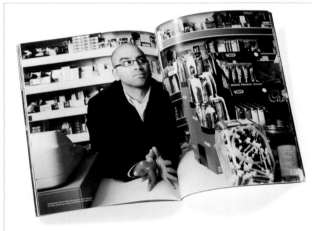

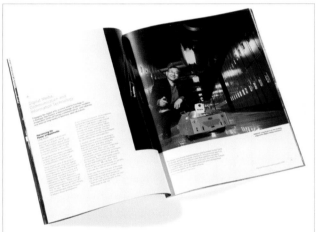

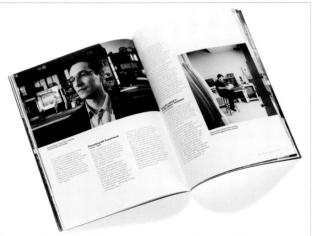

AEGIS_ **TORONTO, ON, CANADA**
**CREATIVE TEAM**: Greg Salmela, Nation Wong, Pat Morden, Bruce Piercey
**CLIENT**: Ryerson University

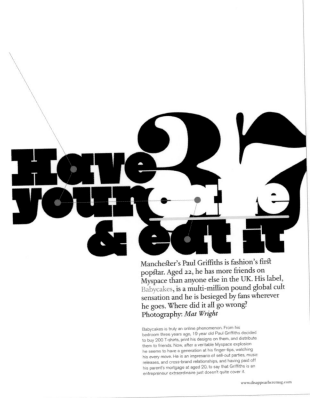

Manchester's Paul Griffiths is fashion's first popstar. Aged 22, he has more friends on Myspace than anyone else in the UK. His label, Babycakes, is a multi-million pound global cult sensation and he is besieged by fans wherever he goes. Where did it all go wrong?
Photography: *Mat Wright*

Babycakes is truly an online phenomenon. From his bedroom three years ago, 19 year old Paul Griffiths decided to buy 200 T-shirts, print his designs on them, and distribute them to friends. Now, after a veritable Myspace explosion he seems to have a generation at his finger-tips, watching his every move. He is an impresario of sell-out parties, music releases, and cross-brand relationships, and having paid off his parent's mortgage at aged 20, to say that Griffiths is an entrepreneur extraordinaire just doesn't quite cover it.

www.disappearheremag.com

## An In-Depth Look

## Disappear Here

Most every magazine out there is recognizable by certain unchanging hallmarks. With London quarterly Disappear Here, however, evolution is not only expected but encouraged.

"Essentially [the client] wanted a fanzine idea of a magazine," says Stuart Tolley, art director at Transmission in nearby Brighton. "They wanted something quite playful, quite lively… basically that was the brief." The magazine's publishers left it up to Tolley to come up with everything from the logo to the entire approach and reader perception; while the header remains unchanged, the cover art and inside type are ever in flux.

The free style magazine—designed freestyle exclusively by Tolley—is designed to appeal to men and women from sixteen to thirty and features coverage of culture, music and fashion, with a decidedly post-punk sensibility. "It's free, so we're not as restricted by other rules putting it on the newsstand," he explains. "We can get away with some things you can't do with more mainstream publications. We can be more playful with design and content." To help put together each issue in a short amount of time—the inaugural 112-page issue had a two-week deadline—Tolley enlists the help of article writers, photographers and artists. "A lot of it is written in-house," he says. "You work like crazy and commission a few things out. But as soon as we knew what we wanted, we started calling people. People were really keen to get involved with the project." Despite the breakneck production schedule, Tolley feels that is what gives Disappear Here a particular vibrancy. "It's what gives the magazine its energy," he says. "There's not a

strict working regime, and you have to persuade people to get involved and people get energetic about it." (An invitation to contributors reads, "We want your words, pictures, drawings, ideas, designs, presents, reviews, articles, stories, diaries and interviews. Let's make the best pop culture fanzine in the world.")

As both Tolley and Disappear Here's publishers have worked on music magazines before, there was a lot of mutual trust from the start. And while the magazine is free, it is not cheap. "The hardest part was at first attracting advertisers, and [the client] didn't want it to look trashy," Tolley says of the magazine's thick pages with full-color images that pop off the paper. Selling the client on a relatively expensive, decidedly non-homemade homage to the fanzine wasn't a problem, he says. "It was something they were looking to do anyway," he says. "They were already quite keen on it."

In the land of the Underground, audiences can find Disappear Here in such underground, non-mainstream venues as independent record shops, bars, clubs and university campuses in London's trendiest areas (and in a handful of New York places too). In getting the magazine to its ultimate destination, Tolley works as hard as the magazine's audience plays. "You end up working twenty-hour days no problem, and that can get quite painful," he says. "Within [the attitude of] 'I can do anything I want' is a structure. I do a lot of different work—book covers, exhibitions for myself, screenprinted typographic posters—and I have a good idea of what I want to do and how I want to play."

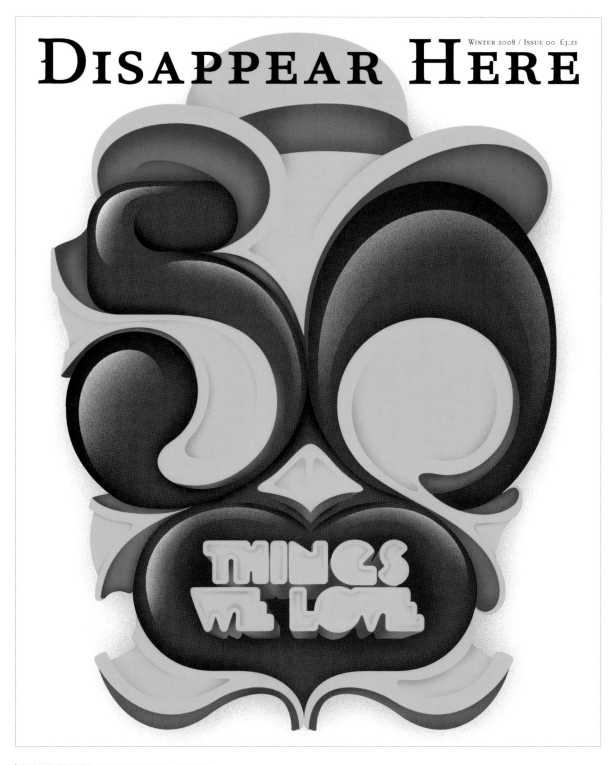

# DISAPPEAR HERE

WINTER 2008 / ISSUE 00 £3.21

TRANSMISSION_ BRIGHTON, UNITED KINGDOM
**CREATIVE TEAM**: Stuart Tolley, Alex Trochut, Mat Wright
**CLIENT:** Disappear Here

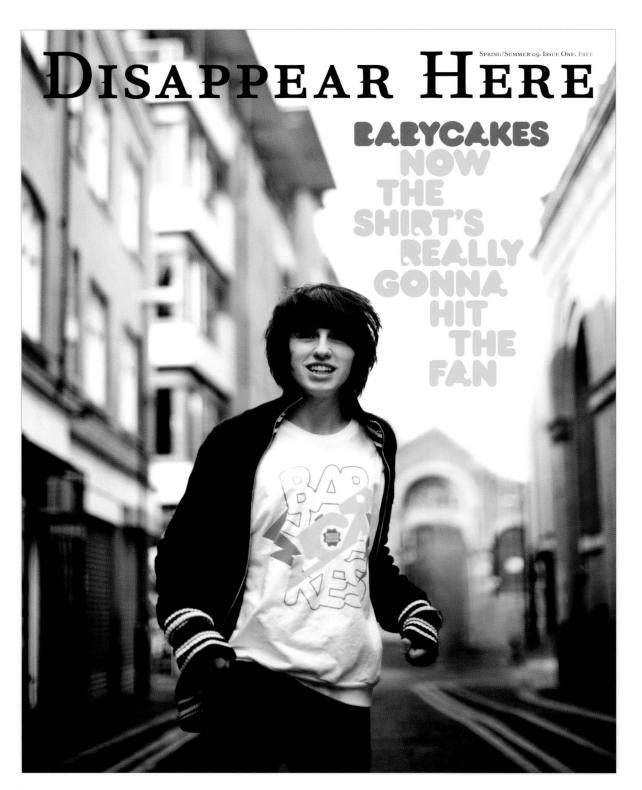

Spring/Summer 09. Issue One. Free

# Disappear Here

BABYCAKES NOW THE SHIRT'S REALLY GONNA HIT THE FAN

TRANSMISSION_ BRIGHTON, UNITED KINGDOM
**CREATIVE TEAM**: Stuart Tolley, Alex Trochut, Mat Wright
**CLIENT:** Disappear Here

## 41 Plastic Band

50s burlesque outfit Plastic Hearts do sexy like you've never seen it before. From smut-cake bake-offs to bath-time singalongs, they're every aspiring husband's wet dream. Club kids with a difference, they're putting the 'life' back into nightlife, spicing up discotheques everywhere with their risqué antics and bawdy tomfoolery.
Interview: *Dan Jude* Photography: *Ivan Jones*
Costumes made by Jenn, make up by Donna, styled by Leora

Plastic Hearts ooze sex appeal. A 1950s burlesque-inspired collective of tantalisingly beautiful damsels, they spend every minute of their free time gallivanting across the country with one sole mission: to inject an unhealthy dose of entertainment and titillation into the days and nights of clubbers, festival-goers and menuirsakers nationwide. Indulging is all manner of activities, from baking 'smut-

www.disappearfeenmag.com

## Floggy Style

Meet Cumbio, the Argentinean DIY superstar who has become the Queen of the most exciting new subculture on Earth, the Floggers.
Photography: *Emiliano Granado*

You can get famous for anything, from laying patios to prattling chairs. That's what the internet does. It promotes, influences, exaggerates and lies. It makes stars. And now millions of Argentine kids are drawing their cultural lines from a pouting teen star called Cumbio and her online photo collection.

'Flogging' began about two years back when the 17-year-old Cumbio – aka Agustina Vivero – began tapping up 'friends' on social networking site Fotolog who became obsessed with her look, strangers, Nuino t-shirts and a swept-up hairdo. A three hundred-strong posse meeting down the local mall became a thousand, a thousand became ten thousand... Now millions of like-minded teens pray at the church of Cumbio.

They look like emo kids but a new-rave night, but heavy electro is their thing, to which they match a curious dance couture falling somewhere between the Flaming Man and the Charleston. And Cumbio is their queen.

But don't think this lock are all light-hearing complete nerds huddled in sweaty bedrooms, with crushy socks and mouldy Coke cans – Floggers are social animals, meeting up anywhere and everywhere to chat, dance, get-off with each other and generally piss off the general public. And as these pictures by snapper Emiliano Granado show, they're having a pretty good time with it too.

Of course not everyone likes Cumbio and her loyal subjects. Go online and you'll find dozens of Facebook fatwas on the sensation. There is a genuine hatred for Floggers in their home nation, a feeling that exploded tragically when, it was alleged, a 16-year-old boy was beaten to death by a gang for wearing clothes that identify Floggers' in December last year.

Reports of fighting between gangs of Floggers and other kids aren't uncommon, and Cumbio hardly shies away from trouble with her touche online rantings. 'With time you realise this one that humiliates or despises a human being will sooner or later suffer the same humiliation or contempt multiplied to the square.' Hmm.

Still, there's nothing new about Flogging as such, and Flogging is just the latest in a long line of disenfranchised youths begging to be part of a crowd, to feel important and powerful. Is Queen Cumbio's idea a step too far? Probably not – after all, what's the difference between her loyal subjects and the millions of scenes we've managed to invent in the past – and we'd hardly have pop culture if it weren't for punks, skins, hippies and mods; groups of angry boys and girls who took pleasure in tunes, fairwents and testing the living shit out of each other.

Cumbio's hardly slowing down, either – she's followed the tried and tested method for modern celebrity by writing an autobiography in her teens, frankly entitled 'Yo, Cumbio' (I, Cumbio). Appearances at clubs, shops and the like attract thousands of her loyal subjects and it must surely be a matter of time before Britain is invaded by hoards of Cumbio copycats. And in these tribeless times, someone needs to stand up and show their stripes.
www.emilianogranado.com

www.disappearfeenmag.com

Worshipped by everyone from Kurt Cobain to Jack White, Billy Childish is a punk icon. Aloof, brilliant, a rebel to the end.
Interview: **Dan Jude**
Photography: **Ivan Jones**

## Meet 73 Billy Childish

Billy Childish is a true craftsman. Over the past 30 years, he has produced over 40 collections of poetry, recorded more than 110 full-length LPs, created over 2500 paintings and written two novels. Not bad for someone who left school at 16 as an undiagnosed dyslexic. After being refused entry to the local art school, he worked briefly as an apprentice stonemason in Chatham Dockyard, before purposefully smashing in his own hand with a 3lb club hammer, declaring that he'd never work again.

True to his word, Childish has dedicated his entire life to creative pursuit. After dating Tracey Emin in the 80s, he has now turned his back on mainstream culture, and lives a no-frills life in the leafy environs of Chatham, Kent. His house, where we meet, is a time warp to a different era. Sporting braces, a neckerchief and a handlebar moustache, 't is not just the decor that looks out of place in 2008. But then again here it no ordinary man, this is a man who attracts a cult following like no other. Meet Billy Childish. Artist, hero, God.

**DJ:** Jack White has said that he is a huge fan of yours, are you familiar with The White Stripes?
**BC:** Here are my comments on Jack White. Sterling chap, congratulations, I hope you have a nice life. That's for Jack. Kylie Minogue, sterling lady, very polite, hope she has a lovely life. Tracey Emin, sterling artist, lovely girl, hope she has a nice life.
**DJ:** Kurt Cobain?
**BC:** Bit too late on, maybe he's having a new one somewhere, and I hope he had a nice one.
**DJ:** That's all the celebrity stuff out of the way.
**BC:** And David Bowie, a piece of advice, you are not a rockstar, grow up. And I'm sure if that's upsetting, please like me and buy one of my paintings.
**DJ:** What advice do you have for the people that think you're a freak?
**BC:** I'm meant to be some sort of weird freak, because I'm sincere and intelligent and interested in the things I do and that is freakish, and that makes me somehow wildly eccentric. I've got some advice for you, don't wear a baseball cap and be interested in what you do, and people will think you're a complete freak. You might not dress exactly the same as the next person on the street and you might have your own taste in things.
**DJ:** Seriously, one more celebrity question. You never invited on to Celebrity Big Brother right?
**BC:** Yeah, hasn't I think it's my plot to be on a program like that and

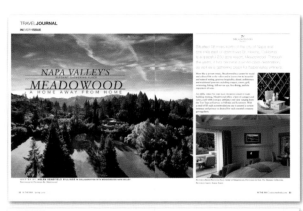
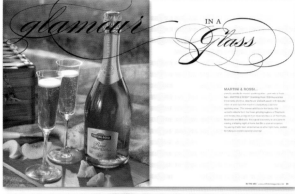
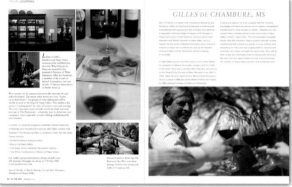

248

**SELLIER DESIGN_** MARIETTA, GA, UNITED STATES
**CREATIVE TEAM:** Julie Cofer, Mike Raven
**CLIENT:** iMi Agency

**MOXIE SOZO_** BOULDER, CO, UNITED STATES
**CREATIVE TEAM:** Leif Steiner, Teri Gosse, Nate Dyer
**CLIENT:** Running Times Magazine

**JASON HILL DESIGN_** PHOENIX, AZ, UNITED STATES
**CREATIVE TEAM:** Jason Hill, Andrew Urban
**CLIENT:** Java Magazine

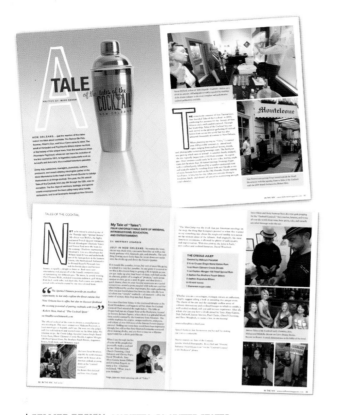

**SELLIER DESIGN_** MARIETTA, GA, UNITED STATES
**CREATIVE TEAM:** Julie Cofer, Mike Raven
**CLIENT:** iMi Agency

**CALAGRAPHIC DESIGN_** ELKINS PARK, PA, UNITED STATES
**CREATIVE TEAM:** Ronald J. Cala II, Genevieve Astrelli, Curtis Clarkson
**CLIENT:** CMYK Magazine

249

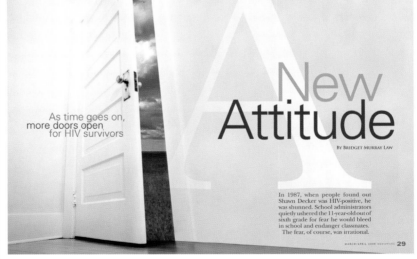

**ROY CREATIVE_** ROCKVILLE, MD, UNITED STATES
**CREATIVE TEAM:** Nancy Mogel Roy
**CLIENT:** The Magazine Group - National Hemophilia Foundation, HemAware magazine

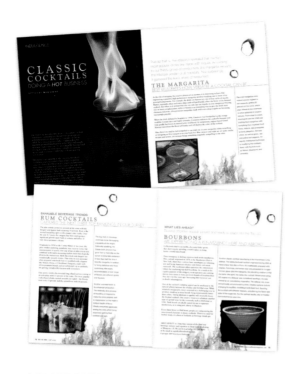

**SELLIER DESIGN_** MARIETTA, GA, UNITED STATES
**CREATIVE TEAM:** Julie Cofer, Mike Raven
**CLIENT:** iMi Agency

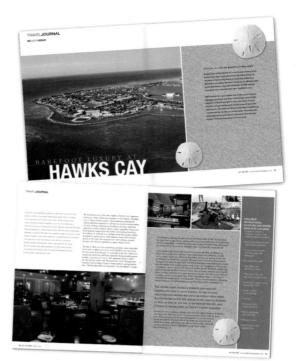

**SELLIER DESIGN_** MARIETTA, GA, UNITED STATES
**CREATIVE TEAM:** Julie Cofer, Mike Raven
**CLIENT:** iMi Agency

250

**IVY TECH COMMUNITY COLLEGE_** SELLERSBURG, IN, UNITED STATES
**CREATIVE TEAM:** Justin McClure, Justin Pellman, Matt Phillips, Melissa Richardson, Susan Morganti
**CLIENT:** Ivy Tech Southern Indiana

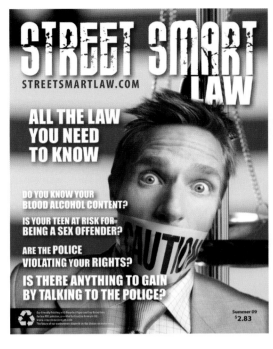

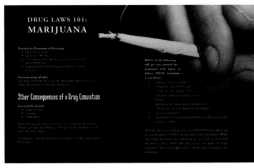

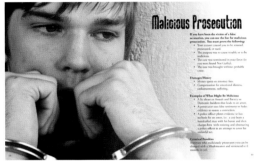

BUCKNELL UNIVERSITY_ LEWISBURG, PA, UNITED STATES
**CREATIVE TEAM:** Josie Fertig, Bill Cardoni, Gigi Marino
**CLIENT:** Bucknell University

251

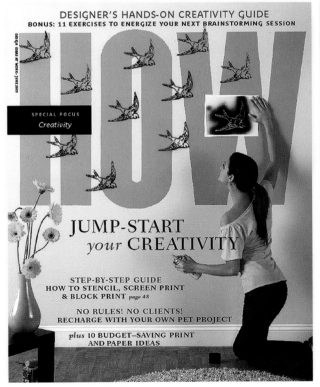

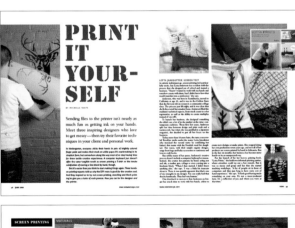

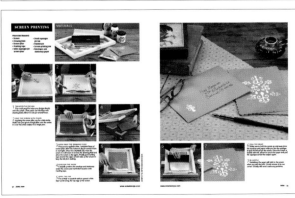

HOW MAGAZINE_ CINCINNATI, OH, UNITED STATES
**CREATIVE TEAM:** Bridgid McCarren
**CLIENT:** F+W Media, HOW magazine

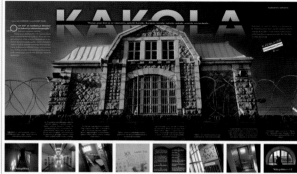

ADVERTISING AGENCY ZEELAND_ TURKU, FINLAND
**CREATIVE TEAM**: Ville Laihonen, Sari Lommerse, Paula Puikko, Anna Korpi-Kyyny
**CLIENT:** Turku Energia

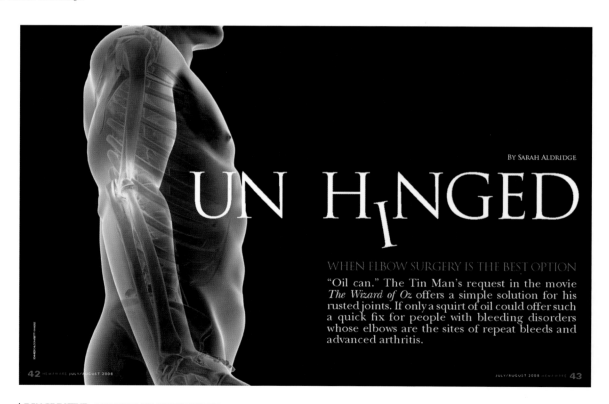

BY SARAH ALDRIDGE

# UN H₁NGED

WHEN ELBOW SURGERY IS THE BEST OPTION

"Oil can." The Tin Man's request in the movie *The Wizard of Oz* offers a simple solution for his rusted joints. If only a squirt of oil could offer such a quick fix for people with bleeding disorders whose elbows are the sites of repeat bleeds and advanced arthritis.

ROY CREATIVE_ ROCKVILLE, MD, UNITED STATES
**CREATIVE TEAM**: Nancy Mogel Roy
**CLIENT:** The Magazine Group - National Hemophilia Foundation, HemAware magazine

EYE DESIGN STUDIO_ CHARLOTTE, NC, UNITED STATES
**CREATIVE TEAM:** Chris Bradle, Jason Robinson, Gage Mitchell, Rhonda Sergeant
**CLIENT:** The Palisades

253

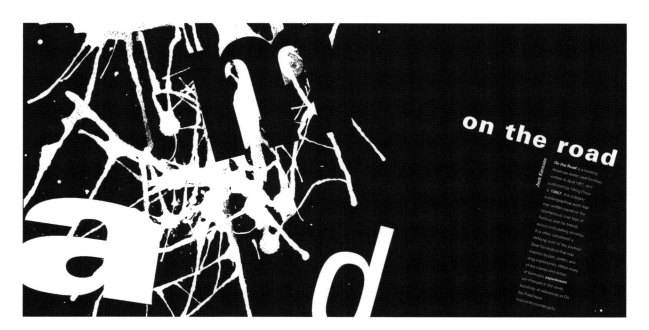

on the road

LINDSAY DEISHER_ CHADDS FORD, PA, UNITED STATES
**CREATIVE TEAM:** Lindsay Deisher
**CLIENT:** Student work

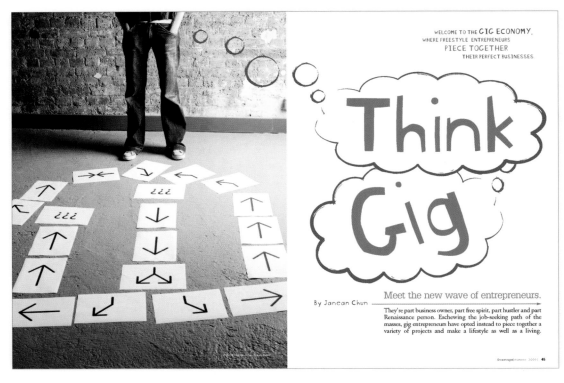

ROY CREATIVE_ ROCKVILLE, MD, UNITED STATES
**CREATIVE TEAM**: Nancy Mogel Roy, Megan Roy
**CLIENT**: Entrepreneur Media

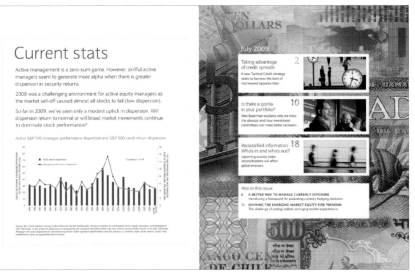

ANDY GABBERT DESIGN_ OAKLAND, CA, UNITED STATES
**CREATIVE TEAM:** Frederique Clay, Andy Gabbert, Laura Nemeth
**CLIENT:** Barclays Global Investors

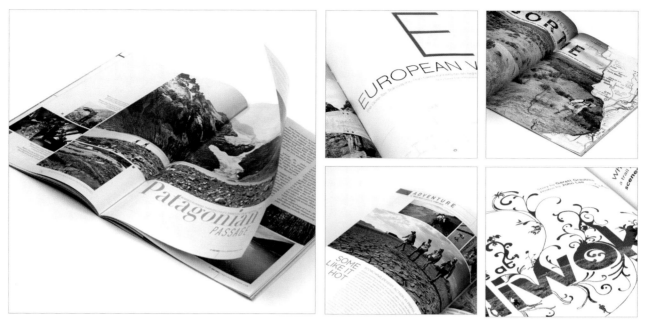

MOXIE SOZO_ BOULDER, CO, UNITED STATES
**CREATIVE TEAM**: Leif Steiner, Sarah Layland, Sarah Johnson
**CLIENT**: TrailRunner Magazine

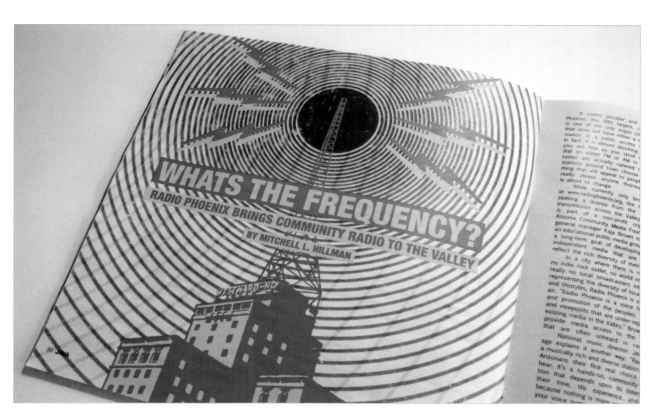

JASON HILL DESIGN_ PHOENIX, AZ, UNITED STATES
**CREATIVE TEAM**: Jason Hill
**CLIENT**: Java Magazine

STAUBER DESIGN STUDIO INC._ CHICAGO, IL, UNITED STATES
**CREATIVE TEAM:** Joy Panos Stauber, Rebecca Schlei Hartman, Dylan Schleicher, 800-CEO-Read Staff
**CLIENT:** 800-CEO-Read

# DCfocus

Defined Contribution News and Trends from Barclays Global Investors

JANUARY 2009

## STAY THE COURSE
Tips to keep your plan—and
your employees—on track

LIFEPATH LESSONS    p. 2
15 years of target-
date investing

IT'S TIME FOR INCOME    p. 6
Olivia S. Mitchell and
Jeffrey Brown on annuities

GLIDE PATHS RUN
THE GAMUT    p. 12
Four questions
you should ask

ANDY GABBERT DESIGN_ OAKLAND, CA, UNITED STATES
**CREATIVE TEAM:** Frederique Clay, Andy Gabbert, Laura Nemeth
**CLIENT:** Barclays Global Investors

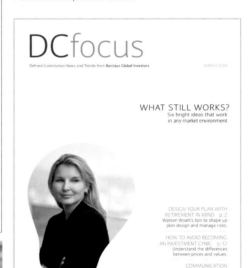

## DCfocus

Defined Contribution News and Trends from Barclays Global Investors

MARCH 2009

### WHAT STILL WORKS?
Six bright ideas that work
in any market environment

DESIGN YOUR PLAN WITH
RETIREMENT IN MIND    p. 2
Watson Wyatt's tips to shape up
plan design and manage risks.

HOW TO AVOID BECOMING
AN INVESTMENT CYNIC    p. 12
Understand the differences
between prices and values.

COMMUNICATION
SCIENCE    p. 16
Best practices for communicating
about income solutions.

January 2009

FEATURE STORY

### IT'S TIME FOR INCOME
Wharton's Olivia S. Mitchell and Illinois' Jeffrey Brown on why DC plans need annuities now

6

LIFEPATH LESSONS
What BGI has learned in 15 years
of target-date investing and how
it can help you.

2

WHY DO TARGET-DATE FUNDS
PERFORM DIFFERENTLY?
What you need to know about equity
landing points and glide paths.

12

COMMUNICATION SCIENCE
Five tips to keep your participants
from panicking and three DC
best practices to remember.

16

WHICH TYPE OF SAVER
ARE YOU?
Sample communications to help par-
ticipants keep a long-term perspective.

18

## Focal Points

Percentage of pre-retirees who underestimate
the amount of pre-retirement income they will
need in retirement: **49%**

Number of pre-retirees who underestimate
their chances of living beyond a given average
life expectancy: **6 out of 10**

Number of pre-retirees who overestimate how
much they can draw down from their retirement
savings: **7 out of 10**

Percentage of pre-retirees who say they believe
they can withdraw 10% or more while preserving
their principal, even though experts suggest a
maximum withdrawal rate of 4% annually: **43%**

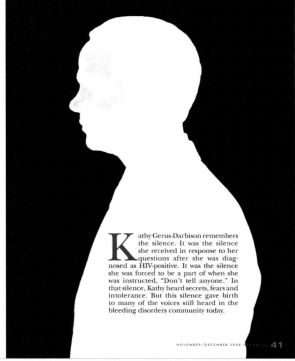

ROY CREATIVE_ ROCKVILLE, MD, UNITED STATES
**CREATIVE TEAM**: Nancy Mogel Roy, Joshua Coleman
**CLIENT:** The Magazine Group - National Hemophilia Foundation, HemAware Magazine

CALAGRAPHIC DESIGN_ ELKINS PARK, PA, UNITED STATES
**CREATIVE TEAM:** Ronald J. Cala II, Justin Renninger, Genevieve Astrelli, Curtis Clarkson
**CLIENT:** CMYK Magazine

ROY CREATIVE_ ROCKVILLE, MD, UNITED STATES
**CREATIVE TEAM:** Nancy Mogel Roy , David Johnson
**CLIENT:** WiesnerMedia - Boomer Market Advisor Magazine

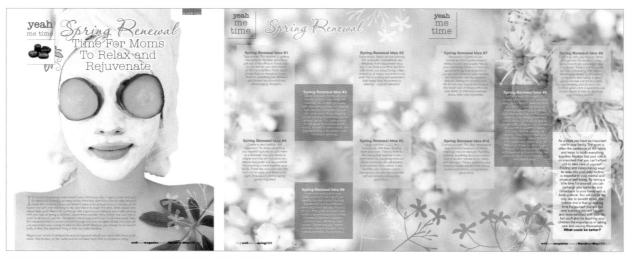

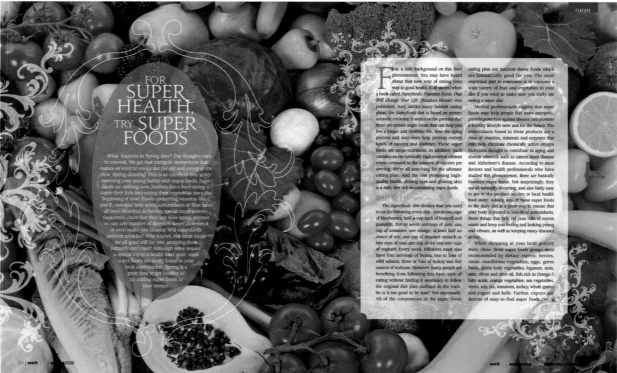

260

2ND FLOOR DESIGN_ PORTSMOUTH, VA, UNITED STATES
**CREATIVE TEAM**: Mary Hester
**CLIENT**: Well Now Magazine

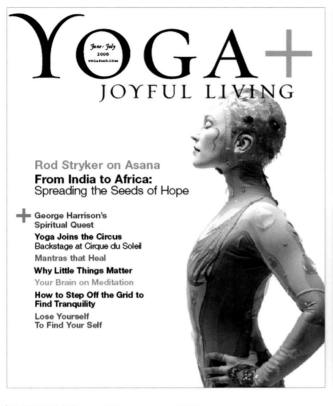

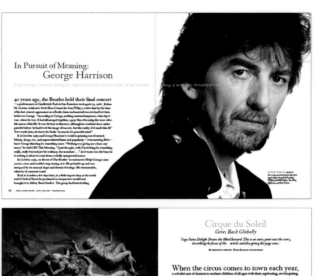

IRIDIUMGROUP_ NEW YORK, NY, UNITED STATES
**CREATIVE TEAM:** Dwayne Flinchum
**CLIENT:** Yoga+ Joyful Living Magazine

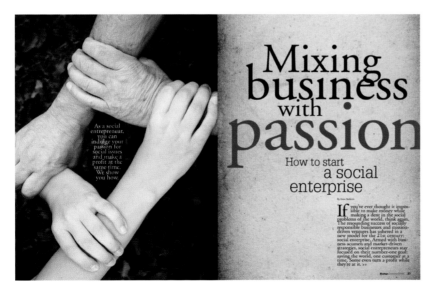

ROY CREATIVE_ ROCKVILLE, MD, UNITED STATES
**CREATIVE TEAM:** Nancy Mogel Roy
**CLIENT:** Entrepreneur Media

ANA PAULA RODRIGUES DESIGN_
NEWARK, NJ, UNITED STATES
**CREATIVE TEAM:** Ana Paula Rodrigues
**CLIENT:** Elevated Existence Magazine

IVY TECH COMMUNITY COLLEGE_ SELLERSBURG, IN, UNITED STATES
**CREATIVE TEAM:** Justin McClure, Justin Pellman, Matt Phillips, Melissa Richardson, Susan Morganti
**CLIENT:** Ivy Tech Southern Indiana

ANA PAULA RODRIGUES DESIGN_ NEWARK, NJ, UNITED STATES
**CREATIVE TEAM:** Ana Paula Rodrigues
**CLIENT:** Nielsen Business Media

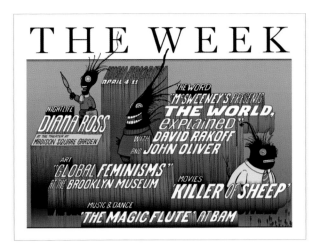

344 DESIGN, LLC_ PASADENA, CA, UNITED STATES
**CREATIVE TEAM:** Stefan G. Bucher
**CLIENT:** New York Magazine

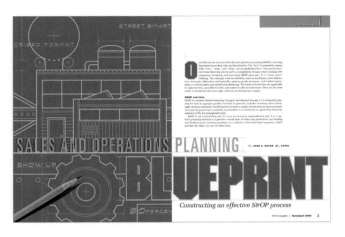

DEVER DESIGNS_ LAUREL, MD, UNITED STATES
**CREATIVE TEAM:** Jeffrey L. Dever
**CLIENT:** APICS magazine

263

# Moments of lucidity

### Why do people with mental illness have good days and bad ones?

BY HEATHER BOERNER

Some days, Lisa Halpern can get quite a fright from a soccer ball. Other days, an empty grocery aisle sends her leaping behind displays.

But Halpern isn't baffled by such experiences; she's prepared. She asks herself: Is that really a skull or will it turn into a soccer ball when I glance back at it? Is the person in the grocery aisle someone I should avoid or just a shadow on the floor?

Halpern, who has undergraduate and graduate degrees in public policy from Duke and Harvard universities, knows her brain plays tricks on her. She has schizophrenia. And she's learned that monitoring her reactions can tell her if she's getting worse.

"It's my way of trying to piece together a barometer of my health," she says. "If it takes me a half an hour to notice that the skull is really a soccer ball, then my brain health is not doing that well. If it takes a split second, my brain health is doing pretty well."

She pauses and adds thoughtfully, "After all, everyone mistakes what they see every now and then."

It's true, everyone has good days and bad. But new research is explaining why people with conditions such as schizophrenia, traumatic brain injury, attention-deficit hyperactivity disorder and dementia may have more extreme inconsistencies. The explanation is rooted in the fact that all these disorders are linked to damage in the frontal lobe. Psychologists are

discovering what Halpern already knows intuitively: Wide swings in thought and perception may foreshadow worsening symptoms or even a psychotic episode.

"What's interesting about this field is that it's looking at errors or lapses of attention as predictive of other adverse outcomes," says Kaarin Anstey, PhD, who directs the Ageing Research Unit at the Centre for Mental Health Research of Australian National University in Canberra. In the past, evidence for such errors and lapses was blamed on methodological flaws or measurement errors in the studies.

Now, they're the main event.

**Possible causes**

Relatives of people with diseases such as Alzheimer's disease or schizophrenia have noticed that people with neurological disorders can be clear one day and foggy the next, or calm one minute and then explode with rage.

Preliminary research suggests that such extremes may result from damage to the frontal lobes, home to such executive functions as impulse control, multitasking, judgment and attention, according to a literature review by University of Victoria psychology professor Stuart MacDonald, PhD, published in *Trends in Neurosciences* (Vol. 29, No. 8). That damage includes frontal lobe lesions and reduced gray-matter density.

NOVEMBER 2008

51

MCGAUGHY DESIGN_ CENTREVILLE, VA, UNITED STATES
**CREATIVE TEAM:** Sara Martin, Malcolm McGaughy
**CLIENT:** American Psychological Association

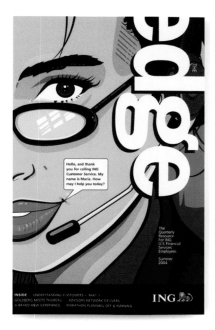

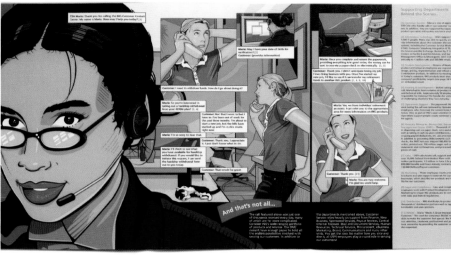

BERTZ DESIGN GROUP_ MIDDLETOWN, CT, UNITED STATES
**CREATIVE TEAM:** Bertz Design, Greg Paprocki
**CLIENT:** ING

264

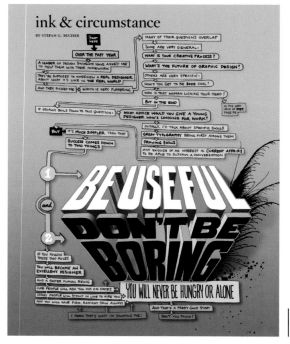

JASON HILL DESIGN_
PHOENIX, AZ, UNITED STATES
**CREATIVE TEAM:** Jason Hill, Kristen Wright
**CLIENT:** Java Magazine

344 DESIGN, LLC_ PASADENA, CA, UNITED STATES
**CREATIVE TEAM:** Stefan G. Bucher, Tom Biederbeck
**CLIENT:** STEP inside design Magazine

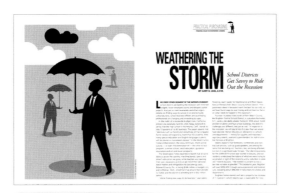

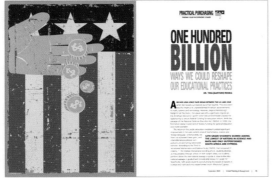

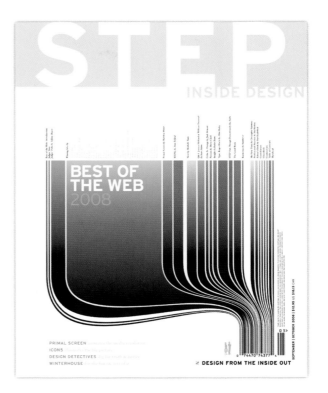

PETER LI EDUCATION GROUP_ DAYTON, OH, UNITED STATES
**CREATIVE TEAM:** Matt Cole
**CLIENT:** School Planning & Management magazine

344 DESIGN, LLC_ PASADENA, CA, UNITED STATES
**CREATIVE TEAM:** Stefan G. Bucher, FWIS
**CLIENT:** STEP inside design Magazine

265

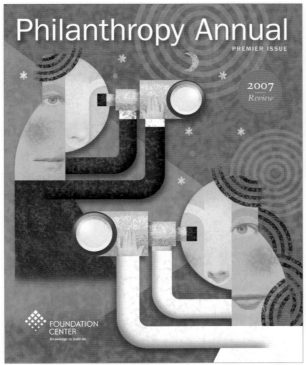

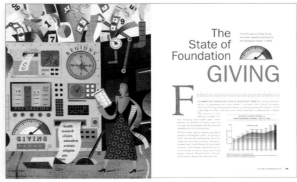

TOM DOLLE DESIGN_ NEW YORK, NY, UNITED STATES
**CREATIVE TEAM**: Chris Riely, Tom Dolle, Cheryl Loe
**CLIENT**: Foundation Center

Posters

**268**

SYMBIOTIC SOLUTIONS_ LANSING, MI, UNITED STATES
**CREATIVE TEAM:** Chris Corneal
**CLIENT:** Alarm Will Sound

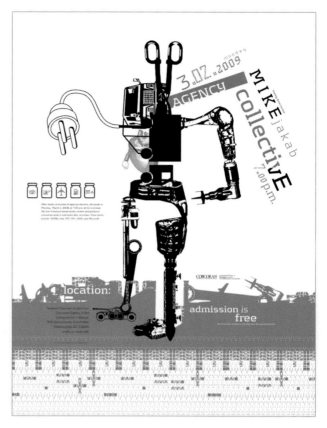

UNFOLDING TERRAIN_ HAGERSTOWN, MD, UNITED STATES
**CREATIVE TEAM:** Francheska Guerrero
**CLIENT:** Corcoran College of Art + Design

I2FLY_ BANGALORE, KARNATAKA, INDIA
**CREATIVE TEAM:** Kumar Vivek
**CLIENT:** one97 communication Pvt. Ltd.

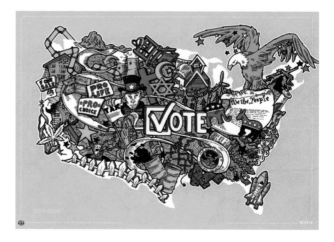

RULE29_ GENEVA, IL, UNITED STATES
**CREATIVE TEAM:** Justin Ahrens, Kerri Liu, Tim Damitz
**CLIENT:** Rule29

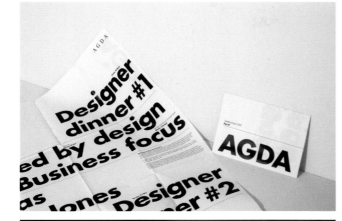

269

LANDOR ASSOCIATES_ SYDNEY, AUSTRALIA
**CREATIVE TEAM:** Jason Little, Sam Pemberton, Ivana Martinovic
**CLIENT:** The Australian Graphic Design Association (AGDA)

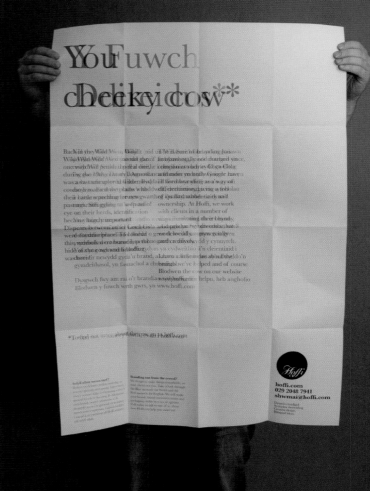
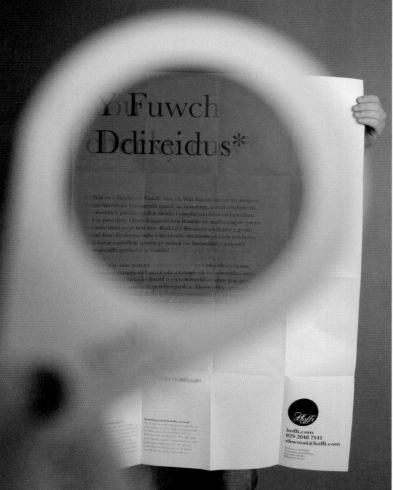
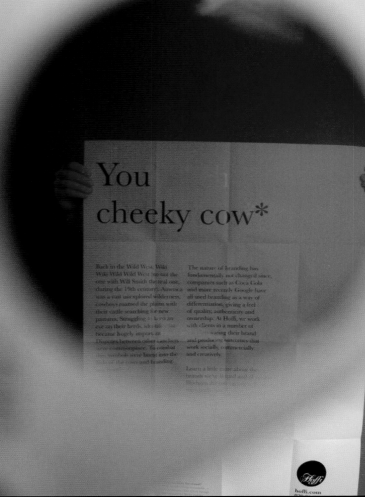

GDLOFT_ PHILADELPHIA, PA, UNITED STATES
**CREATIVE TEAM:** Allan Espiritu, Matthew Benarik
**CLIENT:** AIGA Philadelphia

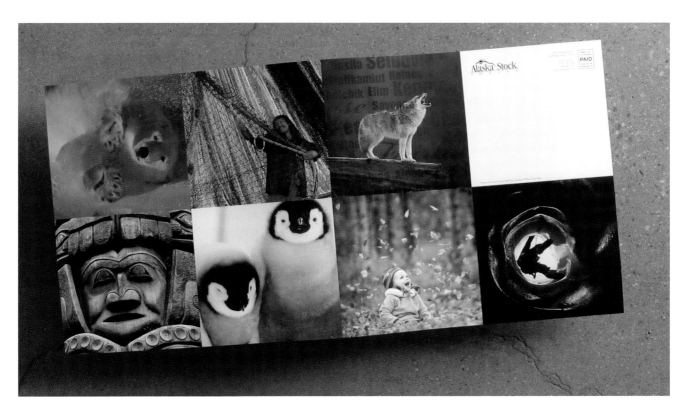

271

MAD DOG GRAPHX_ ANCHORAGE, AK, UNITED STATES
**CREATIVE TEAM:** Michael Ardaiz
**CLIENT:** Alaska Stock Images

HOFFI LIMITED_ CARDIFF, UNITED KINGDOM
**CREATIVE TEAM:** Andrew Thomas, Carwyn Jones, Julian Sykes
**CLIENT:** Hoffi

GEMINI 3D_ ÎLES DE LA MADELEINE, QC, CANADA
**CREATIVE TEAM:** Daniel Bouffard, Nancy Thorne,
Dany Bouffard
**CLIENT:** Desjardins-Îles-de-la-Madeleine

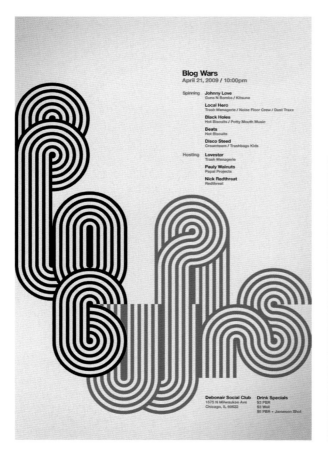

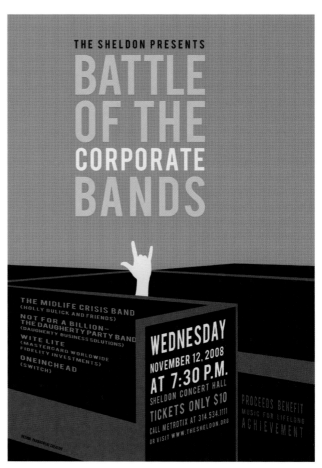

PARADOWSKI CREATIVE_ ST. LOUIS, MO, UNITED STATES
**CREATIVE TEAM:** Maggie Middeke, Scott Tripp
**CLIENT:** The Sheldon Concert Hall

SKINNYCORP / THREADLESS_ CHICAGO, IL, UNITED STATES
**CREATIVE TEAM:** Mig Reyes
**CLIENT:** Blog Wars

D STREET DESIGN_ SAN CLEMENTE, CA, UNITED STATES
**CREATIVE TEAM:** Lynne Door
**CLIENT:** D Street Design

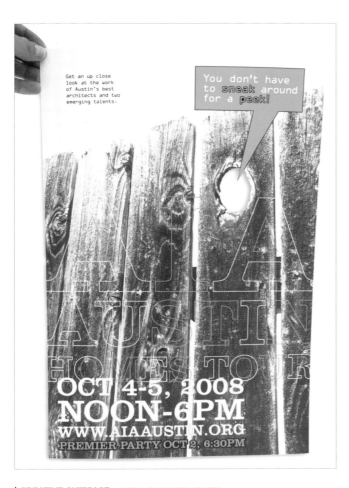

AIRTYPE STUDIO_ WINSTON-SALEM, NC, UNITED STATES
**CREATIVE TEAM:** Bryan Ledbetter
**CLIENT:** The Civics

CREATIVE SUITCASE_ AUSTIN, TX, UNITED STATES
**CREATIVE TEAM:** Rachel Clemens, Mackenzie Walsh
**CLIENT:** American Institute of Architects

WICHITA STATE UNIVERSITY_ KS, UNITED STATES
**CREATIVE TEAM:** Jeff Pulaski
**CLIENT:** Out of Sorts Press

COPIA CREATIVE, INC._ SANTA MONICA, CA, UNITED STATES
**CREATIVE TEAM:** Copia Creative Team
**CLIENT:** Artisan Cocoa, Inc.

273

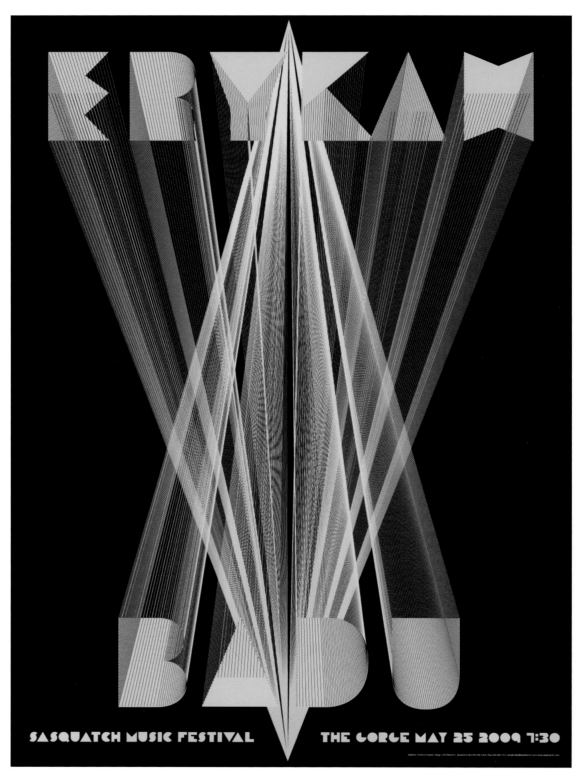

WEATHER CONTROL_ SEATTLE, WA, UNITED STATES
**CREATIVE TEAM:** Josh Oakley
**CLIENT:** House of Blues

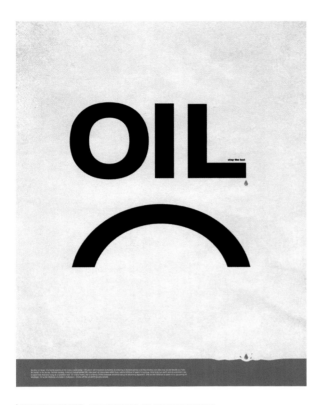

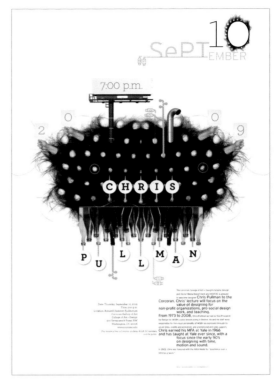

ERWIN HINES_ PITTSBURGH, PA, UNITED STATES
**CREATIVE TEAM:** Erwin Hines
**CLIENT:** Mesh

UNFOLDING TERRAIN_ HAGERSTOWN, MD, UNITED STATES
**CREATIVE TEAM:** Francheska Guerrero
**CLIENT:** Corcoran College of Art + Design

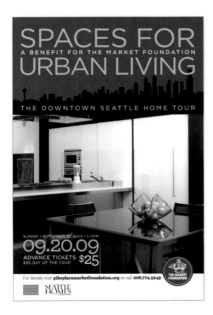

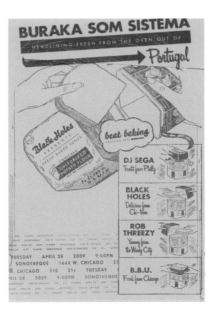

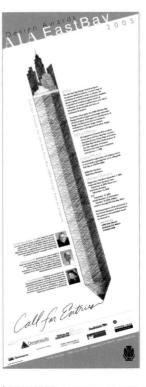

CLOCKWORK STUDIOS_
SAN ANTONIO, TX, UNITED STATES
**CREATIVE TEAM:** Terri Gaines, Steve Gaines
**CLIENT:** The Market Foundation

SKINNYCORP / THREADLESS_
CHICAGO, IL, UNITED STATES
**CREATIVE TEAM:** Mig Reyes
**CLIENT:** Buraka Som Sistema

DEANARTS_ BERKELEY, CA, UNITED STATES
**CREATIVE TEAM:** Anko Chen, Dean Hunsaker
**CLIENT:** American Institute of Architects, East Bay

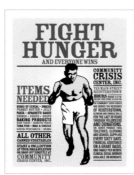

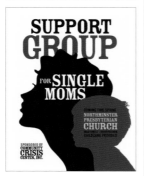

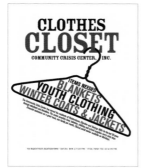

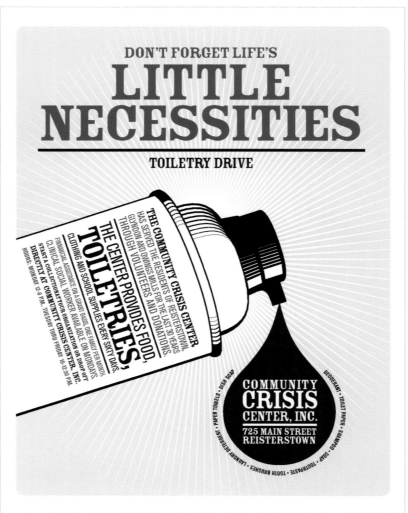

ROY CREATIVE_ ROCKVILLE, MD, UNITED STATES
**CREATIVE TEAM:** Nancy Mogel Roy
**CLIENT:** Community Crisis Center

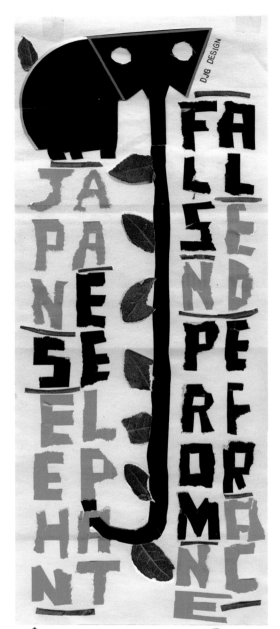

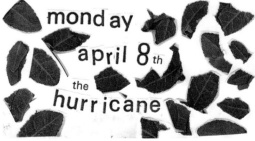

DJG DESIGN_ KANSAS CITY, MO, UNITED STATES
**CREATIVE TEAM:** Danny J. Gibson
**CLIENT:** Falls End Performance

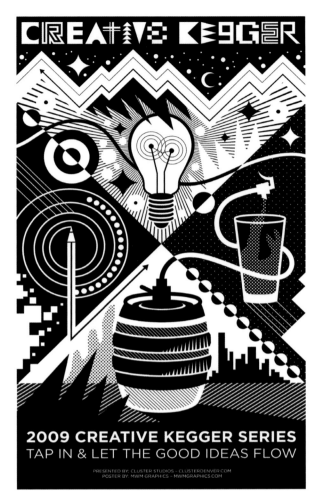

**2009 CREATIVE KEGGER SERIES**
TAP IN & LET THE GOOD IDEAS FLOW

PRESENTED BY: CLUSTER STUDIOS ~ CLUSTERDENVER.COM
POSTER BY: MWM GRAPHICS ~ MWMGRAPHICS.COM

MWM GRAPHICS_ PORTLAND, ME, UNITED STATES
**CREATIVE TEAM:** Matt W. Moore
**CLIENT:** Cluster Studios

277

AIRTYPE STUDIO_
WINSTON-SALEM, NC, UNITED STATES
**CREATIVE TEAM:** Bryan Ledbetter
**CLIENT:** Blue Dogs

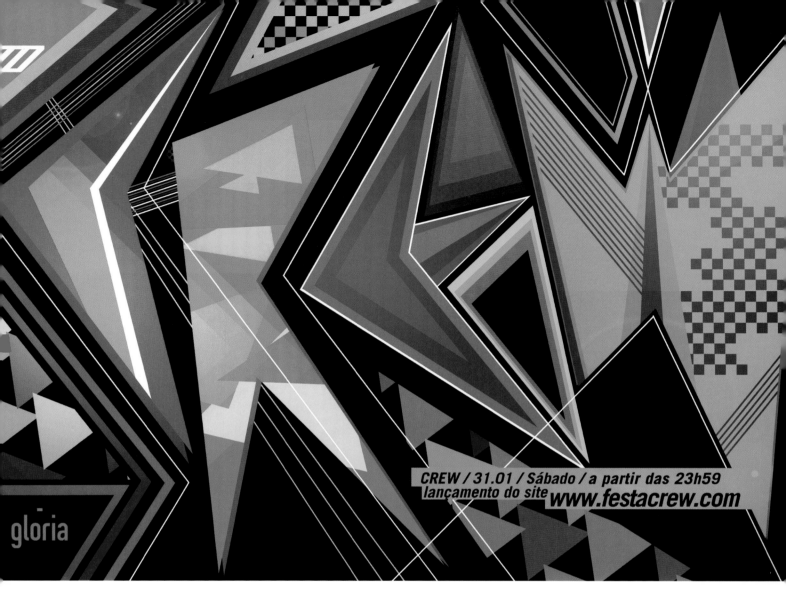

CREW / 31.01 / Sábado / a partir das 23h59
lançamento do site www.festacrew.com

gloria

FTOFANI_ SÃO PAULO, BRAZIL
**CREATIVE TEAM:** Felipe Tofani
**CLIENT:** CREW

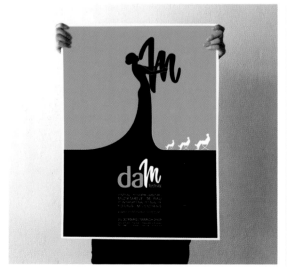
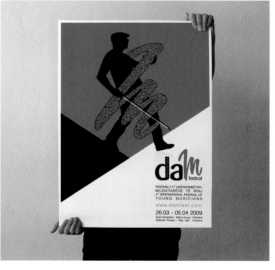

PROJECTGRAPHICS.EU_ PRISHTINA, KOSOVA, ALBANIA
**CREATIVE TEAM:** Agon Çeta, Armelina Hasani
**CLIENT:** Prishtina Dam Festival

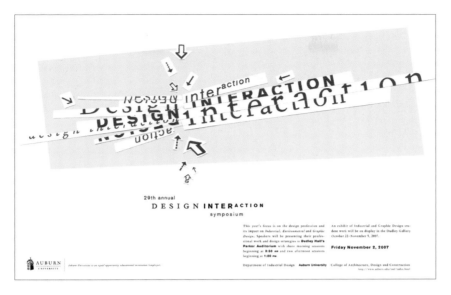

KELLY BRYANT DESIGN_ AUBURN, AL, UNITED STATES
**CREATIVE TEAM:** Kelly Bryant, Shea Tillman, Clark Lundell
**CLIENT:** Department of Industrial + Graphic Design, Auburn University

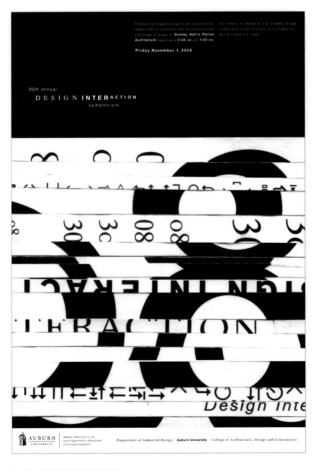

279

PROJECTGRAPHICS.EU_ PRISHTINA, KOSOVA, ALBANIA
**CREATIVE TEAM:** Agon Çeta, Armelina Hasani
**CLIENT:** National Theatre of Kosova

KELLY BRYANT DESIGN_ AUBURN, AL, UNITED STATES
**CREATIVE TEAM:** Kelly Bryant, Clark Lundell, Randy Bartlett
**CLIENT:** Department of Industrial + Graphic Design, Auburn University

RANGE DESIGN, INC_ DALLAS, TX, UNITED STATES
**CREATIVE TEAM:** Garrett Owen
**CLIENT:** Dallas Society of Visual Communications

280

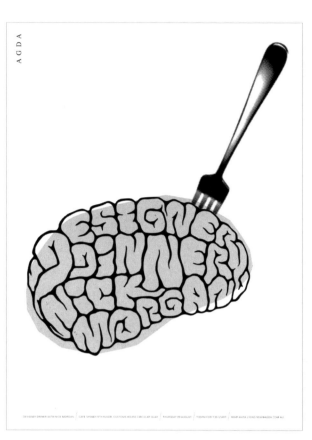

LANDOR ASSOCIATES_ SYDNEY, AUSTRALIA
**CREATIVE TEAM:** Jason Little, Jefton Sungkar
**CLIENT:** The Australian Graphic Design Association (AGDA)

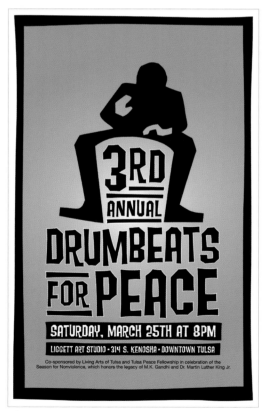

CLAY MCINTOSH CREATIVE_ TULSA, OK, UNITED STATES
**CREATIVE TEAM:** Clay McIntosh
**CLIENT:** Tulsa Peace Fellowship

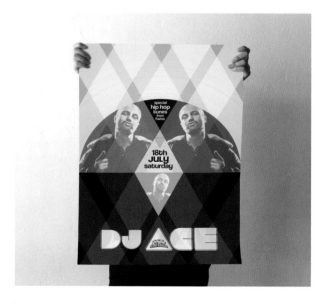

PROJECTGRAPHICS.EU_ PRISHTINA, KOSOVA, ALBANIA
**CREATIVE TEAM:** Agon Çeta
**CLIENT:** Next Level

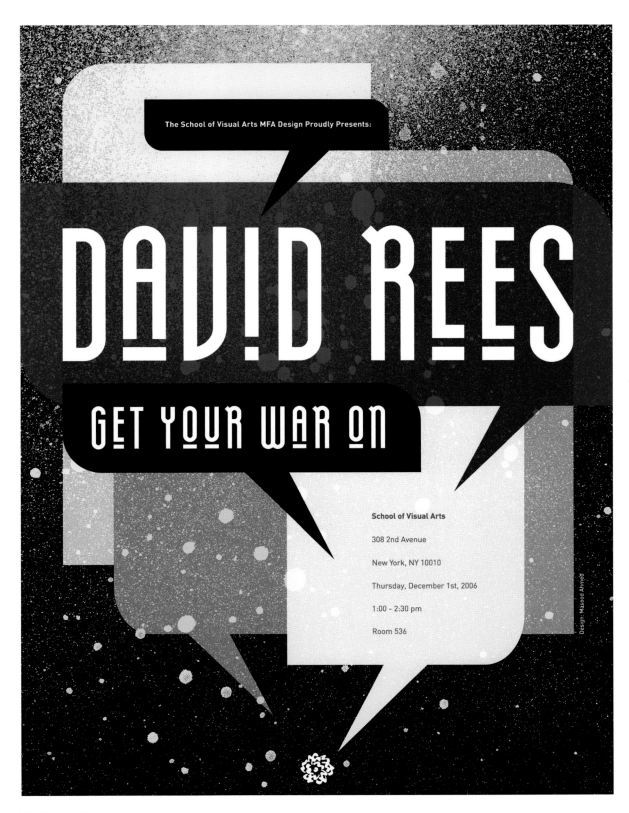

281

MASOOD BUKHARI _ BRONX, NY, UNITED STATES
**CREATIVE TEAM:** Masood Bukhari
**CLIENT:** School of Visual Arts, MFA Design

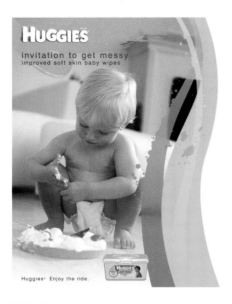 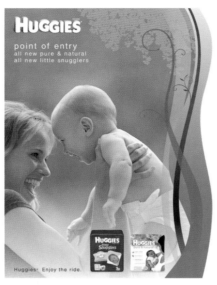 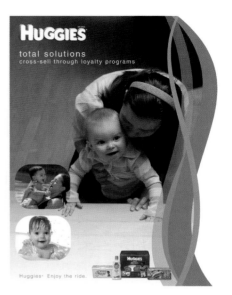

LEIBOLD ASSOCIATES, INC._ NEENAH, WI, UNITED STATES
**CREATIVE TEAM:** Nick Maggio, Jane Oliver
**CLIENT:** Kimberly-Clark, Inc.

LANDOR ASSOCIATES_ SYDNEY, AUSTRALIA
**CREATIVE TEAM:** Jason Little, Joao Peres
**CLIENT:** The Australian Graphic Design Association (AGDA)

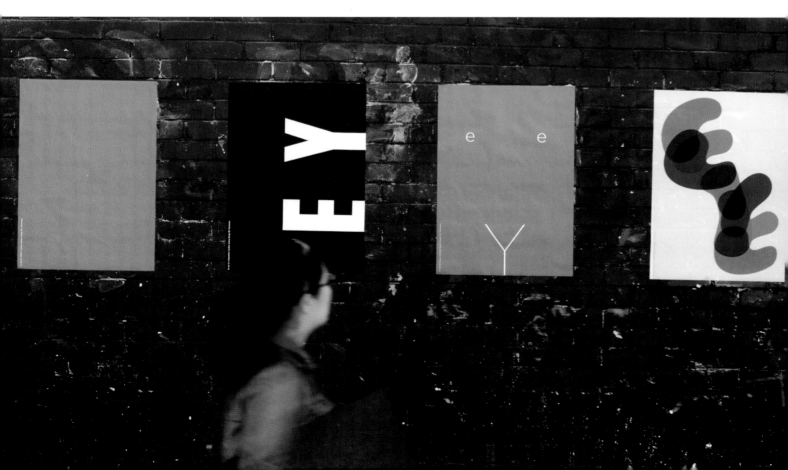

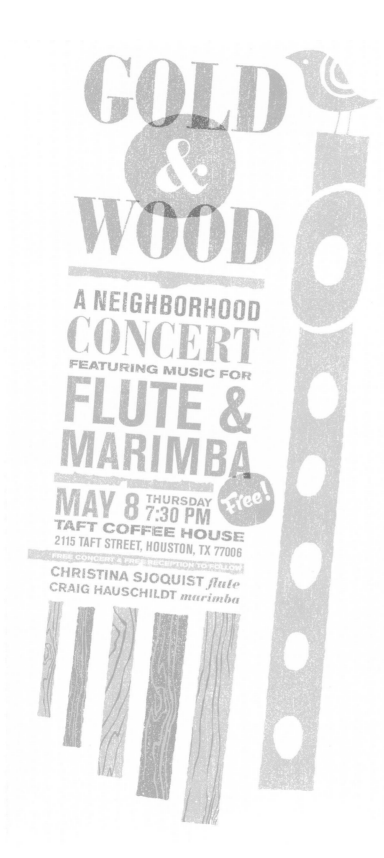

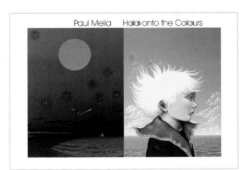

JAMES MARSH DESIGN_ KENT, UNITED KINGDOM
**CREATIVE TEAM:** James Marsh
**CLIENT:** Paul Melia

283

WEATHER CONTROL_ SEATTLE, WA, UNITED STATES
**CREATIVE TEAM:** Josh Oakley
**CLIENT:** Christina Sjoquist

AIRTYPE STUDIO_ WINSTON-SALEM, NC, UNITED STATES
**CREATIVE TEAM:** Bryan Ledbetter
**CLIENT:** Brach Music

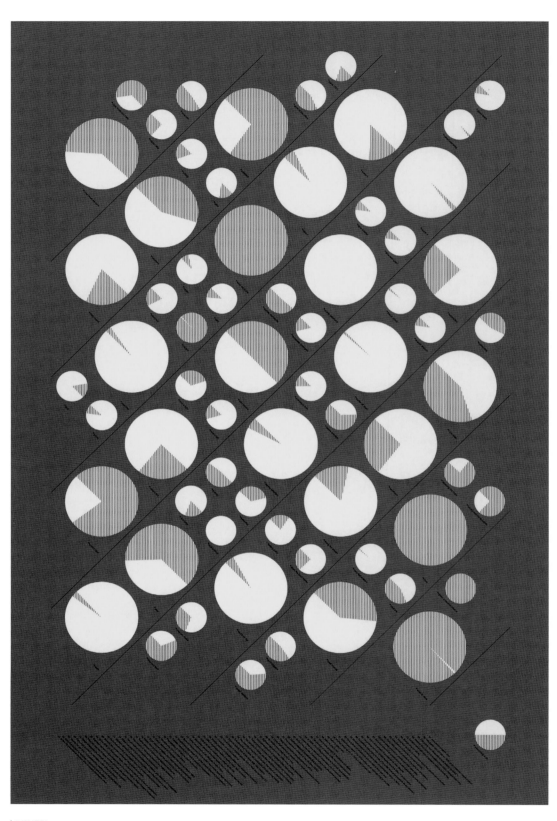

MINE™_ SAN FRANCISCO, CA, UNITED STATES
**CREATIVE TEAM:** Christopher Simmons, Tim Belonax, Nathan Sharp
**CLIENT:** Everything is OK

BiG
BOOK
LAYOUT

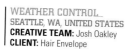

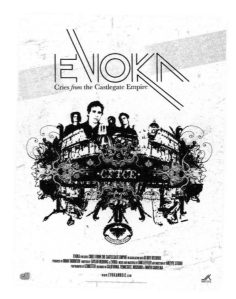

WEATHER CONTROL_
SEATTLE, WA, UNITED STATES
**CREATIVE TEAM:** Josh Oakley
**CLIENT:** Hair Envelope

AIRTYPE STUDIO_
WINSTON-SALEM, NC, UNITED STATES
**CREATIVE TEAM:** Bryan Ledbetter
**CLIENT:** Evoka

285

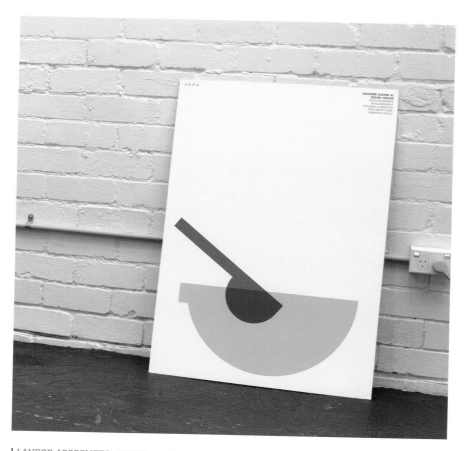

LANDOR ASSOCIATES_ SYDNEY, AUSTRALIA
**CREATIVE TEAM:** Jason Little
**CLIENT:** The Australian Graphic Design Association (AGDA)

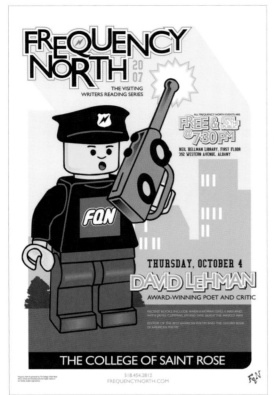

THE COLLEGE OF SAINT ROSE_ ALBANY, NY, UNITED STATES
**CREATIVE TEAM:** Mark Hamilton, Chris Parody, Daniel Nester
**CLIENT:** The College of Saint Rose

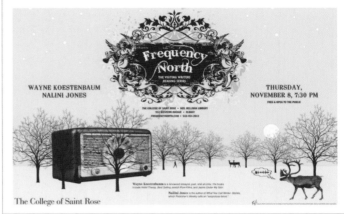

CREATIVE SUITCASE_ AUSTIN, TX, UNITED STATES
**CREATIVE TEAM:** Rachel Clemens, Jennifer Wright
**CLIENT:** Creative Suitcase

287

SKINNYCORP / THREADLESS_ CHICAGO, IL, UNITED STATES
**CREATIVE TEAM:** Mig Reyes, McCall Marshall
**CLIENT:** McCall Marshall & Ana Sofia Joanes

DARCYLEA DESIGN_ SIDNEY, NE, UNITED STATES
**CREATIVE TEAM:** Darcy Hinrichs
**CLIENT:** Self-promotion

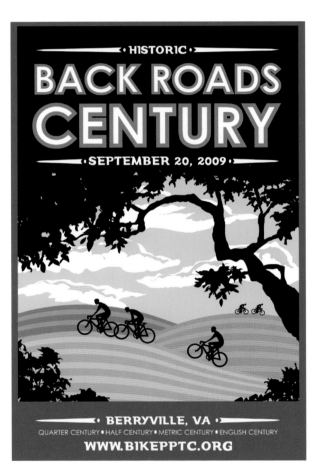

HEATHERGRIMSTEAD.COM_ MCLEAN, VA, UNITED STATES
**CREATIVE TEAM:** Heather Grimstead
**CLIENT:** Potomac Pedalers Touring Club

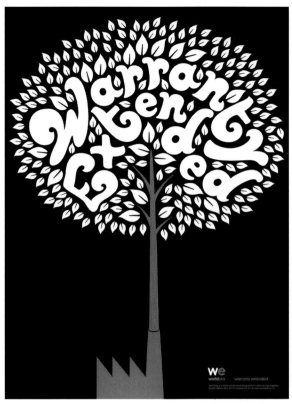

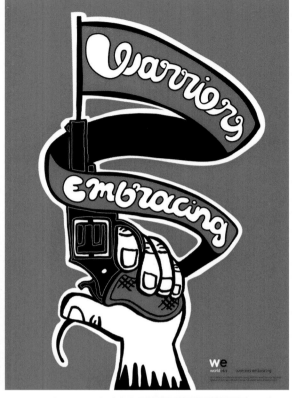

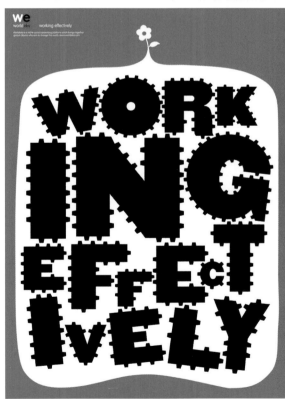

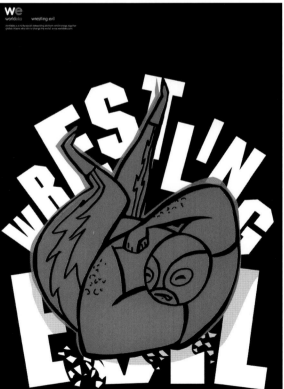

LANDOR ASSOCIATES_ SYDNEY, AUSTRALIA
**CREATIVE TEAM:** Jason Little, Mike Staniford, Joao Peres, Serhat Ferhat
**CLIENT:** Worldeka

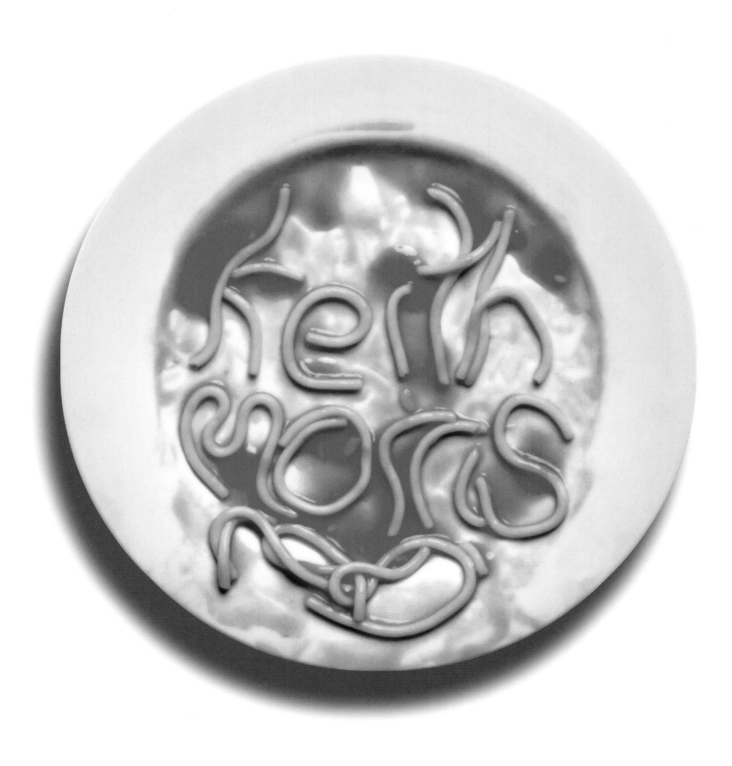

LANDOR ASSOCIATES_ SYDNEY, AUSTRALIA
**CREATIVE TEAM:** Jason Little, Sam Pemberton
**CLIENT:** Keith Morris

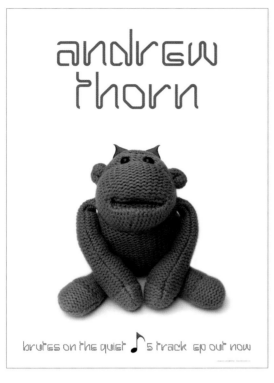

**JAMES MARSH DESIGN_ KENT, UNITED KINGDOM**
**CREATIVE TEAM:** James Marsh
**CLIENT:** Andrew Thorn

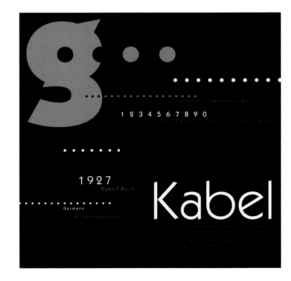

**LINDSAY DEISHER_ CHADDS FORD, PA, UNITED STATES**
**CREATIVE TEAM:** Lindsay Deisher
**CLIENT:** Student work

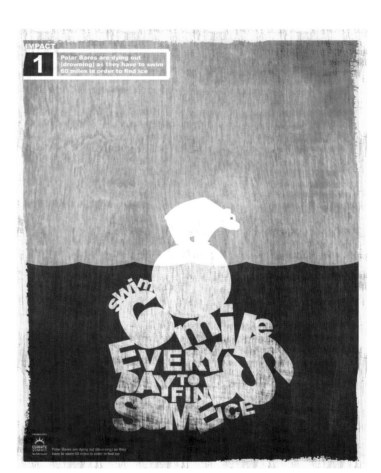

**ERWIN HINES_ PITTSBURGH, PA, UNITED STATES**
**CREATIVE TEAM:** Erwin Hines
**CLIENT:** International Climate Summit

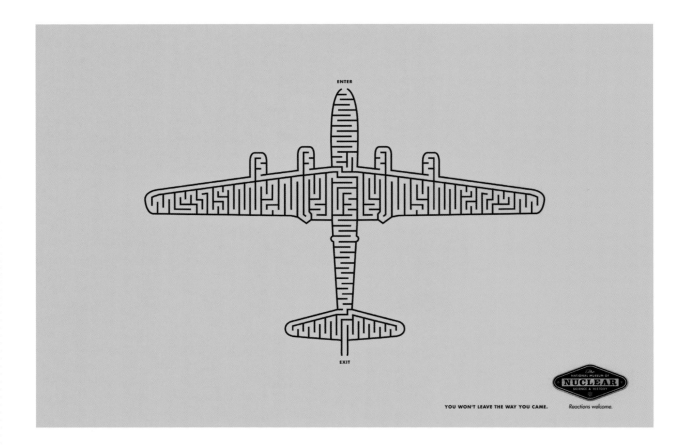

# An In-Depth Look

## The National Museum of Nuclear Science & History

Ever since Robert Oppenheimer developed the first atomic weapons in the 1940s, scientists, politicians and everyday people all have pondered the question of how to escape from the maze of nuclear power's ever-escalating potential. However, at 3 Advertising in Albuquerque—just ninety miles from Oppenheimer's Los Alamos Manhattan Project labs—creating a maze is as much about the journey as it is the destination.

For their client, the National Museum of Nuclear Science & History, creative director Sam Maclay and designer Tim McGrath created a print and poster campaign designed to attract visitors to a place where they could learn about the applications of nuclear science beyond the bomb. "Albuquerque has a really strong scientific community," says Maclay, "and the client wanted to educate people on what nuclear science is all about and let them form their own perceptions." The museum—the only one of its kind in the nation—examines all facets of nuclear science, including its role in history, war, deterrence and medicine. "People forget the benefits—it's not just bombs and war," he says. "The toothpaste is out of the canister, and so we should have a say in how it affects our lives and our society." And by inviting visitors to share their thoughts—pro or con—the museum fulfills their mission, summed up by Maclay's tagline, "Reactions Welcome." He says, *"We came up with it based on the strategy that the museum is a place where debate is welcome.* People come there from all over the world, and we wanted to make sure people feel comfortable in that environment and

come away with their own ideas. It's all about education."

Making such a serious subject fun and appealing for the non-science crowd came in a circuitous manner—in more ways than one. Says Maclay: *"There are so many stories to tell—Trinity, Oppenheimer, Los Alamos—so we thought a copy-heavy approach would be best. But we also needed to appeal to as many people as possible; instead of having it be like a lecture, we wanted to make it stand out visually."* McGrath drew upon an exhibit, known as the Maze, where museum visitors can walk and then write down their impressions of everything from Hiroshima to the thirty-three thousand nuclear medicine procedures performed daily. "It's a place where people can see some good and some bad things about our history that we're being judged on—and will still be judged on by future generations," Maclay explains.

To illustrate the Maze literally, McGrath took some famous icons of nuclear science and turned them into actual working mazes for the campaign using Adobe Illustrator. It was a challenge unlike any other he'd ever worked on: Not only had he never drawn a maze, but he had two weeks to make six of them in the shapes of an airplane, a warhead, a submarine and a radiation warning symbol for the posters, along with a beaker for the kids' program and a syringe to represent nuclear medicine in print ads.

And then there was the logistics issue. "They were pretty tough," McGrath says. "It took several hours to get started, but it was a lot of fun."

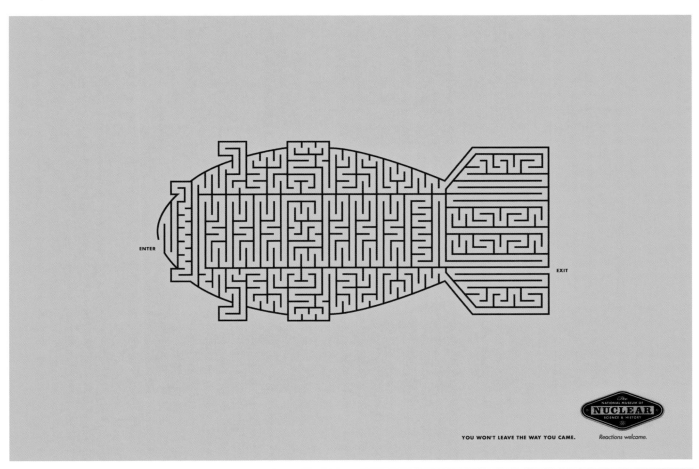

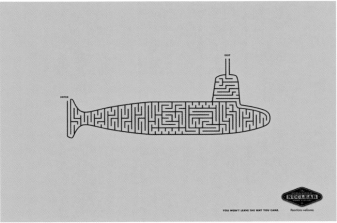

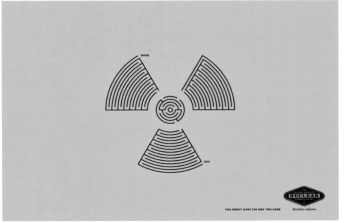

3 ADVERTISING_ ALBUQUERQUE, NM, UNITED STATES
**CREATIVE TEAM:** Tim McGrath, Sam Maclay
**CLIENT:**The National Museum of Nuclear Science & History

And, in the spirit of science, each part worked, with each maze having a beginning and an end, with the lines moving around each particular shape. "I thought the maze kind of makes sense for a museum because you enter in one place and you leave from another entry… but you explore the place in detail, every place. You learn everything there is to know about the B-29 bomber or Fat Man or a nuclear submarine."

The images, which also appear on t-shirts, coffee mugs and other items for sale in the museum's gift shop, had its own, well, fallout for McGrath. "For several weeks after I drew them, everything I looked at became a maze," he says. Still, it worked out. Adds Maclay: "Once the client saw our approach and how it gelled with their mission, they really embraced it."

**LINDSAY DEISHER_ CHADDS FORD, PA, UNITED STATES**
**CREATIVE TEAM:** Lindsay Deisher
**CLIENT:** Self-promotion

**CALAGRAPHIC DESIGN_ ELKINS PARK, PA, UNITED STATES**
**CREATIVE TEAM:** Ronald J. Cala II, Katie Hatz
**CLIENT:** Somewhat Awesome Design

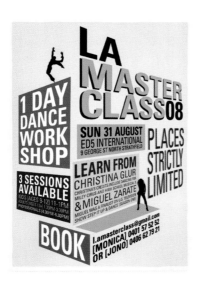

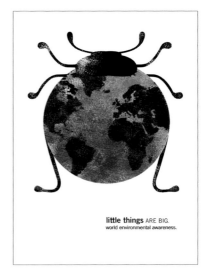

little things ARE BIG.
world environmental awareness.

SPATCHURST_ BROADWAY, AUSTRALIA
**CREATIVE TEAM:** Steven Joseph, Sarah Magro
**CLIENT:** Self-promotion

UNFOLDING TERRAIN_ HAGERSTOWN,
MD, UNITED STATES
**CREATIVE TEAM:** Francheska Guerrero
**CLIENT:** Corcoran College of Art + Design

DOUG BARRETT DESIGN_ BIRMINGHAM,
AL, UNITED STATES
**CREATIVE TEAM:** Doug Barrett
**CLIENT:** Self Promo, exhibited in the
4th Biannual Design Exhibition

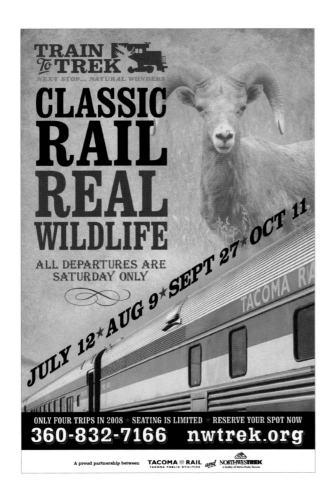

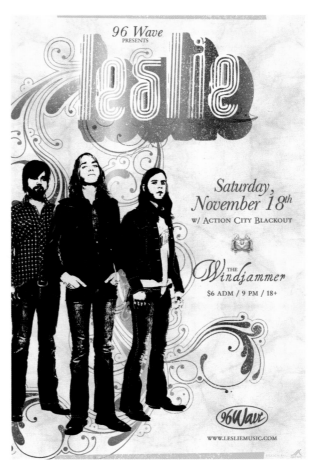

295

CLOCKWORK STUDIOS_ SAN ANTONIO, TX, UNITED STATES
**CREATIVE TEAM:** Terri Gaines, Steve Gaines
**CLIENT:** Metro Parks Tacoma: Northwest Trek

AIRTYPE STUDIO_ WINSTON-SALEM, NC, UNITED STATES
**CREATIVE TEAM:** Bryan Ledbetter
**CLIENT:** 96 Wave FM

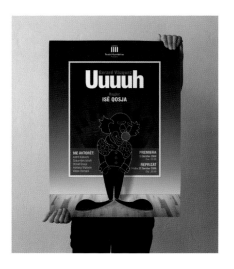

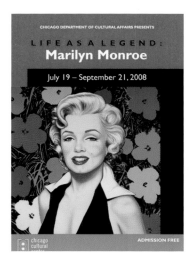

PROJECTGRAPHICS.EU_
PRISHTINA, KOSOVA, ALBANIA
**CREATIVE TEAM:** Agon Çeta, Armelina Hasani
**CLIENT:** National Theatre of Kosova

MC2 COMMUNICATIONS_
CHICAGO, IL, UNITED STATES
**CREATIVE TEAM:** Michelle Crisanti,
Ruby Ruan, D'anna Pawlenko
**CLIENT:** Self-promotion

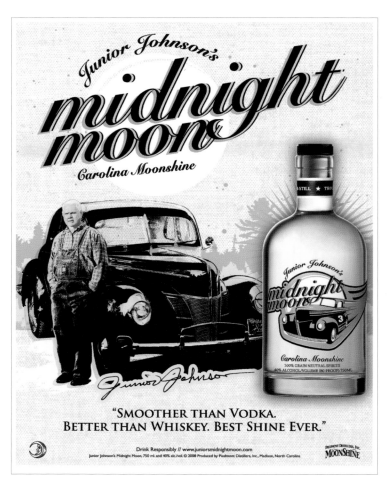

AIRTYPE STUDIO_ WINSTON-SALEM, NC, UNITED STATES
**CREATIVE TEAM:** Bryan Ledbetter
**CLIENT:** Piedmont Distillers

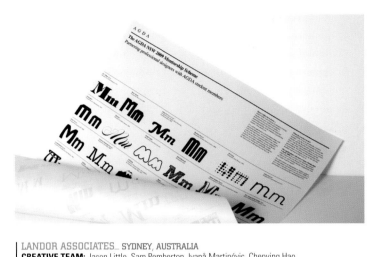

LANDOR ASSOCIATES_ SYDNEY, AUSTRALIA
**CREATIVE TEAM:** Jason Little, Sam Pemberton, Ivanā Martinóvic, Chenying Hao
**CLIENT:** The Australian Graphic Design Association (AGDA)

YOTAM HADAR_ TEL AVIV, ISRAEL
**CREATIVE TEAM:** Yotam Hadar
**CLIENT:** Self Initiated

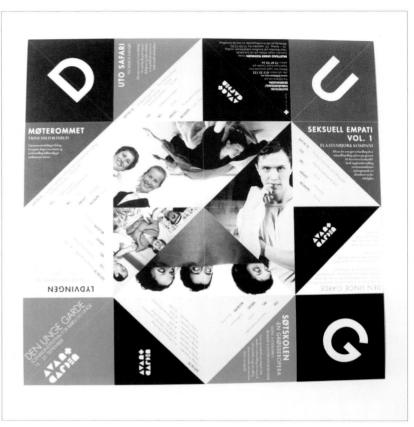

298

UREDD_ TRONDHEIM, TRONDHEIM, NORWAY
**CREATIVE TEAM:** Gaute Busch
**CLIENT:** Teaterhuset Avant Garden

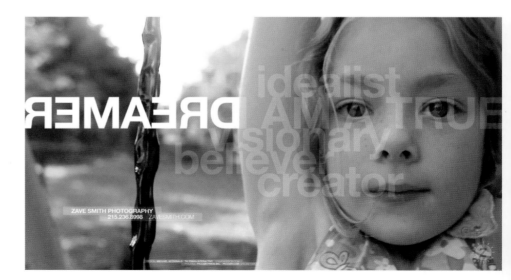

ORGANIC GRID_ PHILADELPHIA, PA, UNITED STATES
**CREATIVE TEAM:** Michael McDonald, Zave Smith
**CLIENT:** Zave Smith Photography

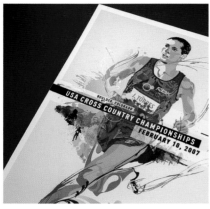  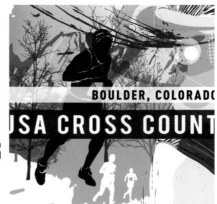

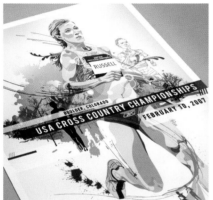  

MOXIE SOZO_ BOULDER, CO, UNITED STATES
**CREATIVE TEAM:** Leif Steiner, Laura Kottlowski
**CLIENT:** USA Track and Field

ZAVE SMITH PHOTOGRAPHY
215.236.8998  ZAVESMITH.COM

UREDD_ TRONDHEIM, TRONDHEIM, NORWAY
**CREATIVE TEAM:** Ståle Gerhardsen, Hilde Holta-Lysell
**CLIENT:** Mercur

PROJECTGRAPHICS.EU_ PRISHTINA, KOSOVA, ALBANIA
**CREATIVE TEAM:** Agon Çeta
**CLIENT:** Sound VIsion

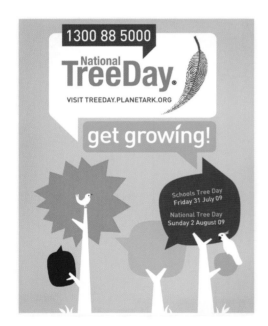

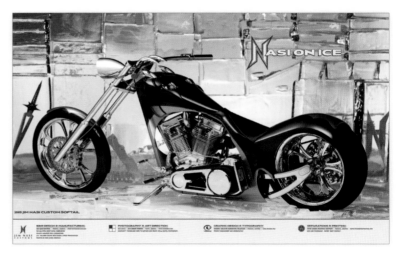

VISIONN CREATIVE MARKETING_ TEMPE, AZ, UNITED STATES
**CREATIVE TEAM:** Marvin Forte
**CLIENT:** Jim Nasi Customs

SPATCHURST_ BROADWAY, AUSTRALIA
**CREATIVE TEAM:** Steven Joseph, Sarah Magro
**CLIENT:** Planet Ark

300

SYMBIOTIC SOLUTIONS_ LANSING, MI, UNITED STATES
**CREATIVE TEAM:** Chris Corneal
**CLIENT:** Symbiotic Solutions

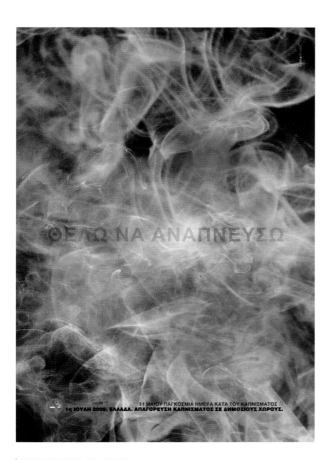

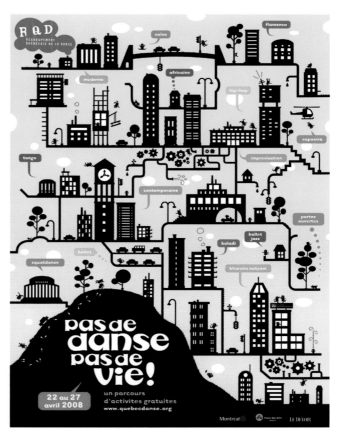

301

VAMADESIGN_ GR, GREECE
**CREATIVE TEAM:** Vasilis Magoulas
**CLIENT:** Self-Promotion / Social Design

SUBCOMMUNICATION_ MONTREAL, QC, CANADA
**CREATIVE TEAM:** Sebastien Theraulaz, Valerie Desrochers
**CLIENT:** Regroupement Quebecois de la Danse

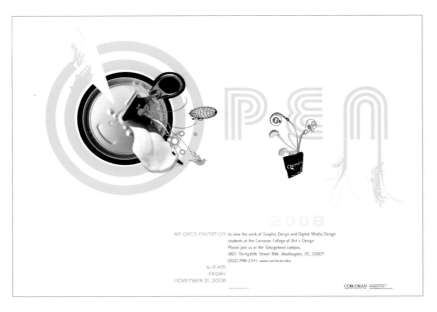

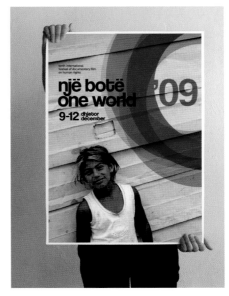

UNFOLDING TERRAIN_ HAGERSTOWN, MD, UNITED STATES
**CREATIVE TEAM:** Francheska Guerrero
**CLIENT:** Corcoran College of Art + Design

PROJECTGRAPHICS.EU_
PRISHTINA, KOSOVA, ALBANIA
**CREATIVE TEAM:** Agon Çeta, Hazir Reka
**CLIENT:** One World Festival

302

PROJECTGRAPHICS.EU_ PRISHTINA, KOSOVA, ALBANIA
**CREATIVE TEAM:** Agon Çeta
**CLIENT:** Multisound Connection

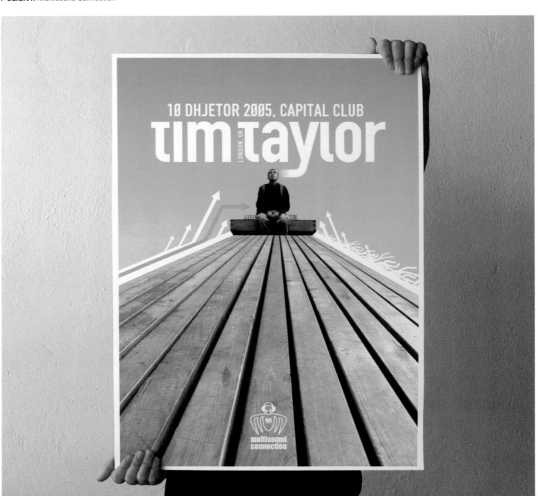

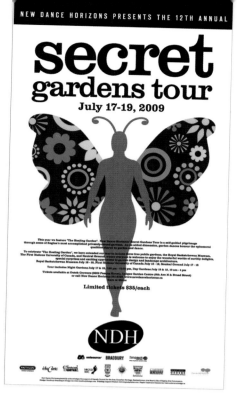

BRADBURY BRANDING & DESIGN_
REGINA, SK, CANADA
**CREATIVE TEAM:** Catharine Bradbury
**CLIENT:** New Dance Horizons

BRADBURY BRANDING & DESIGN_ REGINA, SK, CANADA
**CREATIVE TEAM:** Catharine Bradbury
**CLIENT:** New Dance Horizons

303

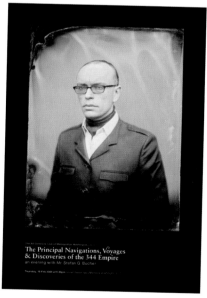

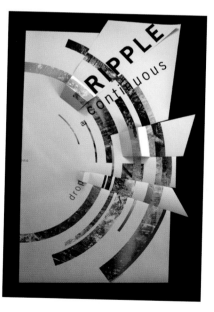

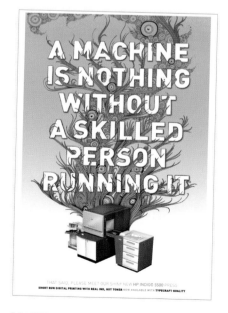

344 DESIGN, LLC_
PASADENA, CA, UNITED STATES
**CREATIVE TEAM:** Stefan G. Bucher, Stephen Berkman
**CLIENT:** Art Directors Club of Metropolitan Washington

THRIVE DESIGN_
EAST LANSING, MI, UNITED STATES
**CREATIVE TEAM:** Kelly Salchow MacArthur
**CLIENT:** Thrive Design

344 DESIGN, LLC_
PASADENA, CA, UNITED STATES
**CREATIVE TEAM:** Stefan G. Bucher
**CLIENT:** Typecraft Wood & Jones

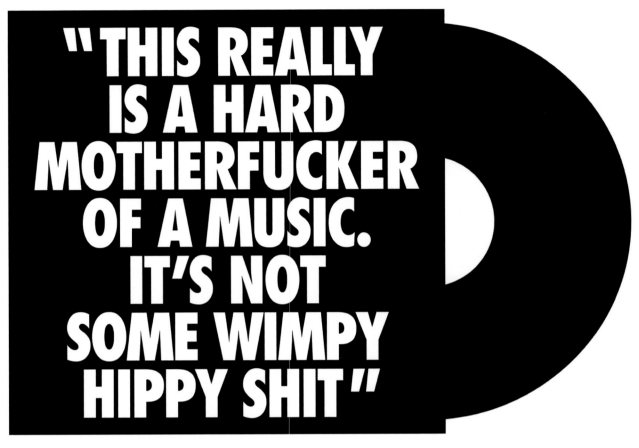

"THIS REALLY IS A HARD MOTHERFUCKER OF A MUSIC. IT'S NOT SOME WIMPY HIPPY SHIT"

304

PAUL SNOWDEN_ BERLIN, GERMANY
**CREATIVE TEAM:** Paul Snowden
**CLIENT:** GALERIE A/K/A

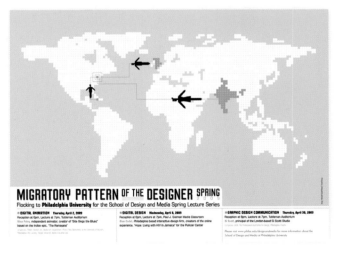

KRADEL DESIGN_ PHILADELPHIA, PA, UNITED STATES
**CREATIVE TEAM:** Maribeth Kradel-Weitzel
**CLIENT:** Philadelphia University School of Design and Media

PRYOR DESIGN COMPANY_ ANN ARBOR, MI, UNITED STATES
**CREATIVE TEAM:** Scott Pryor, Laura Hervey
**CLIENT:** Ozone House

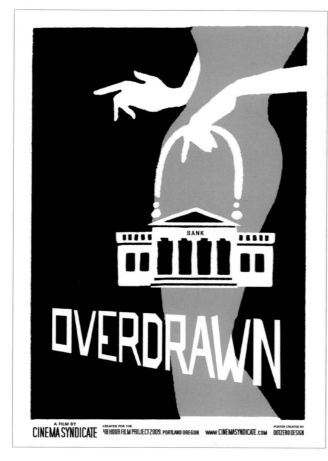

DOTZERO DESIGN_ PORTLAND, OR, UNITED STATES
**CREATIVE TEAM:** Karen Wippich, Jon Wippich
**CLIENT:** Cinema Syndicate

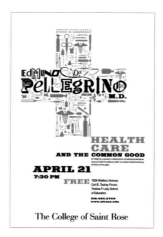

THE COLLEGE OF SAINT ROSE_
ALBANY, NY, UNITED STATES
**CREATIVE TEAM:** Mark Hamilton,
Chris Parody
**CLIENT:** The College of Saint Rose

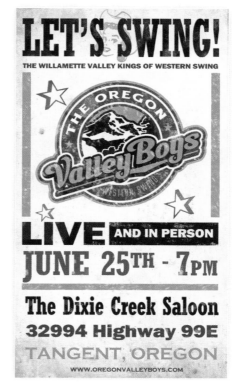

305

HILL DESIGN STUDIOS_ SALEM, OR, UNITED STATES
**CREATIVE TEAM:** Randy Hill
**CLIENT:** The Oregon Valley Boys

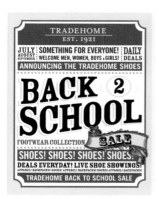

13THIRTYONE DESIGN_
HUDSON, WI, UNITED STATES
**CREATIVE TEAM:** Angela Ferraro-Fanning
**CLIENT:** Tradehome Shoe Stores

SUBCOMMUNICATION_ MONTREAL, QC, CANADA
**CREATIVE TEAM:** Sebastien Theraulaz,
Valerie Desrochers, Sebastien Raymond
**CLIENT:** Académie de Danse d'Outremont

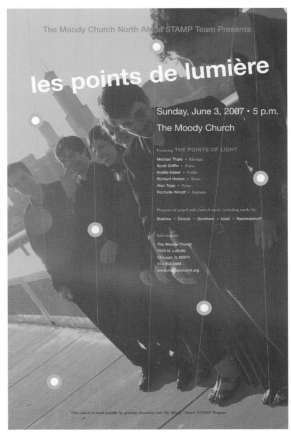

DJG DESIGN_ KANSAS CITY, MO, UNITED STATES
**CREATIVE TEAM:** Danny J. Gibson
**CLIENT:** The Brick

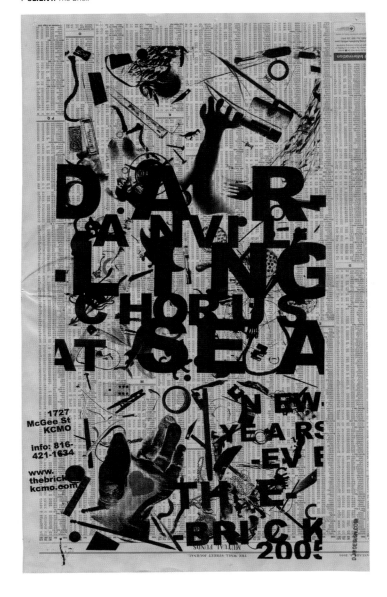

306

HA DESIGN_ GLENDORA, CA, UNITED STATES
**CREATIVE TEAM:** Handy Atmali
**CLIENT:** The Moody Church - STAMP (Short Term Adult Missions Program)

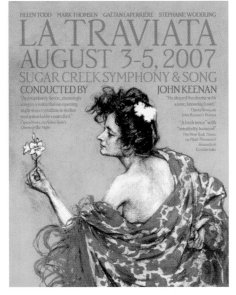

NEVER TRUST A DAME_
SAN FRANCISCO, CA, UNITED STATES
**CREATIVE TEAM:** Carri Corbett
**CLIENT:** Sugar Creek Symphony & Song

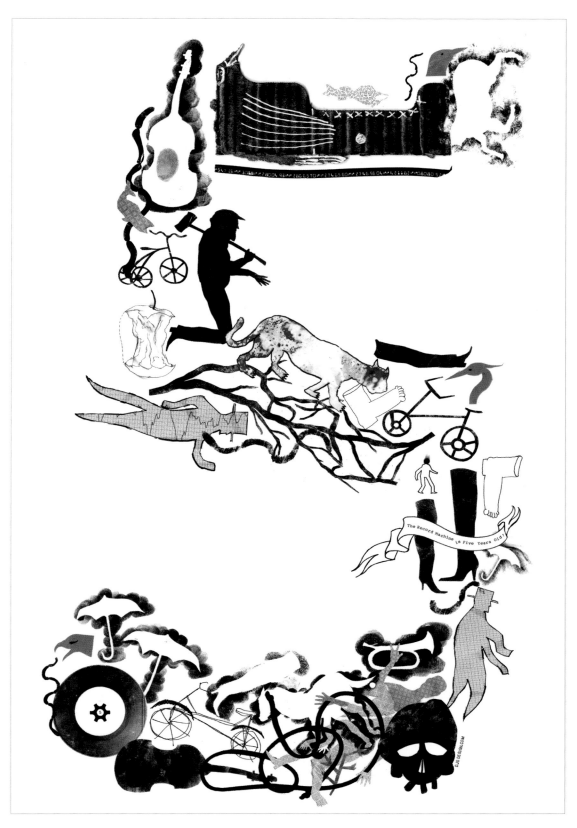

DJG DESIGN_ KANSAS CITY, MO, UNITED STATES
**CREATIVE TEAM:** Danny J. Gibson
**CLIENT:** The Record Machine

**AKARSTUDIOS_**
**SANTA MONICA, CA, UNITED STATES**
**CREATIVE TEAM:** Sean Morris
**CLIENT:** Rival Sons

**STOUT DESIGN_**
**ATLANTA, GA, UNITED STATES**
**CREATIVE TEAM:**
Matthew McKenny
**CLIENT:** Live Nation

**DAVIDPCRAWFORD.COM_**
**PITTSBURGH, PA, UNITED STATES**
**CREATIVE TEAM:** David Patrick Crawford
**CLIENT:** Caravan Theatre

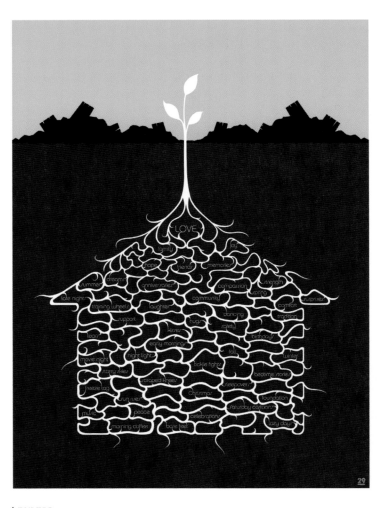

**RULE29_ GENEVA, IL, UNITED STATES**
**CREATIVE TEAM:** Justin Ahrens, Kerri Liu
**CLIENT:** So Cal Fire Poster Project

**21XDDESIGN_ BROOMALL, PA, UNITED STATES**
**CREATIVE TEAM:** Dermot Mac Cormack, Patricia Mcelroy
**CLIENT:** Tyler School of Art

"If SLAVERY is not WRONG

NOTHING IS WRONG.

—*Abraham Lincoln*, April 4, 1864 Letter to Albert Hodges

stophumantraffic.com

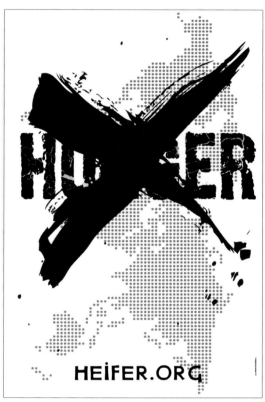

HEiFER.ORG

BIG FIG DESIGN_ BELLEVUE, WA, UNITED STATES
**CREATIVE TEAM:** Daniel Flahiff
**CLIENT:** Power to the Poster/stophumantraffic.com

SQUARE DANCE
GET ON DOWN
FOR THE MARKET
THE MARKET FOUNDATION

MONDAY MARCH 16
AT TRACTOR TAVERN
$10 BROWN PAPER TICKETS.COM
$15 AT THE DOOR
DOORS 7:30 DANCE 8:00 FEATURING THE TALLBOYS AND THE ROVING CHARMAINE

CARAVAN THEATRE OF PITTSBURGH PRESENTS:

SAVAGE IN LIMBO
BY JOHN PATRICK SHANLEY

STARRING: TONY BINGHAM, DANA HARDY, BRIDGET CAREY, WILLIAM MANN & AMY MARSALIS
DIRECTED BY: JOHN GRESH

FIVE ROOTLESS YOUNG LOSERS CONGREGATE IN AN ANONYMOUS BRONX BAR TO WRESTLE WITH THE EXISTENTIAL QUESTION OF HOW TO CHANGE THEIR LIVES. CAN THEY DO IT ON A MONDAY NIGHT BEFORE LAST CALL?

PITTSBURGH PLAYWRIGHTS THEATRE
542 PENN AVENUE
IN THE JACKMAN BUILDING BETWEEN STARBUCKS AND SUBWAY SANDWICH SHOP
WARNING: CONTAINS ADULT LANGUAGE
DONATIONS ARE ACCEPTED

FOR RESERVATIONS CALL:
(412) 288-0358

CLOCKWORK STUDIOS_
SAN ANTONIO, TX, UNITED STATES
**CREATIVE TEAM:** Terri Gaines,
Steve Gaines, Rudy Ortiz
**CLIENT:** The Market Foundation

DAVIDPCRAWFORD.COM_
PITTSBURGH, PA, UNITED STATES
**CREATIVE TEAM:** David Patrick Crawford
**CLIENT:** Caravan Theatre

DJG DESIGN_ KANSAS CITY, MO, UNITED STATES
**CREATIVE TEAM:** Danny J. Gibson
**CLIENT:** The Vines and Jet

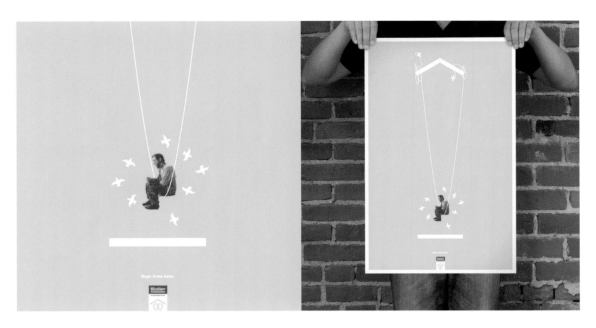

PRYOR DESIGN COMPANY_ ANN ARBOR, MI, UNITED STATES
**CREATIVE TEAM:** Scott Pryor, Chris Wisniewski
**CLIENT:** Shelter Association of Washtenaw County

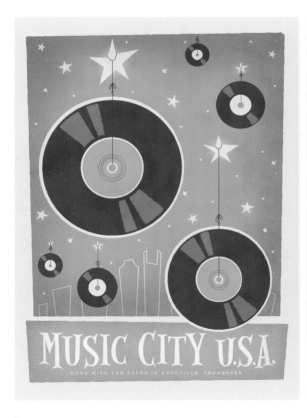

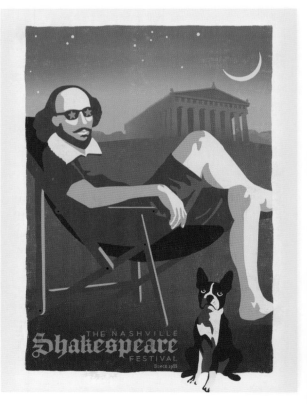

ANDERSON DESIGN GROUP_ NASHVILLE, TN, UNITED STATES
**CREATIVE TEAM:** Joel Anderson, Darren Welch, Kristi Smith
**CLIENT:** Spirit of Nashville

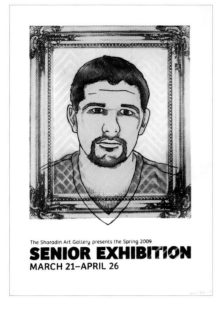

KUTZTOWN UNIVERSITY_ BLANDON, PA, UNITED STATES
**CREATIVE TEAM:** William Michael Riedel, Brenda Innocenti, Dan R Talley
**CLIENT:** Sharadin Art Gallery, Kutztown University of Pennsylvania

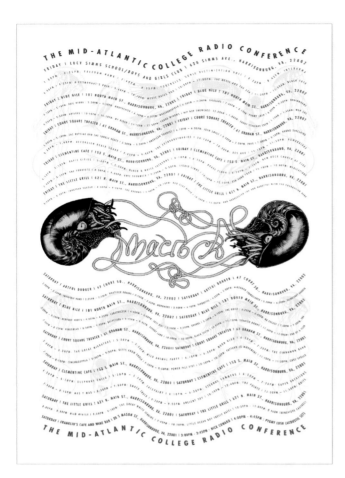

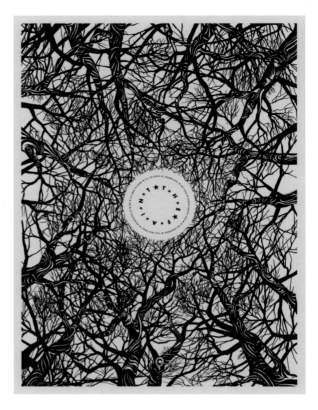

312

CALAGRAPHIC DESIGN_ ELKINS PARK, PA, UNITED STATES
**CREATIVE TEAM:** Ronald J. Cala II, Kate Crosgrove
**CLIENT:** R5 Productions

CALAGRAPHIC DESIGN_ ELKINS PARK, PA, UNITED STATES
**CREATIVE TEAM:** Ronald J. Cala II, Kate Crosgrove
**CLIENT:** Shy Girl Design

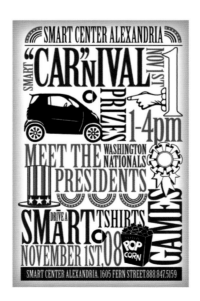

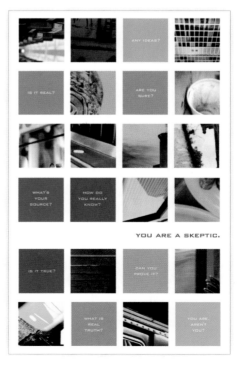

SIMPATICO DESIGN STUDIO_
ALEXANDRIA, VA, UNITED STATES
**CREATIVE TEAM:** Amy Simpson
**CLIENT:** Lindsay smart Center Alexandria

D STREET DESIGN_ SAN CLEMENTE, CA, UNITED STATES
**CREATIVE TEAM:** Lynne Door
**CLIENT:** Personal design

CREATIVE SUITCASE, AUSTIN, TX, UNITED STATES
**CREATIVE TEAM:** Rachel Clemens, Mackenzie Walsh
**CLIENT:** UB Ski

# Websites

**DANIEL ROTHIER_** RIO DE JANEIRO, BRAZIL
**CREATIVE TEAM:** Daniel Rothier
**CLIENT:** Amazonutry Beauty Products

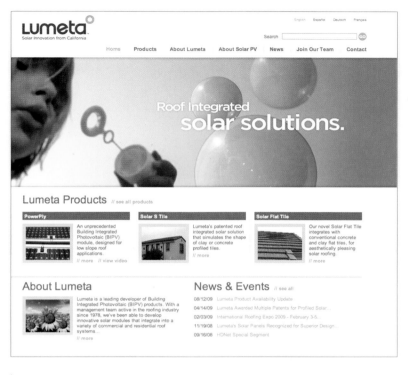

**CREATIVE SUITCASE**_ AUSTIN, TX, UNITED STATES
**CREATIVE TEAM:** Rachel Clemens, Jennifer Wright
**CLIENT:** Andrew Harper

**THE UXB**_ BEVERLY HILLS, CA, UNITED STATES
**CREATIVE TEAM:** Nancy Jane Goldston, Daiga Atvara, William Quinn, Hannah Cheadle
**CLIENT:** Lumeta™

317

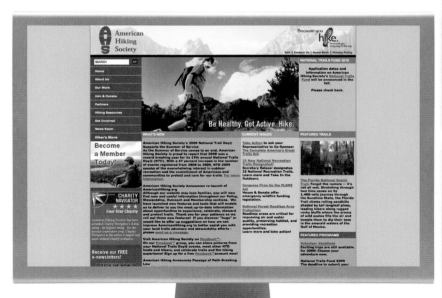

**SELLIER DESIGN**_ MARIETTA, GA, UNITED STATES
**CREATIVE TEAM:** Pauline Pellicer, Kriston Sellier
**CLIENT:** American Hiking Society

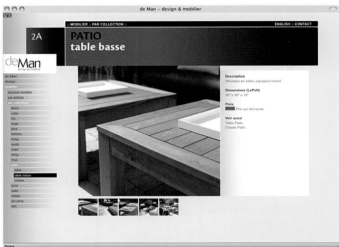

**SUBCOMMUNICATION_** MONTREAL, QC, CANADA
**CREATIVE TEAM:** Sebastien Theraulaz, Valerie Desrochers, Gregoire Buquet
**CLIENT:** De Man design Inc.

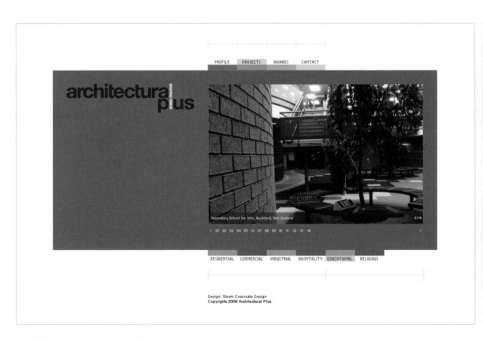

**STORM CORPORATE DESIGN_** AUCKLAND, NEW ZEALAND
**CREATIVE TEAM:** Rehan Saiyed
**CLIENT:** Architectural Plus

PROJECTS | SELECTED | ON THE BOARDS | LIST

ABOUT US |

PRESS |

CONTACT |

**University District Mixed-Use**

*Seattle, WA*

Working with 58,000 SF lot in the University District, analysis of the zoning and building codes have yielded a 7 story mixed use residential building with 15,000 sf at grade retail space and 270 residential units with 170 enclosed below grade parking spaces. As part of the design for this apartment building, amenity spaces such as open courtyards and roof decks have been incorporated.

H+dIT

collaborative, llc
architecture+planning+design

© H+dIT Collaborative

**NETRA NEI** SEATTLE, WA, UNITED STATES
**CREATIVE TEAM:** Netra Nei, Mik Nei
**CLIENT:** H+dlt Collaborative

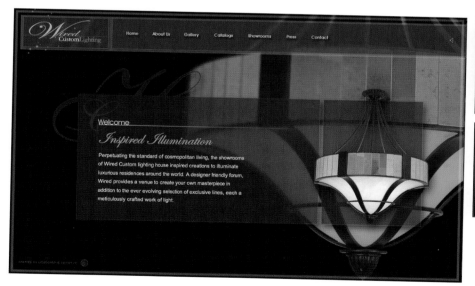

**LIQUIDCHROME DESIGN INC.** VAUGHAN, ON, CANADA
**CREATIVE TEAM:** Johnny Molina
**CLIENT:** Wired Custom Lighting

**LEVINE & ASSOCIATES, INC._** WASHINGTON, DC, UNITED STATES
**CREATIVE TEAM:** Lena Markley, Marco Javier
**CLIENT:** American Chemical Society

 320

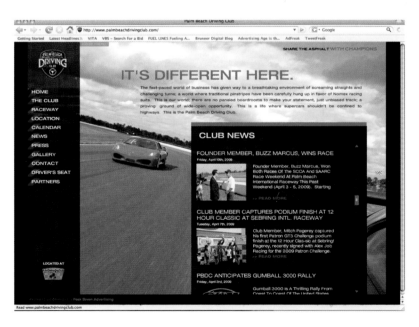

**PEAK SEVEN ADVERTISING_** DEERFIELD BEACH, FL, UNITED STATES
**CREATIVE TEAM:** Darren Seys, Josh Munsee, Luis Salinas
**CLIENT:** Palm Beach International Raceway

**COPIA CREATIVE, INC._** SANTA MONICA, CA, UNITED STATES
**CREATIVE TEAM:** Copia Creative Team
**CLIENT:** Self-promotion

**1H05_** PARIS, FRANCE
**CREATIVE TEAM:** Pierrick Calvez
**CLIENT:** Self-promotion

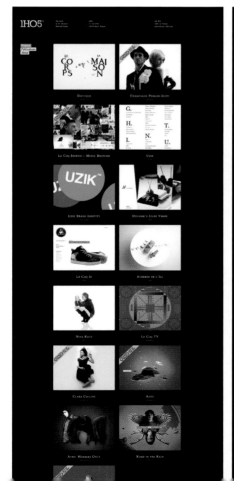

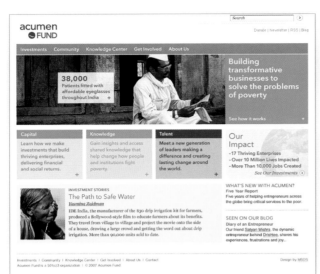 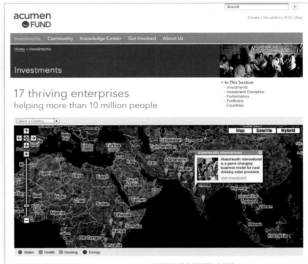

**MSDS_** NEW YORK, NY, UNITED STATES
**CREATIVE TEAM:** Matthew Schwartz, David Ross
**CLIENT:** Acumen Fund

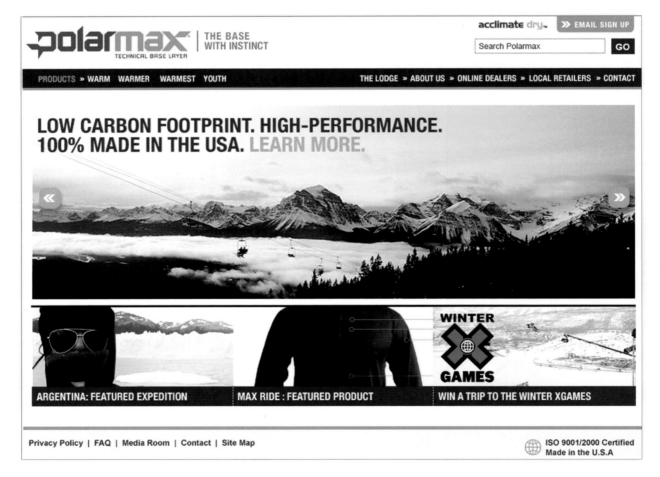

**AIRTYPE STUDIO_** WINSTON-SALEM, NC, UNITED STATES
**CREATIVE TEAM:** Bryan Ledbetter, James Greene
**CLIENT:** Longworth Industries

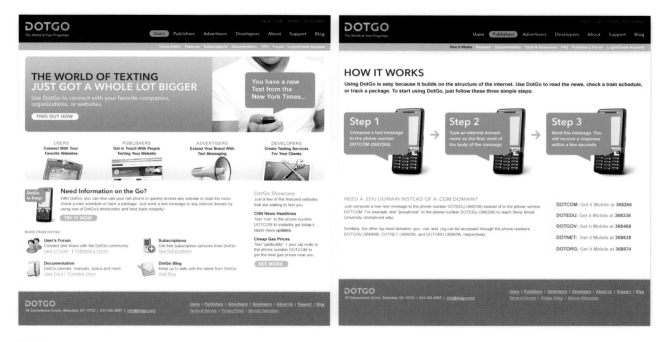

**MSDS_** NEW YORK, NY, UNITED STATES
**CREATIVE TEAM:** Matthew Schwartz, Niall O'Kelly, Paul Chamberlain
**CLIENT:** DotGo

323

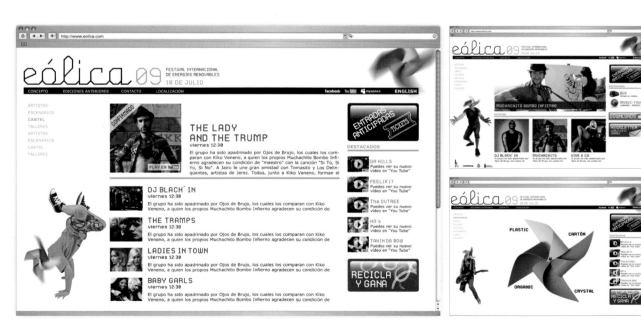

**VALLADARES DISEÑO Y COMUNICACIÓN_** SANTA CRUZ, SANTA CRUZ DE TENERIFE, SPAIN
**CREATIVE TEAM:** José Jiménez Valladares
**CLIENT:** Elementhal

**SUBCOMMUNICATION_** MONTREAL, QC, CANADA
**CREATIVE TEAM:** Sebastien Theraulaz, Valerie Desrochers
**CLIENT:** Soclarke Productions

**UNIT DESIGN COLLECTIVE_**
SAN FRANCISCO, CA, UNITED STATES
**CREATIVE TEAM:** Ann Jordan, Shardul Kiri
**CLIENT:** City of Santa Monica

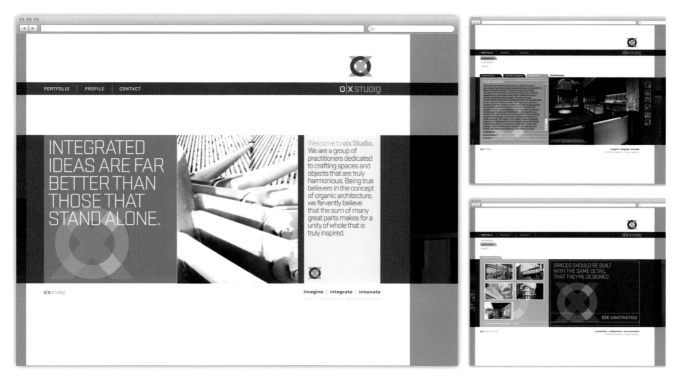

**PRYOR DESIGN COMPANY_** ANN ARBOR, MI, UNITED STATES
| **CREATIVE TEAM:** Scott Pryor, Chris Wisniewski
| **CLIENT:** o|x Studio

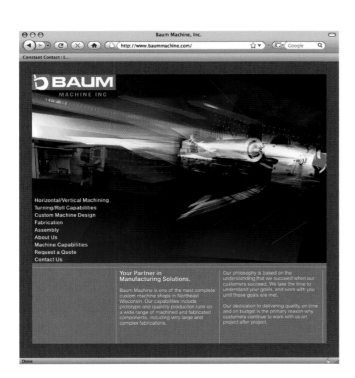

**LEIBOLD ASSOCIATES, INC._** NEENAH, WI, UNITED STATES
| **CREATIVE TEAM:** Jason Konz, Greg Madson, Kris Peterson
| **CLIENT:** Baum Machine, Inc.

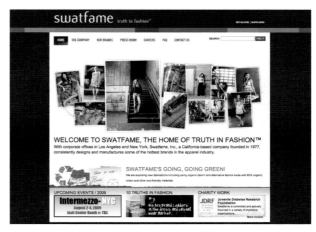

**THE UXB_** BEVERLY HILLS, CA, UNITED STATES
| **CREATIVE TEAM:** NancyJane Goldston, Daiga Atvara, William Quinn, Hannah Cheadle
| **CLIENT:** Swatfame®

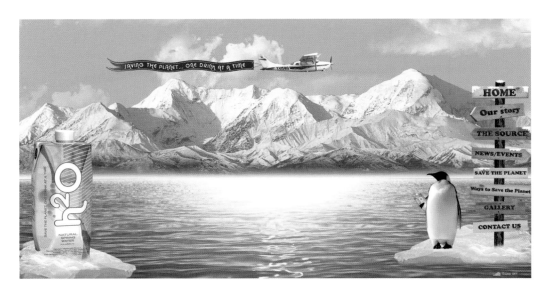

CREA7IVE_ CORAL SPRINGS, FL, UNITED STATES
CREATIVE TEAM: Maria Pia Celestino, Paula Celestino
CLIENT: RatedRRims.com

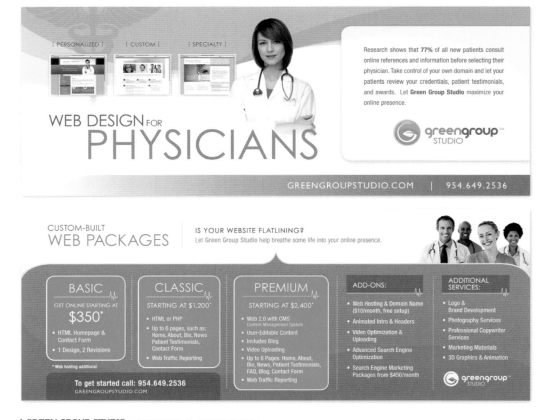

GREEN GROUP STUDIO_ GREENACRES, FL, UNITED STATES
CREATIVE TEAM: Clara Mateus, Allen Borza
CLIENT: Self-promotion

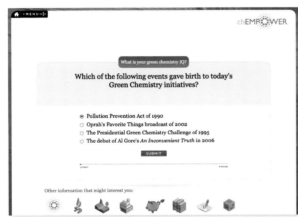

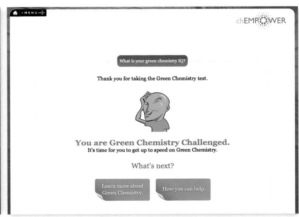

**LEVINE & ASSOCIATES, INC._** WASHINGTON, DC, UNITED STATES
**CREATIVE TEAM:** Marco Javier
**CLIENT:** American Chemical Society

**NORA BROWN DESIGN_** BROOKLINE, MA, UNITED STATES
**CREATIVE TEAM:** Nora Brown
**CLIENT:** Behind The Knife

**22SPARKS-DIGITAL CREATIVE AGENCY_** ASCHAFFENBURG, GERMANY
**CREATIVE TEAM:** Thorsten Marks
**CLIENT:** Augenklinik Aschaffenburg

**ZAVE SMITH PHOTOGRAPHY SIX DEGREES OF CONCEPTUALIZATION**

INFO

ORGANIC GRID_ PHILADELPHIA, PA, UNITED STATES
**CREATIVE TEAM:** Michael McDonald, Max Liberman, Zave Smith
**CLIENT:** Zave Smith Photography

PEAK SEVEN ADVERTISING_ DEERFIELD BEACH, FL, UNITED STATES
**CREATIVE TEAM:** Darren Seys, Luis Salinas, Brian Tipton
**CLIENT:** Dublin Scrap Metal

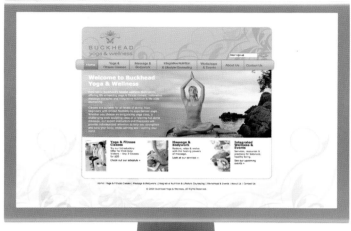

SELLIER DESIGN_ MARIETTA, GA, UNITED STATES
**CREATIVE TEAM:** Pauline Pellicer
**CLIENT:** Buckhead Yoga and Wellness

DOUG BARRETT DESIGN_ BIRMINGHAM, AL, UNITED STATES
**CREATIVE TEAM:** Douglas Barrett
**CLIENT:** Ink to Paper

ink to paper

**HOME**

**SERVICES**

**GALLERY**

**PRICING**

PREP

**UPLOAD**

**WELCOME** to Ink to Paper! We provide high-quality injet printing services for the fine arts and commerical disciplines. Specializing in large format printing and acid-free papers, let us show you how easy and affordable quality inkjet printing can be.

**EASY AS 1-2-3.**
Use our easy cost calculator to figure out your cost per page, we offer generous discounts for multiple prints. You can always talk directly to the printing specialist who is printing your job and our white glove delivery service means that your prints will be carefully wrapped, packaged and shipped directly to your door via USPS or FedEx. Choose your paper, size, quantity, upload your file and pay all from your computer.

**QUALITY ASSURED.**
We use only the highest quality inkjet pigments, acid-free papers and the latest in color correction techniques and drivers to assure that your prints are perfect and will last a lifetime. Send us your files and print with confidence.

 The digital printing experts!
**INK TO PAPER.NET** | SERVICE@INKTOPAPER.NET
1215 Woolco Way, Birmingham, AL 45009-1215 | 322.456.3232

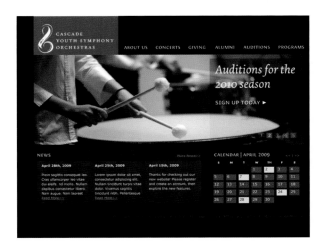

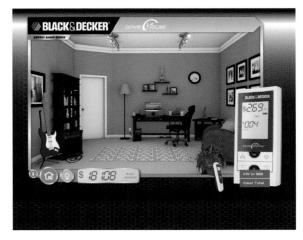

**WEATHER CONTROL_** SEATTLE, WA, UNITED STATES
**CREATIVE TEAM:** Josh Oakley
**CLIENT:** CYSO (Cascade Youth Symphony Orchestra)

**DIXON SCHWABL_** VICTOR, NY, UNITED STATES
**CREATIVE TEAM:** Ian Auch, Marshall Statt, Will Browar, Jim Tausch
**CLIENT:** Black & Decker

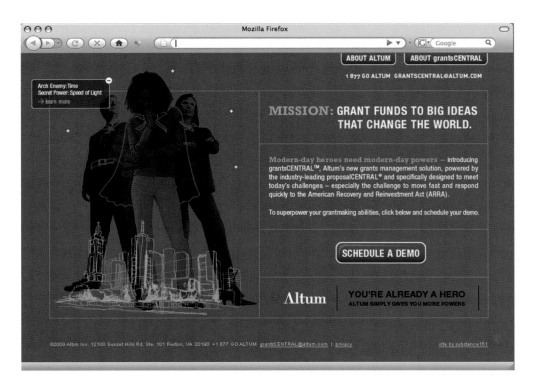

**SUBSTANCE151_** BALTIMORE, MD, UNITED STATES
**CREATIVE TEAM:** Ida Cheinman, Rick Salzman, Susan Olson, Dani Bradford
**CLIENT:** Altum

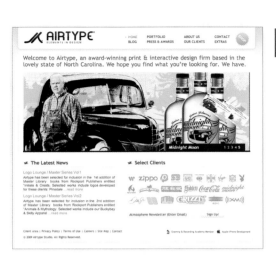

**AIRTYPE STUDIO_** WINSTON-SALEM, NC, UNITED STATES
**CREATIVE TEAM:** Bryan Ledbetter, James Greene
**CLIENT:** Self-promotion

**CAMP CREATIVE GROUP_** BLUE RIDGE SUMMIT, PA, UNITED STATES
**CREATIVE TEAM:** Sarah Camp
**CLIENT:** Self-promotion

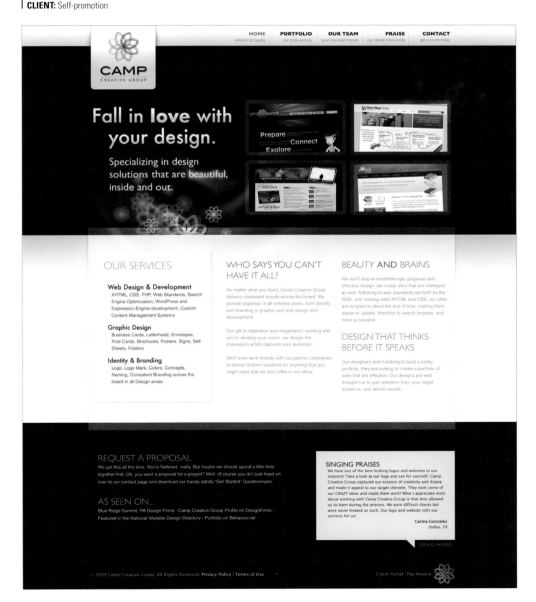

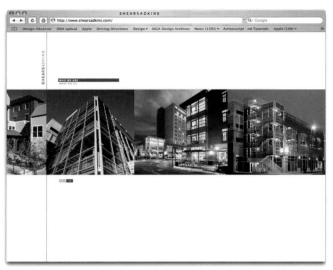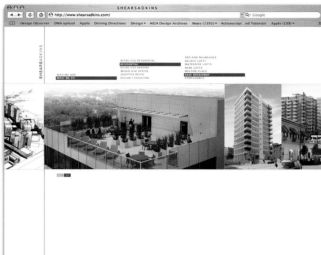

**ELLEN BRUSS DESIGN_** DENVER, CO, UNITED STATES
**CREATIVE TEAM:** Ellen Bruss, Jorge Lamora
**CLIENT:** Shears Adkins Architects

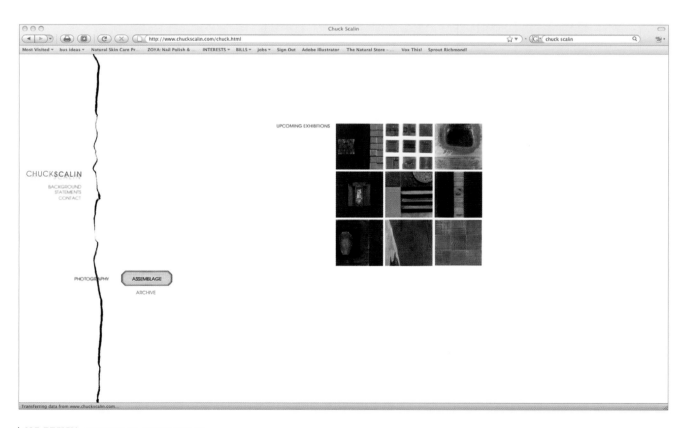

**ALR DESIGN_** RICHMOND, VA, UNITED STATES
**CREATIVE TEAM:** Noah Scalin
**CLIENT:** Chuck Scalin

**LIFEBLUE MEDIA_** ALLEN, TX, UNITED STATES
**CREATIVE TEAM:** Phillip Blackmon, Jeff Nunn, Shauna Kamer
**CLIENT:** Cellcom

333

**MSDS_** NEW YORK, NY, UNITED STATES
**CREATIVE TEAM:** Matthew Schwartz, David Ross
**CLIENT:** Touch Foundation

**IMAGEBOX PRODUCTIONS INC_** PITTSBURGH, PA, UNITED STATES
**CREATIVE TEAM:** John Mahood, David Patrick Crawford, Anthony Bruno
**CLIENT:** College Bound Admissions Academy

**BRONSON MA CREATIVE_** SAN ANTONIO, TX, UNITED STATES
**CREATIVE TEAM:** Bronson Ma, Orion Linekin, Mark Priddy
**CLIENT:** Hirschfeld Industries

**SUBSTANCE151_** BALTIMORE, MD, UNITED STATES
**CREATIVE TEAM:** Ida Cheinman, Rick Salzman,
Susan Olson, John Barrick
**CLIENT:** Altum

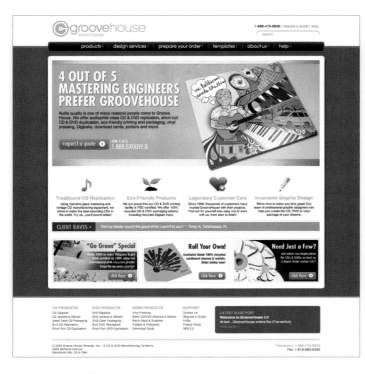

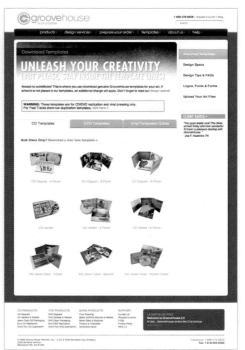

335

**VERSION-X DESIGN CORP_** BURBANK, CA, UNITED STATES
**CREATIVE TEAM:** Chris Fasan, Adam Stoddard
**CLIENT:** GrooveHouse

**TALBOT DESIGN GROUP, INC._** WESTLAKE VILLAGE, CA, UNITED STATES
**CREATIVE TEAM:** Anitsa Barr, Gaylyn Talbot, Lindsey Bergman
**CLIENT:** Pindler & Pindler Inc.

**CALAGRAPHIC DESIGN_** ELKINS PARK, PA, UNITED STATES
**CREATIVE TEAM:** Ronald J. Cala II, Genevieve Astrelli, Curtis Clarkson
**CLIENT:** CMYK Magazine

336

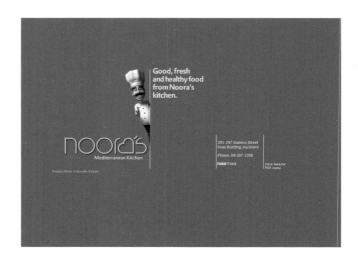

**OHTWENTYONE_** COLLEYVILLE, TX, UNITED STATES
**CREATIVE TEAM:** Jon Sandruck
**CLIENT:** ohTwentyone

**STORM CORPORATE DESIGN_** AUCKLAND, AL, NEW ZEALAND
**CREATIVE TEAM:** Rehan Saiyed
**CLIENT:** Noora's Mediteranean Kitchen

**DOUG BARRETT DESIGN**_ BIRMINGHAM, AL, UNITED STATES
**CREATIVE TEAM:** Douglas Barrett, Christopher Lowther, Kim Duong
**CLIENT:** University of Alabama at Birmingham, Department of Art & Art History

337

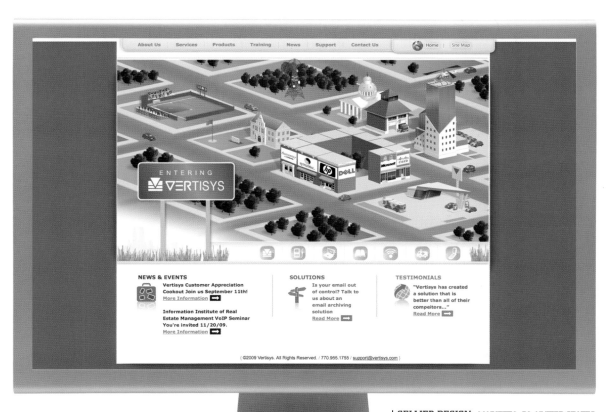

**SELLIER DESIGN**_ MARIETTA, GA, UNITED STATES
**CREATIVE TEAM:** Kriston Sellier, Dan Pieper,
Robert Thompson, Nick Villaume
**CLIENT:** Vertisys

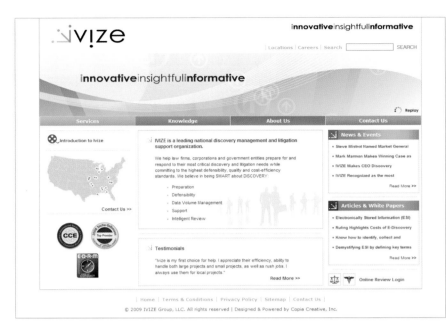

**COPIA CREATIVE, INC._** SANTA MONICA, CA, UNITED STATES
**CREATIVE TEAM:** Copia Creative Team
**CLIENT:** IVIZE Group, LLC.

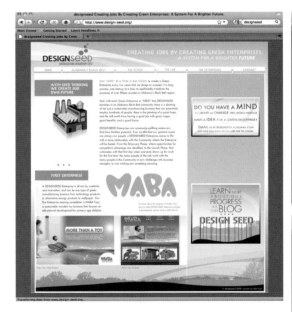

**JUST NIKKI_** BROOKLYN, NY, UNITED STATES
**CREATIVE TEAM:** Nikki Kurt, Daniel Reece
**CLIENT:** Mark Smith

Capital Metro Leander Park and Ride

McKinney York is now firmly established as a leading general practice firm in Texas with expertise across the full spectrum of building types from residential to institutional.

**CREATIVE SUITCASE_** AUSTIN, TX, UNITED STATES
**CREATIVE TEAM:** Rachel Clemens, Jennifer Wright
**CLIENT:** McKinney York Architects

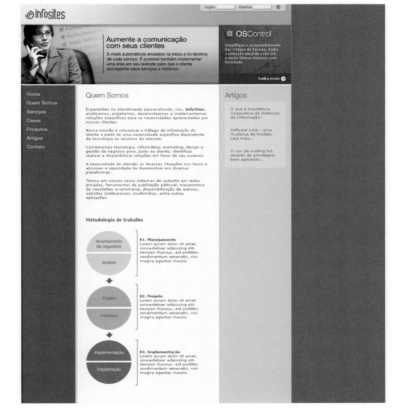

**STOUT DESIGN_** ATLANTA, GA, UNITED STATES
**CREATIVE TEAM:** Matthew McKenny
**CLIENT:** GMP International

**288_** RIO DE JANEIRO, RIO DE JANEIRO, BRAZIL
**CREATIVE TEAM:** Guilherme Howat
**CLIENT:** Infosites

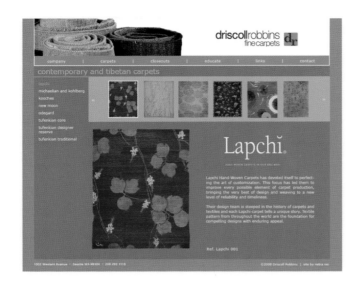

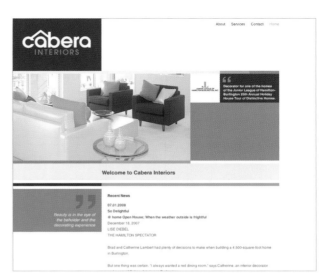

**NETRA NEI_** SEATTLE, WA, UNITED STATES
**CREATIVE TEAM:** Netra Nei, Mik Nei
**CLIENT:** Driscoll Robbins

**CARDEO CREATIVE_** NORTH VANCOUVER, BC, CANADA
**CREATIVE TEAM:** Matt Lambert
**CLIENT:** Cabera Interiors

**NALINDESIGN_** NEUENRADE, GERMANY
**CREATIVE TEAM:** Andre Weier
**CLIENT:** The Asura

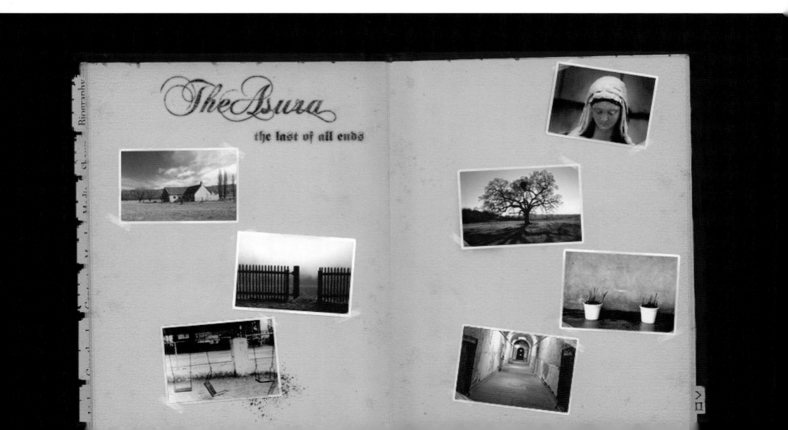

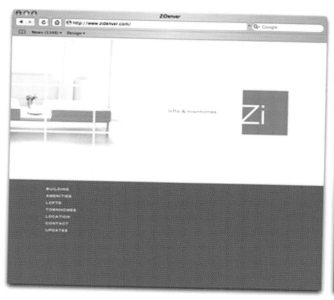

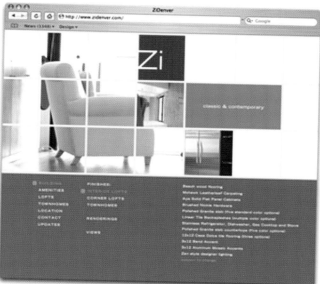

**ELLEN BRUSS DESIGN_** DENVER, CO, UNITED STATES
**CREATIVE TEAM:** Ellen Bruss, Jorge Lamora
**CLIENT:** Zi Denver

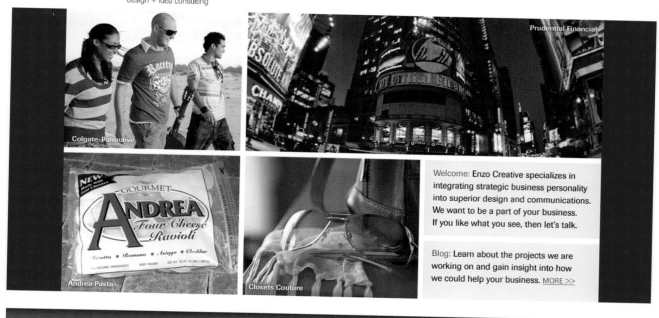

**ENZO CREATIVE_** SUMMIT, NJ, UNITED STATES
**CREATIVE TEAM:** Lou Leonardis
**CLIENT:** Self-promotion

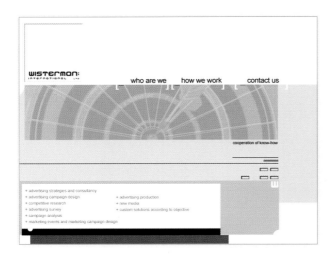

**TYPOGRAPHICSPELL_** ISTANBUL, TURKEY
**CREATIVE TEAM:** Didem Carikci Wong
**CLIENT:** Wisterman International

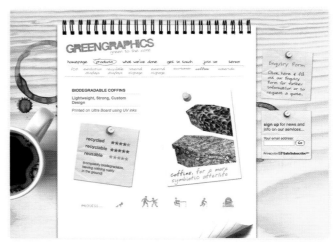

**CRUMPLED DOG DESIGN_** LONDON, UNITED KINGDOM
**CREATIVE TEAM:** David Tennant-Eyles
**CLIENT:** Green Graphics

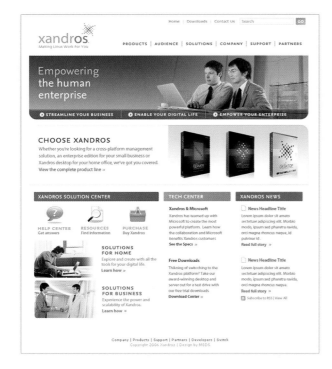

**MSDS_** NEW YORK, NY, UNITED STATES
**CREATIVE TEAM:** Nathan Jones, Matthew Schwartz, David Ross
**CLIENT:** Xandros

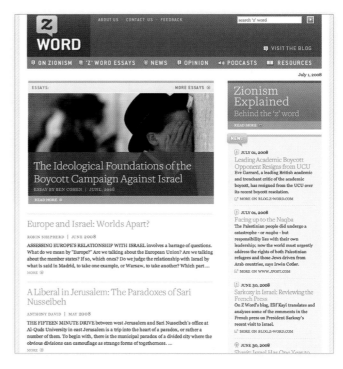

**MSDS_** NEW YORK, NY, UNITED STATES
**CREATIVE TEAM:** Zoya Edylman, Matthew Schwartz, David Ross, Guang Yan Wang
**CLIENT:** American Jewish Committee

343

**ORGANIC GRID_** PHILADELPHIA, PA, UNITED STATES
**CREATIVE TEAM:** Michael McDonald, Zave Smith, Tony Profeta
**CLIENT:** Gravica Design

**RUTGERS UNIVERSITY_** NJ, UNITED STATES
**CREATIVE TEAM:** Jun Li, Matt Weiss
**CLIENT:** IDG, International Data Group

THE *Quentin Blake* WEBSITE

News & Events
About Quentin Blake
Books · Exhibitions
International · Kids
Illustrators · Fossicking
Teachers & Parents
Prints · Contact

© Quentin Blake 2007 | Site Map | Terms & Conditions

## An In-Depth Look

## Quentin Blake

Quentin Blake, the renowned illustrator and children's book author, has created or contributed to more than three hundred books in half a century—but the web was terra incognita for the English artist. "Web sites and all things digital were not his natural or favorite domain," says Dominic Latham-Koenig of London's Beam design firm, "and so this dream commission required careful planning to respect his genius and not blur or distract from his unique and effervescent visual language."

Blake, who had recently turned seventy-five, had been gently encouraged by colleagues to make a home on the web, and Latham-Koenig happened to have a mutual colleague who was working with Blake on an editorial level when the former Children's Laureate and the much younger creative director met. The collaboration, which lasted five months, grew out of trust. "He invited us in to explore his archives," Latham-Koenig says. "I think he trusted us to respect the integrity of his artwork, and we got off to a pretty good start." Latham-Koenig and the font-loving Blake agreed to base the web site upon a strong typographic element, featuring the artist's trademark Goudy Old Style font. Latham-Koenig describes Blake as "a great layout artist" who worked closely with text in all the books he designed. "We gave him a tangible design process he could see," he says. "That gave him confidence in letting us work."

Latham-Koenig handled the extraordinary project with the same sensitivity with which he handled Blake's original drawings: with white gloves. "I think I was inevitably in awe of the project but also incredibly excited about it," he says. *"When you're working with an artist with so much suc-cess and international respect, someone who is kind of untrusting of computers as a medium, I knew I had to go in gently and get him excited about the opportunities they could present."* A previous, BBC-spearheaded attempt to animate some of Blake's characters years before had failed badly, but Latham-Koenig dared to bring them boldly to this newest medium. "I was aware of so much natural movement in his images so I wanted to use that to create the energy," he says.

Latham-Koenig particularly enjoyed going through the archives, as would many people raised on Blake's work, but kept in mind the need to present an evenhanded representation of his client's work. "He illustrated all of Roald Dahl's books, such as James and the Giant Peach, all these wonderful characters I grew up with as a child. But I was aware he'd drawn a lot of other books in his own right, so getting the balance between the Roald Dahl images and the non-Roald Dahl images was important, as there are people who knew him more as Quentin Blake the writer and illustrator in his own right. I wanted to address that balance." Blake, while giving Latham-Koenig free rein in the site's design, contributed personal insight to the finer points of the layout. "Occasionally he wanted other images to be chosen that he thought were more appropriate for the part of the site we were trying to illustrate," Latham-Koenig says.

The Quentin Blake archives also yielded unexpected delights for Quentin Blake himself and led to its own site section, "Fossicking." "It means, 'searching for things you've got hidden away,'" Latham-Koenig explains. "It's got

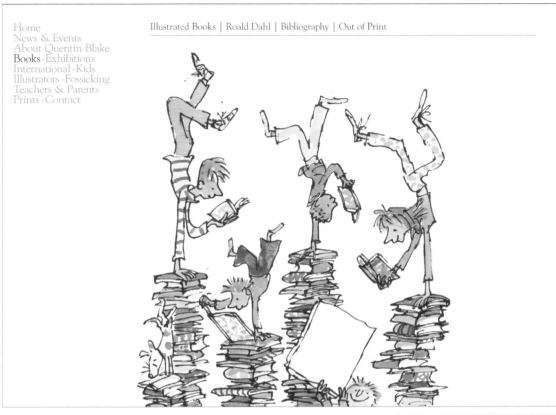

**BEAM_** LONDON, UNITED KINGDOM
**CREATIVE TEAM:** Dominic Latham-Koenig
**CLIENT:** Quentin Blake

a wonderful onomatopoeic quality to it, but it's also very Quentin Blake. *For the fans and aficionados, it was very exciting—from unpublished books, cartoons from the Sixties for Punch and American publications, books that had gone out of print, stuff that had been hidden away…* It had a chance to be seen by anyone who had a connection to the web. He really started to see the excitement and potential of having an online presence."

The site pays homage to a still-vital artist in a way that's still warm, fun and irreverent—much like Quentin Blake himself. "He's an institution," Latham-Koenig says. "He's now doing an extraordinary amount of work in hospitals and other institutions to let his illustrations help kids. He has amazing energy still."

**LEVINE & ASSOCIATES, INC._** WASHINGTON, DC, UNITED STATES
**CREATIVE TEAM:** Marco Javier, Lauren Hassani
**CLIENT:** American Chemical Society

**DESIGN NUT, LLC_** KENSINGTON, MD, UNITED STATES
**CREATIVE TEAM:** Brent M. Almond, Michael Schafer
**CLIENT:** Apartment and Office Building Association of Metropolitan Washington

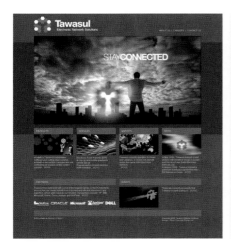

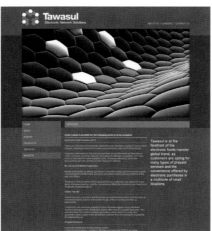

STORM CORPORATE DESIGN_ AUCKLAND, NEW ZEALAND
CREATIVE TEAM: Rehan Saiyed
CLIENT: Tawasul Networking Solutions

PAIGE1MEDIA_ BROKEN ARROW, OK, UNITED STATES
CREATIVE TEAM: JP Jones, Nicholas Clayton
CLIENT: Nicholas Clayton

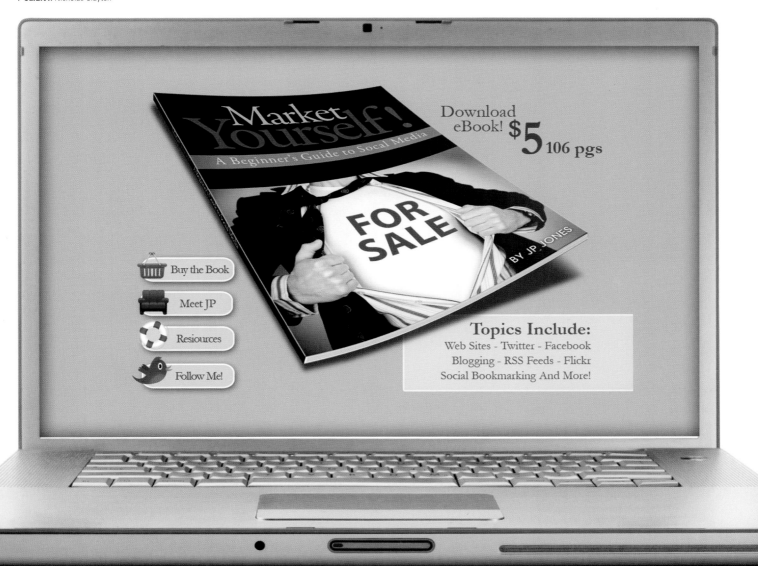

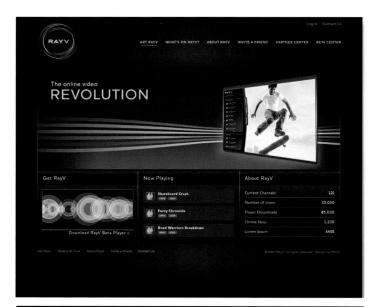

**MSDS_** NEW YORK, NY, UNITED STATES
**CREATIVE TEAM:** Nathan Jones, Matthew Schwartz
**CLIENT:** Ray V

**ORGANIC GRID_** PHILADELPHIA, PA, UNITED STATES
**CREATIVE TEAM:** Michael McDonald, Max Liberman, Zave Smith
**CLIENT:** Margraffix

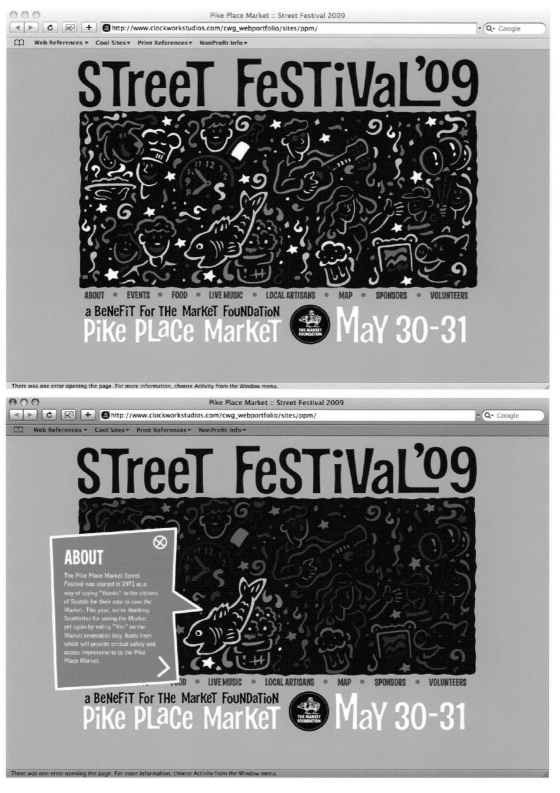

**CLOCKWORK STUDIOS**_ SAN ANTONIO, TX, UNITED STATES
**CREATIVE TEAM:** Terri Gaines, Steve Gaines, Shawn Meek
**CLIENT:** The Market Foundation

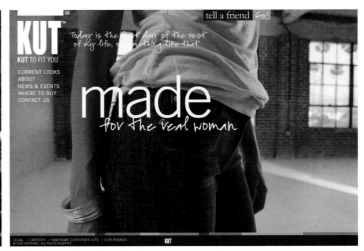

THE UXB_ BEVERLY HILLS, CA, UNITED STATES
**CREATIVE TEAM:** NancyJane Goldston, Daiga Atvara, William Quinn, Hannah Cheadle
**CLIENT:** Swatfame®

PRYOR DESIGN COMPANY_ ANN ARBOR, MI, UNITED STATES
**CREATIVE TEAM:** Scott Pryor, Chris Wisniewski, Brandon Goldsworthy
**CLIENT:** Nexcess

PRYOR DESIGN COMPANY_ ANN ARBOR, MI, UNITED STATES
**CREATIVE TEAM:** Scott Pryor, Chris Wisniewski
**CLIENT:** Synthogy

351

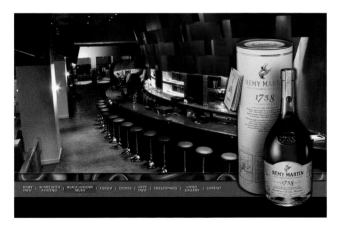

GIGAPIXEL CREATIVE, INC._ NEW YORK, NY, UNITED STATES
**CREATIVE TEAM:** Joey Kilrain, Yao Hui Huang
**CLIENT:** Rémy Martin

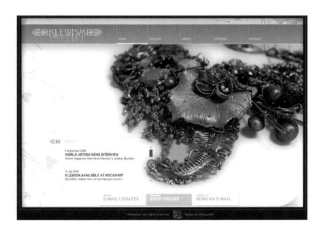

CAROUSEL30_ ALEXANDRIA, VA, UNITED STATES
**CREATIVE TEAM:** Greg Kihlstrom
**CLIENT:** Klewism

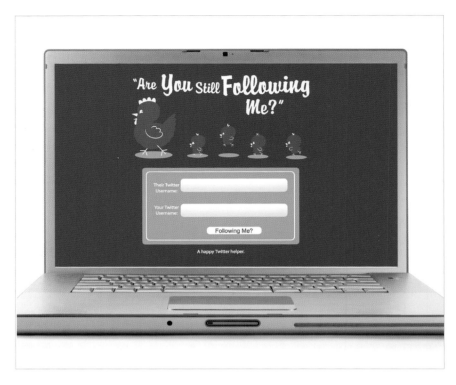

PAIGE1MEDIA_ BROKEN ARROW, OK, UNITED STATES
**CREATIVE TEAM:** Nicholas Clayton, JP Jones
**CLIENT:** Still Following Me.com

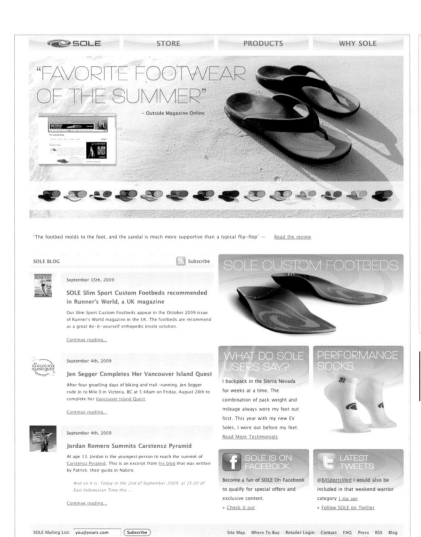

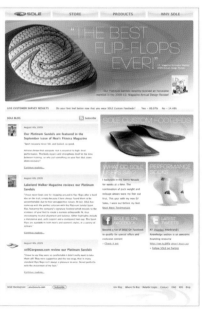

CARDEO CREATIVE_
NORTH VANCOUVER, BC, CANADA
**CREATIVE TEAM:** Matt Lambert, Ryan Lawrie,
Greg Davidson, Andrew Baerg
**CLIENT:** SOLE

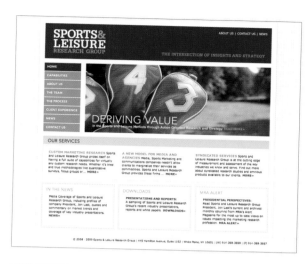

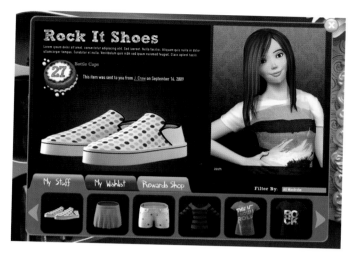

**MCMILLIAN DESIGN_** BROOKLYN, NY, UNITED STATES
**CREATIVE TEAM:** William McMillian, Lindsay Giuffrida, James Birch
**CLIENT:** Sports and Leisure Research Group

**LIFEBLUE MEDIA_** ALLEN, TX, UNITED STATES
**CREATIVE TEAM:** Phillip Blackmon, Jeff Nunn, Shauna Kamer
**CLIENT:** So2Gether (Fine Print Publishing)

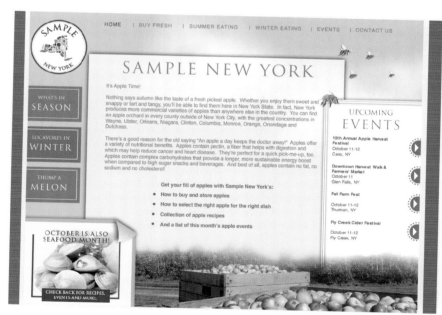

**DIXON SCHWABL_** VICTOR, NY, UNITED STATES
**CREATIVE TEAM:** Deanna Varble, Will Browar, Wayne Gormont, Dana Denberg, Jim Tausch
**CLIENT:** The New York Wine & Culinary Center

**ALEXANDER EGGER_** VIENNA, AUSTRIA
**CREATIVE TEAM:** Alexander Egger, Stefan Rinner
**CLIENT:** Mika Vember

**LIQUIDCHROME DESIGN INC._** VAUGHAN, ON, CANADA
**CREATIVE TEAM:** Johnny Molina
**CLIENT:** Hain Celestial Canada

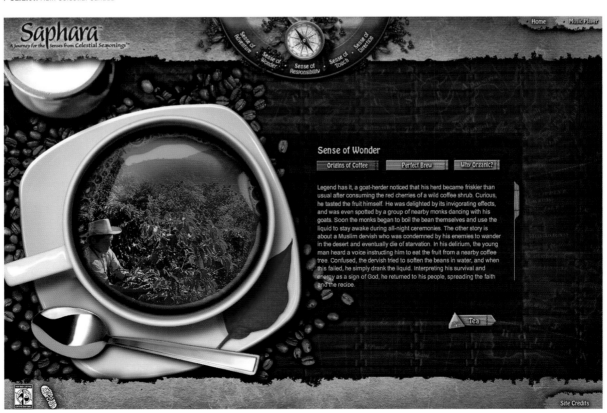

LIFEBLUE MEDIA_ ALLEN, TX, UNITED STATES
**CREATIVE TEAM:** Phillip Blackmon
**CLIENT:** Mom And Popcorn Shop, Mckinney, TX

355

**AXIOMACERO** _ MONTERREY, NUEVO LEON, MEXICO
**CREATIVE TEAM:** Mabel Morales, Carmen Rodriguez, Mauricio Kuriel
**CLIENT:** Harbar Tortillas

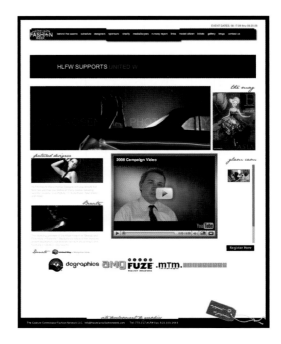

**DCGRAPHICS**_ ATLANTA, GA, UNITED STATES
**CREATIVE TEAM:** Dionna Collins, Layla K
**CLIENT:** Haute.lanta Fashion Week

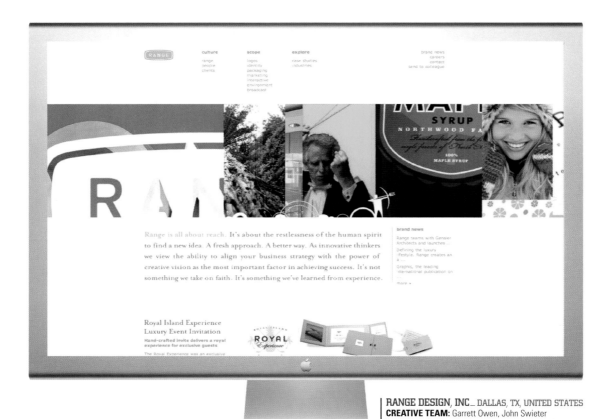

**RANGE DESIGN, INC**_ DALLAS, TX, UNITED STATES
**CREATIVE TEAM:** Garrett Owen, John Swieter
**CLIENT:** Self-promotion

**DEZINEGIRL CREATIVE STUDIO, LLC_**
SAN DIEGO, CA, UNITED STATES
**CREATIVE TEAM:** Pam Brown
**CLIENT:** Porch Light Psychology Services

357

**PRYOR DESIGN COMPANY_** ANN ARBOR, MI, UNITED STATES
**CREATIVE TEAM:** Scott Pryor, Chris Wisniewski
**CLIENT:** RealKidz

**RIBBONS OF RED_** CINCINNATI, OH, UNITED STATES
**CREATIVE TEAM:** Renee Rist
**CLIENT:** Ribbons of Red

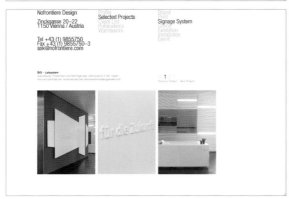

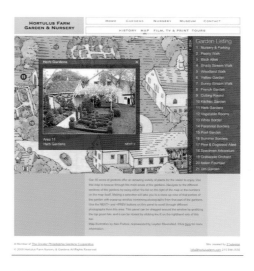

**358**

**ALEXANDER EGGER_** VIENNA, AUSTRIA
**CREATIVE TEAM:** Alexander Egger
**CLIENT:** Nofrontiere dsign

**STOUT DESIGN_** ATLANTA, GA, UNITED STATES
**CREATIVE TEAM:** Matthew McKenny
**CLIENT:** Historic Roswell Massage

**21XDDESIGN_** BROOMALL, PA, UNITED STATES
**CREATIVE TEAM:** Dermot Mac Cormack,
Patricia Mcelroy, Lena Cardell
**CLIENT:** Hortulus Farm

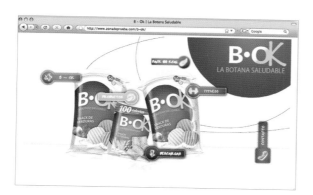

AXIOMACERO _ MONTERREY, NUEVO LEON, MEXICO
**CREATIVE TEAM:** Mabel Morales, Carmen Rodriguez, Mauricio Kuriel
**CLIENT:** Bokados

CONRY DESIGN_ TOPANGA, CA, UNITED STATES
**CREATIVE TEAM:** Rhonda Conry
**CLIENT:** Nui

UNIT DESIGN COLLECTIVE_ SAN FRANCISCO, CA, UNITED STATES
**CREATIVE TEAM:** Ann Jordan, Shardul Kiri
**CLIENT:** GALA (Globalization & Localization Association)

359

ADAM KATZ_ SOMERVILLE, MA, UNITED STATES
**CREATIVE TEAM:** Adam Katz
**CLIENT:** Archdesign

RUTGERS UNIVERSITY_ NJ, UNITED STATES
**CREATIVE TEAM:** Jun Li, Robin Rolikowski, Matt Weiss
**CLIENT:** Macmillan

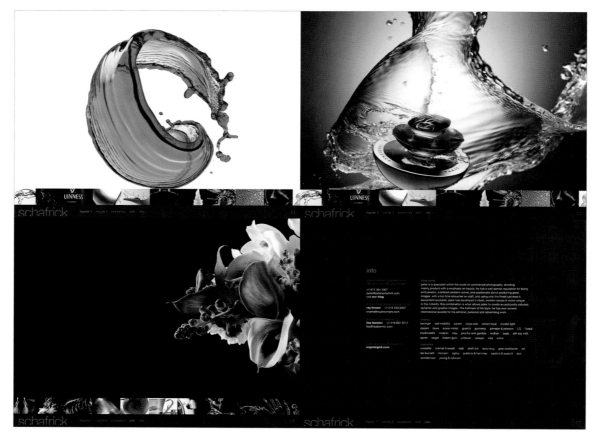

ORGANIC GRID_ PHILADELPHIA, PA, UNITED STATES
**CREATIVE TEAM:** Michael McDonald, Max Liberman, Peter Schafrick
**CLIENT:** Peter Schafrick Photography

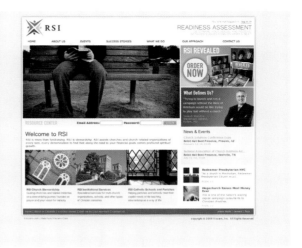

**LIFEBLUE MEDIA** ALLEN, TX, UNITED STATES
**CREATIVE TEAM:** Phillip Blackmon, Jeff Nunn, Russel Dubree
**CLIENT:** RSI & Ketchum (Pursuant Group)

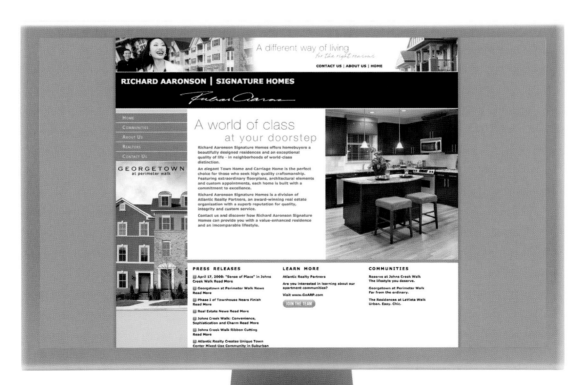

**SELLIER DESIGN** MARIETTA, GA, UNITED STATES
**CREATIVE TEAM:** Pauline Pellicer, Robert Thompson
**CLIENT:** Richard Aaronson Signature Homes

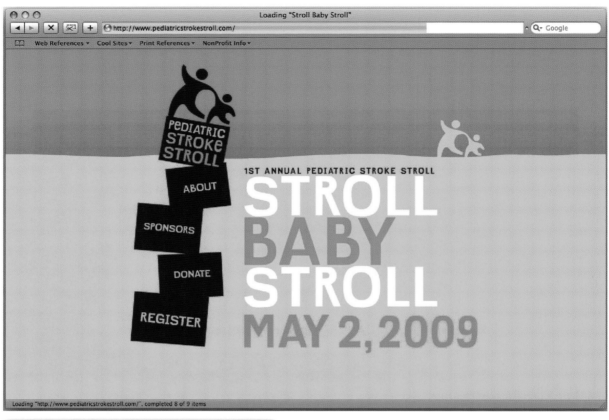

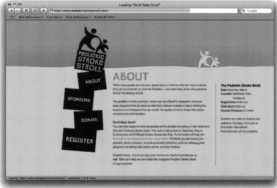

**CLOCKWORK STUDIOS_** SAN ANTONIO, TX, UNITED STATES
**CREATIVE TEAM:** Terri Gaines, Steve Gaines, Shawn Meek
**CLIENT:** Pediatric Stroke Network

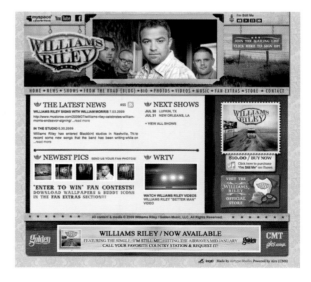

**AIRTYPE STUDIO_** WINSTON-SALEM, NC, UNITED STATES
**CREATIVE TEAM:** Bryan Ledbetter, James Greene
**CLIENT:** Golden Music, LLC

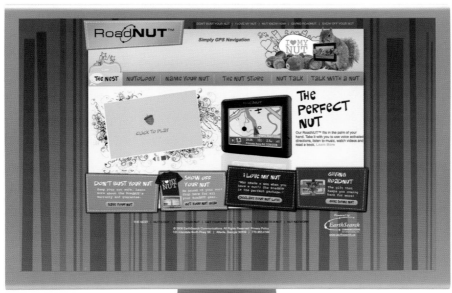

**SELLIER DESIGN_** MARIETTA, GA, UNITED STATES
**CREATIVE TEAM:** Pauline Pellicer, Robert Thompson
**CLIENT:** EarthSearch Communications

**DIXON SCHWABL_** VICTOR, NY, UNITED STATES
**CREATIVE TEAM:** Marshall Statt, Deanna Varble, Ian Auch, Dana Denberg
**CLIENT:** Pier 45

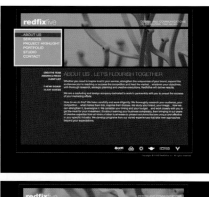

| **REDFIXFIVE_** IRVINE, CA, UNITED STATES
**CREATIVE TEAM:** Craig Mannino
**CLIENT:** Redfixfive

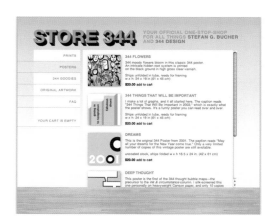

**344 DESIGN, LLC_** PASADENA, CA, UNITED STATES
**CREATIVE TEAM:** Stefan G. Bucher
**CLIENT:** Self-promotion

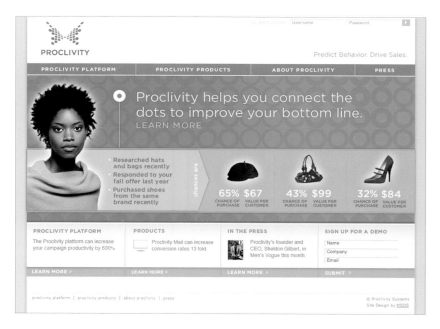

**MSDS_** NEW YORK, NY, UNITED STATES
**CREATIVE TEAM:** Zoya Edylman, Matthew Schwartz
**CLIENT:** Proclivity Systems

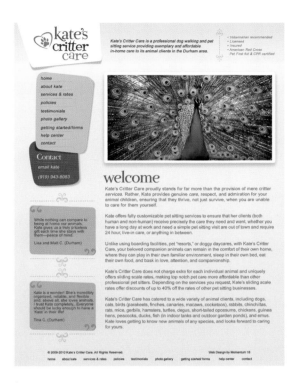

**CREATIVE SUITCASE_** AUSTIN, TX, UNITED STATES
**CREATIVE TEAM:** Rachel Clemens, Mackenzie Walsh, Dena Taylor
**CLIENT:** Vacation Rentals by Owner

**MOMENTUM 18_** DURHAM, NC, UNITED STATES
**CREATIVE TEAM:** Matt Chansky
**CLIENT:** Kate's Critter Care

**SYNTHVIEW_** PARIS, FRANCE
**CREATIVE TEAM:** Jan Tonellato
**CLIENT:** Regina di Picche

# Miscellaneous

WE'RE POLISHING THE
SILVER, VACUUMING
THE CARPET AND
MOWING THE ROOF.

KARACTERS DESIGN GROUP_ VANCOUVER, BC, CANADA
**CREATIVE TEAM**: James Bateman, Dan O'Leary, Brandon Thomas, Neil Shapiro
**CLIENT**: Vancouver Convention Centre

EVAN POLENGHI STUDIO_
NEW YORK, NY, UNITED STATES
**CREATIVE TEAM:** Evan Polenghi
**CLIENT:** Klutz Publishing

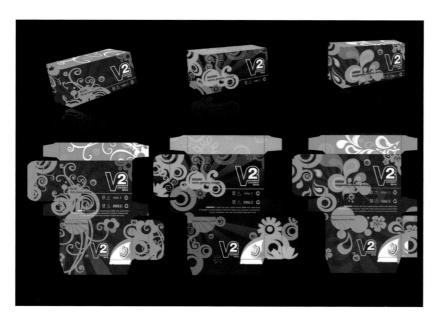

ANGELA POWIRO_ INDONESIA
**CREATIVE TEAM**: Denny Christian, Angela Powiro
**CLIENT**: V2

CAPSTONE STUDIOS, INC._
IRVINE, CA, UNITED STATES
**CREATIVE TEAM:** Jo-Anne Redwood, John T. Dismukes,
Dan Kitsmiller, Masa Lau
**CLIENT:** CostaBaja Resort & Marina

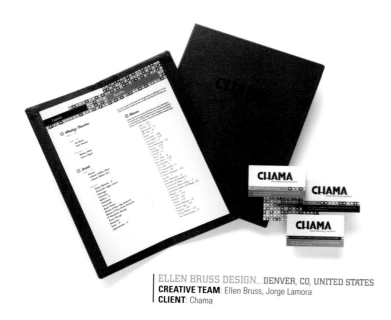

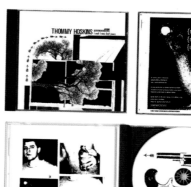

**ELLEN BRUSS DESIGN_** DENVER, CO, UNITED STATES
**CREATIVE TEAM**: Ellen Bruss, Jorge Lamora
**CLIENT**: Chama

**DJG DESIGN_** KANSAS CITY, MO, UNITED STATES
**CREATIVE TEAM**: Danny J. Gibson
**CLIENT**: Thommy Hoskins

369

**AKARSTUDIOS_** SANTA MONICA, CA, UNITED STATES
**CREATIVE TEAM**: Matt Lutz, Sat Garg
**CLIENT**: Tanzore

**MINE™_** SAN FRANCISCO, CA, UNITED STATES
**CREATIVE TEAM:** Christopher Simmons, Tim Belonax
**CLIENT:** Coalition of Essential Schools

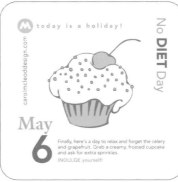

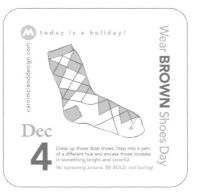

CAROL MCLEOD DESIGN_ MASHPEE, MA, UNITED STATES
**CREATIVE TEAM**: Carol McLeod, Chris Daigneault, Amy Caracappa-Qbeck
**CLIENT**: Carol McLeod Design

PRYOR DESIGN COMPANY_ ANN ARBOR, MI, UNITED STATES
**CREATIVE TEAM**: Scott Pryor, Laura Hervey
**CLIENT**: ULitho

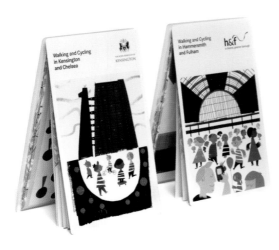

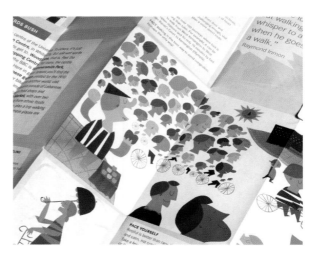

BEAM_ LONDON, UNITED KINGDOM
**CREATIVE TEAM**: Christine Fent, Dominic Latham-Koenig
**CLIENT**: Royal Borough of Kensington and Chelsea & Hammersmith and Fulham Councils

370

IPPOLITO FLEITZ GROUP_ STUTTGART, GERMANY
**CREATIVE TEAM**: Axel Knapp, Yuan Peng, Sarah Meßelken
**CLIENT**: Bella Italia Weine

YURKO GUTSULYAK_ KYIV, UKRAINE
**CREATIVE TEAM**: Yurko Gutsulyak
**CLIENT**: Kimberly-Clark Ukraine

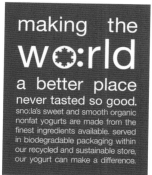

371

ROYCROFT DESIGN_ BOSTON, MA, UNITED STATES
**CREATIVE TEAM**: Jennifer Roycroft
**CLIENT**: John Hancock

AKARSTUDIOS_ SANTA MONICA, CA, UNITED STATES
**CREATIVE TEAM**: Sean Morris, Sat Garg
**CLIENT**: Sno:LA

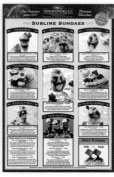

PLAINE STUDIOS_ NEW ORLEANS, LA, UNITED STATES
**CREATIVE TEAM**: Jacee Brown, Chris Brown
**CLIENT**: LePhare

GHIRARDELLI CHOCOLATE COMPANY_
SAN LEANDRO, CA, UNITED STATES
**CREATIVE TEAM**: Alissa Chandler, Leigh Beisch,
Heather Jordan, Yvo Smit
**CLIENT**: Ghirardelli Chocolate Company

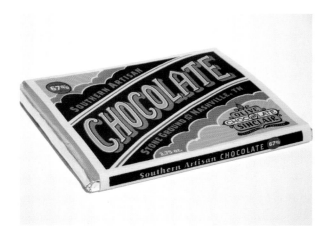

ANDERSON DESIGN GROUP_ NASHVILLE, TN, UNITED STATES
**CREATIVE TEAM**: Joel Anderson, Bryce McCloud
**CLIENT**: Olive and Sinclair Chocolate Company

LANDOR ASSOCIATES_ SYDNEY, AUSTRALIA
**CREATIVE TEAM**: Jason Little, Ivana Martinovic, Joao Peres, Sam Pemberton
**CLIENT**: Spicers Paper

WEATHER CONTROL_ SEATTLE, WA, UNITED STATES
**CREATIVE TEAM**: Josh Oakley
**CLIENT**: Eddie Bauer

MYTTON WILLIAMS LTD_ BATH, UNITED KINGDOM
**CREATIVE TEAM**: Bob Mytton, Keith Hancox, James Mcnaughton
**CLIENT**: Mytton Williams Ltd.

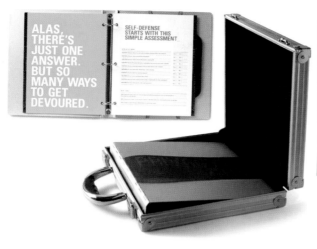

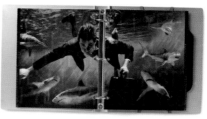

BERTZ DESIGN GROUP_
MIDDLETOWN, CT, UNITED STATES
**CREATIVE TEAM**: Bertz Design Group
**CLIENT**: Darwin Professional Underwriters

344 DESIGN, LLC_ PASADENA, CA, UNITED STATES
**CREATIVE TEAM**: Stefan G. Bucher
**CLIENT**: Burst Records

344 DESIGN, LLC_
PASADENA, CA, UNITED STATES
**CREATIVE TEAM**: Stefan G. Bucher, Mac Barnett, Jon Korn, Christina Galante
**CLIENT**: 826LA

373

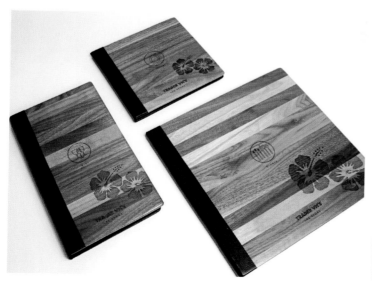

JACOB TYLER_ SAN DIEGO, CA, UNITED STATES
**CREATIVE TEAM**: Les Kollegian, Gordon Tsuji, Jessica Recht
**CLIENT**: Trader Vic's Las Vegas

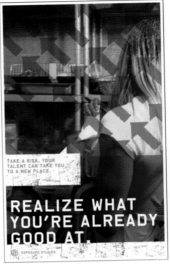
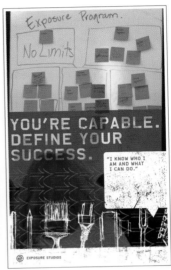

AVENUE MARKETING_ CHICAGO, IL, UNITED STATES
**CREATIVE TEAM**: Ian Watts, Jonathan Sarmiento, KyoYoung Park
**CLIENT**: Exposure Studios

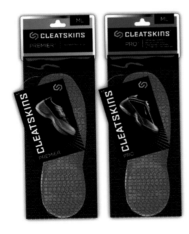

374

UNIT DESIGN COLLECTIVE_ SAN FRANCISCO, CA, UNITED STATES
**CREATIVE TEAM**: Ann Jordan, Shardul Kiri, Ryne Schillinger
**CLIENT**: Re:Vive Bodywork

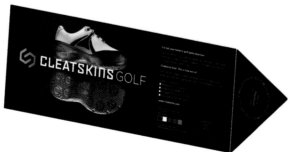

THE UXB_ BEVERLY HILLS, CA, UNITED STATES
**CREATIVE TEAM:** NancyJane Goldston, Glenn Sakamoto, Elizabeth Bennett,
Rick Chou, Ashlee McNulty, Siobhan
**CLIENT:** Cleatskins™

2CREATIVO_ BARCELONA, SPAIN
**CREATIVE TEAM**: Abel de Benito, Mariona López
**CLIENT**: 2creativo

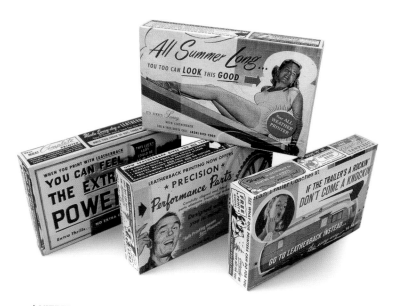

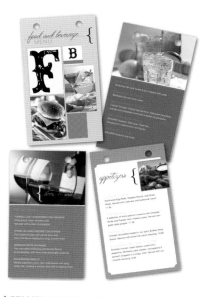

NIEDERMEIER DESIGN_ SEATTLE, WA, UNITED STATES
**CREATIVE TEAM**: Kurt Niedermeier
**CLIENT**: Leatherback Printing

SELLIER DESIGN_ MARIETTA, GA, UNITED STATES
**CREATIVE TEAM**: Julie Cofer, Pauline Pellicer
**CLIENT**: iMi Agency for Delaware North Companies, Inc.

375

ROCK, PAPER, SCISSORS_
LAWRENCEVILLE, GA, UNITED STATES
**CREATIVE TEAM**: Cynthia Sutt, Ting Low,
Nicole Hopkins, Amanda Sutt
**CLIENT**: Jacabee

ANDY GABBERT DESIGN_ OAKLAND, CA, UNITED STATES
**CREATIVE TEAM**: Andy Gabbert
**CLIENT**: Mama Lou American Strong Woman

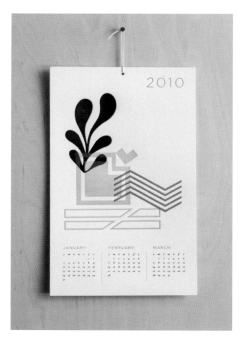

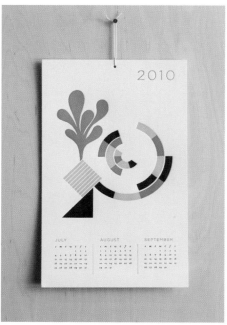

SEESAW DESIGNS_ SCOTTSDALE, AZ, UNITED STATES
**CREATIVE TEAM**: Angela Hardison, Raquel Raney, Lindsay Tingstrom
**CLIENT**: SeeSaw Designs

BRIGHT HORIZONS FAMILY SOLUTIONS_
WATERTOWN, MA, UNITED STATES
**CREATIVE TEAM**: Brianna Thomas,
Jessica Fein, Sarah Thomas
**CLIENT**: Bright Horizons Family Solutions

LEIBOLD ASSOCIATES, INC_ NEENAH, WI, UNITED STATES
**CREATIVE TEAM**: Jake Weiss
**CLIENT**: Leibold Associates, Inc.

AKARSTUDIOS_ SANTA MONICA, CA, UNITED STATES
**CREATIVE TEAM**: Sean Morris, Sat Garg
**CLIENT**: Seoul Bros.

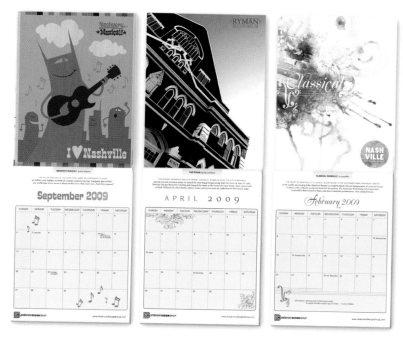

ANDERSON DESIGN GROUP_ NASHVILLE, TN, UNITED STATES
**CREATIVE TEAM**: Joel Anderson, Amy Olert, Edward Patton, Dawn Verner
**CLIENT**: Parris Printing

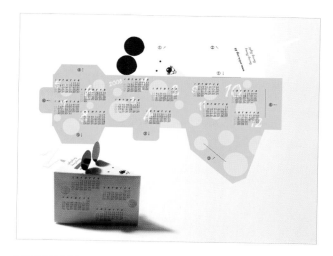

377

TINKVISUALCOMMUNICATION_ HONG KONG, CHINA
**CREATIVE TEAM**: Kelvin Hung, Fat Tsoi
**CLIENT**: ORBIS Hong Kong

YURKO GUTSULYAK_ KYIV, UKRAINE
**CREATIVE TEAM**: Yurko Gutsulyak
**CLIENT**: VS Energy International Ukraine

COLORYN STUDIO_ RICHMOND, VA, UNITED STATES
**CREATIVE TEAM:** Ryn Bruce
**CLIENT:** Pigtale Books

TOMAZ PLAHUTA DESIGN_ LJUBLJANA, SLOVENIA
**CREATIVE TEAM:** Tomaz Plahuta
**CLIENT:** Meta Shops

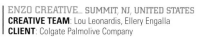

ENZO CREATIVE_ SUMMIT, NJ, UNITED STATES
**CREATIVE TEAM:** Lou Leonardis, Ellery Engalla
**CLIENT:** Colgate Palmolive Company

LANDOR ASSOCIATES_ SYDNEY, AUSTRALIA
**CREATIVE TEAM:** Jason Little, Joao Peres
**CLIENT:** Good Co. Coffee

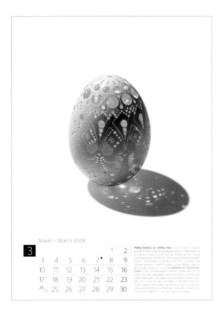

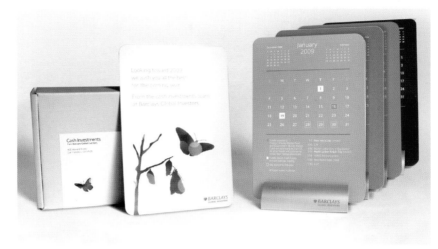

ANDY GABBERT DESIGN_ OAKLAND, CA, UNITED STATES
**CREATIVE TEAM**: Andy Gabbert, Claire Kurmel, Frederique Clay
**CLIENT**: Barclays Global Investors

KROG_ LJUBLJANA, SLOVENIA
**CREATIVE TEAM**: Edi Berk, Dragan Arrigler
**CLIENT**: Kmecki glas, Ljubljana

379

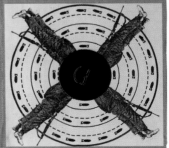

DJG DESIGN_ KANSAS CITY, MO, UNITED STATES
**CREATIVE TEAM**: Danny J Gibson,  Nathan Reusch
**CLIENT**: Konnor Ervin / The ACB's

DJG DESIGN_ KANSAS CITY, MO, UNITED STATES
**CREATIVE TEAM**: Danny J Gibson
**CLIENT**: Elevator Division

288 / Rio De Janeiro, Brazil / doisoitooito.com

13ThirtyOne Design / Hudson, WI, United States / 13thirtyone.com

1HO5 / Paris, France / pierrickcalvez.com

21XDDesign / Broomall, PA, United States / 21xdesign.com

22 Sparks / Aschaffenburg, Germany 22sparks.com

2Creativo / Barcelona, Spain 2creativo.net

2nd Floor Design / Portsmouth, VA, United States / www.2ndfloordesign.com

3 Advertising / Albuquerque, NM, United States / 3advertising.com

344 Design LLC / Pasadena, CA, United Kingdom / www.344design.com

Adam Katz Graphic Design / Somerville, MA, United States

Advertising Agency Zeeland / Turku, Finland

Aegis / Toronto, ON, Canada aegisbrand.net

Airtype Studio / Winstom-Salem, NC, United States / airtypestudio.com

AkarStudios / Santa Monica, CA, United States / http://akarstudios.com

Alexander Egger / Vienna, Austria www.satellitesmistakenforstars.com

Aloof Design / Lewes, East Sussex, United Kingdom / aloofdesign.com

Alphabet Arm / Boston, MA, United States / www.alphabetarm.com

ALR Design / Richmond, VA, United States / www.alrdesign.com

Ambient / Miller Place, NY, United States / www.theambientmind.com

Ana Paula Rodrigues Design / Newark, NJ, United States /anapaularodrigues.com

Anderson Design Group / Nashville, TN, United States / andersondesigngroup.com

Andy Gabbert Design / Oakland, CA, United States / andygabbertdesign.com

Angel D'Amico Illustration and Design / Chicago, IL, United States

Angela Powiro / Indonesia

Archetype Design Studio / Flushing, NY, United States / archetypedesignstudio.com

Arson / San Francisco, CA, United States

Avenue Marketing / Chicago, IL, United States / avenue-inc.com

AxiomaCero / Monterrey, Nuevo Leon, Mexico / www.axiomacero.com

B.G. Design / Los Angeles, CA, United States

Beam / London, United Kingdom / designbybeam.com

Bertz Design Group / Middletown, CT, United States / www.bertzdesign.com

Beth Singer Design / Arlington, VA, United States / www.bethsingerdesign.com

Big Fig Design / Bellevue, WA, Unites States / www.bigfigdesigngroup.com

Blue Marble Creative / White Salmon, WA, United States / bluemarblecreative.net

BlueSpark Studios / Santa Monica, CA, United States / www.bluesparkstudios.com

Bradbury Branding & Design / Regina, SK, Canada / www.bradburydesign.com

Bright Horizons Family Solutions / Watertown, MA, United States / brighthorizons.com

Bronson Ma Creative / San Antonio, TX, United States / www.bronsonma.com

Bucknell University / Lewisburg, PA, United States

Buro North / Melbourne, Australia www.buronorth.com

Calagraphic Design / Elkins Park, PA, United States

Call Me Amy Design / Seattle, WA, United States / callmeamy.com

Camp Creative Group / Blue Ridge Summit, PA, United States

Capstone Studios Inc. / Irvine, CA, United States / capstonestudios.com

Caracol Consultores / Morelia, Michoacan, Mexico / www.caracolconsultores.com

Cardeo Creative / North Vancouver, BC, Canada / cardeo.ca

Carol McLeod Design / Mashpee, PA, United States / www.carolmcleoddesign.com

Carousel30 / Alexandria, VA, United States / carousel30.com

Cerebral Leasing / Harrisburg, PA, United States

Chip Forelli Studio LLC / Damascus, PA, United States / www.chipforelli.com

CincoDeMayo Design / Monterrey, Nuevo Leon, Mexico / www.cincodemayo.to

Clay McIntosh Creative / Tulsa, OK, United States / claymcintosh.com

ClockWork Studios / San Antonio, TX, United States / www.clockworkstudios.com

Coloryn Studio / Richmond, VA, United States / www.colorynstudio.com

Conry Design / Topanga, CA, United States / conrydesign.com

Copia Creative Inc / Santa Monica, CA, United States / www.copiacreative.com

Courtney & Co. Design / Forest Hill, MD, United States

Cranium Studio / Denver, CO, United States / www.craniumstudio.com

Crea7ive / Coral Springs, FL, United States / crea7ive.com

Creative Suitcase / Austin, TX, United States / www.creativesuitcase.com

Crumpled Dog Design / London, United Kingdom / www.crumpled-dog.com

Cyan Concept Inc. / Saguenay, QC, Canada / cyan-concept.com

D Street Design / San Clemente, CA, United States

Daniel Rothier / Rio De Janeiro, Brazil

DarcyLea Design / Sidney, NE, United States

Dartmouth College / Hanover, NH, United States

DC Graphics / Atlanta, GA, United States / dionnacollinsgraphics.com

DeanArts / Berkeley, CA, United States

Defteling Design / Portland, OR, United States / defteling.com

Delphine Keim-Campbell / Moscow, ID, United States

Design Grace / Jersey City, NJ, United States / designgrace.com

Design Nut LLC / Kensington, MD, Unites States / www.designnut.com/

Dever Designs / Laurel, MD, United States / deverdesigns.com

DezineGirl Creative Studio / San Diego, CA, United States / dezinegirlcreative.com

Dixon Schwabl / Victor, NY, United States / www.dixonschwabl.com

DJG Design / Kansas City, MO, United States

Dotzero Design / Portland, OR, United States / dotzerodesign.com

Doug Barrett Design / Birmingham, AL, United States

DSN / Warsaw, Poland

Elements / New Haven, CT, United States / elementsdesign.com

Ellen Bruss Design / Denver, CO, United States / http://www.ebd.com

Emspace Group / Hagerstown, MD, United States / www.emspacegroup.com

Enzo Creative / Summit, NJ, United States / enzocreative.com

Erwin Hines / Pittsburgh, PA, United States

Essence Design Limited / Sutton Coldfield, WM, United Kingdom / www.essence-design.co.uk

Evan Polenghi Studio / New York, NY, United States / evanpolenghi.com

Eye Design Studio / Charlotte, NC, United States / evokeresponse.com

F+W Media / Cincinnati, OH, United States

Firebox Media / San Francisco, CA, United States / www.fireboxmedia.com

Foundry / Calgary, AB, Canada / foundrycreative.ca

Ftofani / Sao Paulo, Brazil

Future Imaging Design / Montreal, Canada www.futureimaging.co.uk/

Gabrielle Gozo / Philadelphia, PA, United States / gabriellegozo.com

GDLoft / Philadelphia, PA, United States / gdloft.com

Gee + Chung Design / San Francisco, CA, United States / geechungdesign.com

Gemini 3D / Iles De La Madeleine, QC, Canada / gemini3d.com

Geyrhalter Design / Santa Monica, CA, United States / geyrhalter.com

Ghirardelli Chocolate Company / San Leandro, CA, United States / ghirardelli.lindt.com

GHL Design / Raleigh, NC, United States / ghldesign.com

GigaPixel Creative Inc / New York, NY, United States / gigapixelcreative.com

Graphic Faction Inc / Minneapolis, MN, United States

Graphicat Limited / Hong Kong / www.graphicat.com/

Green Group Studio / Greenacres, FL, United States / greengroupstudio.com

HA Design / Glendora, CA, United States

Heather Grimstead / McLean, VA, United States / heathergrimstead.com

Hill Design Studios / Salem, OR, United States

Hoffi Limited / Cardiff, United Kingdom / hoffi.com

Holly Dickens Design Inc / Chicago, IL, United States / www.hollydickens.com/

HouseMouse / Melbourne, Australia / housemouse.com.au

I2Fly / Bangalore, Karnataka, India / i2fly.com

Ian Lynam Creative Direction & Graphic Design / Toyko, Japan / ianlynam.com

IdeaStream Design Inc. / Vancouver, Canada / ideastreamdesign.com

IE Design + Communications / Hermosa Beach, CA, United States / www.iedesign.com

ImageBox Productions / Pittsburgh, PA, United States / iedesign.com

Imagine / Manchester, United Kingdom / imagine-cga.co.uk

Innovative Interfaces Marketing / Emeryville, CA, United States / www.iii.com

Ippolito Fleitz Group / Stuttgart, Germany / ifgroup.org

Iridium Group Inc / New York, NY, United States / www.iridiumgroup.com

Ivy Tech Community College / Sellersburg, IN, United States

Jackson-Dawson Communications / Dearborn, MI, United States / jdcomm.com

Jacob Tyler / San Diego, CA, United States / jacobtyler.com

Jam Design & Communications / London, United Kingdom / www.jamdesign.co.uk/

James Marsh Design / Kent, United Kingdom / jamesmarsh.com

Jason Hill Design / Phoenix, AZ, United States / jasonhilldesign.com

JM Designs / Loveland, CO, United States / jm-designs.com

Judit Design / Malmo Skane, Sweden

Just Nikki / Brooklyn, NY, United States

Kalico Design / Frederick, MD, United States / kalicodesign.com

Karacters Design Group / Vancouver, BC, Canada / karacters.com

Kelly Bryant Design / Auburn, AL, United States

Kelsey Advertising & Design / Lagrange, GA, United States / kelseyads.com

Kradel Design / Philadelphia, PA, United States

Krog / Ljubljana, Slovenia / krog.si

Kutztown University / Blandon, PA, United States

Landor Associates / Syndey, Australia / www.landor.com

LCDA / San Diego, CA, United States / coedesign.com

Legacy Design Group / Hockley, TX, United States / legacydesigngroup.com

Lehman Graphic Arts / Queensbury, NY, United States / lehmangraphicarts.com

Leibold Associates Inc. / Neenah, WI, United States / leibold.com

Leo Mendes Design / Rio De Janeiro, Brazil / leomendes.net

Levine & Associates Inc. / Washington, DC, United States / levinedc.com

LifeBlue Media / Allen, TX, United States / lifeblue.com

LiquidChrome Design Inc / Vaughan, ON, Canada / liquidchrome.net

Little Utopia Inc. / Los Angeles, CA, United States / littleutopia.com

Mad Dog Graphx / Anchorage, AK, United States / thedogpack.com

Mary Hutchinson Design LLC / Seattle, WA, United States / maryhutchinsondesign.com

Masood Bukhari / Bronx, NY, United States

Matchstic / Atlanta, GA, United States / matchstic.com

Mayda Freije Makdessi / Beirut, Lebanon

MC2 Communications / Chicago, IL, United States / mc2chicago.com

McMillian Design / Brooklyn, NY, United States / mcmilliandesign.com

Mendes Publicidade / Balem, Para, Brazil

Michelle Roberts Design / Barneveld, NY, United States / michellerobertsdesign.com

MINE / San Francisco, CA, United States / minesf.com

Momentum 18 / Durham, NC, United States / momentum18.com

Moonlight Creative Group / Charlotte, NC, United States / moonlightcreativegroup.com

Mowaii / Cyriax, NRW, Germany / mowaii.com

Moxie Sozo / Boulder, CO, United States / moxiesozo.com

MSDS / New York, NY, United States / ms-ds.com

Mueller Design / Oakland, CA, United States / muellerdesign.com

MWM Graphics / Portland, ME, United States / mwmgraphics.com

Mytton Williams / Bath, United Kingdom / myttonwilliams.co.uk

NalinDesign / Neuenrade, Germany / nalindesign.com

Narendra Keshkar / Indure, Madhya Pradesh, India

Netra Nei / Seattle, WA, United States / netranei.com

Never Trust a Dame / San Francisco, CA, United States / nevertrustadame.com

Nico Ammann / Zurich, Switzerland

Nicole Ziegler Design / Chicago, IL, United States

Niedermeier Design / Seattle, WA, United States / kngraphicdesign.com

Nils-Peter Ekwalls Illustrationsbyra / Malmo, Sweden / nilspetter.se

Nora Brown Design / Brookline, MA, United States

NovieNatalie / Bandung, Jawa Barat, Indonesia / Novienatalie.com

Oakley Design Studio / Portland, OR, United States / oakleydesign.com

ohTwentyOne / Euless, TX, United States / www.ohtwentyone.com

Omma Creative / Marietta, GA, United States / ommacreative.com

Organic Grid / Philadelphia, PA, United States / organicgrid.com

P & J Designs / Atlanta, GA, United States

Paige1Media / Broken Arrow, OK, United States / paige1media.com

Paradowski Creative / St. Louis, MO, United States / paradowski.com

Pat Sloan Design / Fort Worth, TX, United States

Paul Snowden / Berlin, Germany / paul-snowden.com

Peak Seven Advertising / Deerfield Beach, FL, United States / peak7.com

People Design / Grand Rapids, MI, United States / peopledesign.com

Peter Li Education Group / Dayton, OH, United States

PH.D A Design Office / Santa Monica, / CA, United States / phdla.com

Plaine Studios / New Orleans, LA, United States / plainestudios.com

Planet Ads & Design PTE LTD / Singapore / planetad.com.sg

Ponderosa Pine Design / Reno, NV, United States

ProjectGraphics EU / Prishtina, Kosova, Albania / projectgraphics.eu

Pryor Design Company / Ann Arbor, MI, United States / prydesign.com

Range / Dallas, TX, United States / rangeus.com

RedFixFive / Irvine, CA, United States / redfixfive.com

Remo Strada Design / Lincroft, NJ, United States / remostrada.com

Ribbons of Red / Cincinnati, OH, United States / ribbonsofred.com

Ripe Creative / Phoenix, AZ, United States / ripecreative.com

Robinson Thinks / Charlotte, NC, United States / robinsonthinks.com

Rock, Paper, Scissors / Lawrenceville, GA, United States / 123shoot.com

Roy Creative / Rockville, MD, United States

Roycroft Design / Boston, MA, United States / roycroftdesign.com

Rule29 / Geneva, IL, United States / rule29.com

Saint Dwayne Design / Charlotte, NC, United States / stdwayne.com

Sandals Resorts / Miami, FL, United States

Sandormax / Sandy Hook, CT, United States

Scott Adams Design Associates / Minneapolis, MN, United States / sadesigna.com

ScratchDisk Creative SDN BHD / Selangor, De, Malaysia / scratchdisk.biz

Seesaw Designs / Scottsdale, AZ, United States / seesawdesigns.com

Sellier Design / Marietta, GA, United States / sellierdesign.com

Shine Advertising / Madison, WI, United States / www.shinenorth.com

Silver Creative Group / Norwalk, CT, United States / silvercreativegroup.com

Simpatico Design Studio / Alexandria, VA, United States / simpaticodesignstudio.com

skinnyCorp / Threadless / Chicago, IL, United States /spigumus.com

Solak Design Co. / New Hartford, CT, United States

Spatchurst / Broadway, Australia / spatchurst.com.au

Splash:Design / Kelowna, BC, Canada / splashdesign.biz

Stauber Design Studio Inc / Chicago, IL, United States / stauberdesign.com

Sterk Water / Antwerp, Belgium /sterkwater.be

Storm Corporate Design / Auckland, New Zealand / storm-design.co.nz

Stout Design / Atlanta, GA, United States / http://stoutdesign.com

Studio E Flett Design / Gorham, ME, United States / www.erinflett.com

Subcommunication / Montreal, QC, Canada / subcommunication.com

Substance151 / Baltimore, MD, United States / substance151.com

Susquehanna University / Selinsgrove, PA, United States

Symbiotic Solutions / Lansing, MI, United States

Synthview / Paris, France / synthview.com

Talbot Design Group Inc. / Westlake Village, CA, United States / talbotdesign.com

Team Us Design / Philadelphia, PA, United States

Ten26 Design Group Inc / Crystal Lake, IL, United States / ten26design.com

The College of Saint Rose / Albany, NY, United States

The Grafiosi / New Delhi, India / thegrafiosi.com

The O Group / New York, NY, United States / ogroup.net

The Phelps Group / Santa Monica, CA, United States / thephelpsgroup.com

The UXB / Beverly Hills, CA, United States / www.theuxb.com

Think Studio NYC / New York, NY, United States / thinkstudionyc.com

Thinkhaus / Richmond, VA, United States / thinkhausdesign.com

Thrive Design / East Lansing, MI, United States

TiNKvisioncommunications / Hong Kong / tink.com.hk

Tom Dolle Design / New York, NY, United States / www.dolledesign.com

Tomato Graphics / Amarillo, TX, United States / tomatographics.com

Tomaz Plahuta Design / Ljubljana, Slovenia / eno.si

Towson University / Towson, MD, United States

Tracy Kretz / Harrisburg, PA, United States /

Transmission / Brighton, United Kingdom / thisistransmission.com

Typographicspell / Istanbul, Turkey

Unfolding Terrain / Hagerstown, MD, United States

Unit Design Collective / San Francisco, CA, United States / unitcollective.com

University of Northern Iowa / Ely, IA, United States

URedd / Trondhiem, Germany / uredd.no

Valladares Diseño y Comunicación / Santa Cruz De Tenerife, Spain / valladaresdc.net

VamaDesign / Greece / vamadesign.com

Version-X Design Group / Burbank, CA, United States / version-x.com

VGreen Design / Corsicana, TX, United States / vgreendesign.com

Visionn Creative Marketing / Tempe, AZ, United States / www.visionn.com

VKP Design / Haarlem, Netherlands

Weather Control / Seattle, WA, United States /

Werner Design Werks / St. Paul, MN, United States / wdw.com

West Pomeranian University of Technology / Szczecin, Poland

Yotam Hadar / Tel Aviv, Israel